The Metaphor of Painting

Essays on Baudelaire, Ruskin, Proust, and Pater

For Richard Howard

Baudelairean lecteur

Fondly

Jen

Studies in the Fine Arts:
Criticism, No. 7

Donald B. Kuspit
Chairman, Department of Art
State University of New York at Stony Brook

Kenneth S. Friedman, Ph.D.
Consulting Editor

Other Titles in This Series

The Metaphor of Painting

Essays on Baudelaire, Ruskin, Proust, and Pater

by
Lee McKay Johnson

RESEARCH PRESS

Produced and distributed by
UMI Research Press
an imprint of
University Microfilms International
Ann Arbor, Michigan 48106

Library of Congress Cataloging in Publication Data

Johnson, Lee McKay.
 The metaphor of painting.

 (Studies in fine arts : Criticism ; no. 7)
 Bibliography: p.
 Includes index.
 1. English prose literature—19th century—History and
criticism. 2. French prose literature—19th century—History
and criticism. 3. Aesthetics, Modern—19th century.
4. Symbolism (Literary movement) 5. Art criticism. 6. Art
and literature. I. Title. II. Series.

PR788.A38J6 809 80-23131
ISBN 0-8357-1092-0

To Alice, for everything

Contents

Acknowledgments

I would like to thank Professors Ian Watt, Albert Guerard, Robert Cohn, and Barbara Charlesworth of Stanford University and Professor S. Dale Harris of Sarah Lawrence College for their help as teachers in directing the original dissertation and in reading the revised manuscript and offering critical commentary; I would also like to thank Professors Fred Warner and Paul Davis of the University of New Mexico and Michel Butor of the Université de Nice for their helpful reading of the final manuscript, and I would like to add special thanks to Professor Claude-Marie Senninger of the University of New Mexico for her aid in translating.

Foreword

The role of the art critic is paradoxical. He makes the first, and presumably freshest, response to the work of art, grasps it when it is still new and strange, and gives us a preliminary hold on its meaning. Yet his response is not comprehensive, for it is inexperienced: the work has not yet had a history, a context of response to give its "text" density. When the critic encounters it as a contemporary product, it lacks historical "bearing." Indeed, part of the critic's task is to win it a hearing at the court of history. This is why, as Baudelaire says, the critic is often a "passionate, partisan observer" of the work, rather than a detached judge of its value. As its contemporary, he plays the role of advocate, knowing the case only from the viewpoint of the work itself. For the sensitive critic the work will always remain a surprise, and he will always be its enthusiast. He will leave it to the future historian to engage in that dissection of art which presupposes a settled opinion of its significance.

Yet—and this is the paradox—the temporary opinion of the critic often becomes the characteristic one. The critic's response is, if not the model, then the condition for all future interpretation. His attention is the work's ticket into history.

A sign of the critic's power, in modern times, is his *naming* of new art. Louis Vauxcelles' labels "Fauvism" and "Cubism," for instance, have had an enormous influence on the understanding of these styles. Through such names art assumes an identity for future generations. And an understanding which begins as no more than a "semiotic enclave," to use Umberto Eco's term, becomes a whole language of discourse, creating an entire climate of opinion. Clearly, the responsibility is awesome. Clement Greenberg once wrote that the best moment to approach a work of art critically was after the novelty had worn off but before it became history. Yet it is at just that moment that the work is most unsettled and vulnerable, when the critic's swift "decision," in the form of an impromptu name, can seal its destiny forever. In so seemingly trivial an instance as naming we see criticism's enormous power of determination.

Criticism, then, as Oscar Wilde wrote in "The Critic as Artist," is vital to art. Criticism grasps and preserves, cultivates and exalts. The history of art criticism is the history of different generations' responses to the art. No doubt

the interests of the generation determine what is interesting about the art. As Reinhild Janzen tells us in her study of Altdorfer criticism, the assumption of *Rezeptionsgeschichte*—the history of critical response to an art—is that "a work of art is a piece of dead matter until it is drawn into a dialectic, dynamic relationship with an observer," and the interests of the observer obviously influence the nature of the relationship. The history of art criticism is both the record of such relationships and the demonstration of their significance to the work of art. This insight underlies the Janzen study as well as the other volumes in this series.

At stake in the encounter between art and its observer is ideology or, in H. R. Jauss' words, the "recipient's ... horizon of expectation." That ideology both conditions the recipient's response to the work of art and is itself affected by the encounter.

At the same time, as Janzen says, the recipient's horizon of expectation leads to the differentiation between "primary and secondary types of reception. The first is the original experience or encounter with a work of art." The second is influenced by "knowledge of preceding, traditional interpretations." In Janzen's study, Freidrich Schlegel's essay on Altdorfer's *Battle of Alexander* is an example of primary reception and Oskar Kokoschka's later interpretation of the same painting illustrates secondary reception. Clearly, from the viewpoint of *Rezeptionsgeschichte,* there are no absolute criticisms of art, for even the primary reception is determined by the interests of the critic, and thus is dialectical. Indeed, as Janzen implies in her endorsement of Herder's concept of criticism, the recognition of the dialectical character of criticism that *Rezeptionsgeschichte* forces upon us is an antidote to "aesthetic historicism's static view of history," i.e., its concept of the aesthetic finality of the work of art.

This series of titles selected from dissertation literature exemplifies *Rezeptionsgeschichte* in a variety of ways. First, it shows us the history of the reception of artists whom we have come to regard as "major," in particular Altdorfer (in the Janzen volume) and Van Gogh (in Zemel's study). The authors discuss both how these artists moved from minor to major status and the meaning of the move for the culture in which it was made.

Second, the series offers us the history of individual critics' reception of a variety of art. We trace the development of a characteristic view of art in Baudelaire, Ruskin, and Pater (in the Johnson work), in Champfleury (Flanary), and in Claudel (Gelber). Sometimes, as in the case of Champfleury and Claudel, we are dealing with figures whose primary identity does not seem connected with the visual arts. At other times, as in the cases of Baudelaire, Ruskin, and Pater, even when the figure is associated with the visual arts, the ideology is grounded in larger cultural issues as well as other, usually literary, arts. The perspective of such a mind often leads to unexpected insights and lends fresh significance to the work of art.

Third, the series addresses the critical response to whole movements of art, in particular Cubism (in the Gamwell treatise) and Abstract Expressionism (Foster). We learn how an art that seemed aberrant came to seem central and how critical response created a unified outlook on a highly differentiated group of artists.

Fourth, we have portraits of figures—Félix Fénéon by Halperin and Roger Fry by Falkenheim—who are more or less exclusively art critics. As professionals their horizons of expectation developed in close encounters with art. And their outlooks are also shown to involve larger cultural orientations—the ideology that makes their responses to art dramatic, part of a larger dialectic, dynamic relationship with their culture.

Finally, Olson's treatise examines the development of journalistic criticism in New York. We see *Rezeptionsgeschichte* as it enters a new, democratic, populist phase. Journalistic critics spearhead the advance of culture for the masses in which the encounter with art is there for the asking by anyone.

These five genres of *Rezeptionsgeschichte* demonstrate the richness and complexity of art criticism as an intellectual and cultural enterprise. They also make clear that there is no such thing as neutral, ideology-free criticism. Indeed, the very meaning of criticism is to put information to a larger use, to subject it to an *Aufhebung* or mediation which makes it truly telling—truly revelatory of the art. Art criticism, as it is examined in these volumes, is neither description nor evaluation of art. It is a means of entry, through art, into a study of the complex intentions that structure the life-world, and a demonstration of art's structural role in the life-world that produces it.

In concluding, let us note some particulars of the volumes in this series, especially the ways in which they tie in with broader cultural issues. Janzen makes clear that Altdorfer's reputation hangs on the familiar North/South— Northern Romantic/Southern Classical—conflict. Altdorfer's slow acceptance corresponds to the reluctant acceptance of Northern irrationality or abnormality and Southern (Italianate) rationality and normativeness. In her study of Van Gogh Zemel shows that at issue in the reception of Van Gogh's art was the artist's temperament or emotionality, as the foundation of his creativity. Van Gogh came to be accepted when it was recognized that emotions were a major component of creativity. Van Gogh's art became the proof of this assumption.

Johnson shows us that the art criticism of Baudelaire, Ruskin, and Pater demonstrates the growth of bourgeois individualism. The "poetic" individuality the critic can achieve through the art becomes emblematic of bourgeois self-possession and integrity in the eyes of the world. Their art criticism is also caught up in the shift from the concept of art as a (romantic) depiction of nature to the idea of art for art's sake. Art for art's sake is another means whereby individuality is achieved and refined.

In her work on Claudel, Gelber offers us a new perspective: modern art

seen in a religious context. Claudel is haunted by the possibility of a modern religious, specifically Christian, art. Gelber shows how one well-formed ideology, even if based more on non-art than art encounters, can lead to a powerful analysis of art. Flanary makes a similar point in her study of Champfleury, although here the ideology is secular rather than sacred. Champfleury's sense of the importance of realism and Claudel's sense of the importance of Christianity as comprehensive *Weltanschauungs* shape their perspectives on art.

In Gamwell's volume on Cubist criticism and Foster's on Abstract Expressionist criticism we see the way in which complexity of meaning can interfere with an understanding of art. In these studies we have a sense of how much an art can deliver, and how uncertain we finally are about what is delivered. Yet, we sense that the art is aesthetically important because it has become a stylistic idiom for many.

Halperin's work on Fénéon offers us a study of a critic's language. In Falkenheim's book we learn the historical background of Roger Fry's formalism, which became a major ideology as well as an empirical mode of analysis of 20th-century art. Olson acquaints us with critics who claim to represent the masses in their encounter with art—popularizers of criticism as well as of art. All three studies show us criticism in a practical as well as theoretical light. Criticism can be a short, sharp look as well as a considered opinion, a way of dealing with a newly given object as well as with a standing problem.

These volumes demonstrate the versatility and subtlety of art criticism. Whether we accept Robert Goldwater's notion that criticism is a "provisional perspective" on art and so implicity journalistic, or Pater's notion that it is a means to profound spiritual experience and self-discovery, or Claudel's view that criticism is the study of art in the light of a dominant *Weltanschauung,* art criticism displays a unique range of methods for the investigation of art.

Donald B. Kuspit
Series Editor

Introduction

The idea of painting as a metaphor for literature is ancient. The analogy between the "sister arts" of poetry and painting has been a recurring concept in aesthetics from Greek civilization to the present day. This book is focussed on a new interpretation of the metaphor which emerged in England and in France during the 1840s in reaction to Romanticism. As M.H. Abrams has pointed out,[1] the doctrine of the "sister arts" dropped into insignificance during the Romantic revolution: a major premise of this book is that the analogy was revised, by Baudelaire in France, and by Ruskin in England, exactly at the point of breaking with Romantic doctrine. Ruskin and Baudelaire are the initiators of aesthetic changes that came to be retrospectively termed Symbolism; as I try to show in the first part of this book, most of their criticism of Romantic literary theory is based on an application of principles derived from visual art to writing. Both Ruskin and Baudelaire invent a personal version of the traditional analogy between writing and painting, and in explaining this analogy in their criticism, and in applying the aspects of the analogy to their own writing of poetry and prose, they define the aesthetic outlines of the next half century and provide a background of ideas and examples for the development of Symbolism. This Symbolist version of the metaphor of painting, its inception and its continuance, is the subject of this book.

The term Symbolism is used throughout this book with a broad and loose intention, much as it is used by Edmund Wilson in *Axel's Castle* to describe the literary movement which arose in reaction to Romanticism and continues down to the present day, where the original ideas have been absorbed and diluted into the general public attitude toward art. Briefly stated, the Symbolist attitude is based on the autonomy of the work of art, its privileged position as a spiritual object, and its independence from its creator. Almost all of the major writers who are conditioned by the Symbolist aesthetic have the same general ideal of form; comprehensively defined, the Symbol is a self-contained unit which contains a multiplicity of meaning that cannot be paraphrased. The work of art, the poem, the novel, the essay is considered as an expanded Symbol, the meaning of which is established through the relative and reciprocal relations of parts within the structure. There are two governing aspects that are invariably

attached to the idea of the Symbol, but which vary in interpretation from writer to writer. The first is the idea that language is a concrete medium, and that words, like colored pigments or musical notes, have physical substance and a sensory impact as well as their function as intellectual signs. The physicality of language is related to the autonomy of the Symbolist work; the text becomes an object with its own unique existence, no longer an extension of the author's voice in printed form. The second aspect is related to the Symbolist values of multiplicity, relativity and reciprocity: if the meaning of a work of art as Symbol must be perceived as a totality, then literature must somehow manage to approximate the simultaneous effect of painting, in which all parts of the canvas are seen in relation together all at once. Painting is the art traditionally associated with simultaneity, and in fact literate painters from Leonardo to Delacroix have claimed that the superiority of painting lies in its ability to produce a total effect instantaneously, while the writer is bound by the laws of linear sequence and temporal succession. But during the Symbolist period, writers challenged the painters, and created a variety of literary equivalents for the structure of a painting, forms which are organized around the ideal of totality and designed to operate with theoretical simultaneity. Throughout the long history of the sister arts as an aesthetic *dictum,* there had never been an explicit attempt to duplicate the structural aspects of painting in literature: as Jean Hagstrum has stated in *The Sister Arts,* the closest approximation to a structural transference from painting to writing up to the end of the eighteenth century occurs in the Hellenistic Greek prose Romances.[2] As Hagstrum describes the tradition of the analogy, he emphasizes the mimetic function of painting and literature as the basis for their comparison: the implication is that in attempting to imitate or mirror nature, the writer can learn from the painter how to add *enargeia* to his depiction ("enargeia implies the achievement in verbal discourse . . . of a pictorial quality that is highly natural"[3]). Hagstrum shows how the locus classicus of the "sister arts" tradition is found in Horace's offhand comment "ut pictura; poesis," and how Horace's comment is elevated to a kind of aesthetic command that the writer imitate the painter. But the imitation that is practiced is either an attempt to borrow from painting iconographically, or to produce a form of literary pictorialism. Hagstrum defines pictorialism as the writer's attempt to present a verbal work of art that is either "picturable" or the effect of which "seems to arise from the *visibilia* present. General didactic statement may appear, but in a pictorial context it must seem, like an inscription on a statue, to be subordinate to the visual presentation."[4] Pictorialism, therefore, in literature is the writer's attempt to imitate the painter in rendering the visible world in verbal depiction. This attempt, as Hagstrum notes, frequently involves a sense of stasis, motion within literature reduced to a minimum. Although the writer necessarily imitates the stasis of painting, there is no attempt to translate the compositional techniques of painting or the meta-

physical implications of the structure of painting into literary form. Thus the Symbolist version of *ut pictura; poesis* represents a major stage in the historical development of the analogy. For the first time, the writer imitates the actual form of communication represented by a painting. Baudelaire, for example, was more interested in the pictorial structure of his poetry than in pictorial content. Although he wrote traditional pictorial poems, in the eighteenth-century sense of the word, his major innovation as a poet was to reinvent language[5] so that a poem could produce the same order of sensation that he felt when viewing a painting by Delacroix, whether or not there was any specific visual content in the poem. A painting for Baudelaire was an experience of the "surreal," a state of mind that transcends boundaries and categories and reaches a level of pure perception, pure understanding. The silent communication of painting, which radiates a complex of meaning which is perceived all at once, represents for Baudelaire the highest level of the imagination in operation, both for the creator and the observer. Baudelaire is often described as the father of Symbolism particularly because of the value that he placed on sensation. Baudelaire felt that the sensation produced by a Delacroix canvas contained thought, reason, and intelligence but at the same time went beyond thought to a direct realization of the 'universal analogy.' So for Baudelaire, painting communicates a metaphysical sense directly and concretely, viscerally in fact. Baudelaire is one of the first moderns because he understands the failure of language to render the fullness of sensation; in imitating Delacroix, Baudelaire is trying to free language from its traditional linear and causal description of experience, and to push language to new limits, into new patterns that can produce a particular state of consciousness directly in the same way that a Delacroix painting can silently radiate meaning. In a sense Baudelaire's emphasis on the "radiant" aspect of painting could be seen as a new interpretation of the traditional concept of "enargeia" associated with the "sister arts"; but Baudelaire is not only rivalling painting in producing intensity of sensation, he is reorganizing language to imitate the simultaneous structure of communication which painting represents. Baudelaire goes beyond *visibilia* to the visionary: literature imitates painting because painting reveals the metaphysical structure of reality more directly than any other art form. Thus when the metaphor of painting is revived in the mid-nineteenth century, it reemerges with intrinsic philosophical values that had never been explored during the long history of the analogy.

As I try to show in each chapter of this book, the two governing aspects of Symbolist theory, the concepts of tangible language and simultaneous form, are both directly based on the analogy to painting, and both have a distinctly "modern" metaphysical dimension. In trying to describe the change in the writer's concept of language as a medium, it would be helpful to look at two modern "philosophers" of language, George Steiner and Merleau-Ponty. In *After Babel*, Steiner states:

The concept of 'the lacking word' marks modern literature. The principal division in the history of Western literature occurs between the early 1870s and the turn of the century. It divides a literature essentially housed in language from one for which language has become a prison. Compared to this division all preceding historical and stylistic rubrics or movements—Hellenism, the medieval, the Baroque, Neo-Classicism, Romanticism—are only subgroups or variants. From the beginnings of Western literature until Rimbaud and Mallarmé (Holderlin and Nerval are decisive but isolated forerunners), poetry and prose were in organic accord with language. . . . So far as the Western tradition goes, an underlying classicism, a pact negotiated between word and world, lasts until the second half of the nineteenth century. There it breaks down abruptly. Goethe and Victor Hugo were probably the last major poets to find that language was sufficient to their needs. . . . After Mallarmé nearly all poetry which matters, and much of the prose that determines modernism, will move against the current of normal speech. The change is immense and we are only now beginning to grasp it.[6]

Although Steiner uses Mallarmé and Rimbaud as the dividing line in this major reorientation in our concept of language, what he is, of course, describing is the change that occurred in the writer's attitude towards his medium during the Symbolist period. Steiner believes that the change has to do with a new conviction that there is a "matrix of thought more immediate, more fluid and intense than is that of language." This awareness of a level of thought or consciousness which lies beyond language naturally challenges the writer and forces him to invent new linguistic structures to express this silent content which seems to elude articulation. If we take Steiner's view of the history of language seriously, we must concur that the period of Symbolism marks a major shift in thinking in and about words. The running thesis of this book is that the writers who grasped the impact of painting as an alternate form of communication had a clear view of how the silent content of the mind, the moment of pure sensation or pure consciousness, could be expressed. Painting becomes a metaphor for this new content and the art of painting is used as a guide to new forms of expression. In attempting to find verbal equivalents for the technical aspects of painting, these four representative writers were helping to forge a major change in the use of language, forcing language beyond the implicit frontiers and boundaries of its linear grammar into new structures. Thus the attempt to make language concrete, to give the word a new tangible dimension, is an attempt to make language itself a form of primary communication, an attempt to use the inner power of the word to *be* what it signifies. Merleau-Ponty has tried to explain this inner force of language in his articles collected in *The Prose of the World*. He says:

.... One can have no idea of the power of language until one has taken stock of that working or constitutive language which emerges when the constituted language, suddenly off center and out of equilibrium, reorganizes itself to teach the reader—and even the author—what he never knew how to think or say. Language leads us to the

things themselves to the precise extent that it is signification before *having* a significa-
tion. If we concede language only its secondary function, it is because we presuppose
the first as given, because we make language depend upon an awareness of truth
when it is actually the vehicle of truth. In this way we are putting language before
language.[7]

Merleau-Ponty is differentiating between the discursive function of language
and the primary function, which is creative or constitutive; that is the ability of
language to bring new experience into being. This distinction is exactly the same
as that used by M.A. Ruff to describe the new quality in Baudelaire's poetry:

This poetry is undoubtedly the first which is absolutely direct, that is to say
which claims to be, without pretext or intermediary subject, the very object of all
poetry.[8]

Thus Baudelaire's originality is a result of a new approach to words as a medium;
language becomes the subject of poetry, not the vehicle for a separable para-
phrasable content. As I try to show throughout this book, this new concept of
language is directly related to the writer's absorption in painting. Baudelaire,
Ruskin, Pater, and Proust all see in the actual paint on a canvas a form of
spiritualized matter, and as writers they try to endow words with the same
concrete and metaphysical aura. This view of language as magically "real," both
in the physical and abstract sense, is, of course, most clearly expressed in the
poetry and criticism of Mallarmé. But as Mallarmé's theory of the "word" (Le
Dire) has been extensively studied, I have used Mallarmé throughout this book
only as a figure for comparison to the four writers under review. What I am
trying to establish, in each individual case, is that the metaphor of painting is
the key to a new vision of language itself.

Merleau-Ponty has also commented on the relation between modern
literature and modern painting in a long essay on the analogy between the arts,
which is focused on the "indirect language" of painting. He states in reference
to the "other" world which a painting can open to the viewer:

'Another world'–by this we mean the same world that the painter sees and that
speaks his own language, but freed from the nameless weight which held it back and
kept it equivocal. How could the painter or the poet be anything else than his en-
counter with this world? . . . The painter rearranges the prosaic world and, so to
speak, makes a holocaust of objects, just as poetry melts ordinary language. But in
the case of works that one likes to see or read again, the disorder is always another
order. It is a new system of equivalences which demands *this* upheaval and not just
any one, and it is in the name of a *truer* relation among things that their ordinary
ties are broken.[9]

The analogy between the modern "sister arts" is based on the similarity in the
attempts to break down and reconstruct the medium, "to purify the language

of the tribe," in Mallarmé's phrase. As I try to show in each chapter of this book, this Symbolist reconstruction of language is modelled on the art of painting because painting has opened up new worlds for each writer. During the Symbolist period the word *sensation* is elevated to the eminence which *reason* occupied for the eighteenth century and *emotion* for the Romantics. All four writers feel that the sensation produced by a painting reveals a new world of "consciousness," another word that acquires a new predominance during the second half of the nineteenth century. Baudelaire, Ruskin, Proust, and Pater all explore physical sensation, particularly visual perception, as a form of communication that both precedes and transcends intellectualization. Each writer, in a sense, idealizes sensation or perception as a unit of communication that is closer to total consciousness than to the deductive processes of logical thought which operate in a causal sequence. Perception occurs in a flash, and a whole truth is assimilated instantaneously, so that the component parts of the whole are grasped as a totality. Sensation precedes intellectualization which "comes after," as Proust says, to analyze the parts and subsequently put them back into a related whole. Perception for all four writers carries the mystical sanction of revelation: it represents knowledge that is felt as direct impact, total bodily awareness of a precise but mysterious change in being. So the literary structure that approximates the simultaneous effect of a painting also approximates the instantaneous form of complete consciousness. Visual perception becomes a metaphor for ideal communication, just as painting is a metaphor for ideal form. It is in Pater, less of a novelist than Proust and more of a philosopher, that this connection is made explicit: Pater tries to define his "modern" sense of consciousness as sensation and express it in the "modern" medium of "conscious prose" which acquires the concreteness of painting and aspires to the ideal form of a "single, visible image."

 The four writers studied in this book actively transform the formal aspects of painting as a "sister art" into literary equivalents. This transformation goes beyond the traditional pictorial imitation implied by the analogy, so that the concept of language as a medium and the internal structure of literary composition is radically altered by the Symbolist interpretation of the metaphor of painting. Although the "correspondence between the arts" which emerges from Romantic thinking and is converted into doctrine by the Symbolists has often been discussed, the dominance of the analogy to painting has rarely been emphasized. Although all four writers examined here use analogies to other arts, such as architecture and music, painting is considered by each to be the most comprehensive metaphor for ideal literary form. It must be understood that even though each writer had a passionate interest in a particular painter or school, each was primarily concerned with the formal aspects and values of the art of painting in general, even though those values are exemplified in the work of a favorite painter. Baudelaire bases his view of painting on Delacroix, just as

Ruskin founds his aesthetic on Turner, but both critics use their idolized painters and the specific revelations provided by their canvases, to reach an understanding of the *general* laws of the art. Throughout this book the emphasis is on the *analogy* between the arts, rather than on specific stylistic correlation. Since a major purpose of this book is to provide concrete documentation which shows the central position of the metaphor of painting for Symbolist literary theory, I try to stay within the critical framework provided by each writer, and I try to avoid subjective views based on stylistic analogies of my own. In studying each writer, I underline the writer's own statements about the relations between the arts and then proceed to apply these aesthetic concepts to an analysis of the writing itself. Thus I use the writer's own terms as tools for criticism, and avoid drawing correlations between the arts that are not explicitly recorded as part of the writer's own system of thought. The affinities between writing and painting during this period have frequently been discussed by critics in terms of stylistic analogies between particular writers and particular painters (Proust resembles Monet, Virginia Woolf makes someone else think of Cézanne, Gertrude Stein is a verbal Picasso.) As Harry Levin says, this search for a stylistic base of comparison is too loose to carry authority:

> A catchword of recent discussion has been baroque: after hearing it applied to mystical ecstasy and classical symmetry, Jesuit churches and Lutheran chorales, the Royal Society and the commedia dell'arte, Racine and Shakespeare, we may ask whether any shred of connotation is left beyond the mere accident of chronological proximity. Such skepticism is prompted more by respect for the richness of the material than by scorn for the inadequacy of the formulation.[10]

I believe that I have provided an extremely adequate formulation for a study of the relations between arts, by using writers who not only comment on this relation, but who consciously use the analogy as a part of their working aesthetic systems. All four writers make a clear effort to explain their own aesthetic, incorporating criticism into literature in the case of Proust or writing criticism that is in itself literature, with Baudelaire, Ruskin and Pater. Not one of these writers is a professional aesthetician, like Lessing or Croce. Instead they are all known for their achievements as literary artists: Baudelaire as poet, Proust as novelist, and Ruskin and Pater as critics whose style exerted equal influence with their ideas. But as Yves le Dantec has said, Baudelaire's criticism should be considered as important and creative as his poetry. To go back to Harry Levin's words, the "richness of material" in this group of essays which bridge two art forms is doubled by the fact that the writers, as critics, create literature which initiates a new approach to paintings as well as effecting a radical change in literary theory. Ruskin and Baudelaire are practically the inventors of a new form of art criticism (although Hazlitt, Lamb and Gautier are forerunners): both bring a new philosophical and poetic intensity to the "reading" of painting. By

the late nineteenth century, largely due to the attitude created by Baudelaire and Ruskin, and continued by their disciples, Proust and Pater, painting acquired a new metaphysical status which it had never before possessed. Although the emphasis in this book is on the effect of painting on literature, the opposite influence was also profound: Ruskin's writing, for example, inspired the doctrine behind Pre-Raphaelite painting. In each chapter of this book I try to make manifest the intricate fusion of the aspects of critic and artist, so that the criticism itself is not distinguished in verbal density, complexity, beauty and power from "non-critical" writing. All four writers defy categorization: Proust incorporates pieces of his essays on Ruskin into his novel, Baudelaire transposes sections of his art criticism into prose poetry, and both Ruskin's and Pater's writing on painting is self-sustaining as literature. All four writers not only emphasize the concreteness of language as part of their aesthetics, but they embody the quality of concreteness in their criticism as well as in poems and novels: thus Pater's discussion of visible structure in his essay on "Style" is exemplified by the structure of his essay on Leonardo. Baudelaire, in describing the color harmonies in Delacroix, writes a prose poem in response to the canvas. What I have tried to do in each chapter is to outline the writer's major aesthetic concepts and then to provide a detailed analysis of the style and structure of the writing to illustrate how ideas about painting are transformed into literary equivalents. The book as a whole is designed to explain four individual interpretations of the metaphor of painting as well as to illustrate the continuity of the analogy during the Symbolist period.

The chronological continuity is obviously interrupted by placing the chapter on Proust before that on Pater: that displacement is due to the fact that Proust was so directly influenced by Ruskin's thinking that it seemed appropriate to discuss Proust's interpretation of Ruskin directly after the Ruskin chapter. In the first two chapters, the reader can see that Baudelaire and Ruskin, although they did not influence one another, made similar and contemporaneous discoveries: both use their favorite painters as model artists by which to measure the failure of Romantic aesthetic doctrine. Thus Ruskin's position as the forerunner of English Symbolism parallels Baudelaire's role in French literary history. Proust states quite clearly that he is most profoundly influenced by Ruskin and Baudelaire; thus Proust continues and amplifies the implicit tradition started by his two admired predecessors, who although they did not know one another, come together in the mind of Proust. There are many striking parallels between Pater's work and Proust's, and it is possible that Pater exerted a minor influence on Proust's imagery. But as far as the logic of this book is concerned, Pater is viewed as a parallel to Proust; just as Proust synthesized the group of ideas he found in Baudelaire and Ruskin, so Pater codified what he learned from Ruskin, the French Symbolists (again primarily Baudelaire), and German philosophy. Thus Pater and Proust are the major disciples of the two earlier writers.

Naturally there are other influences involved; Proust and Pater both felt the impact of Flaubert very strongly; and Flaubert and Mallarmé are mentioned frequently throughout this study. But the four writers studied in these chapters group together coherently because all of them were radically influenced by the metaphor of painting. All four were innovators who exerted a wide aesthetic influence, and in studying them intensively we can see how modern literary theory has been conditioned by a new Symbolist version of the ancient analogy between the "sister arts." Symbolist ideas have consistently been "discovered" throughout the twentieth century; when Joseph Frank described the concept of "spatial form" in the novels of Djuna Barnes he was apparently unaware of similar descriptions of prose structure in Pater, Ruskin, and Proust. When Charles Olson discovered his "field theory" of poetry in Mayan glyphs, he might have found the same idea of a reciprocal field of words in Baudelaire's criticism or Mallarmé's essays. The aesthetic richness of the four writers in this book is inestimable: they are not only representative writers of the Symbolist period, they are among the major creators of modern literary theory, along with Flaubert, Mallarmé, and Henry James.

A later Symbolist, Wallace Stevens, has written on the relations between painting and literature in his book of criticism, *The Necessary Angel.* Stevens is trying to define the particular points of contact between the two arts, to account for the fact that "often a detail or remark, apropos in respect to painting, applies also to poetry." Instead of expanding Baudelaire's idea of a "fundamental aesthetic of which poetry and painting are related but dissimilar manifestations" Stevens is looking for a less general and more immediate perspective on the relations between the sister arts:

> But aesthetic creeds, like other creeds, are the certain evidences of exertions to find the truth. I have tried to say no more than was necessary to evince the relations, in which we are interested, as they exist in the manifestations of today. What, when all is said and done, is the significance of the existence of such relations? Or is it enough to note them? The question is not the same as the question of the significance of art. We do not have to be told of the significance of art. "It is art," said Henry James, "which makes life, makes interest, makes importance . . . and I know of no substitute whatever for the force and beauty of its process." The world about us would be desolate except for the world within us. There is the same interchange between these two worlds that there is between one art and another, migratory passings to and fro, quickenings, Promethean liberations and discoveries.[11]

Stevens is asking the critic who examines the relationship between painting and literature to look for the point of direct contact between the sister arts; he implies that the critic must go under the surface of a generalized "aesthetic creed" and search out the fertilizing moment when the discovery of the analogy between the arts crystallizes in the writer's mind. This book documents a number of these "quickenings," these "Promethean liberations and discoveries"

that occur when writers look at painting and see a direct analogy to their own art of literature: the whole book is premised upon a belief that for each writer discussed, the metaphor of painting provided a "Promethean liberation": Baudelaire writes about his discovery of Delacroix as a "spiritual shock," a phrase that precisely describes Ruskin's response to Turner, and Proust's to Vermeer, and in a qualified way, Pater's subdued ecstasy in looking at the paintings of Leonardo and Botticelli. All four writers used painting as a lens for intensifying their perception of literature, and because of their love for painting and the "spiritual shock" it produces, they changed, pervasively, our sense of language and literary structure.

Baudelaire and Delacroix: Tangible Language

Throughout his journals which he kept from 1822 to 1863, Delacroix returns again and again to the comparison of his own art of painting with the other major art forms of literature and music. In most of these comparisons Delacroix is attempting to define the unique attributes of painting as an aesthetic form, the aspects of the medium itself which distinguish the act of looking at a painting from the act of reading a novel or listening to music. In most cases the comparisons tend to emphasize the superior concreteness of painting as a form. A typical discussion, entered October 17, 1853, underlines the tangibility of the aesthetic response to painting:

> The type of emotion peculiar to painting is, so to speak, *tangible;* poetry and music cannot give it. You enjoy the actual representation of objects as if you really saw them, and at the same time the meaning which the images have for the mind warms you and transports you. These figures, these objects, which seem the thing itself to a certain part of your intelligent being are like a solid bridge on which imagination supports itself to penetrate to the mysterious and profound sensation for which the forms are, so to speak, the hieroglyph, but a hieroglyph far more eloquent than a cold representation, a thing equivalent to no more than a character in the printer's font of type: it is in this sense that the art is sublime, if we compare it to one wherein thought reaches the mind only with the help of letters arranged in an order that has been agreed upon; it is a far more complicated art, if you will (since the font of type is nothing and thought seems to be everything), but a hundred times more expressive if one considers that, independently of the idea, the visible sign, the speaking hieroglyph, a sign without value for the mind in the work of the writer becomes a source of the liveliest enjoyment in the work of the painter. And so, looking upon the spectacle of created things, we have here the satisfaction given by beauty, proprortion, contrast, harmony of color, and everything that the eye looks upon with so much pleasure in the outer world—one of the great needs of our nature.[1]

What Delacroix so eloquently puts into words is the particular difference between verbal art and visual art: literature, he feels, is at one remove from the reader, who must use the cold hieroglyphs of the printed alphabet as intermediary signs for the real experience, whereas the painting is an object existing within the same space as the observer, who is able to perceive the painter's signs

as concrete and tangible, as objectively *there* as the rest of nature. Delacroix believes that the power of painting lies in its direct accessibility, in the fact that the painter's hieroglyphs are physically present, real in a way that the printed word is not. Delacroix ends the comparison, in this instance, by referring to the classic distinction between literature and painting, so heavily emphasized by Lessing in the *Laoköon:* literature is successive and painting is perceived all at once. Although tangibility and simultaneity may not seem at first related qualities, throughout his journals Delacroix consistently associates these two aspects of painting as a form. In this case, after having identified the power of painting as its ability to produce an "émotion tangible" he goes on:

> It will now be clearer why I have spoken as I have about the *power of painting.* If it possesses but a single moment, it concentrates the *effect* of that moment; the painter is far more the master of that which he wants to express than is the poet or the musician, who is in the hands of interpreters; in a word, if his memory is directed toward fewer aspects of things, he produces an effect which is absolutely one and which can satisfy completely . . .[2]

The implication is simple; because a painting exists as a physical object, it can be seen all at once and theoretically understood "in a moment," whereas literature and music depend on the memory to retain "aspects" which are no longer there. The fact that painting can be perceived as a simultaneous whole adds to the "émotion tangible." As Delacroix says in another entry when complaining about the excessive length of modern novels:

> Painting is fortunate in demanding no more than one glance to attract and to fix.[3]

Delacroix's most famous critic, Baudelaire, fully appreciated and understood the "émotion tangible" produced by his paintings and in all of his critical writing about Delacroix, Baudelaire tries to explain in his own terms the "plaisir primitif," (the initial pleasure) the emotional effect of the first impression. In an article on Wagner, Baudelaire states that his critical method is to move from *volupté* (pleasure: the full, undiluted aesthetic response) to *connaissance* (knowledge: a rational account of that response) and in his articles on Delacroix he first tries to recreate the sensation or the "émotion tangible" for his reader and then give an intelligible explanation for his intuitive feeling. His response to Delacroix, the initial *volupté,* is so strong that he takes on the role of the impassioned critic and defends Delacroix as "the most original painter of ancient times or modern times"[4] much in the same way that Ruskin undertakes to prove that Turner is the greatest painter of all time in *Modern Painters.* It is extremely rare that a major painter has a major writer as a devoted critic and the two cases just mentioned are the only two that come readily to mind. Turner's effect on Ruskin and Ruskin's influence on English literary history is the subject of

another chapter, while the primary aim of this chapter is to show that Baudelaire's innovations in poetry are directly related to his critical appreciation of Delacroix. Most contemporary critics look at Baudelaire retrospectively as the first modern, the poet who changed French verse most radically, the poet who opened the way for the varieties of Symbolist poetry to follow. Even Baudelaire's contemporaries, such as Victor Hugo, felt his poetry to be "new," and the newness to be somehow related to an almost physical quality which produces a "frisson," the same kind of "nervous convulsion"[5] which Baudelaire had felt when reading the poetry of Gautier. Twentieth-century critics such as Marcel Raymond identify the "new" quality in Baudelaire with *sensation* as opposed to *emotion,* a greater component of physicality. In attempting to explain Baudelaire's originality M.A. Ruff says:

> This poetry is undoubtedly the first which is absolutely direct, that is to say which claims to be, without pretext or intermediary subject, the very object itself of all poetry.[6]

Poetry which is directly accessible, poetry which produces a tangible *frisson,* poetry which is physical: all of these attributes of language are of course the qualities which Delacroix had reserved exclusively for painting. Baudelaire has subtly appropriated the qualities in the painting of Delacroix which he so much admired and translated these qualities into literary equivalents. The key to Baudelaire's originality is the fact that instead of using another writer as a model for his work, he found in Delacroix an example of the ideal artist, a "poète peintre." In Baudelaire's aesthetic the artist is a universal figure; he can be either painter, poet or musician, and the essential qualities of will and imagination pertain to an artist working in any medium. Because Baudelaire had such a highly developed understanding of Delacroix's painting, and because he was interested in the relationship between various art forms, there was no barrier in translating the values of one art form into another. Painting becomes a symbol of the ideal form for Baudelaire because it is tangible, direct, and capable of being perceived as a totality. While Delacroix felt that these aspects of painting were impossible in literature, Baudelaire actively translates these values into his poetry so that it approximates the powerful effect of Delacroix's painting in producing an "émotion tangible," and words instead of being printed signs "without value" attain the full resonance of painted hieroglyphs.

In his major articles on Delacroix Baudelaire begins by pointing out that Delacroix is a great artist because he has both a creative imagination and a critical intelligence. Not only does Delacroix produce great paintings but he has the literary background, the verbal skill, the mental lucidity necessary to analyze his own work and explore the aesthetics of his craft. Baudelaire believes that the finest work in any field is accomplished by an artist who is also a critic, and the

three major figures in his pantheon are Delacroix, Poe, and Wagner, who have
each attempted to explain the methods and techniques of their respective arts.
Baudelaire also feels that his own criticism is an integral part of his *oeuvre*, on
an equal imaginative plane with his poetry. In his relationship with Delacroix,
both as friend and interpreter, Baudelaire profited from Delacroix's critical
intelligence. When Baudelaire looks at a painting by Delacroix it is with eyes
that have, to a certain extent, been trained by the painter himself: as Baudelaire
puts it, much of his criticism of Delacroix, written at the feet of the master, is
inseparable from what he has learned in his conversation with the painter him-
self. Therefore one could easily expect that the detailed comparisons between
the arts of painting and literature which are recorded in Delacroix's journals
were also the subject of conversation between the poet and the painter. It is also
easy to imagine that while Baudelaire learned to see paintings through Delacroix,
he might also have taken the painter's views on the limitations of literary art as
a kind of challenge. Delacroix himself seems to set up many comparisons be-
tween the arts which are almost in the form of a Renaissance *paragone*, a set
aesthetic battle between the merits of the traditionally associated "sister arts."
What finally emerges from the relationship between Baudelaire and Delacroix
is a new definition, on Baudelaire's part, of the ancient aesthetic doctrine of
ut pictura; poesis. Baudelaire wants his poetry to be more like painting and less
like the Romantic poetry which preceded his own work, and the attempt on
Baudelaire's part to translate the formal qualities of Delacroix's painting into
poetic practice results in establishing a new sense of language and poetic form
which is the basis for Symbolism and all its extensions. As several critics have
noted, the analogy between the "sister arts," so popular in the eighteenth
century, almost completely disappeared during the Romantic period. When the
analogy is revived by Baudelaire in France, and in another way by Ruskin in
England, it is used, in both cases, as the basis of an anti-Romantic aesthetic.
The analogy, writing should be like painting, produces a fertile variety of impli-
cations and is interwoven with the history of Symbolist aesthetics both in
France and in England.

Returning to Delacroix one finds throughout the journals the classic
argument for the superiority of painting; a canvas can be seen all at once, as
a whole, or as Delacroix is intelligent enough to admit, the perception of a
painting is at least theoretically simultaneous while the great disadvantage of
literature is the successive nature of the perceptive process:

> Although the author professes much respect for the book, properly so called, he,
> like a pretty considerable number of readers, has often experienced a king of diffi-
> culty in giving the necessary attention to all the deductions and all the linking-toge-
> ther of a book, even one that has been well conceived and executed. We see a picture
> all at once, at least in its ensemble and its principal parts: for a painter accustomed
> to an impression like that, which is favorable to the understanding of the work,

the book is like an edifice of which the front is often a sign-board, behind which, once he is introduced there, he must again and again give equal attention to the different rooms composing the monument he is visiting, not forgetting those which he has left behind him, and not without seeking in advance, through what he knows already, to determine what his impression will be at the end of his expedition.

It has been said that rivers are moving roads. It could be said that books are portions of pictures in movement, among which one follows the other without its being possible to grasp them at one time; to seize upon the connection among them demands from the reader almost as much intelligence as from the author.[7]

Literature, which is like successive paintings in movement, is better, according to Delacroix, the shorter it is in extension, the closer it comes to approximating the totality of a painting. The painter consistently prefers brevity in literature:

I profess before everything my predilection for short-winded works of literature.[8]

The longness of books is a capital fault.[9]

Nothing is more important for the writer than proportion in this matter. Since he presents his ideas in succession, the reverse of what the painter does, bad divisions of the material and an excess of material fatigue the mind.[10]

Delacroix is arguing that a painting can attain a much more apparent and direct kind of unity because it can be seen as a simultaneous whole, while literature and music are plagued with succession.

Is memory so fugitive that one cannot establish relationships amongst the different parts of a piece of music unless the principal idea is affirmed almost to satiety by continual repetition? A letter, a piece of prose or of poetry presents a deduction, an ensemble, arising from the development of ideas born one from the other, and it does not do so through the repetition of some phrase, which might be regarded as the capital point of the composition.[11]

Music depends on successive repetition, poetry and prose on successive development, while painting presents a more satisfying unity because the form can be perceived all at once:

A painting is a thing that seems as if it should satisfy this need for unity the most completely and easily, since one has the impression of taking the whole thing in at once; yet it will not succeed more than anything else if it is not well composed.[12]

The painter has the advantage and the responsibility of a form that can be grasped as a whole, while the essential problem of literature is one of length. Delacroix feels that if a writer tries to render the totality that the painter is able to record, the length and successive nature of the rendering will dissipate the effect of unity.

The poet succeeds by the succession of images; the painter by their simultaneity. Example; I have under my eyes birds who are bathing in a little puddle of water which is formed when it rains on the sheet of lead which covers the flat, protruding edge of a roof; I see at the same time a crowd of things which, not only the poet cannot mention, but even less describe, under the pain of being fatiguing and heaping volumes without rendering (the scene) other than imperfectly. Note that I only take *one* instant. The bird plunges in the water; I see its color, the underneath silver of its little wings, its color, its light form, the drops of water which it splashes up into the bright sunlight. Here is the importance of the art of the poet. It is necessary that of all these impressions he chooses the most striking to make me imagine all the rest.[13]

Delacroix believes that, as the writer feels the "impuissance" of his art he attempts to compensate by rendering everything, which results in the loss of unity. The painter, he thinks, can record everything at once in an instantaneous sketch, which even if only a sketch, still has the advantage of a unified effect. At one point Delacroix uses an extended metaphor to explain the predicament of the writer and the reader in dealing with successiveness:

Another question. Is not the most desolating part of human work this incompleteness in the expression of sentiments, in the expression resulting from the reading of a book? It is only nature who creates complete things. On reading this preface, I said to myself: "Why this point of view and why not another, or why not both, or why not everything that may be said on the subject?" An idea serving as a starting point, and leading you on to another idea takes you away completely from the point of view which at first gave unity, from that general impression of an object which one conceives. In explanation, I would compare the state of an author preparing to describe a situation or to establish a system or to produce a piece of criticism, with that of a man on a hilltop who sees before him a vast countryside with woods, brooks, meadows, dwellings, and mountains. If he undertakes to give a detailed idea of all this, and if he enters one of the paths offered to him, he will arrive either at cottages, or at forests or at only a few parts of the vast landscape. He will often lose sight of the principal and most interesting parts, and will neglect them, because he made a bad decision at the start . . . but, I shall be told, what remedy do you see for that? I see none, and there is none.[14]

According to Delacroix there is no solution; he believes that literature is bound by succession, and that it is impossible for a literary work to retain the total unity, the sense of the "ensemble primitif," the general impression of the whole work which is afforded by the perception of all aspects of painting simultaneously. Ironically, Delacroix's metaphor is precisely the same as the metaphor that Proust uses to describe the successful writer who has reached the culminating point in his work from which the entire design is visible. Proust compares the writer to a painter who is climbing a mountain and who sees bits and pieces of countryside until he reaches the top where the entire landscape is seen as a whole. The point that Proust is making is precisely in contradiction to Delacroix: the writer, even of a work as vast as *A la recherche,* can imitate the

painter in achieving a total design, so that the final view of the literary work achieves a kind of theoretical simultaneity; the whole seen all at once in all of its various parts like the landscape from the top of the mountain.

Delacroix feels that the ability to see a painting *tout d'un coup, tout d'une fois,* is the key to its unity, totality and wholeness, which insures that the effect will be concentrated and direct and the emotion of the observer will be *tangible.* The successful painting becomes a concrete object which has a real existence for Delacroix, while literature only refers to reality through print. The great painter is able to animate his work with

> . . . this "breath" which makes a painting cease to be a painting and become a "being," an object, and an object which takes its place in the creation, to no longer perish, which has a name, which is called the transfiguration etc. . .[15]

Perhaps Delacroix trails off at this point because he felt that his claim for the transfigured reality of the object was becoming too metaphysical, but in another long passage he says the same thing less flagrantly.

> I confess my predilection for the silent arts, for those mute things of which Poussin made profession, as he said. Words are indiscreet; they break in on your tranquillity, solicit your attention and arouse discussion. Painting and sculpture appear more serious: it is you who must seek them out. The book, on the contrary, is importunate; it follows you, you find it everywhere. You have to turn the pages, follow the reasoning of the author, and go to the end of the work in order to judge it. How often has one not regretted the attention one has had to give to a mediocre book for the small number of ideas scattered here and there in its pages, ideas that one extracted with difficulty! The reading of a book not wholly frivolous is work: it causes a certain fatigue at least; the man who writes seems to be trying his strength with the critic. He discusses and one can discuss with him.
>
> The work of the painter and the sculptor is all of a piece like the works of nature. The author is not present in it, and is not in communication with you like the writer or the orator. He offers what might be called a tangible reality, which is, however, full of mystery.[16]

The tangible reality of painting, in this case, is not only connected to the fact that a painting is *tout d'une pièce,* but also to the quality of silence. Specifically Delacroix is reacting against the rhetorical, persuasive aspect of literature which 'moves' towards you with an intention, whereas painting simply exists. The painting exists, objectively separated from the painter, while in literature the writer is always present. It is no random coincidence that Delacroix points to one of the major problems in modern literary aesthetics, the attempt to detach the work from the author and give it an autonomous existence of its own. Delacroix's contemporary, Flaubert, was trying to disappear as an authorial presence from his novels, and Baudelaire was trying to write poems that were clearly in opposition to the Romantic cult of the poetic personality. The silence of painting, which

Delacroix defines as the lack of overt rhetoric and the absence of the artist, is perhaps for Baudelaire the quality which makes painting the ideal aesthetic anti-dote to the debased romanticism of his day. Baudelaire's hatred for popularized romanticism is embodied in his description of a *bonne bourgeoise* who claims that her lawyer husband is intrinsically a poet because of the intensity of his emotions:

> During the chaotic epoch of Romanticism, the epoch of fervent effusions, people often resorted to the use of this formula: *The poetry of the heart!* Thus passion was fully sanctioned and a sort of infallibility attributed to it. How many absurdities and sophisms an error of aesthetics can impose on the French language! The heart con-tains passion, the heart contains devotion, crime; Imagination alone contains poetry. But today the error has taken a different course and assumed greater proportions. For example, in a moment of fervent gratitude, a woman says to her husband, a lawyer: *O poet! I love you!* Sentiment encroaching on the domain of reason! Typical reasoning of a woman who doesn't know how to use words correctly! Now all this simply means: "You are an honest man and a good husband; *hence* you are a poet and even more of a poet than those who use meter and rhyme to express ideas of beauty. I shall even maintain," firmly continues this inverted *precieuse,* "that every honest man who can please his wife is a sublime poet. Moreover, I declare, in my bourgeois infallibility, that whoever writes excellent poetry is much less a poet than any honest man who is fond of his home; for the ability to compose verses is obvious-ly detrimental to a husband's faculties, *which are the basis of all poetry!"*[17]

Like Emma Bovary, who is victimized by romantic doctrine, Baudelaire's *bonne bourgeoise* has disastrously confused art and life by taking the romantic identifi-cation of poetry with emotion to its logical extreme. What Baudelaire is trying to emphasize, of course, is the distinction between an aesthetic response and natural passion, and his whole cult of artifice and the glorification of the con-trolled impersonality of the dandy is an attempt to disengage the poet from the romantic notion of the sensitive individual full of spontaneous feeling. The caricature of the romantic aesthetic represented by the *bonne bourgeoise* is aimed at a serious flaw: Baudelaire felt that the final outcome of romantic think-ing was to believe that the poetical emotion was itself poetry and that the poem was merely a record or transcription of the poetical experience. The composition of the poem is therefore secondary to the poetic experience which is recorded as 'naturally' as possible, i.e., left up to inspiration or the spontaneous flow of the lyric voice. Although it is unfair to judge romanticism by its own aesthetic ideals ("spontaneous overflow of natural emotion," "strains of unpremeditated art") it is not untrue that many romantic poems fall into the category of loosely structured narratives ("Nuit de mai," Wordsworth's "Prelude") with no attempt at the kind of formal unity or tight verbal organization typical of the poetry of Baudelaire.

The persuasive effect of Baudelaire's poetry, the seminal influence of his work is due to the fact that he made a clear break with the aesthetic ideals of

Romanticism and defined a new aesthetic direction which is known, in general terms, as Symbolism (the term is used in this chapter not to refer to the group of French poets associated with the *Revue Wagnerienne,* but in a larger sense to refer to a whole movement in modern literature that includes, as Edmund Wilson does in *Axel's Castle,* writers as diverse as Joyce and Mallarmé, Proust and T.S. Eliot). There is a great difference between comparing a romantic poem and Symbolist poem and comparing the aesthetic ideals which exist behind the actual writing itself: the following comparison is intended as an exaggerated statement of different aesthetic ideals, not as a critical appraisal of the value of specific poems. One of the threads that runs throughout Symbolist criticism (extending down to the American New Critics) is the idea that a literary work must have a kind of autonomy and integrity, an internal coherence, a unity that comes from within the work itself and gives it an independence from the "life" of its author. Connected with the idea of autonomy is an emphasis on the craft aspect of the art of writing; the author must intentionally *make* a work in order to give it the internal unity and self-sufficiency to exist on its own. This dominant idea of the separation of art and life, which begins by disengaging the work from the writer's personality, leads to an even more complex distinction, which has been a major point of contention between the defenders and detractors of Symbolist thinking. Theoretically the experience produced by a Symbolist work is contained by and within its form; not only is it unnecessary to refer to the life of the author, but it is also unnecessary to place the work back in the world of the reader's associations. Again, theoretically, the Symbolist work can be an experience that is entirely new, that depends only on its own verbal unity, that is, in short, entirely self-contained. The furthest extension of this idea, in Mallarmé for example, leads to another distinction between the language of art and *les mots de la tribu,* the everyday language of the newspapers and the dinner table. In general the Symbolist writers are more interested in the aspects of language as a medium than the romantics had been; the romantics (as Symbolist critics would have it) were content to use language to transcribe or record experience, while the Symbolists believed that language is itself the literary experience, an experience which is contained and embodied by the actual words on the page. This sense of autonomy, of self-contained form, of concreteness is, of course, precisely the form, the aesthetic ideal revealed to Baudelaire through Delacroix's painting and which appeared as a clear light to show the way around the impasse of romantic doctrine. Instead of the poetic voice, imbued with personality, there was the silent language of form and color. Instead of the record of personal experience there was the painting as a separate artifact. Instead of a compositional method based on natural spontaneity, there was the obvious artifice, the manual craft and technique represented by the canvas worked with paint. Instead of loose, casual narrative structure there was the total unity of the painting perceived simultaneously as a whole. And instead

of using words as mere printed signs, Baudelaire saw the possibility of language handled as a physical substance, so that the words of a poem would have the same direct effect on the reader and produce the same kind of *émotion tangible* as the paint on a Delacroix canvas.

As Symbolism has been variously misinterpreted, it is enlightening to go back to the conceptual origin of the Symbolist ideal of literary form, and one important origin can be located in Baudelaire's translation of the values that he found in Delacroix's painting into verbal equivalents. For example, in *The Romantic Image,* Frank Kermode states that the Symbolist notion of a Symbol is "an image radiantly devoid of meaning" which exists "outside space and time." It would be more accurate to describe the Symbolist ideal as a complex of words which radiates a total meaning, a meaning which depends on perceiving the work as a whole as a painting is perceived, and a meaning which, although it is communicated through words, is incapable of being paraphrased (in the New Critical sense), any more than the *réalité tangible* of a painting can be separated from the actual paint. Most Symbolist theory which emphasizes the non-discursive aspect of language is simply pointing to the fact that the words that make up any given literary structure are inseparably related, and that the complex meaning produced by these interrelationships is precisely too complex to be reduced to the normal, discursive level of language. Far from being "devoid" of meaning, the structure is so full of meaning that the whole work is the only adequate way of embodying it: as Emeric Fiser puts it, the symbol is not a single image, instead the whole work as a total unit and as a complete process becomes the symbol:

> It is the poem which constitutes the literary symbol, and in decomposing the poem into 'objects' and 'states of soul' we, at the same time make the literary symbol disappear, to replace it with static symbols.[18]

The rest of Kermode's definition of the symbol, its existence "outside space and time," is also misleading; although Mallarmé occasionally writes about the pure work of art in tones that sound transcendent, he also emphasizes the fact that the final, pure symbolic work, *le livre,* must be embodied in an actual book, which is a physical object. Instead of transcending space, most Symbolist critics, from Baudelaire on, stress the physical attributes of literature, the literal space on the page, the book as a spatial entity, as a concrete object: and instead of transcending time, the Symbolist writer usually acknowledges the existence of literature in time, the inherent temporal succession of reading, by developing a structure which works against sequence and attempts to develop a kind of total unity which enables the reader to grasp the work as a whole, a final perception of the structure which is, at least theoretically, simultaneous. The idea of a simultaneous view of an entire poem, or as Symbolism progressed, an entire

novel, is not, as Kermode puts it, an attempt to escape time but a recognition of the importance of time in the process of perception. The idea of simultaneity, borrowed from painting, becomes a modern preoccupation: the chronological structure of the modern novel, field theory and the concept of the gestalt applied to modern poetry, the numerous phrases such as "spatial time," "pure time," "aesthetic stasis," are all, in a way, challenges to the traditional notion that the spatial art of painting can achieve simultaneity while the temporal art of literature must operate within the laws of sequence and succession. As many aspects of Symbolist theory are related to the concepts of total unity and simultaneous perception, it is surprising that the aesthetic connections between literature and painting are so seldom mentioned in books about Symbolism. Symbolist writers often underline their interest in the relationships between the arts, but most critics who write about Symbolism as a movement tend to single out the analogy to music as predominant. The analogy appears in several writers (Pater, Mallarmé) who use it as an example of the perfect fusion of form and content. But music, like literature, is successive and does not provide the model for the concept of total unity of form which is characteristic of the Symbol. When Mallarmé discusses the musical qualites of his *ouverture* to *Hérodiade* he also compares the entire section of the poem to "une peinture de Léonard" and when Pater introduces the famous phrase, "all arts aspire to the condition of music," it is within the context of an essay on *Giorgione* in which he describes the painting of a musical interval, a frozen "moment" of music. In both cases the analogy to music is combined with an analogy to painting; a composite of aesthetic qualities from other art forms to which literature "aspires." In the first section of his *Oeuvre et vie d'Eugène Delacroix* Baudelaire points directly to the Symbolist interest in the inter-relationship of art forms:

> It is, moreover, one of the characteristic symptoms of the spiritual condition of our age that the arts aspire if not to take one another's place, at least reciprocally to lend one another new powers.[19]

The reciprocal relations between the arts are emphasized in Baudelaire's criticism as he finds similar qualities in Delacroix, Poe and Wagner. As le Dantec says in his introduction to Baudelaire's critical writing:

> The various studies, spontaneous or occasional, of Baudelaire on the Beaux-arts, literature, and music should be considered immediately as creations no less endowed with genius than *Les Fleurs du Mal* or *Le Spleen de Paris*. They carry in them a veritable aesthetic doctrine, philosophical and mystical. Let me be allowed to insist not only on the interest, at least equal, of the aesthetician, but again on the necessity, for whoever wishes to obtain a real idea of the great writer, of not separating in our admiration the poetry, rhythmed or rhymed, from the true poetic which emerges, for example, from the *Salon de 1859* or from "Richard Wagner." A word, which Baudelaire applies to Delacroix, characterizes singularly well his own genius: universality.[20]

Although the criticism is scattered over the years and in various degrees of com-
pletion, the aesthetic doctrine emerges whole and consistent and the fact that
Baudelaire treats at length a painter, a writer, and a musician lends a kind of
implicit order to his collected criticism, almost as if he had planned to use
Delacroix, Poe and Wagner as representatives of each major art form, in the same
way that Proust uses the triumvirate of Elstir, Bergotte and Vinteuil in *A la
recherche du temps perdu.* As Delacroix comes first, in the chronology of Baude-
laire's criticism as well as in importance, we will move directly to Baudelaire's
discussion of painting.

In the *Salon* of 1846 Baudelaire uses a prologue to his section on Dela-
croix which takes the form of a prose poem, a color symphony, describing the
changes that occur in light and color from dawn to dusk every day. The *sym-
phonie* is intended to emphasize the musical aspect of the art of coloring, the
fact that the painter deals in his own way with "harmony, melody and counter-
point"[21] but more important than the musical analogy is the idea of pictorial
unity on which the description is based. Baudelaire tries to show that the colors
are continually readjusted by each change in the light, so that the general har-
mony remains intact, even though the local tones are constantly different. The
colors mingle together and reflect each other and "continue to live in harmony
by making reciprocal concessions."[22] The main point of the whole piece is that
harmony in color depends on the *reciprocal* relations between the colors which
mutually affect one another. After the color symphony passage Baudelaire
extends this point more emphatically:

> Colour is thus the accord of two tones. Warmth and coldness of tone, in whose
> opposition all theory resides, cannot be defined in an absolute manner; they only
> exist in a relative sense.[23]

Baudelaire concludes that the whole art of coloring consists in adjusting the
relations between tones, and instead of blending color, the true painter will
have the tones separate because reciprocal action between colors is the key to
harmony;

> The lens is the colorist's eye.
> I do not wish to conclude from all this that a colourist should proceed by a
> minute study of the tones commingled in a very limited space. For if you admit that
> every molecule is endowed with its own particular tone, it would follow that matter
> should be infinitely divisible; and besides, as art is nothing but an abstraction and a
> sacrifice of detail to the whole, it is important to concern oneself above all with
> *masses.* I merely wished to prove that if the case were possible, any number of tones,
> so long as they were logically juxtaposed, would fuse naturally in accordance with
> the law which governs them.[24]

Another extension of the idea of reciprocal harmony is that this harmony pertains to any part of the whole: an object examined with a magnifying glass will reveal the same combination of colors on a small scale as it does in its entirety:

> A study of the same object, carried out with a lens, will afford, within however small an area, a perfect harmony . . .[25]

At first there may seem to be no apparent connection between the idea of a scale, the notion of reciprocal harmony and the separation of color but the whole complex of thought is illuminated by the quote Baudelaire uses to conclude the color section, the famous quote from Hoffmann on *correspondances.* The doctrine of correspondences is too well known to need rehearsal, but it is worth quoting Hoffmann again in order to show why Baudelaire feels that the idea of *correspondances* perfectly expresses what he has been attempting to explain about the art of coloring. The core of the quotation is:

> I do not know if any *analogist* has ever established a complete scale of colours and feelings, but I remember a passage in Hoffmann which expresses my idea perfectly and which will appeal to all those who sincerely love nature: 'It is not only in dreams, or in that mild delirium which precedes sleep, but it is even awakened when I hear music—that perception of an analogy and an intimate connexion between colours, sounds and perfumes. It seems to me that all these things were created by one and the same ray of light, and that their combination must result in a wonderful concert of harmony.[26]

The kind of analogy and reunion that Hoffmann finds between the senses is similar to Baudelaire's theory of color relationships: in both cases the key idea is reciprocity. The impression produced by the concept of audible perfume or colored sound depends upon the same fusion of elements perceived to be separate that Baudelaire found in the color combinations of Delacroix's painting. Like Hoffmann's *correspondances,* the correspondence between colors in a painting produces a reciprocal harmony that is, in effect, mutual reflection and mutual fusion, just as in a phrase such as "parfum . . . doux comme les hautboys" the sound and smell are mingled together yet remain distinct. Much later in his career Baudelaire wrote another verbal color symphony, this time as a transcription of his impressions of Wagner's overture to *Tannhäuser.* Again Baudelaire explains the relevance of correspondences:

> The reader knows what we are trying to do: to show that true music suggests analogous ideas to different minds. Besides, it would not be ridiculous in this connection to argue *a priori,* without analysis and without comparisons; for what would be really surprising would be that sound *could not* suggest color, that colors could not convey a melody, and that sound and color were unsuited to translating ideas, things always having been expressed by a reciprocal analogy since the day when God created the world as a complex and indivisible whole.[27]

As a conclusion to this discussion of a color symphony Baudelaire quotes his own sonnet *Correspondances*. The important ideas in the sonnet and the passage which precedes it are first the belief in the *analogie réciproque,* the mutual reflection of disparate elements, and second the feeling that particular analogies are a reflection of the *analogie universelle,* the whole world as a *"complexe et indivisible totalité."* If we return to the original color symphony of *1846* we can see how Baudelaire's vision fits together. Just as Baudelaire thought of a Delacroix painting as an indivisible totality, he could see the local harmonies of the painting as a reflection of the total complexity of the canvas; this idea of similar relations on the small scale and the large, in the part as a reflection of the whole is a graphic illustration of Baudelaire's vision of the world as a giant system of corresponding elements. Painting, as interpreted by Baudelaire, is a perfect structural model of the world as a "complex and indivisible whole."

In a long passage about Delacroix's color, first printed in the *Salon de 1859* and then repeated verbatim in the *Vie et oeuvre d'Eugène Delacroix* Baudelaire gives a condensed and complete version of his aesthetic of painting. In order to avoid lengthy quotation I will summarize the major aspects of Baudelaire's conception of painting which is extended into an aesthetic statement to cover all art. The passage begins with a metaphor taken directly from Delacroix; that nature is a dictionary, a collection of raw material, a list of separate elements to be used by the artist. Instead of trusting nature and inspiration, as the Romantics had claimed to do, Baudelaire specifically relegates nature to an inferior position; the artist must transform the raw material of nature and give it significance through composition. The value of art is in detecting the relations between the separate elements in the dictionary list and recombining them into a significant whole. Painting is a perfect example of this process of transformation because the reciprocal relations between parts are so apparent and visible. Baudelaire sees that the painter must be in control of the total harmony of the canvas; his craft depends upon his ability to manipulate and regulate the mutual effect of colors on each other:

> With such a method, which is essentially logical, all the figures, their relative disposition, the landscape or interior which provides them with horizon or background, their garments—everything, in fact, must serve to illuminate the general idea, must wear its original colour, its livery, so to speak. Just as a dream inhabits its own proper, coloured atmosphere, so a conception which has become a composition needs to move within a coloured setting which is peculiar to itself. Obviously a particular tone is allotted to whichever part of a picture is to become the key and to govern the others. Everyone knows that yellow, orange and red inspire and express the ideas of joy, richness, glory and love; but there are thousands of different yellow or red atmospheres, and all the other colours will be affected logically and to a proportionate degree by the atmosphere which dominates. In certain of its aspects the art of the colourist has an evident affinity with mathematics and music.[28]

The mathematical and musical aspect of painting is a way of describing the fact that color harmonies seem to have a kind of systematic logic. Baudelaire feels that Delacroix has acquired an almost scientific control over the disposition of effects and that like Leonardo, his conscious research on the laws of painting makes him a great artist.

At this point Baudelaire returns to the two aspects of the science of painting that he first pointed out in the color symphony of 1846. First that the *touches de couleur* remain distinct and separate so that the process of combination takes place in the eye of the beholder:

> It is obvious that the larger a picture, the broader must be its *touch;* but it is better that the individual touches should not be materially fused, for they will fuse naturally at a distance determined by the law of sympathy which has brought them together. Colour will thus achieve a greater energy and freshness.[29]

Second, Baudelaire returns to the idea of total unity on the small scale and the large by comparing the way in which a Delacroix painting is developed and the compositional method of Horace Vernet.

> 'A good picture, which is a faithful equivalent of the dream which has begotten it, should be brought into being like a world. Just as the creation, as we see it, is the result of several creations, in which the preceding ones are always completed by the following, so a harmoniously-conducted picture consists of a series of pictures superimposed on one another, each new layer conferring greater reality upon the dream and raising it by one degree towards perfection. On the other hand, I remember having seen in the studios of Paul Delaroche and Horace Vernet huge pictures, not sketched but actually begun—that is to say, with certain passages completely finished, while others were only indicated with a black or a white outline. You might compare this kind of work to a piece of purely manual labor—so much space to be covered in a given time—or to a long road divided into a great number of stages. As soon as each stage is reached, it is finished with; and when the whole road has been run, the artist is delivered of his picture.[30]

The significance, of course, is that the method of Delacroix keeps the total unity of the canvas in focus from the first germ of the *ébauche* to the completed painting; as Baudelaire describes it, the process results in a series of paintings, each containing its total harmony, superimposed over each other. The whole canvas is deepened *tout entière;* as each *couche* (layer) adds new finish and new complexity, the essence of the total composition, which is there from the beginning, is brought into greater relief. The method reflects Delacroix's belief that the primary attribute of painting as a form is its simultaneous unity. On the contrary, Vernet's method conforms precisely to the terms of limitation that Delacroix applied to literary composition; the canvas is treated as a number of successive stages to be completed in sequence so that at no point along the *route* is the canvas treated as a whole. After this example it is easier to see the

connection that Baudelaire has made between the concept of unity in a painting and the theory of *correspondances:* a single *correspondance* reflects the world as an *analogie universelle,* just as Delacroix's original *ébauche* reflects the unity and harmony of the finished painting. Baudelaire finds in Delacroix's method of composition another metaphor for his vision of the *analogie réciproque;* the painting is produced "comme un monde" so that the reciprocal relations which exist on the small scale in the original sketch are not changed, but deepened and expanded into the large scale of the completed painting.[31]

After praising Delacroix for his control over the science of painting Baudelaire suddenly veers into an aside about the laws of language:

> For it is obvious that systems of rhetoric or prosody are no arbitrarily invented tyrannies, but rather they are collections of rules demanded by the very constitution of the spiritual being.[32]

Baudelaire defines the category of *l'homme spirituel* as a true artist working in any medium, and in this case the sudden reference to literature is a way of leading into the definition of a *formule principale,* a general aesthetic statement which would apply to all the arts (although Baudelaire seems to have visual art and literature primarily in mind; the application to music would be somewhat oblique, although Baudelaire's translation of Wagner's music into a verbal color symphony would provide an approach). The statement which contains "the entire formulary of a true aesthetic (la véritable ésthetique)" is an expansion of the idea of the dictionary:

> 'To be brief, I must pass over a whole crowd of corollaries resulting from my principal formula in which is contained, so to speak, the entire formulary of the true aesthetic, and which may be expressed thus: The whole visible universe is but a store-house of images and signs to which the imagination will give a relative place and value; it is a sort of pasture which the imagination must digest and transform. All the faculties of the human soul must be subordinated to the imagination, which puts them in requisition all at once. Just as a good knowledge of the dictionary does not necessarily imply a knowledge of the art of composition, and just as the art of composition does not itself imply a *universal* imagination, in the same way a *good* painter need not be a *great* painter. But a great painter is perforce a good painter, because the universal imagination embraces the understanding of all means of expression and the desire to acquire them.[33]

Again Baudelaire emphasizes that nature is formless. Signs and images have no intrinsic value in the world of nature; it is only when they are put in relation to each other through the process of art that they gain significance. The art of composition establishes relations and gives a *valeur relative* to the disparate elements of the world which have lost, for Baudelaire, the sense of absolute value rooted in nature which had sustained much romantic poetry. The great

artist will depend on himself, not on natural inspiration, to find the technical means to make the *valeur relative* of his work apparent.

The emphasis on relativity throughout Baudelaire's aesthetic is one of the aspects that make his ideas modern. For Baudelaire, the content of a painting or a poem depends upon the relation of parts, the reciprocal effect of colors or images, on the way in which elements are combined into a total composition so that content becomes relative to technique. As Baudelaire stresses the fact that content is inseparably related to composition, craft, and technique, painting again serves as an appropriate metaphor for the literary artist. The sheer amount of manual effort necessary to produce a painting cannot be attributed to *pure* inspiration in the way that the romantic poets often claimed to produce a poem by writing straight from nature. What Baudelaire points out in the final section of his *véritable esthétique* is that imagination and technique are interrelated and interdependent: a great painter or a great poet will have both vision and conscious control over the medium in which the vision is expressed. Because the production of a canvas so clearly involves craft and artifice, as well as spiritual insight, Baudelaire sees the art of painting as an example of the way in which imagination and technical workmanship should be combined in literature. Baudelaire's cult of artifice in all of its manifestations grows out of his hatred for the debased Romantic aesthetic; the *femme du monde* who triumphs over nature with the artifice of cosmetics and *le dandy* who lives an artificially regulated existence through willed self-control are the two most famous examples. But in a more complex way, Baudelaire's concept of painting is an illustration of the idea of artifice, because a painting is such a concrete example of the transforming power of the imagination. The physical substance of paint itself, the texture of the surface of the canvas (which is so pronounced in Delacroix) the quality of the brush strokes, are all blatant reminders that the painter has transformed the world of nature into an obviously artificial two-dimensional object which is yet "un monde" by itself. The interplay of physical and spiritual elements, the transformation of the raw material of signs and images and the paint itself into a self-contained world designed to convey an *émotion tangible,* makes painting a symbol for Baudelaire of the transformation of the dead world of nature into the *surnaturel, spirituel* world of art. It is precisely because a painting is an obvious and artificial reconstruction of nature that Baudelaire admires it; in his criticism Baudelaire consistently refuses to judge a painting on how well it copies nature, but uses instead his own criteria of how the painter has transformed nature into another context, so that a painting is considered on the merits of its own internal values rather than in reference back to nature. The internal structure of a work of art, whether painting or poem, is necessarily an artifice when the world of nature provides only the disparate elements of the dictionary list, but for Baudelaire the process of art which restructures the world gives it a value which it does not have in the natural state, so that aesthetic

value and spiritual value become synonymous. As Baudelaire puts it, nature's only function is to provide the artist with raw material:

> External nature does nothing more than provide the artist with a constantly-renewed opportunity of cultivating that seed; it is nothing but an incoherent heap of raw materials which the artist is invited to group together and put in order—a stimulant, a kind of alarum for the slumbering faculties.[34]

In returning to Baudelaire's description of his *véritable esthétique* it is not difficult to understand that the basic ideas apply to his own craft of poetry, although most of the terms in the formula are specifically visual. The dictionary of the writer, like that of the painter, contains an indefinite number of signs and images which acquire significance when put in relation to each other; the poet, like the painter, must control the reciprocal effects of all the elements contained within the structure of his work. Immediately following the statement of his *véritable esthétique* Baudelaire points to the fact that his concepts about painting are also relevant to literature:

> but there are still so many things that I should have mentioned, particularly concerning the concordant aspects of all the arts, and their similarities in method![35]

Unfortunately nothing specific comes after the exclamation point, and the reader is left to intuit which of the preceding aspects of painting have their correspondence in literary technique. But in the *Préface de les fleurs du mal* where Baudelaire pretends to give out his literary trade secrets (which can be taught in twenty easy lessons, again a blow at the Romantic doctrine of inspiration) he provides a more direct clue to the resemblances between the arts:

> That the poetic phrase can imitate (and hence it touches on the art of music and the science of mathematics) the horizontal line, the strong ascending line, the strong descending line; that it can climb at a steep angle towards the sky, without losing breath, or descend perpendicularly towards hell with all the velocity of its weight, that it can follow the spiral, describe the parabola, or the zigzag figuring a series of superimposed angles.
>
> That poetry is connected to the arts of painting and cooking and cosmetics by the possibility of expressing any sensation of sweetness or bitterness, of beatitude or horror, by the coupling of such and such a noun with such and such an adjective, analogous or contrary.[36]

The first paragraph, which links poetry with music and mathematics, is paradoxically dominated by visual and spatial terms. The poetic line is not simply a certain number of syllables for Baudelaire; it becomes a literal line, a physical substance with weight, mass, velocity and direction capable of moving vertically, horizontally and even describing *une série d'angles superposés*. The effect of the

whole paragraph is to emphasize the concreteness of language and the fact that a poem has a spatial dimension like a painting, or in this case, an existence in space which approaches something like kinetic sculpture. The values claimed for the poetic line, tangibility and direct representation, are the same qualities Delacroix had reserved for painting. In the second paragraph the connection between literature, painting, cooking and cosmetics is based on the coupling of noun-adjective units. Baudelaire is not trivializing poetry but insisting again on its concrete quality: just as two flavors can be combined in a sauce, or two colors combined on a canvas, the combination of words in a poem can produce the same direct and tangible response, as physical as taste or sight and as fundamental as the sexual response to a certain style of make-up. This idea of combining a noun and an adjective to produce a certain kind of direct effect on the reader is both simple and elusive. It appears as early as 1846, in an article on Senneville, when again it is connected in Baudelaire's mind to visual terminology:

> . . . he ignores (Senneville) strongly colored rhymes, these lanterns which light up the road of the idea; he also ignores the effects one is able to draw from a certain number of words, variously combined.[37]

A certain number of words diversely combined is a vague statement, but the meaning is clarified by an example of noun-adjective combination that Baudelaire records in *Fusées:*

> Tragic heaven *(Ciel tragique.)* Abstract epithet applied to a material being.[38]

What Baudelaire has in mind is the discrepancy between the noun and the adjective; there is an implicit metaphysical gap between the two terms which produces the effect of a subtle jolt or *frisson* in the reader when the words are combined and fused together in a unit. This technique of yoking words together in startling combination is a dominant aspect of Baudelaire's poetry and is, in effect, the literary equivalent of the color theory expounded in his art criticism. Baudelaire sees that Delacroix achieves greater vibrancy in his color because he keeps the *touches de couleur* separate and allows the process of fusion to take place in the eye of the spectator. In his word combinations Baudelaire emphasizes the disparity between noun and adjective which forces the reader into a heightened awareness of language; the effect produced is a kind of verbal intensity which results from the fusion of elements perceived to be separate. The reader is aware simultaneously of the combined effect of the words together as well as the gap between them. In combinations such as "cheveux bleues" or "soleil noir," each word acquires greater distinctness and higher relief because they are not normally associated; and in the resultant combination the words mutually alter each other in the same way that

Delacroix's juxtaposed spots of color produce a reciprocal harmony. The reciprocal interaction between words adds a physical component to the poetic line; first because the apparent disparity between the elements combined tends to stop the easy flow of thought and creates a slight pause in the rhythm of the line. In writing about Pater's prose, Saintsbury points out that the use of *catachresis* (the rhetorical term for the slight diversion of words from normal usage) has a definite effect on rhythm.[39] Even subtle diversions such as the phrases "green shadow" or "solemn water" give the reader a momentary mental pause which alters the rhythm of a sentence. Pater's technique of combining words so as to throw the meaning slightly askew ("moral landscape") is ultimately derived from Baudelaire; in fact Baudelaire's simple discovery of the power of combining words in new ways becomes one of the distinguishing characteristics of Symbolist literature. The implications of this simple idea are numerous because it is the basis of Baudelaire's entire poetic practice. In trying to explain the concrete quality that Baudelaire feels that language has in common with painting and cooking, it is necessary to understand that Baudelaire is using language with a new end in mind. While the romantic poet thought of language as a medium for self-expression, Baudelaire tries to make language produce an effect on the reader, an effect as tangible as the impact of a painting or a well cooked meal. The simple idea of word combinations is so important to Baudelaire because it represents in a condensed way his whole approach to language as a physical substance. In Baudelaire's poetry there is a great variety of effects produced by the noun-adjective unit ranging from the mild tension of combinations such as "enivrante monotonie" or "monstre délicat" to the full jolt of "parfums, riches corrompus triomphants." In all cases, however, the effects have similar components. First there is the mental shock, subtle or pronounced, of associating disparate qualities which creates the pause in the rhythm; because of this pause the reader is more aware of the resonance of each word, the presence of each word, the separate quality of each element put into the combination. And within this pause the reader is actively engaged with the words of the poem as words; the implicit gap between elements must be bridged, the reader must participate in the process of fusing the separate components into a unit. The reader helps to energize language in the same way the spectator is involved in fusing the color spots on a Delacroix canvas; in both cases there is a kind of built-in technical interaction between audience and medium. Baudelaire intends for the reader to pause at "enivrante monotonie" or "monstre délicat"; the phrases are calculated to generate imaginative activity on the part of the reader who must grasp for himself how to combine the ideas of exhilaration and monotony, delicacy and grotesqueness. This activity, the shock, the pause, the resolution of tension is just as physical as the optical combination of color tones in looking at a painting. Language is handled as a medium capable of stimulating a direct response involving specific energy, an actual *frisson*, an *émotion tangible*.

In Baudelaire's poetry the most salient word combinations are those which embody the idea of *correspondances*. Clearly, the phrases which combine color and sound, or sound and smell are examples of the poet's ability to restructure the world as a free translation of the dictionary of nature: in "un parfum vert" or "parfum doux comme les hautboys" the implicit boundaries between the sense have been crossed through a verbal connection. In phrases such as "ciel tragique," "paysage morale," or "oeil spirituel" there is an implied jump from one plane of reality to another (often called vertical correspondence in Baudelaire criticism) which again underlines the metaphysical gap which can be bridged through language. The distinctions which exist in the world of nature between categories of experience, between senses, between levels of reality, between the material realm and the spiritual, are all abolished in the world of the poem, where the universe can be seen as an infinite and complex analogy, all elements potentially in relation to each other. In the verbal world of the poem, language restructures perception; the reader is asked to combine, relate and fuse elements together which are explicitly separate in the world of nature. In effect, Baudelaire demands the reader's participation in reorganizing nature; the poem does not reflect nature but transforms it into a new context which is specifically verbal. In order to enter fully into the verbal world, the reader must actively respond to the changes in perception generated by the language. A phrase such as "pierres inouïes" cannot be assimilated unless the reader registers the discrepancy between the tactile and audible, material and spiritual components of the word combination and then accepts the fusion of qualities. Language not only refers to the theory of *correspondances* or the vision of the *analogie universelle* but embodies it concretely: the process of reading forces the reader to experience the reciprocal analogy directly because the phenomenon being described is totally contained within the verbal structure of the poem. A phrase like "pierres inouïes" does not refer back to nature or depend upon traditional associations, but establishes its own relative value within the context of the poem. Because the words are freed from their dictionary definition, they acquire their meaning through their interaction with other words in the poem. Because the poem as a verbal construction is liberated from reflecting nature, the language of the poem becomes, in a sense, synonymous with the reality it represents: instead of using words as mere signs for experience Baudelaire makes the act of reading the poem the primary experience itself. With Baudelaire language attains a new concreteness and a new metaphysical status: language not only restructures reality but it gives this vision physical substance with the actual words on the page. The poem, the verbal transformation of nature, *is* the experience, the reality it describes; there is no separation between words and what they represent. Because the verbal world replaces the world of nature, the reader has direct access to the poetic experience. Language is not simply a medium for transmitting the poetic experience; the poetic experience

is literally contained in the words themselves and the act of reading the text of the poem becomes a kind of metaphysical exercise. Baudelaire says of the art of criticism, "there is never a moment when criticism is not in contact with metaphysics."[40] He also feels that writing ("hygiène spirituel") and reading are direct forms of participating in the process of structuring reality; as the world of language is more real than nature to Baudelaire, an involvement with words, whether as writer, critic, or reader, is a kind of physical contact with metaphysics. As Marcel Raymond has pointed out,[41] one of the characteristics of Baudelaire's thought is the proximity of the lowest and highest aspects of existence, the unexpected connection between material and spiritual values which is perfectly illustrated by Baudelaire's sense of verbal reality. Words, like paint or the ingredients of a good sauce, are physical particles which can be combined by the imaginative artist to produce *une oeuvre d'âme,* which is both a concrete object and a spiritual entity. Like a painting, the text of a poem contains a spiritual experience within a physical form: and in both cases the experience, the *émotion tangible* is present in the actual substance of the words or the paint, in the matter itself which has been spiritualized by the process of art.

This metaphysical sense of the concrete forms the basis of Baudelaire's analogy of writing to painting. Because a painting clearly embodies physicality and spirituality at the same time, it is almost a symbol for Baudelaire of the inseparable nature of reality, the interwoven world of analogies in which matter and spirit, *âme* and *sensation* are interrelated. Throughout all of Baudelaire's writing there is a strong emphasis on materiality, even in its most extreme forms of filth, rot, and corruption. The implication is consistently untranscendental and anti-romantic; spirit is embedded in matter, the soul is conditioned by things, reality is a complex mixture of substance and thought, and art is rooted in physical sensations. Baudelaire's metaphysics is based on the awareness of the mutual relation between matter and spirit which influence each other reciprocally. For this reason Baudelaire's definition of his role as a poet is a double figure who is both chemist and saint; the alchemical process of art which transforms mud into gold involves a recognition of the relation of spirit to matter:

Anges revêtus d'or, de pourpre et d'hyacinthe,
O vous, soyez témoins que j'ai fait mon devoir
Comme un parfait chimiste et comme une âme sainte.

Car j'ai de chaque chose extrait la quintessence,

Tu m'as donné ta boue et j'en ai fait de l'or.[42]

Baudelaire defines an attitude which is pervasive throughout the Symbolist period: briefly stated it is that spiritual reality is not a grand abstraction but is everywhere present under the surface of daily life. The point of access can be anything; the smell of a woman's hair, the sight of a carriage rolling down the street, the sound of logs being tossed into a courtyard. Even the most trivial, mundane, and material aspects of existence can provide the key to awareness; for Proust the taste of a tea-cake opens up a new world, and Virginia Woolf locates the sense of eternity in a dish of *daube glacé*. Both Proust and Baudelaire compare literature to cooking in order to destroy the idea of an aesthetic hierarchy which carries with it the concept of transcendence, a progression from more material art forms to more spiritual. Literature can be compared to cooking because for both writers the universe is a complex whole in which the physical and spiritual elements are inseparable and the art form which reflects this vision must not attempt to disguise the material nature of the medium in which the vision is contained. Proust, like Baudelaire, uses painting as a primary metaphor for writing and in both cases the analogy to cooking is only a more blatant way of declaring the physical basis of art.

After having established the metaphysical basis of Baudelaire's analogy of writing to painting, it might be helpful to go back and review the implications of the metaphor which have been discussed thus far. Painting is an appropriate metaphor primarily because the concrete components are more obvious than in literature: the text of the paint, the surface of the canvas, the two-dimensional aspect of the form, all combine in the final sense of the painting as an artifact, which is both an object and a transformation of nature. In an early poem entitled "Le Cadre" Baudelaire explains that the significance of the frame in adding beauty to a painting is its effect of making a clear separation from nature:

> Comme un beau cadre ajoute à la peinture,
> Bien qu'elle soit d'un pinceau très-vanté,
> Je ne sais quoi d'étrange et d'enchanté
> En l'isolant de l'immense nature . . . [43]

When the metaphorical implications are transferred to literature the major concept of the painting as a framed artifact results in a concept of the literary text as an objective entity, a specific transformation of the world of experience into an artificial medium; the further implication is that if language, like paint, is a tangible medium then the text literally can embody the poet's vision on the page just as a painting is a physical representation of the artist's vision. All of this is of course a kind of theoretical ideal of what a literary text should be; a theoretical approach to language as a medium. It is relatively easy to understand the analogy of writing to painting in theoretical terms which pertain to an ideal

of form, but is much more difficult to explain how this form is actually achieved in literature, how the theoretical ideal specifically affects poetic practice. So far the essay has attempted to define the variety and subtlety of aesthetic implications Baudelaire has drawn from the analogy of writing to painting through his contact with Delacroix, treating the analogy on the level of an aesthetic ideal. But, as part of the aesthetic ideal represented by painting is the direct and physical effect of the medium, I have tried to show how Baudelaire has used word combinations as Delacroix uses color combinations to produce a tangible effect on the reader. But this illustration has been the only attempt at showing how the ideas are applied. At this point, in moving on to the final sections of Baudelaire's *véritable esthétique* as set forth in his Delacroix article, I would like to try to apply the theoretical analogy to specific poems in order to illustrate more clearly the final points in Baudelaire's aesthetic comparison between the arts. The two major aspects of the analogy to painting which each subsume other minor or more subtle points are the idea of language as a concrete medium and the idea of the total unified form of a painting or a literary structure that approaches that ideal of simultaneous perception. As the final section of Baudelaire's *véritable esthétique* deals with each of these aspects I will quote the first section which pertains more to the general idea of a concrete medium first and then try to apply the principles involved before moving on to the second section which is more precisely related to the idea of form. Throughout this final section of the essay I will be turning to extended examples in Baudelaire's poetry of certain theoretical ideas already introduced in the preceding part of the essay, but adding to these ideas from the final paragraphs of his *véritable esthétique* which tend to clarify points which were left in relative obscurity earlier on. As Baudelaire's thought forms a complex whole, it is often necessary to approach the same concept from different angles and in different relations. The separation, for example, of the idea of language as a concrete medium from the ideal of painterly form is an arbitrary one on my part—in Baudelaire's criticism the ideas are always interrelated; but such a division is necessary in order to build up to a final sense of how Baudelaire's use of painting as a metaphor for literature is a pervasive and innovative force in his poetry which produces a whole new direction in modern aesthetics.

In the final section of the *véritable esthétique*, after Baudelaire has reminded the reader of the "concordant aspects of all the arts and their similarity in methods" he goes on to define a general theory of abstraction in the art of painting—which is in essence one of the first attempts to conceptualize the nonrepresentational aspects of the formal qualities of painting. The standard approach of the nineteenth-century art critic is to categorize a painting according to subject or genre (landscape, portrait, history), an approach which Baudelaire himself conforms to in the organization of his *Salons*. But while the standard critic is bound by the idea of the painting as a treatment of a subject, as a

reflection of nature, Baudelaire blatantly asserts that there is an aesthetic value which is completely independent of the nominal subject, and this assertion represents a major change in critical perspective. Whereas it takes John Ruskin practically his whole career to work beyond the dominance of nature to an appreciation of the abstract qualities of Turner's color harmonies, Baudelaire immediately perceives the importance of the purely formal qualities of painting as revealed through Delacroix. Baudelaire discovers that the line, color, shapes, masses and forms of the painting produce a definite effect which is absolutely independent from their representational function. The first part of his explanation of this effect reads as follows:

> Strictly speaking there is neither line nor colour in nature. It is man that creates line and colour. They are twin abstractions which derive their equal status from their common origin.
>
> 'A born draughtsman (I am thinking of him as a child) observes in nature, whether at rest or in motion, certain undulations from which he derives a certain thrill of pleasure, and which he amuses himself in fixing by means of lines on paper, exaggerating or moderating their inflexions at his will. He learns thus to achieve stylishness, elegance and character in drawing. But now let us imagine a child who is destined to excel in that department of art which is called colour; it is the collision or the happy marriage of two tones, and his own pleasure resulting therefrom, that will lead him towards the infinite science of tonal combinations. In neither case has nature been other than a pure *excitant*.
>
> 'Line and colour both of them have the power to set one thinking and dreaming; the pleasures which spring from them are of different natures, but of a perfect equality and absolutely independent of the subject of the picture.'[44]

When Baudelaire ends the paragraph with "absolument indépendante du sujet du tableau," he is making a consciously bold statement because the idea is extremely new to the contemporary appreciation of painting. Baudelaire even goes so far as to disclaim any associative values rooted in nature as part of the initial effect of line and color; he claims that the values established are pure invention on the part of the artist; line, color, form are artificial, invented, pure. But Baudelaire's sense of purity is not as acute as the later developments in aesthetic theory which grow from his perception; he insists that the initial effect of pure form is a moral impression; a spiritual revelation which somehow emanates from the canvas before the subject of the painting is brought into focus. In his introduction to the *Oeuvre et vie* of Delacroix he states:

> It is the invisible, the impalpable, the dream, the nerves, the *soul;* and this he has done—allow me, please, to emphasize this point—with no other means but colour and contour; he has done it better than anyone else—he has done it with the perfection of a consummate painter, with the exactitude of a subtle writer, with the eloquence of an impassioned musician. It is, moreover, one of the characteristic symptoms of the spiritual condition of our age that the arts aspire if not to take one another's place, at least reciprocally to lend one another new powers.[45]

The implication is that the spiritual essence of the painting can be communicated through the purely formal elements, without recourse to nature or an explanatory "subject," and again Baudelaire suggests that this impression which can be generated by formal elements alone is also possible in the medium of language. Baudelaire gives us a specific example of this translation of effect from one medium to another by illustrating his point with his own stanza on Delacroix from *Les Phares* the very first time that he mentions the idea of abstraction in the *Exposition universelle de 1855*.[46] Again he begins by describing the effect of an initial view of a canvas before the subject is actually apparent:

> The minute and careful examination of these pictures can only reinforce certain irrefutable truths suggested by a first rapid and generalized glance. First of all it is to be noted—and this is very important—that even at a distance too great for the spectator to be able to analyse or even to comprehend its subject-matter, a picture by Delacroix will already have produced a rich, joyful or melancholy impression upon the soul. It almost seems as though this kind of painting, like a magician or a hypnotist, can project its thought at a distance. This curious phenomenon results from the colourist's special power, from the perfect concord of his tones and from the harmony, which is pre-established in the painter's brain, between colour and subject-matter. If the reader will pardon me a stratagem of language in order to express an idea of some subtlety, it seems to me that M. Delacroix's colour *thinks for itself*, independently of the objects which it clothes. Further, these wonderful *chords* of colour often give one ideas of melody and harmony, and the impression that one takes away from his pictures is often, as it were, a musical one. A poet has attempted to express these subtle sensations in some lines whose sincerity must excuse their singularity:—

> > *Delacroix, lac de sang, hanté des mauvais anges,*
> > *Ombragé par un bois de sapins toujours vert,*
> > *Où, sous un ciel chagrin, des fanfares étranges*
> > *Passent comme un soupir étouffé de Weber.*

> *Lac de sang* (lake of blood)—the colour red; *hanté des mauvais anges* (haunted by bad angels)—supernaturalism; *un bois toujours vert* (an ever-green wood)—the colour green, the complementary of red; *un ciel chagrin* (a sullen sky)—the turbulent, stormy backgrounds of his pictures; *les fanfares et Weber* (fanfares, and Weber)—ideas of romantic music awakened by the harmonies of his colour.[47]

What Baudelaire is trying to transpose into literature is the effect of the color which "thinks for itself, independently of the object which it clothes"; in relation to language this would mean an attempt to use the concrete, sensory aspects of words to produce an impression before the denotations of the words have come into focus. Throughout the history of modern aesthetics, the words "abstract" and "concrete" have been complexly related. Often, as in this case, they amount to about the same thing: what Baudelaire is trying to establish is the *primary* effect of the medium itself, whether paint or words, an effect which

communicates the essence of the work of art directly and which precedes the identification or recognition of the nominal subject. In his poetic example Baudelaire uses explicitly artifical images which have no location in the world of nature; in a phrase such as "lac du sang" the impact of the words produces the same kind of *atmosphère morale* as Delacroix's red. Baudelaire feels that the peculiar quality of the red paint produces a *sensation morale* which is independent of its signification in terms of subject; similarly he feels that the artificial verbal construction "lac du sang" communicates a sensation which does not depend on a rational or associated grasp of meaning—the image is purely verbal, the result of combining words into a unit which is not necessarily visualized or in any sense referred back to the dictionary of nature. Just as Baudelaire sees that Delacroix is able to produce his essential impression "without other means than contour and color," so he tries to produce the essential effect of his poetry by using the physical properties of words, the latent color, texture, sound, shape, and image value, rather than relying on their specific meaning, in order to approximate the painter's power of direct and tangible communication. As much poetic theory that grows from Baudelaire's beginnings deals with the impossibility of escaping the denotative or discursive condition of language, it is important to remember that what Baudelaire identifies as the *primary* effect of a work of art involves moral communication; he does not believe that either paint or words operate within a pure aesthetic vacuum, but that somehow the essence of a work of art lies within the concrete conditions of the medium itself. For this reason his poetry attempts to maximize the ability of language to produce a tangible sensation, to release the mysterious qualities which are contained within the physical components of the words themselves, to bring the sensory aspects of language to the foreground; but none of this implies an attempt to use language as if, in Frank Kermode's derogatory phrase, it were "divinely devoid of meaning." It is extremely difficult to gauge the relative emphasis on the sensory aspect of language; in modern concrete poetry where the choice of words may depend upon the shape of the poem on the page the emphasis is clear; in Baudelaire's poetry, however, the degree to which the physical nature of language is emphasized involves a more complex demonstration. First, it is easy to see that throughout his poetry there is an emphasis on sensation in the crudest terms. In poems such as *La Charogne* or *Le Voyage à Cythère* the images of rotting corpses are specifically calculated to create a visceral response that almost amounts to physical discomfort, a very tangible *frisson*. Or in lines such as

> Je sentis, à l'aspect de tes membres flottants,
> Comme un vomissement, remonter vers mes dents
> Le long fleuve de fiel des douleurs anciennes;[48]

the comparison is so precisely physical that it almost causes the phenomenon it describes. But Baudelaire expects language to create more complex sensations than simple gut reactions—and when he claims in the *Projet de préfaces* that words can rival painting or cooking he is referring to more subtle possibilities. Again it is easy to see that many of his images are designed to be acutely visualized, especially the grotesque images which seem to be derived from his study of engravings such as his description of the old man in *Les Sept Vieillards:*

> Il n'était pas voûté, mais cassé, son échine
> Faisant avec sa jambe un parfait angle droit,
> Si bien que son bâton, parachevant sa mine,
> Lui donnait la tournure et le pas maladroit

> D'un quadrupède infirme ou d'un juif à trois pattes.[49]

The ability to make the reader visualize an image or feel repugnance is the most simple way in which Baudelaire attempts to use the concrete powers of language. The real innovation is Baudelaire's ability to take words out of their normal context and put them into new combinations which emphasize their purely verbal quality. As discussed previously in relation to the word and color combinations, the writer, like the painter, finds his pleasure in experimenting with the *choc* and *accord* produced by different relations between elements. Often in Baudelaire there is both a shock and harmony operating in combination; the meaning or sense of a phrase clashes with the harmonious verbal perfection. The abstract beauty of *cheveux bleues* produces an *accord* of sound and image which is also perceived as a *choc* to reason. By placing words in contexts that force the reader to examine the disparity underlying the verbal harmony, Baudelaire brings the physical qualities of words into the foreground of the reader's attention. This effect has been discussed in relation to the noun-adjective unit which parallels Delacroix's color units, but it is also the extended working principle of all Baudelaire's poetry. Often a whole line of poetry is designed to create a number of related shocks and accords. An example taken from a prose poem illustrates again the metaphysical texture of Baudelaire's verbal art. At the end of "Un Hémisphère dans une chevelure," which is a prose transposition of "La Chevelure" from *Les Fleurs du mal,* Baudelaire writes: "Quand je mordille tes cheveux élastiques et rebelles, il me semble que je mange des souvenirs."[50] The impossibility of eating memories, the strange vitality given to the hair by the adjectives "élastiques et rebelles," the transference of those qualities to "souvenirs," produces a complex of shocks which gives each word in the line greater distinctness, higher relief, more presence as *language* because the poet has forced the words out of an easily accepted, "natural" relationship and put them into an artificial verbal construction. In most of Baudelaire's better poems the

principle of *choc et accord* is in subtle, implicit operation; for example *Le Crépuscule du soir* begins with:

> Voici le soir charmant, ami du criminel.

The light, frivolous first half of the line suggests an almost traditional sense of charm which is distinctly altered by the sinister quality of the second half; the two words *charmant* and *criminel* mutually affect one another and the reader is persuaded to feel the combination of charm and criminality. What Baudelaire effectively does is to reinvent the meaning of words by placing them in a new context; charm is redefined in sinister terms, criminality acquires an aura of lightness. Just as Baudelaire sees that Delacroix invents the significance of line and color in his painting, he tries to invent the significance of words within the poetic structure. As Baudelaire defines the occupation of poet, he places an emphasis on the manual aspect of his craft, on the power of the writer to manipulate language: "Manier savamment une langue, c'est pratiquer une espèce de sorcellerie évocatoire." (To know how to handle language wisely is to practice a kind of evocative sorcery.)[51] Baudelaire understands that the sorcery of language is involved with the actual handling of words, the shaping and placing of words in the structure of a poem is just as physical an activity as forming the paint on a canvas. Baudelaire's boast in the *Project de préface* about his ability to use the physical properties of language is entirely serious; he gives the poetic line a definite sense of weight, mass, movement in space. The whole first stanza of *Spleen* (LXXVIII), for example, is calculated to convey the feeling of oppressive density, of downward gravitational pull:

> Quand le ciel bas et lourd pèse comme un couvercle
> Sur l'esprit gémissant en proie aux longs ennuis,
> Et que de l'horizon embrassant tout le cercle
> Il nous verse un jour noir plus triste que les nuits;[52]

When later in the same poem Baudelaire begins a stanza with "Des cloches tout à coup sautent avec furie" there is an opposite effect, an upward lift of mounting rhythm, of surrealistic explosion. But the use of rhythm and sound to accentuate the sense of a line has been a part of traditional poetic stock in trade. What is new in Baudelaire is the degree of importance that the physical aspects of words assume in establishing the total meaning of the poem. Perhaps Baudelaire's most innovative technique is his use of the verbal equivalent of the zigzag line cited in the *Projet du préface;* a phrase such as "Voici le soir charmant ami du criminel" begins moving in one direction and suddenly moves *à rebours,* throwing the reader momentarily off balance. This movement of cross directions, which causes a back and forth effect within the poetic line (one moves back to attach the ideas of *criminel* and *charmant*), as we have seen occurs even

within the single noun-adjective unit. This ability to place words so that they mutually alter one another, to yoke together words in a verbal construction which displaces them from their normal context, to use the built-in metaphysical and sensory gaps between words, to reorganize nature according to the verbal artifice of the poem's structure: all of these techniques work together to give Baudelaire's language a density, a texture, a substantial reality of its own. Perhaps it is easier to see what Baudelaire is striving towards by taking one of his disciples as a further example. Mallarmé says:

> Je dis: une fleur! et, hors de l'oubli où ma voix relègue aucun countour, en tant que quelque chose d'autre que les calices sus, musicalement se lève, idée même et suave, l'absente de tous bouquets.[53]

> I say: a "flower" and, out of the forgetfulness where my voice banishes any contour, inasmuch as it is something other than known calyxes, musically arises, an idea itself and fragrant, the one absent from all bouquets.

What Mallarmé tries to pin down is the difference between accepting language as a sign which refers to a thing—and a word which is a thing of another order in and by itself. It is this sense of the reality of language that Baudelaire tries to define when he claims that poetry can rival painting or cooking; words are as real and substantial as food or paint. Later critics looking back to Baudelaire as an innovator point out this new sense of concreteness as his major breakthrough. Jean Pierre Richard says, for example:

> What constitutes the excellence of language for Baudelaire, is its material docility, its plasticity, its suppleness in translating everything, in resolving everything. Go even further; if Baudelaire considers his verbal landscape superior to all other landscape, it is that there exists between him and his language an immediate relation, an existential familiarity.[54]

Poetry is first of all made up of words, just as a canvas is composed of paint. But as simple as this idea is, it took the followers of Baudelaire and Delacroix a certain length of time to absorb its importance. Later the Impressionist theoretician Signac looks back to Delacroix as the major innovator in painting techniques which lead to Impressionism; he sees that Delacroix's *touche* is entirely new, the broken color, the exposed canvas, the apparent brush stroke all contributing to a new handling of the medium of paint which broke through the slick, illusionistic surface recommended by the Academy. Baudelaire of course saw the originality of Delacroix's technique long before Signac, and it is precisely because he recognized the power of the medium itself, independent of its representational responsibility, that he was able to derive an entire aesthetic theory from his study of Delacroix's art. Again, it is precisely this recognition of the power of language as a concrete medium that enables Baudelaire to make

a major breakthrough in poetics; he gives to words a sense of texture, density, and reality which appears to later poets as the same kind of fundamental innovation as Delacroix's breaking of the academic surface did to subsequent painters. Both artists reinvent their medium; the change is both simple and profound, because it is an entirely new perception of possibilities. Delacroix emphasizes the fact that a canvas is made from paint; Baudelaire forces the reader to experience words as things, and in both cases the new orientation creates a whole range of experimentation which is carried out for the next half-century by the poets and painters who follow the new sense of the medium established by Baudelaire and Delacroix. As far down into the twentieth century as the era of the New Critic, poets seem to be making the distinction between words as signs and words as things ("a poem must not mean but be"); a distinction which is originally connected to Baudelaire's revelations of the concrete power of Delacroix's paint. Again, this is not to imply that all modern poetics come ultimately from Delacroix, but simply to point out that the initial formulation of the modern ideal of poetic language is related to the analogy of writing to painting, and to insist again on the importance of the concept of *ut pictura; poesis* for the whole Symbolist movement.

As we move on to Baudelaire's concluding description of the power of Delacroix's painting and the final section of his *véritable esthétique,* we come back again to the concept of the painting as a model form for simultaneous perception, for total unity of all parts. The final quote emphasizes again the first view of a painting (which is also present in the earlier version from the *Exposition universelle de 1855*), the first view which gives the viewer what Baudelaire here calls the *plaisir primitif:*

'A picture by Delacroix will already have quickened you with a thrill of supernatural pleasure even if it be situated too far away for you to be able to judge of its linear graces or the more or less dramatic quality of its subject. You feel as though a magical atmosphere has advanced towards you and already envelops you. This impression, which combines gloom with sweetness, light with tranquillity—this impression, which has taken its place once and for all in your memory, is certain proof of the true, the perfect colourist. And when you come closer and analyse the subject, nothing will be deducted from, or added to, that original pleasure, for its source lies elsewhere and far away from any material thought.

'Let me reverse my example. A well-drawn figure fills you with a pleasure which is absolutely divorced from its subject. Whether voluptuous or awe-inspiring, this figure will owe its entire charm to the arabesque which it cuts in space. So long as it is skilfully drawn, there is nothing—from the limbs of a martyr who is being flayed alive, to the body of a swooning nymph—that does not admit of a kind of pleasure in whose elements the subject-matter plays no part. If it is otherwise with you, I shall be forced to believe that you are either a butcher or a rake.[55]

Baudelaire underlines the fact that the analysis of the subject adds nothing whatever to the *plaisir primitif,* which is the tangible emotion produced by the

concrete aspects of the painting seen all together in the first moment of simul-
taneous perception. As stated previously, the concepts of concreteness and
totality, tangibility and simultaneity are fused together in Baudelaire's aesthetic,
and in this paragraph he gives a classic example of the effect of painting as
an ideal form. The painting communicates its essence, the "volupté surnatu-
relle," the "atmosphère magique" through the purely formal components per-
ceived as a whole before the process of analyzing the subject or discriminating
the parts has begun. The *plaisir primitif* is an initial response which depends
upon the aspects of concreteness and simultaneity working together. What
Baudelaire sees in Delacroix's painting is a kind of ideal aesthetic form which
gives him the experience of *surnaturel* reality; a sense of total understanding
which operates without intermediary analysis, logic or discourse, a feeling of the
complete and mysterious unity of total perception. Baudelaire tries to define
the sense of total perception throughout his writing, and it appears as a recurring
ideal in many places. For example, in his essay on hashish Baudelaire describes
the kind of transformation of time and space which the drug affords:

> Hashish spreads over the whole of life a sort of veneer of magic, colouring it with
> solemnity and shining through all its depths. Scalloped landscapes; fleeting horizons;
> perspectives of towns blanched by the cadaverous pallor of a storm or illumined by
> the concentrated glows of sunset, depths of space, allegorical of the depths of time;
> the dances, movements or utterances of actors (if you happen to have fetched up in a
> theatre); the first phrase that catches your eye, if you glance at a book: everything in
> short, the universality of all existence, arrays itself before you in a new and hitherto
> unguessed-at glory.
> Even grammar, dry-as-dust grammar, becomes something like a sorcerer's conjura-
> tion ("sorcellerie évocatoire"). The words are resurrected in flesh and bone: the
> noun, in its substantial majesty, the adjective, the transparent robe that clothes and
> colours the noun like a glorious burnish; the verb, angel of motion, that gives a
> sentence its impetus.
> Music, another form of speech beloved by the lazy, or by deep minds seeking
> relaxation in a charge of activity, tells you about yourself, recites to you the poem
> of your life. It enters bodily into you, and you in turn become dissolved in it. It tells
> of your passions—not in a vague, indefinite manner, as it does at a casual evening's
> entertainment, or during a visit to the opera, but circumstantially and positively,
> with each movement of the rhythm recording a well-known movement of your soul,
> and with the entire poem entering your brain, like a dictionary that has come alive.[56]

The drug experience emphasizes only what Baudelaire is already prone to see; he
feels that language has become substance, "l'aride grammaire elle-même, devient
une espèce de sorcellerie évocatrice." Words take on flesh and color and com-
municate directly like notes of music. Music acquires the impact of language, the
abstract notes are comprehended instantaneously, and the whole composite
musical poem enters the head as a simultaneous entirety. This ideal of total
perception is defined again a series of entries in *Fusées* which underline the same

qualities experienced in the state of hashish perception. The key concept again is
the idea of the *surnaturel:*

> . . . The supernatural comprises colour in general, and also accent—that is to say,
> intensity, sonority, lucidity, vibration, depth and resonance, in space and time.
>
> There are moments of existence when time and expanse are more profound,
> and the sense of existence is hugely enhanced.
>
> On language and writing as magical functions, conjurative sorcery.
>
> In certain almost supernatural states of the soul, the profundity of life is entirely
> revealed in any scene, however ordinary, that presents itself before one. The scene
> becomes its Symbol.[57]

Surnaturel perception, as defined in this last entry, approaches the definition
of a symbol; the symbol (according to Mallarmé, Valéry, the New Critics, etc.)
operates as a total unit to communicate an essence which cannot be paraphrased.
"Surnaturel" perception is the process of converting the ordinary spectacle into
a symbol; there is an implicit deepening of awareness, a simultaneous change of
perception which affects everything at once and suddenly reveals the *surnaturel*
essence of existence. Baudelaire, of course, finds *surnaturel* perception most
perfectly exemplified by Delacroix's painting because the process of deepening
awareness of the whole spectacle, the perception of symbolic quality, is specifi-
cally accomplished by the form of a painting which is designed to produce a
simultaneous effect. At one point Baudelaire links the idea of *surnaturel* percep-
tion, the revelation of drugs, and his appreciation of Delacroix all together.

> Edgar Poe has it somewhere that the effect of opium upon the senses is to invest
> the whole of nature with a supernatural intensity of interest, which gives to every
> object a deper, a more wilful, a more despotic meaning. Without having recourse to
> opium, who has not known those miraculous moments—veritable feast-days of the
> brain—when the senses are keener and sensations more ringing, when the firmament
> of a more transparent blue plunges headlong into an abyss more infinite, when
> sounds chime like music, when colours speak, and scents tell of whole worlds of
> ideas? Very well then, M. Delacroix's painting seems to me to *translate* those fine
> days of the soul. It is invested with intensity, and splendour is its special privilege.
> Like nature apprehended through extra-sensitive nerves, it reveals what lies beyond
> nature (le surnaturalisme).[58]

Baudelaire sees Delacroix's paintings as an ideal example of *surnaturalisme;*
but there is an implicit problem involved in transferring *surnaturel* perception to
literature without the benefit of hashish. The structural ideal of *surnaturalisme*
is a form which allows the deepening process of symbolic perception to take
place, in which there is a simultaneous change affecting all parts together at
once; this aspect of total perception, as Delacroix has pointed out, can be
realized in a painting, while literature is conditioned by sequential movment. But
Baudelaire is aware of the fact that the magical *sorcellerie* of total perception is

only theoretically a simultaneous, instantaneous change in vision; in actuality there is an implicit process of movement from the sense of ordinary reality to the sudden transformation of that *spectacle si ordinaire qu'elle soit* into a symbol. The important aspect is that the whole spectacle is transformed all together at once, the original moment of total perception is not broken into separate links. This, in a way, is Baudelaire's critical method as well; he describes his initial revelation of the power of Wagner's music as leading to a desire for further understanding:

> . . . I had experienced a spiritual operation, a revelation. The pleasure that I had felt was so strong and so terrible that I could not help wishing to return to it constantly. . . . I resolved to discover the why and the wherefore and to transform my pleasure into knowledge. . . .[59]

In the process of transforming *volupté* into *connaissance* the original *émotion tangible* is kept intact. Baudelaire never loses the wholeness of his initial response to Wagner as he moves into a more detailed critical discussion. The point is that Baudelaire values the original *volupté* because it is the most direct as well as the most complete response to the work of art. The final *connaissance* grows out of the original *volupté* but does not alter the first sense of tangible and total communication; as Baudelaire has pointed out elsewhere, the critic must necessarily use his intelligence, but the intelligence can only serve to illuminate what has already been discovered by the passionate imagination. The impassioned response is the true test of the critic's perceptiveness. In a similar way Baudelaire applies the same pattern to his appreciation of painting; the first complete response, the *plaisir primitif,* is expanded into fuller *connaissance,* but is never replaced, diminished or augmented by the process of analysis. What Baudelaire tries to establish as a critical method reflects his belief in the importance of the total unity of the work; the initial *volupté* or *plaisir primitif* is a response to the immediate effect of the work as a whole and although the understanding of this effect may be deepened, the sense of complex unity which is established by the initial contact is the true essence which the critic must try to convey to his readers. The task of the critic is to identify, clarify and deepen the original *émotion tangible* and Baudelaire's critical process follows the same movement and rhythm that he has defined as the characteristic of Delacroix's process of composition. Baudelaire points out that in Delacroix's painting the original *ébauche* (sketch) grows by stages into a finished painting, and that this initial germ contains the same unity and wholeness as the completed product. As he says in describing Delacroix's technique, the painting is developed "comme un monde"; there is a simultaneous deepening of all parts of the canvas together rather than a process of filling in the space section by section as in the method of Vernet. Delacroix's technique is a kind of layering process, as Baudelaire says "a series of superimposed layers" which keeps the unity of the whole intact

throughout the process of composition. The progressive movement toward the final achieved total form of the painting is like the movement of *surnaturel* perception; everything deepens and changes together. In returning to the question of how literature can approximate the *surnaturel* ideal, it is possible to see a transference of this compositional technique from Delacroix to Baudelaire. Baudelaire tries to create a poetic structure that moves from an initial germ to a final symbolic form (the whole poem considered as a complex symbol) by establishing the poetic equivalent of Delacroix's *couches superposées*. Many of Baudelaire's best poems are based on a kind of interlocking verbal structure which allows the reader to experience the sense of the whole poem deepening in its totality rather than developing as a narrative or grammatical sequence. Through his handling of words and images Baudelaire produces the effect of a complex, expanding unity which is like *surnaturel* perception; the reader is aware of all the elements of the poem changing and moving together from the opening line to the final view which brings the symbolic process to completion.

Baudelaire often uses an opening line, like an *ébauche,* a germ which contains the essential qualities to be developed and expanded throughout the poem. In *Crépuscule du soir,* for example, the opening line creates a kind of verbal image with the conjunction of the words *charmant* and *criminel,* and the sense of how these words are united is continually reinforced through the poem by the coupling of images from the world of domesticity with images from the criminal underworld of the *cité de fange,* both held in the suspension of twilight as the *aimable soir* deepens into night. This deepening of twilight into "la sombre nuit" is in fact the only movement in the poem; there is no narrative plot or progressive sequence of ideas, the structure is designed to expand on the unity of qualities established in the first line so that by the end of the poem a psychological deepening has taken place and the reader has a more complex sense of how the charming atmosphere of twilight is related, by contrast and association, to the sinister and corrupt aspects of the modern city.

Significantly many of Baudelaire's poems begin with an impersonal verbal image rather than a personal statement. By contrast, a surprising number of French romantic poems begin with the word *je;* the poet starts off by identifying himself as a speaking persona and then proceeds to relate his experience. Baudelaire infrequently uses *je* in an opening line and when he does it is often an explicit way of depersonalizing himself as an author. When he begins with "Je suis la pipe d'un auteur" or "Je suis comme le roi d'un pays pluvieux" he is specifically creating an artificial persona. In *Spleen (LXXVI)* for example he begins with "J'ai plus de souvenirs que si j'avais mille ans." Throughout the poem the abstract *je* of the opening line is identified first as a "gros meuble à tiroirs," then as "un cimetière abhorré de la lune" and then again as "un vieux boudoir plein de roses fanées." The poetic voice is located in objects; there is a complete separation between the author as a personality and the *je* of the

poem. In opposition to romantic practice, Baudelaire tries to free the poem from the authorial speaking presence in order to allow the words to function more as images on the page and less as transcribed speech. The difference in approach is based on a subtle difference in the concept of language: whereas the romantic poet frequently uses language as if it were primarily a spoken medium, secondarily written down, Baudelaire tries to use words as concrete entities, with their own substance and presence in printed form, as if words were verbal images. What Baudelaire attempts is in no sense, however, word painting: he doesn't use language simply to transpose visual images into verbal description. Instead he tries to use words in such a way that they approximate the concreteness and distinctness of visual art, as previously discussed. In two notes Baudelaire stresses the fact that his preoccupation with images and visual art begins at an early age:

> Praise the cult of images (my great, my unique, my primitive passion).[60]
> Permanent taste since childhood for all plastic representation.
> Simultaneous preoccupations with philosophy and beauty in prose and in poetry, the perpetual connection, simultaneous between the ideal and life.[61]

Because of his obsession with "les representations plastiques," Baudelaire, as we have seen, transfers this same plastic power to language: what is curious in this note is the description of a perpetual, simultaneous rapport that exists between *l'idéal et la vie.* The idea of simultaneity is again linked with the concept of plasticity and the whole metaphor might be transposed to describe Baudelaire's sense of the perpetual *accord* between language and reality; Baudelaire's sense of verbal reality is based on a simultaneous *accord* between the concrete words and the essence which they contain and represent. When Baudelaire begins a poem, instead of relying on the personal, poetic voice he tries to give the words on the page a self-sustaining reality, a tangible presence that makes them independent of their relationships to a hypothetical speaking poet. Thus Baudelaire's opening lines often create a verbal impression that functions like a visual image in that it can be retained as a distinct, whole unit, a visible group of words in the mind's eye. An initial line such as

> "Fourmillante cité, cité plein de rêves"
> (Les Sept Vieillards)

does not depend on a specific visual image for its impact; instead the entire line is a kind of verbal image that suggests the vast, teeming physical and psychological life of the city. As the poem is based on a sense of the metaphysically absurd world being suddenly projected into the normal, "où le spectre en plein jour raccroche le passant," the opening line serves to establish the general atmosphere which pervades the poem, and the specific words

"Fourmillante cité, cité plein de rêves"

remain distinctly in the background of the reader's mind and continue to
generate their "sorcellerie evocatrice." The opening line of *Les Petites Vieilles*

"Dans les plis sinueux des vieilles capitales"

is tremendously evocative as it suggests the wrinkles of old age, the sinuosity
of women, the folds of their skirts, the twisting directions of life in the city and
the mysterious, hidden psychological recesses of its inhabitants; in fact all of the
major themes of the poem are evoked in the opening line which again can be
distinctly remembered, because of the condensed pressure of language, through-
out the reading of the poem. Part of Baudelaire's *sorcellerie* is his ability to con-
dense the elements of the poem into an opening line, so that the original verbal
impression, like the germ of Delacroix's *ébauche,* expands into the full poem,
without losing the impact of the initial words. The opening line is not simply the
first in a sequence to be followed in series; it continues to reverberate through-
out the poem and serves as the background or verbal *fond* for the rest of the
words and images in the poem. This ability to produce a verbal impression which
is retained like an image is related to the renunciation of the authorial voice, and
it is curious to find that Proust, in *Contre Ste-Beuve,* connects Baudelaire's
impersonality, his seeming lack of personal relation to his subject, with the meta-
phor of painting. In analyzing the effects of *Les Petites Vieilles* Proust says that
Baudelaire has created a "painting" from which all sentimentality is excluded.
Again referring to *Les Petites Vieilles,* Proust continues:

> It is as though he were employing this extraordinary and unprecedented power of
> language (a hundred times more powerful than Hugo's, for all that people may say),
> in order to state for all time a feeling that he tries not to feel at the time he speaks of
> it, and which he paints rather than expresses.[62]

The extraordinary power of language that Proust identifies is the plastic power
itself; the ability to present the reader with the verbal equivalent of painting; a
concrete representation that functions without the traditional prerogative of the
authorial voice to make rhetorical commentary. What Proust discovers is that
Baudelaire's impersonality is really a preference for image over statement. When
Proust says that Baudelaire is "more pictorial than emotional" he does not mean
that Baudelaire is callous, but that his main poetic objective is to present a
verbal picture which stands on its own in terms of interpretation, judgment and
emotional response. The pictorial poem does not need the authorial voice to
serve as emotional interpreter for the reader, to explain what to feel, to tell how
to respond. The poem is a concrete object which speaks for itself, silently, like
a painting, without the loud contortions of romantic rhetoric. Delacroix's

admiration for "les arts silencieux" is similar to Proust's appreciation of Baude-
laire's pictorial impersonality; Proust has seen immediately that Baudelaire has
borrowed or transferred rhetorical silence from painting to literature and
throughout his essay he continues to use the metaphor of painting to describe
Baudelaire's essential quality.

Lack of rhetoric is connected in Baudelaire's mind to another major anti-
Romantic preoccupation; "l'hérésie de l'enseignement" (the didactic fallacy).
The term comes from Poe and it is significant that Baudelaire continually asso-
ciates Poe with Delacroix in his criticism and tries to establish *rassemblances*
between his two idols. The case against didacticism is a well known aspect of
Baudelaire's aesthetic and needs no real discussion except to point out that
Baudelaire's dislike of "enseignement" is obliquely connected to the ideal of
painting which is "silent" in this respect, just as it is in terms of overt rhetoric.
What is more pertinent is the fact that Baudelaire finds in Poe the precise cor-
roboration of Delacroix's prejudice against length in literature. Both Poe and
Delacroix hold brevity as the main literary criterion and for exactly the same
reason; in order that the total effect of the work will not be dissipated by exces-
sive length. In discussing Poe's preference for the *nouvelle* over the *roman*,
Baudelaire's criticism reflects the exact points which Delacroix makes in his
Journals to explain his preference for "les ouvrages de court haleine":

> Poe is especially fond [of] the *Short Story*. It has the immense advantage over the
> novel of vast proportions that its brevity adds to the intensity of effect. This type of
> reading, which can be accomplished in one sitting, leaves in the mind a more power-
> ful impression than a broken reading, often interrupted by the worries of business
> and the cares of social life. The unity of impression, the *totality* of effect is an
> immense advantage which can give to this type of composition a very special super-
> iority, to such an extent that an extremely short story (which is doubtless a fault)
> is even better than an extremely long story. The artist, if he is skillful, will not
> adapt his thoughts to the incidents but, having conceived deliberately and at leisure
> an effect to be produced, will invent the incidents, will combine the events most
> suitable to bring about the desired effect. If the first sentence is not written with
> the idea of preparing this final impression, the work has failed from the start. There
> must not creep into the entire composition a single word which is not intentional,
> which does not tend, directly or indirectly, to complete the premeditated design.[62]

Here, in his analysis of Poe, Baudelaire specifically links the idea of totality
with his anti-romantic bias against the heresy of inspiration. The poet, like the
painter, must exercise his craft with technical control rather than follow the
example of the romantic poet who claims to trust natural inspiration. As Baude-
laire points out, in order for the literary work to achieve the desired *totalité de
l'effet,* the writer must have a total design in mind from the beginning; the
opening line must prepare for the "impression finale," the "composition tout
entière" must be treated as a whole in order for the work to produce its *totalité*

de l'effet. Baudelaire finds in Poe a model for the new poetic, a figure like Delacroix, who represents an alternative to the popularized romantic aesthetic.

> But above all, I must point out that in addition to the share which Poe granted to a natural, innate poetic gift, he gave an importance to knowledge, work, and analysis that will seem excessive to arrogant and unlettered persons. Not only has he expended considerable efforts to subject to his will the fleeting spirit of happy moments, in order to recall at will those exquisite sensations, those spiritual longings, those states of poetic health, so rare and so precious that they could truly be considered as graces exterior to man and as visitations; but also he has subjected inspiration to method, to the most severe analysis. The choice of means! he returns to that constantly, he insists with a learned eloquence upon the adjustment of means to effect, on the use of rhyme, on the perfecting of the refrain, on the adaptation of rhythm to feeling. He maintained that he who cannot seize the intangible is not a poet; that he alone is a poet who is master of his memory, the sovereign of words, the record book of his own feelings always open for examination. Everything for the conclusion! he often repeats. Even a sonnet needs a plan, and the construction, the armature, so to speak, is the most important guarantee of the mysterious life of works of the mind.[64]

Again Baudelaire emphasizes the fact that technical control makes a new kind of literary experience possible: the sensation of totality.

> It is obvious then that the epic poem stands condemned. For a work of that length can be considered poetic only insofar as one sacrifices the vital condition of every work of art, Unity; I do not mean unity in the conception but unity in the impression, the *totality* of effect, as I said when I had occasion to compare the novel with the short story.

Baudelaire discovers the same ideal of form in his criticism of Poe that had been revealed to him through Delacroix's painting; the ideal of total unity which approximates simultaneous perception. Although the literary structure can never actualize the ideal, it can approach its own kind of *totalité de l'effet* through brevity and the organization of the "composition tout entière." In a short work all of the parts can be mentally retained and work together in producing the *impression finale;* the writer, like the painter, can control and manipulate the reciprocal effects of all elements within the structure, if the structure is reasonably compact.

If we look to see how Baudelaire achieves the *totalité de l'effet* in his poems, we can turn again to Delacroix's method of composition by *couches superposées* as a model. In a curious note on composition in *Conseils aux jeunes littérateurs,* Baudelaire uses the process of covering the canvas as a metaphor for writers:

> To write quickly one must have thought a great deal; one must have mulled over a subject constantly—while walking, bathing, eating, or even making love. E. Delacroix

once said to me: "Art is something so ideal and so fleeting that the tools are never adequate enough or the means sufficiently expeditious." The same thing is true of literature—hence I do not believe in erasing and crossing out; it disturbs the mirror of thought.

Some of the most distinguished and the most conscientious writers—Edouard Ourliac for example—begin by filling up a lot of paper; they speak of this as covering their canvas.—The aim of this chaotic procedure is not to lose anything. Then each time that they recopy, the prune and they trim. The result, even when excellent, is a waste of time and talent. To cover a canvas is not to load it with colors, but to sketch with a thin glaze, to lay out masses in light and transparent tones.—The canvas should be covered—in the writer's mind—at the moment that he picks up his pen to write down the title.[65]

The implication is that the entire composition must already exist as a whole in the writer's mind ("la toile doit être couverte en esprit") before the first line is written. In a poem such as "Crépuscule du matin," the first line is specifically related to the final stanza—as in both the beginning and end of the poem Baudelaire uses classical references in modern dress, which serve as framing figures for the body of the poem which is a distinctly modern cityscape. The poem opens with

> La diane chantait dans les cours des casernes,
> Et le vent du matin soufflait sur les lanternes.[66]

The classical reference is more or less buried within the modern context, but the discrepancy between the goddess and the barracks is registered in any case. Because Baudelaire is creating a verbal image, rather than a visual image transposed into words, the reader can either visualize the implicit image of Diana, or leave the reference within the word and respond only to the ostensible meaning which is strictly auditory; the actual result is probably, for most readers, a composite effect with multiple possibilities which is one of the advantages of the verbal image. In the final stanza the classical reference is specifically visualized:

> L'aurore grelottante en robe rose et verte
> S'avançait lentement sur la Seine déserte,
> Et le sombre Paris, en se frottant les yeux,
> Empoignait ses outils, vieillard laborieux.[67]

The wind associated with morning in the second line of the poem, is present at the end in the word "grelottante," dawn is shivering in her "robe rose et verte," suffering distinctly because of the discrepancy between her classical apparel and the brutal, modern context. "L'aurore" is confronted with an image of Paris personified as "vieillard laborieux," an image which has more iconographic association with the Middle Ages than the Golden Age. The entire last stanza has

the strange sense of allegory taken literally (an extenuation of the buried reference in "la diane chantait"); the final picture emphasizes the disjunctive nature of the modern context, where the Greek and Medieval personifications are juxtaposed in the deserted city and the meeting between the broken old man and the freezing young girl reinforces the atmosphere of cold, exhaustive sensuality which is one of the major components of the poem. It is clear in this case that Baudelaire has covered the entire canvas mentally before the poem begins; the opening line obviously prepares for the "impression finale" of the last stanza. But what is not so obvious is the relation of parts. The references to "la diane" and "l'aurore" are the only verbal notes in the poem which are not specifically modern; thus the final impression includes an awareness of the poet's conscious design to frame the poem with classical images, and the reader returns to the opening line with a new sense of depth which results from the fact that the buried intention of the opening line is realized at the end, which in turn alters the beginning. The images are isolated at either end of the poem, there is no progressive sequence of images, of thought, of emotional logic that leads from "la diane" to "l'aurore"; instead the final image is superimposed over the initial one. Because of the verbal quality of the images, which allows for the evocation of multiple associations at once, there is no problem involved in fitting the images together because there is no precise visual correlation, no strict alignment of outline. Instead the words in the final stanza interpenetrate with the words of the opening lines; there is an effect of mutual illumination as the second layer of words, the final *couche,* adds new dimension to the original verbal image, just as the original image prepares the way for the final impression. The poetic equivalent of Delacroix's *couches superposées* allows for a reciprocal action between parts, so that the unity of the poem, like that of a painting, results from the reciprocal harmony of all elements working together.

In "Crépuscule du matin," this reciprocal effect is the main technique which governs the "composition tout entière." In the body of the poem, each new group of words, each new verbal image, is like a *couche superposée* which deepens the entire poem and alters everything which precedes; instead of a sequence of images there is a kind of compounding reciprocal structure which continually deepens in total complexity and evocative density. The central section opens with lines of terrific suggestive power:

C'était l'heure où l'essaim des rêves malfaisants
Tord sur leurs oreillers les bruns adolescents;[68]

The combination of gothic and realistic elements, the fusion of sexual and metaphysical qualities, makes the lines a verbal image which hovers on the edge of visualization; the lines evoke the numerous depictions of the Temptation of St. Anthony which show the saint dreaming of a swarm of demons as well as

the picture of a vast sleeping city. Again, because Baudelaire creates his *sorcellerie* with words, there are multiple visual images which are combined within the verbal images simultaneously, and no one specific picture is implied. After the gothic introduction Baudelaire immediately uses an explicitly horrific image with a visceral impact:

> Où, comme un oeil sanglant qui palpite et qui bouge,
> La lampe sur le jour fait une tache rouge;
> Où l'âme, sous le poids du corps rêveche et lourd,
> Imite les combats de la lampe et du jour.[69]

The startling physical image of the palpitating bloody eye is used to make a complicated analogy between the night world and quotidian world; the lamp glows intermittently red against the coming daylight just as the soul struggles fitfully against the returning weight of the body. The metaphysical battle of separate realities is concretely embodied by the images of the eye and the lamp; again there is a mutual influence of all these verbal elements on each other, an effect of interpenetration which reflects the mixed light of dawn, an intermediary state in which nightmare and normal daily mentality are momentarily fused together in a tenuous combination. The stanza concludes with a description of the wind mentioned in the opening lines, which is coupled with "un visage en pleurs que les brises essuient" and then associated with the "frisson des choses qui s'enfuient" which is a reminder of the "essaim des reves" and the idea of demons departing at dawn. The final line brings back the contrast and fusion of spiritual and physical existence, as both kinds of activity end in crushing fatigue.

> Et l'homme est las d'écrire et la femme d'aimer.[70]

The stanza develops by superimposing layers of words; each additional group of words grows out of, refers back to and alters the preceding words so that the entire verbal picture deepens in complexity. The second stanza compounds the process: "Les pauvresses . . . (qui) soufflaient sur leurs tisons et soufflaient sur leurs doigts" add a new dimension to the cold wind of dawn, and the second startling image of the poem

> Comme un sanglot coupé par un sang écumeux
> Le chant du coq au loin déchirait l'air brumeux

represents the same complex pattern of one element breaking through another that is initiated by the image of the eye/lamp defined against the daylight. Here the relation of sound and substance is reversed between the first and second line which make up the verbal image: the "sanglot" (sound) is cut through by

the foaming blood (substance) in the same way that the substance of the "air brumeux" is cut through by the sound of the cock-crow. Again the verbal image is more complex than a visual image transposed into words: in this case there is an intricate and multiple relation between the various parts of the metaphor which gives the reader a sense of unfixed meaning, as if the words were capable of producing an infinite number of evocative combinations, just as in Baudelaire's ideal of "correspondances" the combinations of sounds, colors, and smells have "l'expansion des choses infinies." As the second stanza of the body of the poem ends with a composite image of sickness and sexuality, the layering effect is increased:

> Et les agonisants dans le fond des hospices
> Poussaient leur dernier râle en hoquets inégaux.
> Les débauchés rentraient, brisés par leur travaux.[71]

The "dernier râle en hoquets inégaux" is a subtle reminder of the "sanglot coupé" as well as of the intermittent palpitations of the bloody eye; the reader places this image over the preceding ones—a movement backwards within the structure of the poem—while simultaneously the description of the "débauchés . . . brisés par leurs travaux" refers back to the sexual fatigue of the "femme (lasse) d'aimer" and prepares for the final personification of Paris as a "vieillard laborieux." The "impression finale" is the composite effect of all elements in poetic structure working together reciprocally, just as in Delacroix's painting the "harmonie reciproque" is a result of the "affinités chimiques" among all the color notes on the canvas which modify each other. The ideal "totalité de l'effet" is accomplished because the effect of reciprocity works against the natural succession of poetic lines; at each state, from the "ébauche" to the finished poem, the mutual interaction of words and images gives the reader a sense of the entire structure deepening as a whole, so that with each additional layer of words the complex unity of the structure is changed all together, as the preceding lines are brought into new relations and combinations. The ideal of *surnaturel* perception, which is exemplified by the theoretical simultaneity of painting, is also realized, theoretically, in Baudelaire's verbal structure. The final impression of the poem is theoretically based on the mutual effect of all words in the poem operating all together, at once, as if the entire poem could be grasped as a single and complex whole. Again Fiser's definition of the whole poem as a single symbol applies to Baudelaire's theoretical ideal. Baudelaire says that "a painting is a machine all of whose systems of construction are intelligible to the practiced eye."[72] In a similar way, Baudelaire treats a poem as a "machine" for producing a total effect, and in the final view of the poem all of the systems should be visible at once for "un oeil exercé." The entire poem is like a verbal "tableau," a single unit in which all of the parts can be seen in relation together. The word "tableau," when applied to literature, usually

carries with it the connotations of a static, fixed, frozen quality as if the literary tableau were stopped in time, devoid of movement. But Baudelaire's ideal of *surnaturel* perception is not static; instead it is a rearrangement of the limits of time and space which permits the viewer an experience of the simultaneous deepening of the entire spectacle, or expressed another way, the infinite expansion of everything at once. In his discussion of painting Baudelaire does not imply that the effect of simultaneity is a way of freezing colors and forms, but instead a perception of the infinitely complex reciprocal movement which exists between all of the elements on the canvas mutually changing each other. Similarly, as Fiser points out in his discussion of the total poem as symbol, the concept of symbol is not so much that of an enlarged metaphor but rather the sum total of the process involved in reading the poem. Baudelaire's verbal "tableau" is not a static structure, it is simply an attempt to realize a poetic movement which is different from the traditional linear sequence in time, a movement which gives the illusion of everything changing at once. The final impression, the perception of the whole poem as a unit, is not a static perception of a locked pattern; instead it is a view of the reciprocal action between all elements in the structure, in the same way that Baudelaire sees continuous movement in the ostensibly static form of painting. The final perception is theoretically simultaneous, like the first view of a painting, but in both cases the simultaneous effect is a perception of changing relations, mutual alterations, reciprocal movements all happening at once. At the end of "Crépuscule du Matin," the reader is aware that the "complexe et indivisible unité" of the poem is based on the infinite variety of mutual effects which the words have on each other, on the multiplicity of evocations which results from the indefinite number of possible combinations of elements. The poem as a total structure is in perpetual motion, the interaction between parts is capable of infinite expansion, and the unity of the poem, like the reciprocal harmony of a painting, is continually deepening, never still.

As "Crépuscule du matin" is included in the *Tableaux parisiens,* one might expect it to be a good example of the poem which approximates a painting, a verbal "tableau." It is, of course, true that not all of the *Tableaux parisiens* come as close to Baudelaire's ideal of form as the "Crépuscule du matin"; obviously not all of the poems in *Fleurs du mal* realize the ideal to the same degree. In an early poem entitled "Tout entière," for example, the ideal of total unity is the main subject of the poem, but the form of the poem remains relatively conventional. A demon asks the poet to choose the most desirable part of his mistress and the poet replies he cannot separate parts from the whole "tout entière":

> Et l'harmonie est trop exquise,
> Qui gouverne tout son beau corps.

Pour que l'impuissante analyse
En note les nombreux accords.

O métamorphose mystique
De tous mes sens fondus en un!
Son haleine fait la musique,
Comme sa voix fait le parfum.[73]

The poem exemplifies a typical problem for a writer, like Baudelaire, who consciously researches the aesthetic laws of his art; the aesthetic ideal is often in advance of actual practice. In this case Baudelaire clearly sees the ideal of total unity but cannot duplicate the effect of this unity in the poetic structure itself. Frequently, one can see Baudelaire's tentative efforts to find a form that embodies total unity; in "Harmonie du soir," for example, he reverts to a villanelle, but suffuses it with a modern tonality. Each line is treated as a unit which is recombined with other lines, but the device of simple repetition is enriched by the bizarre and jarring nature of the images:

Le violon frémit comme un coeur qu'on afflige.

Un coeur tendre, qui hait le néant vaste et noir.

Le soleil s'est noyé dans son sang qui se fige.[74]

The structure of interlocking lines avoids sequential ordering, but the entire poem doesn't achieve the same "totalité de l'effet" as the "Crépuscule du matin" which is built up out of layered images. In other poems the final "totalité de l'effet" is defeated by length; both "Les Petites Vieilles" and "Les Sept Vieillards," which are long by comparison to the majority of Baudelaire's poems, achieve a kind of compromise between succession and totality. "Les Petites Vieilles" is full of Baudelaire's "sorcellerie," the words interact reciprocally, and the central image of the hypothetical "vieille" is a composite built up through layers of corresponding terms; but the poem is not condensed enough to sustain the theoretical *totalité* of the final impression. "Les Sept Vieillards" is couched in narrative form, but the ostensible story is itself a parody of the idea of succession; the images of the old men which appear in sequence are in fact precisely the same image which reappears, again and again, until the poet shuts his eyes and refuses to see another absurd repetition. Although the central image is explicitly a superposition of identical "couches," the final effect of the whole poem is dispersed because of the length of the narrative framework. In general, although Baudelaire develops a poetic structure based on the reciprocal relation of parts, he is never completely free of the grammatical links between lines, never acquires the same liberation from the underlying sequential order of language that Mallarmé does in his poetry. Because Mallarmé has extended

and refined Baudelaire's aesthetic discoveries, he is a perfect example of what Baudelaire is working towards. Mallarmé's definition of poetic structure as a "constellation," a field of words which exists in independent spatial purity, words which can be infinitely recombined, is a structure which, theoretically, has the maximum degree of reciprocal totality. Baudelaire, of course, sees this literary possibility, and on the larger scale of the book he wants "Les Fleurs du mal" to have an "architecture secrète," a hidden unity which pulls the book together as a whole, composed of distinct parts which can be variously combined, not simply an "album" like a collection to be read in linear sequence. Consequently he announces this ideal structure for an entire book in his preface to "Le Spleen de Paris":

> MY DEAR FRIEND, I send you a little work of which no one can say, without doing it an injustice, that it has neither head nor tail, since, on the contrary, everything in it is both head and tail, alternately and reciprocally. I beg you to consider how admirably convenient this combination is for all of us, for you, for me, and for the reader. We can cut wherever we please, I my dreaming, you your manuscript, the reader his reading; for I do not keep the reader's restive mind hanging in suspense on the threads of an interminable and superfluous plot. Take away one vertebra and the two ends of this tortuous fantasy come together again without pain. Chop it into numerous pieces and you will see that each one can get along alone. In the hope that there is enough life in some of these segments to please and to amuse you, I take the liberty of dedicating the whole serpent to you.[75]

"Le serpent tout entier" is an explicit metaphor for the possible recombinations of a linear sequence; the serpent can be chopped into pieces which exist by themselves and which can be arranged into another order by the reader. The literary structure has no beginning and no end because all parts exist in reciprocal relation to other parts; everything ("tout") is capable of being considered both head and tail, "alternativement et réciproquement." The structure has total unity through disjunction; all the parts are free to be infinitely recombined, to be in a state of continual "correspondance."

Again there is an implicit difference between the description of an aesthetic ideal and actual practice; there is no assurance that any reader, other than Baudelaire, will take advantage of the structural freedom to read the book reciprocally. But the fact that an aesthetic ideal can only be approximated in actuality, either by reader or writer, does not negate its value. In Baudelaire's case the ideal exists so pervasively that it exerts a constant pull, a continual pressure to go beyond the accepted limitations and forms of poetry, to approach new powers, to create a new medium. The concept of reciprocal unity, of simultaneity, of totality is everywhere present for Baudelaire: in criticism as the initial "volupté," in hashish, in states of "surnaturel" perception, in painting as the "plaisir primitif" of the whole view. But the ideal does not exist only as a theoretical abstraction. In painting, for example, we have seen how Baudelaire

uses the ideal to describe the *totalité de l'effet* of the first view, the reciprocal unity of color harmony, and the simultaneity of painting as a form, but he also uses the ideal of totality in discussing various aspects of painting, such as traditional portraiture and topical sketches, aspects which, at first, seem far removed from the domain of aesthetic theory. A prime example is the way in which Baudelaire describes Delacroix's *literary* power as a painter in terms of totality. The usual notion of the literary component of painting is the narrative ability to include a story on the canvas, as in Pre-Raphaelite painting where the iconography, the gestures, and specific details are used to suggest an implicit plot. This "reading" of the subject of a painting is of course the exact opposite of Baudelaire's sense of the canvas as primary substance which communicates through form and color alone, before the subject even comes into focus. When Baudelaire points to Delacroix's literary side, he is quick to distinguish between the accepted concept of literary painting and his own:

> Another very great and far-reaching quality of M. Delacroix's talent, and one which makes him the painter beloved of the poets, is that he is essentially literary. Not only has his art ranged—and successfully ranged—over the field of the great literatures of the world; not only has it translated, and been the companion of, Ariosto, Byron, Dante, Scott and Shakespeare, but it has the power of revealing ideas of a loftier, a subtler and a deeper order than the art of the majority of modern painters. And rest assured that it is never by means of a mere feint, by a trifle or a trick of the brush that M. Delacroix achieves this prodigious result; rather is it by means of the total effect, the profound and perfect harmony between his colour, his subject and his drawing, and the dramatic gesticulation of his figures. [76]

The key words are "ensemble," "accord," and "complet"; Delacroix's ability to fuse color, form and subject into a complete whole is the basis of his power to communicate ideas, to translate literature into paint. The ideal of totality is also at the root of Baudelaire's theory of modernity as he feels that each age has its own complex and total unity:

> Modernity is the transitory, the fugitive, the contingent, the half of art, of which the other half is the eternal and the immutable. Every painter of the past had his own modernity; most of the beautiful portraits that remain to us from bygone days depict the costumes of their period. They are perfectly harmonious because the costume, the coiffure, and even the gesture, the glance and the smile (every period has its own mien, its own glance, its own smile) form a whole that is completely alive. [77]

This vital wholeness which Baudelaire finds in good portraiture makes the portrait a model form which embodies and unites the ideal and the particular:

> Such and such a hand demands such and such a foot; each epidermis produces its own hair. Thus each individual has his ideal. [78]

Totality is defined in terms of transitory ideals, topical and local particularities, which are justified because they guarantee the vital wholeness of any work of art from any age. Ideality is always "modern," and "modernité" is defined, not in terms of what is most recent, but as a variation of "surnaturel" perception, the ability to transform "any spectacle, all together, no matter how ordinary" into a symbol.

The concept of total unity is so pervasive that it structures all of Baudelaire's thinking. The various manifestations of the concept, simultaneity, "surnaturalisme," ideality, modernity, stand in a corresponding relation as facets of a central idea; the terms enrich and interpret each other in the same way the different forms of Art (literature, painting, music) "se prêtent réciproquement des forces nouvelles." The attempt to translate this complex ideal into literature, to produce a verbal "tableau," is the force that drives Baudelaire to new experiments in poetry. As we have seen, Baudelaire's concept of poem as "tableau" is far more developed than a simple transposition of visual images into words because in using the analogy of writing to painting, the concept of painting carries with it the whole complex of related ideas which make up the aesthetic ideal of total unity. The difference between Baudelaire's use of the analogy between the "sister arts" and the traditional meaning of the analogy can be illustrated by an off-hand critical remark that Baudelaire makes about Delacroix's writing style. In describing the difference between Delacroix's prose style and the literary style of the average art critic, Baudelaire says that Delacroix's language is more compact and energetic.

> Now compare that vast essay (by another critic) with the following few lines (by Delacroix) which, in my opinion, are much more forceful and much better adapted to conjure up a picture, even assuming that the picture which they summarize did not already exist.[79]

A writing style that creates a painting even if the actual painting doesn't exist could be called a painterly style, and the association of this style with energy (enargeia)[80] is a recurring theme in the history of the *ut pictura; poesis* analogy. The general idea is that literature acquires freshness and vitality in attempting to rival the descriptive power of painting, which is the sense in which Baudelaire uses the analogy in referring to Delacroix's prose style. But as Jean Hagstrum has pointed out, throughout the long career of the analogy of writing to painting, there are very few examples of the structural transfer of the formal principles of visual art into literature; the concepts of tangibility and simultaneity are discussed by literate painters, such as Leonardo and Delacroix, as the undisputed territory of their own art form. What Baudelaire accomplishes, in his criticism and his poetry, is a completely new application of the *ut pictura; poesis* analogy which results in the transformation of these intrinsic values of painting, the tangible quality of the medium and the simultaneous effect of the

form, into literary equivalents. There is an entirely new kind of energy released by this transformation; instead of language competing with painting on the basis of descriptive power, language competes with paint as a concrete medium capable of producing a direct and physical effect, "un émotion tangible." Baudelaire's attempt to handle words, not as signs with fixed meaning, but as verbal images capable of a multiplicity of meaning opens up a new feeling for the latent evocative power of language which can be manipulated like a plastic substance, molded in context, and chemically altered through reciprocal inter- action, so that the poem, like a canvas, gives the illusion of spatial depth through the density and texture of language. The attempt to give a poem the same compositional unity as a painting, to treat the poem consciously as a "composi- tion tout entière," to write in terms of the "totalité de l'effet" results in a concept of poetic structure that still seems revolutionary in the twentieth century. When Charles Olsen, for example, describes his "field theory" of poetry, he is trying to identify the effect of a simultaneous perception of all words in the poetic "field" at once, precisely the same effect that Baudelaire discovered through Delacroix's painting. Baudelaire's ideal poetic structure, the verbal "tableau," is an early formulation of the Symbolist concept of a Symbol: briefly defined, a complex of words that operate as a whole unit to produce a total and direct impression which cannot be paraphrased, or divided. Baudelaire's aesthetic ideals have a sustained energy that is felt throughout the entire development of modern literature.

It is often difficult to grasp the revolutionary aspect of Baudelaire's poetry in reading a single poem, because Baudelaire's discoveries have been carried further and given more pronounced form in the works of poets such as Mallarmé, Valéry, Eliot, and Stevens. One of Baudelaire's most famous and characteristic poems, "L'Invitation au voyage,"[81] for example, might appear on first reading as a simple and graceful lyric which lacks the "modernité" of a poem like "Le Crépuscule du matin." But the new quality of Baudelaire's verse becomes more apparent when the poetry is analyzed with the aesthetic terms that Baudelaire himself provides in his own critical writing. If the percep- tions of Baudelaire's art criticism are used to illuminate "L'Invitation au voyage" as a verbal "tableau," the effect of the poem is significantly increased. Instead of a simple lyric, the reader is aware of the relative complexity of the verbal structure which produces a definite effect before the subject comes into focus; there is a "plaisir primitif" which comes from the verbal "sorcellerie" before there is any identifiable content. The magic depends on built-in ambivalence; on the conceptual level the poem generates questions: why the ambiguity of "mon enfant, ma soeur" in the opening line, what is the relationship between the woman and the country which resembles her, why are the "traitres yeuxs" crying, why are they charming, what is the analogy between the woman and all the objects which speak secretly to her, the polished furniture, rare perfumes,

the reflecting mirrors and encrusted ceilings. On the denotative level there is no overt clue to the central idea of the poem; instead the essence of the poem is communicated through the interplay of evocative elements, of concrete sounds and images and the reciprocal effect of words, just as Delacroix's painting communicates "sans autres moyens que la forme et la couleur" before the osensible subject is visually or mentally acknowledged. The poem, like a painting, creates a "surnaturel" atmosphere which is independent of specific content. "L'Invitation au Voyage" has no narrative armature, no moral "enseignement," no personal voice or autobiographical experience, no intellectual theme, no emotional adventure; in fact the poem is almost pure in its lack of a recognizable subject. If the poem has a "subject" at all it is the aesthetic ideal of reciprocity itself which is expressed by the analogous relationship between the woman and the landscape, which in turn is embodied by the reciprocal structure of the poem, where all the verbal images mirror and reflect each other like the colors on a Delacroix canvas.

The effect of the poem is condensed into the refrain which operates on a far different level than traditional song-like repetition. The three isolated words in the second line,

Luxe, calme, volupté

acquire a kind of spatial existence on the page; the actual shape of the words, the repetition of the three l's, the flow of vowels, all work together to create a "sorcellerie evocatrice." Like color notes, the words mutually change each other; "luxe" and "volupté" are anchored, subdued and refined by the central word "calme," just as "calme" is altered by its dual association with "luxe" and "volupté." Baudelaire makes the underlying significance of the poem more explicit in the prose version in Le Spleen de Paris,[82] the effect of the refrain is specifically pointed out: "le luxe a plaisir à se mirer dans l'ordre."[83] The interpenetration of qualities such as "volupté" and serenity, which are normally taken as opposites, and the fusion of ordered calm and beauty with richness, abundance, and sensuality creates a final impression which results from the mutual effect of the words "beauté," "ordre," "luxe," "calme," and "volupté" all working together to produce a reciprocal harmony. Just as the reciprocal harmony of a canvas is present in the small scale of local tones as well as in the total effect of the painting, the reciprocal effect of the refrain is reduplicated on the larger scale of the whole poem. The images in the poem, the suns and skies of the first stanza, the furniture of the second and the ships, canals and city of the third all stand in a relationship of "correspondance" to the central image of the woman, so that in an extended sense all of the objects and verbal images tend to mirror and reflect and illuminate each other. Each stanza, like a "couche superposée" deepens and enriches the total picture,

which is a composite image, built out of all the evocations and suggestions within the poem, of the rich serenity of perfected life.

Again the prose poem version is more specific; Baudelaire compares living in the imaginary country to living life as an art:

> Pays singulier, supérieur aux autres, comme l'Art l'est à la Nature, où celle-ci est réformée par le reve, où elle est corrigée, embellie, refondue.[84]

What becomes apparent in the prose version is that the invitation to travel to the "pays superbe" is an invitation into Baudelaire's ideal world of "sur-naturel," symbolic existence. Just as in a state of perception induced by hashish, or in the rare moments of "surnaturel" vision, the sense of time is stretched and all sensations intensified, so it is in the imaginary world of the poem;

> où les heures plus lentes contiennent plus de pensées, où les horloges sonnent le bonheur avec une plus profonde et plus significative solennité.[85]

In the prose poem Baudelaire specifically underlines the corresponding relation of all the objects by presenting the visual reflections as a silent symphony which is changed into a single, dominant perfume; a transformation that involves a "correspondance" between the senses.

> Les miroirs, les métaux, les étoffes, l'orfèverie et la faïence y jouent pour les yeux une symphonie muette et mystérieuse; et de toutes choses, de tous les coins, des fissures des tiroirs et des plis des étoffes s'échappe un parfum singulier, un *revenez-y* de Sumatra, qui est comme l'âme de l'appartement.[86]

Therefore the invitation to the beloved is an invitation to pass over the thresh-old of "surnaturel" reality into a world of deepened sensation where fluid correspondences between the physical and spiritual components are in a state of mutual interaction, a world which exists in continually expanding time, an existence which the poet feels is like living within the symbolic world of art. In the prose version the resemblance between the woman and the country is ex-plicitly described as an analogy, a "correspondance":

> Ne serais-tu pas encadrée dans ton analogie, et ne pourrais-tu pas te mirer, pour parler comme les mystiques, dans ta propre *correspondance?*[87]

By living in the country which resembles her the woman will exist in a con-tinually reciprocal relation with her environment; the larger implication of the poem is that the unnecessary boundary between the inner self and the outer world will dissolve and the woman will live in a state of perpetual awareness of the simultaneous and reciprocal relationship among all things, she will enter into

a state of perception which shows her the total unity of her existence with all other elements in the world, and in short, she will live in a state of reciprocity with the universe. The prose poem approaches this metaphysical goal by degrees: living in the world of art, living in a framed analogy, and finally living within a painting. The poet describes the possibility of stepping into the ideal country as if one could step through the frame into a painting; the enclosed world of the "tableau," which the poet sustains with his vision, is like the state of continual opium perception which is sustained naturally by the inner process of the mind:

> Chaque homme porte en lui sa dose d'opium naturel, incessamment sécrétée et renouvelée, et, de la naissance à la mort, combien comptons-nous d'heures remplies par la jouissance positive, par l'action réussie et décidée? Vivrons-nous jamais, passerons-nous jamais dans ce tableau qu'a peint mon esprit, ce tableau qui te ressemble?[88]

In the final paragraph the poet catalogues all of the reciprocal elements in this ideal country, which is like a painting in its total unity, as everything reflects everything else simultaneously:

> Ces trésors, ces meubles, ce luxe, cet ordre, ces parfums, ces fleurs miraculeuses, c'est toi. C'est encore toi, ces grands fleuves et ces canaux tranquilles. Ces énormes navires qu'ils charrient, tout chargés de richesses, et d'où montent les chants monotones de la manoeuvre, ce sont mes pensées qui dorment ou qui roulent sur ton sein. Tu les conduis doucement vers la mer qui est l'Infini, tout en réfléchissant les profondeurs du ciel dans la limpidité de ta belle âme;—et quand, fatigués par la houle et gorgés des produits de l'Orient, ils rentrent au port natal, ce sont encore mes pensées enrichies qui reviennent de l'Infini vers toi.[89]

The final impression of the prose poem is a picture of an ideal country which is like the verbal "tableau" that embodies it: a country in which all elements exist in simultaneous unity, a unity which is capable of infinite expansion and is also capable of being condensed into the single, concrete image of the woman herself. The poem is a perfect illustration of the relation between Baudelaire's aesthetic ideal, the "surnaturel" world, the simultaneous form of a painting and the corresponding form of the verbal "tableau"; all of the major elements discussed in this essay are located within the reciprocal structure of the poem and mutually illuminate each other. This organic unity on the small scale of a single poem reflects the total unity of Baudelaire's work as a whole.

Baudelaire has left a fitting verbal image of the poet, like himself, for whom words are things, as concrete and physically real as the stones in the street:

Le long du vieux faubourg, où pendent aux masures
Les persiennes, abri des secrètes luxures,
Quand le soleil cruel frappe à traits redoublés
Sur la ville et les champs, sur les toits et les blés,
Je vais m'exercer seul à ma fantasque escrime,
Flairant dans tous les coins les hasards de la rime,
Trébuchant sur les mots comme sur les pavés,
Heurtant parfois des vers depuis longtemps rêvés.[90]

Just as the poet is likely to trip over the "pavés" as he walks through Paris meditating on verbal reality, he is compensated by the fact that the verbal reality, which is his to handle and control, is a substantial world of its own, a world which, reciprocally, gives the poet the dreamed-of possibility, the possibility of transforming intangible experience into tangible language.

A translation of "L'Invitation au voyage" is reprinted below:

There is a wonderful country, a country of Cocaigne, they say, that I dream of visiting with an old love. A strange country lost in the mists of the North and that might be called the East of the West, the China of Europe, so freely has a warm and capricious fancy been allowed to run riot there, illustrating it patiently and persistently with an artful and delicate vegetation.

A real country of Cocaigne where everything is beautiful, rich, honest and calm; where order is luxury's mirror; where life is unctuous and sweet to breathe; where disorder, tumult, and the unexpected are shut out; where happiness is wedded to silence; where even the cooking is poetic, rich, and yet stimulating as well; where everything, dear love, resembles you.

You know that feverish sickness which comes over us in our cold despairs, that nostalgia for countries we have never known, that anguish of curiosity? There is a country that resembles you, where everything is beautiful, rich, honest and calm, where fancy has built and decorated an Occidental China, where life is sweet to breathe, where happiness is wedded to silence. It is there we must live, it is there we must die.

Yes, it is there we must go to breathe, to dream, and to prolong the hours in an infinity of sensations. A musician has written *l'Invitation à la valse;* who will write *l'Invitation au voyage* that may be offered to the beloved, to the chosen sister?

Yes, in such an atmosphere it would be good to live—where there are more thoughts in slower hours, where clocks strike happiness with a deeper, a more significant solemnity.

On shining panels or on darkly rich and gilded leathers, discreet paintings

repose, as deep, calm and devout as the souls of the painters who depicted them. Sunsets throw their glowing colors on the walls of dining-room and drawing-room, sifting softly through lovely hangings or intricate high windows with mullioned panes. All the furniture is immense, fantastic, strange, armed with locks and secrets like all civilized souls. Mirrors, metals, fabrics, pottery, and works of the goldsmith's art play a mute mysterious symphony for the eye, and every corner, every crack, every drawer and curtain's fold breathes forth a curious perfume, a perfume of Sumatra whispering *come back,* which is the soul of the abode.

A true country of Cocaigne, I assure you, where everything is rich, shining and clean like a good conscience or well-scoured kitchen pots, like chiseled gold or variegated gems! All the treasures of the world abound there, as in the house of a laborious man who has put the whole world in his debt. A singular country and superior to all others, as art is superior to Nature who is there transformed by dream, corrected, remodeled and adorned.

These treasures, these furnishings, this luxury, this order, these perfumes, and these miraculous flowers, they are you! And you are the great rivers too, and the calm canals. And those great ships that they bear along laden with riches and from which rise the sailors' rhythmic chants, they are my thoughts that sleep or that rise on the swells of your breast. You lead them gently toward the sea which is the Infinite, as you mirror the sky's depth in the crystalline purity of your soul;—and when, weary with rolling waters and surfeited with the spoils of the Orient, they return to their port of call, still they are my thoughts coming back, enriched, from the Infinite to you.

Let them seek and seek again, let them endlessly push back the limits of their happiness, those horticultural Alchemists! Let them offer prizes of sixty, a hundred thousand florins for the solution of their ambitious problems! As for me, I have found my *black tulip,* have have found my *blue dahlia!*

Incomparable flower, rediscovered tulip, allegorical dahlia, it is there, is it not, in that beautiful country, so calm, so full of dream, that you must live, that you must bloom? Would you not there be framed within your own analogy, would you not see yourself reflected there in your own *correspondence,* as the mystics say?

Dreams! Always dreams! And the more ambitious and delicate the soul, all the more impossible the dreams. Every man possesses his own dose of natural opium, ceaselessly secreted and renewed, and from birth to death how many hours can we reckon of positive pleasure, of successful and decided action? Shall we ever live in, be part of, that picture my imagination has painted, and that resembles you?

Baudelaire, *Paris Spleen,* translated by Louise Varese (New York: New Directions, 1947), pp. 32-34.

Ruskin and Turner: The Innocent Eye

In a strangely paradoxical way, John Ruskin's relationship to Turner's painting parallels Baudelaire's relationship to the art of Delacroix. The English Protestant, who worshipped Nature, and the Parisian dandy, who professed to despise nature, both found an aesthetic on a single idolized painter; in both cases the writer discovers in his study of the painter a system of values which forms the basis of a general aesthetic which applies to literature as well as visual art. Ruskin uses Turner's painting as a model for writing just as Baudelaire had used Delacroix; Ruskin identifies certain primary aspects of Turner's painting and translates these values into literary equivalents. He establishes a type of aesthetic criticism which moves freely back and forth between poetry and painting, so that a particular concept can be illuminated by examples drawn from Homer, Dante, or Shakespeare as well as Turner and Tintoretto. Again like Baudelaire, Ruskin specifically applies his visual criteria to point out the faults of Romantic literature. Turner's painting serves Ruskin as a kind of corrective lens through which he can see and measure the distortions produced by Romantic poetry. Ultimately Ruskin feels that Nature seen through Turner's eyes is perceived both more accurately and more sublimely than through the eyes of Wordsworth, Shelley, or Coleridge. Like Baudelaire, Ruskin works out his own personal version of the *ut pictura; poesis* analogy; Ruskin believes that the highest forms of verbal art and visual art are visionary in exactly the same way. Thus the best writing unconsciously resembles painting, and the writer who is conscious of this fact is able to profit from the study of painting as a sister art. Wordsworth, Ruskin felt, could have learned from Turner how to become a better poet.

Ruskin and Baudelaire treat Turner and Delacroix respectively as ideal, model painters, painters who represent for them the most characteristic aspects of the art of painting. Each critic emphasizes different aspects of painting as primary: Ruskin sees Turner as an example of visual accuracy while Baudelaire underlines the abstract quality of Delacroix's color harmonies and the *totalité de l'effet* of his painting as a form. Although Ruskin's dominant position of "truth to nature" is in direct opposition to Baudelaire's cult of artifice, the two writers often draw strikingly similar conclusions from their studies of Turner and Delacroix. Although their rhetoric is usually entirely different, their direct

responses to Turner and Delacroix frequently produce identical results. For example, Ruskin underlines the importance of the wholeness of conception and execution of Turner's landscape painting.

> But, whatever the means used may be, the certainty and directness of them imply absolute grasp of the whole subject, and without this grasp there is no good painting. This finally let me declare without qualification that partial conception is no conception. The whole picture must be imagined or none of it is.[1]

Turner's painting, he feels, is a record of the artist's *first view* of a landscape seen as a complete whole, and Turner's method of composition is to treat the painting as a whole from the first sketch to the finished canvas. Often Turner accomplished a final spectacular transformation of the whole canvas after it was already hung, during the time allotted by the Academy for varnishing. This final transformation was so close to instantaneous, that hostile critics accused Turner of unpainting the picture at the last minute, removing a wash he had laid over the already finished canvas during the *vernissage*. In fact Turner's miraculous last-minute revisions reflect the same grasp of the total harmony of the canvas that Baudelaire had praised in Delacroix.

Neither Ruskin nor Baudelaire, of course, limits his art criticism to one painter. Ruskin finds it necessary to learn art history in the course of writing *Modern Painters;* he sets out to defend Turner's superiority without knowing much about anyone else. After his discovery of the Venetians, especially Tintoretto and Veronese, Ruskin is able to put forth a comprehensive theory of ideality in painting which links Turner with examples taken from the great painters of the past, according to Ruskin. This concept of ideality, concentrated in particulars, Ruskin names the Naturalist Ideal and his discussion of the theory parallels almost point for point Baudelaire's theory of modernity which he describes in his tribute to Constantin Guys, "Le Peintre de la Vie Moderne." These similarities between Ruskin and Baudelaire are certainly not attributable to any direct influence between the two writers; there is no record whatsoever of either being aware of the other's work in art criticism. But there is a kind of connection implicit through the contact between Delacroix and Turner. Delacroix had seen Turner's painting at an exhibition in London in 1824 and later refers to Turner as a revolutionary painter, a "real reformer" in terms of technique. The influence of Turner on Delacroix is not measurable; the significant fact is that both painters occupy a similar position in the history of art, as Romantic painters who break with academic Romanticism and experiment in a new direction which involves greater attention to color relationships, broken and graduated color and textured pigments, all technical innovations which are seen retrospectively as forerunners of Impressionist methods.[2] The affinity between Turner and Delacroix stands behind the parallels between the two who founded their aesthetics on their painting. In their art criticism, Ruskin

and Baudelaire translate the experimental insights of Turner and Delacroix into terms that can be applied to literature. Thus the break with academic techniques in painting generates a break with Romantic doctrine in literature. Because Baudelaire and Ruskin were influential as writers as well as art critics, their intense interest in Delacroix and Turner and their prolonged contact with visual art results in changes in literary history; both introduce new aesthetic principles into literary domain which are derived from painting and as critics who are also major writers they make painting available to literature in a new way. Baudelaire's poetry and Ruskin's prose serve as examples of literature which imitates, in one way or another, the sister art of painting. Just as Baudelaire's aesthetic ideas condition and form his poetry, Ruskin's ideas about painting are interwoven with his accomplishments as a writer of prose. Ruskin and Baudelaire introduce a new form of criticism which stands as literature in its own right. Baudelaire feels that the best "compte rendu" of a painting may be a sonnet or an elegy, and in his critical articles he is constantly writing sustained passages of lyric density, pieces of poetic prose that have a literary value independent of the works of art they ostensibly describe. Ruskin's criticism is even more crowded with virtuoso passages, sections of prose that embody in themselves the visual values which are under discussion. Ruskin's descriptions of Nature as seen through Turner, and his descriptions of Nature and works of art as seen by his own eyes acquire a literary interest which stems from the fact that the verbal text has absorbed the visual principles which are being described. Ruskin's prose, as an early critic, Frederic Harrison, has put it, "unites the eye of a landscape painter with the voice of a lyric poet."[3] Because Ruskin is such a master of prose style, he is able to translate the visual phenomena and objects which interest him, including paintings and architecture, into verbal equivalents. The experience of seeing is given rhythm, form, and energy through Ruskin's prose. Like the criticism of Baudelaire, much of Ruskin's writing about art and vision is close to poetry in prose form; the object of the prose is not simply to convey information, ideas, and facts but to create a strong, tangible impression for the reader, to reduplicate or closely approximate the writer's own intense visual and psychological experience. Thus Baudelaire and Ruskin invent a new literary genre, poetic criticism of visual art which provides the reader with a composite aesthetic experience: first the recreation of the visual object itself and secondly the experience of the verbal rendering of this object. But in fact the relationship between these two components is inseparable and reciprocal; the visual object or phenomenon only exists through the literary text, while the text exists only in reference to the visual object, real or imaginary, which is being described. For example, take one of Ruskin's most famous prose passages, the contrasting descriptions of St. Mark's and an English gothic cathedral. The aim of the writing is not to give a careful delineation of architectural features, but to give a precise account of the visual effect or impression created

by these two buildings on the eye of the beholder. In the case of St. Mark's, the reader is able to go to Venice, follow the approach used by Ruskin in the passage, step into the piazza and compare his impression of the visual impact of St. Mark's with Ruskin's. But in the case of the English cathedral, this sort of verification of the reference is impossible because the cathedral exists solely in Ruskin's mind's eye; it is a composite imaginary version of many cathedrals that Ruskin had seen. In reading the two passages, however, there is absolutely no difference in the visual pleasure registered through the prose. This type of writing, therefore, acquires a kind of primary interest as literature and only a secondary interest as criticism directed towards the visual artifact. But in Ruskin's passage on St. Mark's and the English cathedral, the vitality of the writing depends upon the quality of visualization, whether the building is real or imaginary. In a similar way Baudelaire sees that writing which is based on painting can produce a definite visual experience "même si la peinture qu'elle décrit n'existe pas." In reading Baudelaire's rapturous descriptions of Delacroix's canvases, the primary interest is in Baudelaire's vision of Delacroix and how he records this vision in words; what the reader experiences is Delacroix seen through Baudelaire's eyes, and the actual value of the description or criticism of Delacroix is secondary to the poet's own experience. But again the writing would not exist without the visual artifact, real or imaginary, and the relationship between text and object remains inextricably complex. In Baudelaire's work the visual principles are most clearly transformed into his poetry, but in the long sustained "poetic" passages of his art criticism, such as the color symphonies, the long section of his *véritable ésthétique,* or the "éloge du maquillage" or "bain de multitude" in *Le Peintre de la Vie Moderne,* the reciprocal relation between ideas, the sensuous and evocative qualites of the prose, and the attempt to create an overall "total" picture are evidence that the visual aesthetic is embodied in the methods and structure of the criticism itself. In Ruskin's case the transference of visual principles to literature is wholly concentrated in his criticism. Frequently passages from Ruskin approximate imitative form so closely that the visual basis for the writing permeates the rhythm, structure, syntax, and imagery of the prose. The relationship of words to visual experience is so obvious that the subtleties of transition are easily ignored: the reader assumes that he is reading a simple piece of descriptive writing and is unaware of the shaping and changing of language necessary in order for Ruskin to present him with such an astonishingly precise verbal picture.

Part of Ruskin's formidable reputation as an eminent Victorian in the nineteenth century was based on his status as a master of prose and as a popularizer of poetic prose. Saintsbury, a contemporary admirer of Ruskin's writing, felt that his influence was too great:

From the date of the first appearance of *Modern Painters,* the prose poetry style has more and more engrossed attention and imitation. It has eaten up history, permeated novel writing, affected criticism so largely that those who resist it in that department are but a scattered remnant.[4]

Saintsbury believed that Ruskin himself revolutionized the practice of prose writing in the same way the "Romantic revolution" had changed poetry. Curiously, while Ruskin's own personal goal was to raise the status of the painter's imagination to the level of "high art" previously reserved for the Romantic poet, one of the consequences of his art criticism was the elevation of the status of prose to the precinct of "fine art" as well. Ruskin's brilliant writing on art changed the general public concept of the painter from that of a figure who is still halfway a craftsman, connected with manual work, to that of a creative genius, as much a spiritual interpreter of the world as a poet. As Graham Hough has stated it:

Ruskin does for the painter's imagination what Coleridge had done for the poet's . . . exalts it into one of the central and dominating seats in the human hierarchy.[5]

Ruskin's art criticism serves a double function; his work also exalts the position of the prose writer and gives the art of prose the same aesthetic significance and weight as poetry. The two writers who profited most directly from the example of Ruskin's prose style, Proust and Pater, both defended writing in prose as equal in subtlety, complexity, and lyricism to poetry, and both felt that the prose artist often surpassed the poet in refinement, restraint and difficulty overcome. Thus again, wee see a change in literary aesthetics and practice related to the sister art of painting. Ruskin's prose, which forms the basis for new writing, like Baudelaire's poetry, derives its vital force from the involvement with visual aesthetics. The development of aesthetic prose as well as Symbolist poetry is conditioned by the analogy of writing to painting. The following essay will be an attempt to show how Ruskin derives aesthetic principles from visual art which he applies to literature, and how his own prose is an example of these transfers from one art to another.

Ruskin first uses the concept of the sister arts in order to raise the painter up the aesthetic hierarchy into a position of equality with the poet. Just as Baudelaire defends the quality of Delacroix's imagination by creating a new title for the artist, a combination of "poète-peintre," Ruskin is concerned with explaining to his public that Turner's paintings of natural landscape are the imaginative equivalent of Romantic nature poetry: in fact his ultimate aim is to show that Turner's interpretation of natural fact is superior to the version offered by most poets. But in order to compare painting with poetry, Ruskin must first establish a common ground. Like Baudelaire, Ruskin enlarges the concept of art to include all forms of expression, not limiting the vatic role to the

poet alone. Throughout *Modern Painters* he uses the terms "poet" and "artist" interchangeably to stand for both painter and writer. He felt that, although painting and writing were two separate disciplines, they were both dealing with a common fund of "poetry":

> Painting is properly to be opposed to speaking or writing but not to poetry. Both painting and speaking are methods of expression. Poetry is the employment of either for the noblest purposes.[6]

What Ruskin is trying to get his public to recognize is a new critical concept: that there are general aesthetic principles which apply to all forms of artistic expression and that the highest level of criticism will reach beyond the categorical division of the fine arts and find the spiritual similarity between great artists, whether painter, poet, architect, or musician. As Ruskin says in *The Stones of Venice*, "Great art" can "express itself in words, colours, or stones."[7]

In the most recent and comprehensive study of Ruskin's aesthetics by George Landow, the opening chapter is devoted to Ruskin's theory of the sister arts. Landow argues that Ruskin has taken the values he has learned from Romantic poetry and applied them to his interpretation of painting. Landow believes that Ruskin locates the significance of painting in the artist who, like the poet, is able to express his beliefs and communicate his ideas, only using visual language rather than words. As Landow continues his discussion he uses the famous passages on the relation of the workman to Gothic architecture to substantiate his argument for Ruskin's Romantic emphasis on the individual as creator:

> A Romantic theory of art, as we have seen, concentrates on the nature and function of the artist. Ruskin begins with such a Romantic theory of the arts, applies its criteria to architecture, and recognizing the plight of the workman whom he considers potentially an artist, moves away from the problem of art to the problems of society.[8]

It is, of course, true that Ruskin's architectural studies lead him into an investigation of the relation of art to society, an outgrowth of his original belief in the inherent correlation between morality and perception. But what Landow, I think, overlooks in his attention to some of the thornier aspects of Ruskin's aesthetic (such as the definitions of Typical and Vital Beauty) is the double nature of many of Ruskin's pronouncements concerning the sister arts. Ruskin believes that the modern craftsman is entitled to the same relationship between his direct response to Nature and the expression of that response in his materials that was available to the Gothic workman or to the nineteenth-century poet or landscape painter. Ruskin again enlarges the concept of art to include the humbler forms of craftsmanship. But the central fact for Ruskin is that the

visible world is overwhelmingly self-sufficient. The most condensed statement of Ruskin's aesthetic belief is the often quoted pronouncement:

> . . . the greatest thing a human soul ever does in this world is to *see* something and tell what it *saw* in a plain way. Hundreds of people can think for one who can see. To see clearly is poetry, prophecy, and religion—all in one.[9]

What Ruskin means by seeing clearly is the main subject of *Modern Painters* which is, in actuality, a book about the act of seeing as much as it is a study of the art of painting. The point is that for Ruskin, the artist working in stone, paint, or words has a responsibility to one general aesthetic law; first to *see* clearly and secondly to record what is seen as precisely as possible. It is obvious that in the recording of clear visual facts, the visual arts will have a certain inherent predominance over literature. As Ruskin elaborates on this condensed aesthetic statement in the course of writing *Modern Painters,* he develops, like Baudelaire, a kind of unorganized but coherent *véritable ésthétique* which refers to both visual and verbal art. Literature is therefore judged by aesthetic principles derived from an exploration of the processes involved in seeing clearly and recording plainly. As Landow correctly points out, Ruskin frequently begins the discussion of a certain principle with literary examples and then moves on to show how painting or architecture can be read like literature, that the visible facts are as morally intelligible as words. But Ruskin does not intend to treat painting or architecture as overtly didactic or narrative in the manner of much standard mid-Victorian art criticism, such as the type practiced by Thackeray. Instead Ruskin is trying to refine the reader's eye so that visual art can be appreciated first of all as a *visual* experience, without attaching poetic, associational, or sentimental values to give it meaning. Ruskin endeavors to attune his reader to visual language, to show the reader how to see more in the visual facts themselves, so that a work of architecture, sculpture or painting will acquire a fuller significance. Landow uses this aspect of Ruskin's work to argue that visual art is approached *through* literature and refers to Ruskin's concept of medieval cathedrals as "living books" as proof. But in fact when Ruskin is engaged in "reading" a cathedral, he is not simply clarifying the iconographic and symbolic meaning of the sculpture, but "reading" the visual information supplied by the rib vaults, the relation of window space to stonework, the floor plan—in short, Ruskin vitalizes all of the formal aspects of the art of architecture, so that the purely structural elements of building are as full of significance for the eye of the beholder as the implicit literary elements contained in the decoration.

In *Modern Painters* Ruskin almost invariably illustrates an aesthetic concept with examples from literature as well as visual art, in order to show the universality of the principle involved. Landow interprets this to mean that in the alliance between the sister arts, literature is the touchstone for providing

the visual arts with a point of reference. But in fact, in every block of material that Ruskin uses to build his own personal aesthetic, the visual arts provide the touchstone and point of reference for literature, or literature is used to confirm a principle derived from the study of painting. *Modern Painters*, like *Curiosités Esthétiques*, was written over a number of years, its main topics approached numerous times from various angles. Like Baudelaire's work it has no formal scheme or plan, but in each case a coherent aesthetic emerges from the random structure, an aesthetic which is organically complete because it grows from the germ of a central idea, and each new approach is essentially a redefinition of the central core of thought. For Baudelaire the central idea is a vision of the reciprocal structure and the tangibility of Delacroix's painting. For Ruskin the central idea is seeing clearly and recording plainly. In most of the early phases of the development of Ruskin's aesthetic, the vision is seen through the painting of Turner. As Ruskin's study of art expanded, he began to find more complex confirmations of his central idea in the works of the Venetian painters and in medieval architecture. *Modern Painters* departs from a specific defense of Turner, to explore the "sum total of visual truth," and returns to Turner in the fifth and last volume, but to Turner seen through the Venetians, Turner seen through the history of architecture, Turner seen through the long process of Ruskin's visual refinement. In Ruskin's final appreciation of Turner in volume five, the governing vision has been deepened, but not changed in essence from the opening descriptions of the aesthetic values of Turner's painting in the first volume. As Ruskin's vision is refined, his criticism becomes more subtle, but the central core of Ruskin's thought, which begins with Turner, returns to Turner at the end, only expanded into more complex and elaborate form. Ruskin's entire visual training is accomplished through Turner; Ruskin learns to see Nature through Turner's eyes and compare his own observations back to "Nature, as painted by Turner." In a parallel way Ruskin sees other painting and works of architecture through the particular optical focus provided by the study of Turner's art. It is not surprising, therefore, that in the final volume of *Modern Painters* Ruskin seems to achieve a kind of coincidence of vision with the painter he idolizes. The reader is made to feel that Ruskin's prose is an absolutely clear and transparent medium for recording the impressions produced by Turner's painting; it is as if the reader is seeing Turner through Ruskin's eyes as Turner might have seen himself, if the painter were able to step momentarily into the position of critic.

In returning to the theory of the sister arts, it is clear that Ruskin was aware of the eighteenth-century tradition of literary pictorialism both through his reading of Reynolds and through Turner's conventional homage to the alliance between the arts. Turner, like many members of the Royal Academy, frequently appended verses under the titles of his painting, which were intended to complement and enhance the subject of the painting by providing a verbal

parallel. More often than not these verses were chosen from the classic pictorial poems of the eighteenth century such as Thompson's "The Seasons." Turner himself composed a long epic poem entitled "The Fallacies of Hope," stanzas of which he also used as the literary pendant to paintings. As Jean Hagstrum has pointed out in *The Sister Arts,* the visual transfer between the arts in the eighteenth century is iconographic: the painter will supply an image or a configuration of objects which the poet refers to in writing about Nature. The effect of overlay between poetry and painting is well defined in Christopher Hussey's book on the picturesque, in which he attempts to show that the early landscape poets, Thompson and Dyer, "look at and describe landscape in terms of pictures." The pictures to which this poetry refers are based on a literary approach to painting and refer, themselves, to classical poetry.

> As regards landscape, the pictorial approach of Thomson and Dyer was something new. DuFresnoy makes not even a passing reference to landscape painting. Painting for him deals only with "history" and portraiture. Landscape is still the poet's province, as it had been till well after the Renaissance; till, in fact, Claude and Poussin made their appearance among the poets. Their landscape is poetic landscape: a presentment of what poets had described. Thomson and Dyer enlarged poetic landscape by describing what the painters had borrowed from earlier poets. Finally a Gainsborough or a James Ward completed this house that Jack built, by painting what a Thomson had seen imitated by Claude from Virgil.[10]

This intricate history of correlations is based on the imitation of the representational subject involved; the details of a Homeric description may be used in a painting, or the objects in a painting may be used in poetry as a conventional description of Nature. But as Hagstrum has pointed out, up through the eighteenth century the doctrine of *ut pictura; poesis* does not involve an attempt to transfer structural or formal principles from one art to another: "Croce and Coleridge's perceptions of stasis in poetry belong to later epochs, and it must be confessed no English neoclassical critic developed the notion."[11] Ruskin's aesthetic, with his attempt to apply formal visual principles to literature, therefore adds a new dimension to the analogy between the arts. Ruskin does not recommend that the writer look to painting for a storehouse of conventional images, but rather that he look at the world through the clarifying lens of the painter's eye. In a curious way Ruskin's central concern of seeing clearly changes along lines that parallel Turner's career. Turner's development as a painter has a certain overall rhythm that can be described in broad terms as a change from the literary pictorialism of the eighteenth century to the kind of scientific abstraction valued by the Impressionists, who theoretically attempted to paint only what the eye actually sees. Turner began as a topographical engraver, learning to render landscape with the accuracy of a photographic eye, and progressed to become the "author" of the final canvases which seem to

be as abstract as twentieth-century expressionism. But it would be misleading to imply that Turner moves from representational art to abstract art; throughout his career Turner maintained, in the face of hostile criticism, that he painted exactly what he saw. The change that occurs is that Turner drops away more and more of the literary props that he was conditioned to include in imitating Claude and Poussin and begins to paint only what he sees most clearly, the seascapes, the skies, the color harmonies and light effects that become the "subjects" of his later painting. The problem for the critics was the inability to find the "subject" without the requisite literary elements. In Turner's earlier paintings there is a comfortable relationship between picture and the lines of poetry added to the title—the poetry refers to a recognizable subject, identifiable icons; but in Turner's later painting the allegorical titles or lines of poetry are often used to anchor the abstraction, to supply the idea of "subject" which is missing, in an obvious way, on the canvas itself. It was during just such a controversy that Ruskin stepped in with *Modern Painters* to defend Turner's truth to Nature. A critic had accused Turner of insulting the public with "Snowstorm: Steamboat Making Signals," of throwing a "pot of soapsuds" in the face of the gallery goer. Ruskin was astute enough to observe that Turner's painting was fully representational of the visual facts and that far from being a spontaneous expression, the painting was actually an extremely refined and precise recording of the scene itself.[12] Turner's progression shows that by painting exactly what he sees, there is an obvious change in the quality of vision. Turner's sight tends to simplify as it refines—the obvious details of a landscape disappear and are replaced with the delicate rendering of light and color effects to that in the final canvases light and color become the 'subject' themselves. In a similar way Ruskin's central idea of seeing clearly changes from a kind of literal attention to precise details, to a final appreciation of pure light and color and a sense of vision as "abstract," as free from specific "content" as Turner's late canvases. In general the change in Ruskin is due to his loss of religion: in the early phases of writing *Modern Painters* Ruskin wants to train the observer to see clearly in order to find evidence of the divine embodied in visual facts. Ruskin's recording of visible facts is always primarily focused on the object itself, but he tends to read universal laws and pantheistic doctrine into the objects he so clearly describes. As Ruskin grew away from his Protestant faith, he dispensed with his religious underpinning, just as Turner dispensed with the conventions of literary pictorialism. Later in his career Ruskin is able to accept the visual facts of light, color, and form as sufficient in themselves, whether or not they reflect a specific Deity. Thus Ruskin attains the same kind of visual purity, the same kind of acceptance of visible beauty as sanctifying in and by itself that enabled Turner to identify the Sun as God on his deathbed.

Ruskin's criticism is based on the idea of seeing clearly, but this idea is deceptively simple because Ruskin is aware of the fact that there is no such thing

as absolute clarity, so the limits of clarity are in constant transformation, gaining new significance and scope as Ruskin's visual training and critical capacities improved. In his autobiography *Praeterita* Ruskin defines his personal governing attribute as his almost unparalleled "visual appetite": he realizes, from an early age when he became aware of himself staring at the figures in the carpet, that his life would be preoccupied with the visual surfaces of the world. In *Modern Painters* he discovers an optical revelation that he finds overwhelming and which he announces in bold type:

WE NEVER SEE ANYTHING CLEARLY[13]

Ruskin had made an initial attempt to define this idea in the chapter on "Truth of Space" in the first volume of *Modern Painters,* where he reaches the conclusion that "nature is never distinct and never vacant, she is always mysterious but always abundant; you always see something, but you never see all."[14] Ruskin is trying to define in this early volume the concept that the representation of visual facts must take into account the effects produced by the intervening space. When he returns to the idea in volume four, he is more concerned with the universality of the principle; seeing clearly is never possible in any absolute sense, because the more you see the more there is to be seen. His discussion in volume four is based on the receding and advancing mystery of objects:

> WE NEVER SEE ANYTHING CLEARLY. I stated this fact partly in the chapter on Truth of Space, in the first volume, but not with sufficient illustration, so that the reader might by that chapter have been led to infer that the mystery spoken of belonged to some special distance of the landscape, whereas the fact is, that everything we look at, be it large or small, near or distant, has an equal quantity of mystery in it; and the only question is, not how much mystery there is, but at what part of the object mystification begins. We suppose we see the ground under our feet clearly, but if we try to number its grains of dust, we shall find that it is as full of confusion and doubtful form as anything else; so that there is literally no point of clear sight, and there never can be. What we call seeing a thing clearly, is only seeing enough of it to make out what it is; this point of intelligibility varying in distance for different magnitudes and kinds of things, while the appointed quantity of mystery remains nearly the same for all. Thus: throwing an open book and an embroidered handkerchief on a lawn, at a distance of half a mile we cannot tell which is which; that is the point of mystery for the whole of those things. They are then merely white spots of indistinct shape. We approach them, and perceive that one is a book, the other a handkerchief, but cannot read the one, nor trace the embroidery of the other. The mystery has ceased to be in the whole things, and has gone into their details. We go nearer, and can now read the text and trace the embroidery, but cannot see the fibres of the paper, nor the threads of the stuff. The mystery has gone into a third place. We take both up and look closely at them; we see the watermark and the threads, but not the hills and dales in the paper's surface, nor the fine fibres which shoot off from every thread. The mystery has gone into a fourth place, where it must stay, till we take a microscope, which will send it into a fifth, sixth, hundredth, or thousandth place, according to the power we use.[15]

Ruskin realizes that there is no single vision of appearances, because the appearance of things is in constant motion, the level of clarity fluctuating, advancing and retreating in relation to the observer. He understands that perception is not a static, fixed gaze at visible facts, but a process with a definite rhythm; there is a temporal component to seeing which is established by the relation between the observer and the object. To see clearly is to recognize the fact that objects are not locked into space, to be studied as an immutable set of appearances; instead seeing clearly is an attempt to penetrate the world of appearances which is in continual transformation, manifesting the visible energy of growth, change, and motion. Like Blake, Ruskin rejects "single vision and Newton's sleep." For Ruskin, seeing is a dynamic process, constantly in motion, intensifying, decelerating, an exchange of energy between viewer and object.

Seeing clearly is thus a life-long process for Ruskin. His work moves towards a kind of visual apocalypse; as he defines the aim of his writing in the introduction to *Praeterita,* he is attempting to bring the world closer to the point where "what is visible in creation will one day be clearly seen."[16] Ruskin imagines a kind of optical omega point where the receding mystery of appearances is finally stopped and the visible world can be perceived in its ultimate clarity. This final sense of vision is spiritual without being religious: Ruskin feels that the world will be seen in all its radiant particularity, not that material appearances will be dissolved into order to reveal a transcendent world beyond. The final vision, for Ruskin, as for Turner, is of things "as they are," the material world of appearances, refined to a point of utmost simplicity. As Turner's career advances, the greater his clarity of perception, the more mystery he seems to record. Like Turner, Ruskin progresses from a sense of topographical clarity to a sense of metaphysical clarity, without losing his grasp on the optical surfaces, visible facts and physical components of his vision. But in order to understand the final point of visionary clarity that Ruskin sees in Turner's painting, we must first go back and follow the process of Ruskin's aesthetics as it develops, stage by stage, from his original perception of Turner's painting to his final pursuit of the total clarity which Ruskin felt could only be seen fitfully through the "dark and broken mirror"[17] of man's limited perception.

Ruskin is at first concerned with defending Turner's truth to nature, his representational accuracy, because the journalist reviewers had ridiculed Turner's "Rainstorm: Steam and Speed." Characteristically, as early in his career Ruskin is an ardent nature worshipper, he does not attempt to defend Turner's artistic right to depart from Nature, but to define why Turner's particular version of Nature is truer than the recommended academic versions modelled on Claude and Poussin. Ruskin jumps head foremost into the field of aesthetics and begins to reject, dispute and qualify various standard doctrines as he intuitively moves toward his own definitions. One of Ruskin's primary targets is the neo-classic doctrine of generalization, as defined by Johnson for poetry (do not number "the

streaks of the tulip") and Reynolds for painting (paint only the "unvariable and general," not the minutiae of "Nature modified by accident"). Throughout Ruskin's discussion, as well as Reynolds', the term "poetry" is used to refer to verse as well as painting, and Ruskin argues with examples taken from Byron as well as referring to the art of Turner. In refuting Reynolds' neo-classic definition of ideality (history attends to details, poetry to the invariable) Ruskin performs a virtuoso piece of exegesis on some lines from "The Prisoner of Chillon" in order to show that every detail which alludes to "nature modified by accident" adds to the poetic effect of Byron's verse. Ruskin concludes that poetry is distinguished from history "by the addition of details" and "its whole power consists in the expression of what is singular and particular."[18] This definition of poetry fits especially well into Ruskin's defense of Turner's topographical particularity. For Ruskin, again like Blake, to generalize is to be an idiot, and most blatantly so in terms of painting. As Ruskin puts it, representing or describing things in generalized terms is obviously false, because "a Rock must be one Rock or another Rock, it cannot be a general Rock, or it is no Rock. . . . Every attempt to produce that which shall be any rock ends in the production of that which is *no* rock."[19] What Ruskin insists on is the fact that the elusive ideality of Poetry is embodied in particulars and neither painter nor poet can bypass or generalize the specific visual facts: in art "the greatness of manner chiefly consists in seizing the specific character of the object along with all the great qualities of beauty it has in common with higher orders of existence."[20] Ideality, "the higher order," was at first connected in Ruskin's mind to the presence of the divine in Nature; but the divine was only apparent through close attention to the "specific character" of the object itself. Later the idea of an unspecified higher force remains for Ruskin, no longer connected to a Wordsworthian sense of nature as religious. But the change in religious connotations has no effect on Ruskin's obsession with particularity.

Ruskin's attempt to see clearly and his realization that nothing is ever seen with total clarity leads him on a kind of quest to see further and to see more, so that he pushes his powers of vision to become microscopic, almost atomistic. In the introduction to the second edition of *Modern Painters* Ruskin underlies the central importance of his new ideal of specificity:

> Every herb and flower of the field has its distinct and perfect beauty . . . The highest art is that which seizes this specific character . . . Every class of Rock, every kind of earth, every form of cloud must be studied with equal industry and rendered in equal precision.[21]

Ruskin goes far beyond the usual conventions of representational theory in his demands for scientific accuracy of perception: he tries almost to see inside the crystalline structure of rocks, into the vapor particles that compose the clouds. The real reason for the long sections of geological and botanical studies that are

included in *Modern Painters* is that Ruskin is trying to see objects as completely as possible, and frequently the information about internal structure explains an aspect of exterior form. The aim of Ruskin's investigations into the patterns of formation growth and fracture is not simply or even primarily to gather scientific data about the inner workings of trees, rocks and clouds; Ruskin's real purpose is to establish as precisely as possible the effect of objects on the eye. Ruskin felt that the eye was a more complex recording instrument than any scientific device and that "those who want to know the real facts of the world's outside aspect, will find they cannot trust maps, nor charts, nor any manner of mensuration"[22] but should rely instead on the perception of a trained eye. Ruskin is primarily interested in the "world's outside aspect" and he establishes in the mid-nineteenth century a kind of phenomenology of visible surfaces. The study of these surfaces, these optical facts, these physical impressions produced by the outside of objects Ruskin called the "science of aspects":

> . . . for there is a science of the aspects of things as well as of their nature; and it is as much a fact to be noted in their constitution, that they produce such and such an effect upon the eye or heart (as, for instance, that minor scales of sound cause melody), as that they are made up of certain atoms or vibrations of matter.[23]

Optical effects are not governed by the hard scientific principles of measurement and tabulation alone, but are connected, as Ruskin says obliquely, to the heart. The role of emotion in perception is complex and forms the subject of the next phase of this essay on the progression of Ruskin's aesthetic. In terms of particularity, it is enough to summarize at this point Ruskin's concept of the function of emotion; briefly stated, emotion intensifies perception and heightens the specificity of objects. ". . . Mental sight becomes sharper with every full beat of the heart . . ." But the strongest point that emerges from Ruskin's discussion of particularity is that he automatically assumes the visual bias to apply to the Poetry of painting and literature equally. For example, early on in *Modern Painters* Ruskin thought of Wordsworth as the best nature poet because of his precise and specific imagery; he found in Wordsworth, at first, the type of poet who exercised scientific perception, the same type of perception exemplified in good landscape painting. Ruskin applies his criteria of visual specificity to Wordsworth's verse and discovers choice bits of "foreground painting" in the image of a violet casting its shadow against a stone.

> The beauty of its star shaped shadow, thrown
> On the smooth surface of the stone.[24]

and instances of pictorial foreshortening in the description of the shadow cast by a pine,

> . . . at the root
> Of that tall pine the shadow of whose bare
> And slender stem, while here I sit at eve,
> Oft stretches to'rds me, like a long straight path
> Traced faintly in the greensward.[25]

In this first volume of *Modern Painters* Ruskin thought of Wordsworth as comparable to Turner, because he was the "Keenest eyed of all modern poets." But Wordsworth himself thought of this sort of precise observation as an inferior, although important part of his art:

> The ability to observe with accuracy things as they are in themselves, and with fidelity to describe them, unmodified by any passion or feeling existing in the mind of the describer . . . though indispensable to a Poet, is one which he employs only in submission to necessity, and never for a continuance of time: as its exercise supposes all the higher qualities of the mind to be passive, and in a state of subjection to external objects. (Wordsworth, *Lyrical Ballads,* preface 1815 edition.)

Ruskin, of course, does not suppose all of the higher orders of the mind to be passive, but to be energized to the highest level by the ability to observe accurately things as they are, by the power of placing the self in reverent subjection to external objects in order to see clearly and tell "with fidelity" what is seen. As Ruskin comes to realize later, Wordsworth often places his own "self" before external objects, thereby obscuring accurate vision for the reader. It is clear to Ruskin that the real master of the "science of aspects" is Turner himself, whose painting can provide a more direct and refined rendering of "optical knowledge" and "optical facts," than any poet, no matter how keen-eyed. Turner's painting replaces Wordsworth's poetry for Ruskin as a model of specificity: Turner opens up a whole new range of "optical facts" which stimulate Ruskin's visual appetite for greater delicacy of perception, more minute detail, and further subtlety of discrimination. When Ruskin returns to Nature, to confirm Turner's accuracy, he begins to look at Nature through the clarifying lens of Turner's painting and he begins to write about Nature as if it were observed through a painter's eye. Ruskin is consciously trying to write in a new way, to write as plainly as possible, to make his style transparently clear, so that the reader is given the "pure facts" as directly as possible. This elemental plain style is designed to render optical facts as clearly as can be done in a verbal medium, to make the reader see with microscopic precision, so that language is stripped of rhetoric and reduced to scientific spareness. But the effect of seeing clearly, through this plain prose, is often astonishing. When Ruskin describes "water as painted by Turner" he is deliberately trying to focus on the visual phenomena, to let the visual facts speak for themselves; the effect is to concentrate the reader's attention on the *visibilia* for an extended period of time, not through the usual technique of descriptive writing which is to poeticize with adjectives, images, and metaphors,

but simply by fixing the reader's mental gaze on the visible surfaces, on the "pure facts" alone. First an example of Ruskin's optical prose directly focused on Turner: the whole effect depends on revealing the minute bit of optical knowledge concealed in the picture within the picture, as plainly as possible.

Now one instance will be sufficient to show the exquisite care of Turner in this respect. On the left-hand side of his Nottingham, the water (a smooth canal) is terminated by a bank fenced up with wood, on which just at the edge of the water, stands a white sign-post. A quarter of a mile back, the hill on which Nottingham Castle stands rises steeply nearly to the top of the picture. The upper part of this hill is in bright golden light, and the lower in very deep gray shadow, against which the white board of the sign-post is seen entirely in light relief, though, being turned from the light, it is itself in delicate middle tint, illumined only on the edge. But the image of all this in the canal is very different. First, we have the reflection of the piles on the bank, sharp and clear, but under this we have not what we see above it, the dark base of the hill (for this being a quarter of a mile back, we could not see over the fence if we were looking from below), but the golden summit of the hill, the shadow of the under part having no record nor place in the reflection. But this summit, being very distant, cannot be seen clearly by the eye while its focus is adapted to the surface of the water, and accordingly its reflection is entirely vague and confused; you cannot tell what it is meant for, it is mere playing golden light. But the sign-post, being on the bank close to us, will be reflected clearly, and accordingly its distinct image is seen in the midst of this confusion. But it now is relieved, not against the dark base, but against the illumined summit of the hill, and it appears, therefore, instead of a white space thrown out from blue shade, a dark gray space thrown out from golden light. I do not know that any more magnificent example could be given of concentrated knowledge, or of the daring statement of most difficult truth. For who but this consummate artist would have had courage, even if he had perceived the laws which required it, to undertake in a single small space of water, the painting of an entirely new picture, with all its tones and arrangements altered—what was made above bright by opposition to blue, being underneath made cool and dark by opposition to gold;—or would have dared to contradict so boldly the ordinary expectation of the uncultivated eye, to find in the reflection a mockery for the reality? But the reward is immediate, for not only is the change most grateful to the eye, and most exquisite as composition, but the surface of the water in consequence of it is felt to be as spacious as it is clear, and the eye rests not on the inverted image of the material objects, but on the element which receives them. And we have a farther instance in this passage of the close study which is required to enjoy the works of Turner, for another artist might have altered the reflection or confused it, but he would not have reasoned upon it so as to find out what the exact alteration must be; and if we had tried to account for the reflection, we should have it false or inaccurate. But the master mind of Turner, without effort, showers its knowledge into every touch, and we have only to trace out even his slightest passages, part by part, to find in them the universal working of the deepest thought, that consistency of every minor truth which admits of and invites the same ceaseless study as the work of nature herself.[26]

Ruskin makes the reader respond to Turner's visual refinement, so that plain facts appear as a revelation of a new order of perception, and at the same time

the reader is aware of the tremendous power of Ruskin's prose in leading the eye through such a complex of visual facts, so simply, so clearly and in such plain language. There is almost nothing in the passage but plain notation; the only rise in the level of rhetoric occurs towards the end when Ruskin describes Turner, showering his knowledge into every touch, in order to emphasize the awesome power of the visual imagination, working at its most intense degree.

When Ruskin writes about Nature himself he uses the pictorial ability to make visual facts clear to the reader. Often, in writing about "water as painted by Turner," for example, Ruskin departs from any specific canvas, to make his own observations about how Nature looks to a painter's eye. Ruskin describes the light effect of ocean waves by breaking the form down into various light notations:

> . . . there are two conditions of foam of invariable occurrence on breaking waves, of which I have never seen the slightest record attempted; first the thick creamy curdling overlapping massy form which remains for a moment only after the fall of the wave, and is seen in perfection in its running up the beach; and secondly, the thin white coating into which this subsides, which opens into oval gaps and clefts, marbling the waves over their whole surface, and connecting the breakers on a flat shore by long dragging streams of white.
> It is evident that the difficulty of expressing either of these two conditions must be immense. The lapping and curdling foam is difficult enough to catch even when the lines of its undulation alone are considered; but the lips, so to speak, which lie along these lines, are full, projecting, and marked by beautiful light and shade; each has its high light, a gradation into shadow of indescribable delicacy, a bright reflected light and a dark cast shadow; to draw all this requires labor, and care, and firmness of work, which, as I imagine, must always, however skilfully bestowed, destroy all impression of wildness, accidentalism, and evanescence, and so kill the sea. Again, the openings in the thin subsided foam in their irregular modifications of circular and oval shapes dragged hither and thither, would be hard enough to draw even if they could be seen on a flat surface; instead of which, every one of the openings is seen in undulation on a tossing surface, broken up over small surges and ripples, and so thrown into perspectives of the most hopeless intricacy. Now it is not easy to express the lie of a pattern with oval openings on the folds of drapery. I do not know that any one under the mark of Veronese or Titian could even do this as it ought to be done, yet in drapery much stiffness and error may be overlooked; not so in the sea,—the slightest inaccuracy, the slightest want of flow and freedom in the line, is attached by the eye in a moment of high treason, and I believe success to be impossible.[27]

Ruskin has created a verbal picture of a painting yet to be painted: and in fact Ruskin's discussions of potential optical clarity lead to the painting of pictures inspired by his verbal accuracy in describing visual facts. Holman Hunt and the Pre-Raphaelite Brotherhood were founded directly on Ruskin's ideas of specificity. But as Ruskin himself later pointed out, the Pre-Raphaelite technique of all over, uniform clarity was something Ruskin had never recommended. As he

says throughout *Modern Painters,* "WE NEVER SEE ANYTHING CLEARLY," and each optical fact varies in the degree of advancing and receding clarity in which it is focussed by the eye. Turner's truth is based on painting exactly what the eye can see, not, like the Pre-Raphaelites, on pretending that every visible surface exists in the same relation to the eye. Turner's accuracy and precision are in fact, totally opposite; he takes into account every accident of atmosphere, every optical fact which conditions the way an object appears to the eye— and his ultimate precision is in rendering the "impossible" effects of water, mist, fog, and light: the kind of visual effects that could never be rendered with the Pre-Raphaelite formula for microscopic clarity.

As Ruskin wrote his way into *Modern Painters* he was, of course, aware of the aesthetic problems involved in explaining what he means by "seeing clearly." Often his emphasis on optical facts sounds as if he considered the observer no more than a photographic eye, seeing with no emotional component, seeing only pure forms and colors, mechanical sight. But Ruskin considered the idea of landscape separated from a living, feeling observer to be empty, and sight divorced from a "moral" center to be no more valuable than the "passionless admiration of herbage and stones."[28] Curiously the idea of vision purified of the human component is anticipated in the eighteenth century by Uvedale Price in his work on the picturesque, and expounded later in the nineteenth century as an aspect of art for art's sake. Uvedale Price imagines a hypothetical aesthete, an offshoot of the concept of the "picturesque," an observer who sees purely in pictorial terms:

> A man of the future who may be born without the sense of feeling, being able to see nothing but light variously modified and that such a way of considering nature would be just for then the eye would see nothing but what in point of harmony was beautiful. But that pure abstract enjoyment of vision, our inveterate habits will not let us partake of.[29]

But later in the version of aestheticism described by Wilde and Huysmans, this theoretical aesthete has been realized in the main characters of the ultimately moral novels, *The Picture of Dorian Grey* and *A rebours.* Both Dorian and Des Esseintes have lost their inveterate habits which would keep them from contemplating the world as pure aesthetic spectacle. In fact the main point of the novels is to offer, and then withdraw, a dogmatic brand of aestheticism which is based on the categorical separation of aesthetic and moral considerations, which supposedly offers complete freedom from emotional involvement. But Ruskin's idea of seeing clearly does not involve a loss of moral meaning; instead Ruskin believes that moral sensitivity can be transferred into visual sensitivity:

> With this kind of bodily sensibility to color and form is intimately connected that higher sensibility which we revere as one of the chief attributes of all noble minds,

and as the chief spring of real poetry. I believe this kind of sensibility may be entirely resolved into the acuteness of bodily sense of which I have been speaking, associated with love, love I mean in its infinite and holy functions, as it embraces divine and human and brutal intelligences, and hallows the physical perception of external objects by association, gratitude, veneration, and other pure feelings of our moral nature. And although the discovery of truth is in itself altogether intellectual, and dependent merely on our powers of physical perception and abstract intellect, wholly independent of our moral nature, yet these instruments (perception and judgment) are so sharpened and brightened, and so far more swiftly and effectively used, when they have the energy and passion of our moral nature to bring them into action—perception is so quickened by love, and judgment so tempered by veneration, that, practically, a man of deadened moral sensation is always dull in his perception of truth.[30]

Like all writers on aesthetic Ruskin comes up against the persistent fact that sense impressions and emotions have no intrinsic correlation; the organs that register sensations and the faculty that generates moral feeling are separate aspects of the human organism. Just as Proust, for example, is constantly exploring the gap that exists between a "sensation" and the "état d'ame" it produces, Ruskin is interested in discovering the connection between the "bodily sense" and the "higher sensibilities." The transition across this gap, the element that stretches between sense impressions and the spiritual inner life, remains for Ruskin, as for Proust, one of the central mysteries of existence. A good deal of *Modern Painters* is given over to an attempt at defining this link between sensation and morality, when morality implies, as it does for Ruskin, not ethics, but man's spiritual and metaphysical understanding of the universe.

An underlying facet of Ruskin's above statement is the *direction* of transition: Ruskin does not simply imply that visible facts can be given a moral interpretation but that, moving the opposite way, the sense of morality can be concentrated *into* the sense of sight, an imaginative leap which essentially fuses moral sensitivity with visual accuracy. One of the main lessons that Ruskin took away from his daily Bible readings with his mother as a child, was that "precision of accent is precision of feeling." In a similar way Ruskin came to believe that visual precision could be equated with "precision of feeling." What Ruskin tries to show is that Taste and Morality stand in a reciprocal relationship. As Ruskin's eye for social conditions taught him, a moral decline can be measured in aesthetic pollution. But Ruskin also felt that the general ugliness of the state of English life in physical terms, of architecture and landscape, was not only a symptom but a cause of moral apathy. One approach to the social problems, Ruskin felt, was to improve the environment. If the visual sense of the public were refined, through education and example, the moral tone was likely to benefit. But the social implications of beautifying the streets, or replacing manufacture with crafts, are only examples on a broader scale of Ruskin's belief that training the eye to be more receptive was a way of training the moral

or spiritual aspect of man. Ruskin felt that he needed to show the public that seeing clearly was a way of attaining moral clarity as well. He therefore attempts to analyze the process of visual perception itself, and to define the role of emotion in determining "optical facts." In his famous chapter on the pathetic fallacy Ruskin tries to demonstrate how emotion is related to the laws of physical sight, and how this relation determines both visual accuracy and spiritual insight.

Again in his chapter on the pathetic fallacy Ruskin is implicitly dealing with the concept of the "sister arts." He uses examples drawn from poetry to confirm his vision of Nature as seen through Turner's painting. At this point Ruskin has done enough writing based on optical facts in *Modern Painters* to realize that most Romantic nature poetry falls far below his standard of specificity. In a chapter "On Modern Landscape" Ruskin reverses his decision about Wordsworth, and claims that Scott and Turner are the representative poet and painter of the modern age because both men are "Seers." Scott is put above the other Romantic poets because of his "habit of looking at Nature, not as altered by his own feelings, in the way that Keats and Tennyson regard it, but as having an animation and pathos of its *own,* wholly irrespective of human presence or passion . . ."[31] Ruskin believes that Keats, Byron, and Shelley have "less truth of perception" because they have "more troublesome selfishness" and even Wordsworth "has a vague notion that Nature would not be able to get on well without Wordsworth; and finds a considerable part of his pleasure in looking at himself as well as at her." This whole question of the relation of emotion to vision is discussed in "The Pathetic Fallacy," and the accusation that Ruskin brings against the poets is that they distort what they see by projecting their personal fancies and emotions into the external world so that they overlay the visual experience.

In discussing the pathetic fallacy, as throughout his writing, Ruskin emphasizes the fact that vision is not a single static look, but a process of perception that grows by stages, in degrees. He describes a graduation of refinement in vision that correlates with emotional states, dividing the progression into four degrees:

> . . . (first) the man who perceives rightly, because he does not feel, and to whom the primrose is very accurately the primrose, because he does not love it. Then, secondly, the man who perceives wrongly, because he feels, and to whom the primrose is anything else than a primrose; a star, or a sun, or a fairy's shield, or a forsaken maiden. And then, lastly, there is the man who perceives rightly in spite of his feelings, and to whom the primrose is for ever nothing else than itself—a little flower, apprehended in the very plain and leafy fact of it, whatever and how many soever the associations and passions may be, that crowd around it. And, in general, these three classes may be rated in comparative order, as the men who are not poets at all, and the poets of the second order, and the poets of the first; only however great a man may be, there are always some subjects which *ought* to throw him off his balance; some, by which his poor human capacity of thought should be conquered, and brought into the

inaccurate and vague state of perception, so that the language of the highest inspira-
tion becomes broken, obscure, and wild in metaphor, resembling that of the weaker
man, overborne by weaker things.

And thus, in full, there are four classes: the men who feel nothing, and therefore
see truly; the men who feel strongly, think weakly, and see untruly (second order of
poets); the men who feel strongly, think strongly, and see truly (first order of poets);
and the men who, strong as human creatures can be, are yet submitted to influences
stronger than they, and see in a sort untruly, because what they see is inconceivably
above them. This last is the usual condition of prophetic inspiration.[32]

This fourth class of perception is an extraordinary exception; Ruskin is generally
concerned with the third level, the clear perception of objects as they are. What
Ruskin apprehends is that the object can be seen clearly as "pure fact" and yet
have a profound effect on the spirit. The moral emotion is condensed into the
object itself, so that the observer can find significance in the plain fact of the
"primrose. . . . for ever nothing else than itself." Ruskin is moving towards a
definition of a kind of natural symbol, the "natural object as adequate sym-
bol," to borrow a phrase from a later admirer of Ruskin, Ezra Pound. When
Pound defines a poet as a man for whom a hawk is a hawk, he is in essential
agreement with Ruskin's vision of the "primrose—for ever nothing else than
itself." Pound's "image," like Ruskin's concept of the pathetic fallacy, is based
on a visual criterion; language should be used to clarify the visible facts of the
object itself. Ruskin feels that the Romantic poet often failed to subordinate
language to the purpose of clarification; instead the poets blurred the object
with emotional responses, or overlaid the object with associations. Whereas, for
Ruskin, a clear vision of the object, seeing it as a painter would see it as "optical
knowledge," focusses on the moral or spiritual meaning inherent in the form,
contained in the visible facts themselves. For Ruskin, like Symbolist critics, the
visible symbol cannot be paraphrased: the poets' personal emotions and associa-
tions are a way of paraphrasing the object, detracting from the "pure facts,"
and distracting the attention from the optical spectacle, which for Ruskin is the
adequate symbol in itself. Ruskin uses lines from *Alton Locke* as an example
of distortion:

They rowed her in across the foam
The cruel, crawling foam.

As Ruskin carefully points out, the intense feeling has caused a *fallacy of sight:*
the image of sea foam has been wilfully blurred by the inaccurate use of an
adjective which pertains to the poet's grief. Ruskin feels that the poet should
imitate the painter, who is able to render his "poetry" through *visibilia,* who is
incapable, because of the form of his art, of confusing a personal emotion with
the external world: as Ruskin defines it, the writer's aim is to achieve the
painter's vision. "It is one of the signs of the highest power in a writer . . . to

keep his eyes fixed firmly on the *pure fact,* out of which if any feeling comes to him or his reader, he knows it must be a true one."

What Ruskin is really doing in the chapter on the pathetic fallacy is applying his standard of visual accuracy, perceived first and foremost in Turner's painting, to literature. This transference is handled with relative simplicity; Ruskin expects the writer to measure up to the test of accuracy in diction, accuracy in the handling of words that reflects a clear moral vision, the kind of clear seeing which is best exemplified by Turner's meticulous respect for "optical facts." He takes, as another example of the special defect of Romanticism, a contrast in imagery between Dante and Coleridge:

> Now we are in the habit of considering this fallacy as eminently a character of poetical description, and the temper of mind in which we allow it, as one eminently poetical, because passionate. But, I believe, if we look well into the matter, that we shall find the greatest poets do not often admit this kind of falseness,—that it is only the second order of poets who much delight in it.
>
> Thus, when Dante describes the spirits falling from the bank of Acheron "as dead leaves flutter from a bough," he gives the most perfect image possible of their utter lightness, feebleness, passiveness, and scattering agony of despair, without, however, for an instant losing his own clear perception that *these* are souls, and *those* are leaves: he makes no confusion of one with the other. But when Coleridge speaks of
>
> > "The one red leaf, the last of its clan,
> > That dances as often as dance it can,"
>
> he has a morbid, that is to say, a so far false, idea about the leaf: he fancies a life in it, and will, which there are not; confuses its powerlessness with choice, its fading death with merriment, and the wind that shakes it with music.[33]

It is not only the technical difference between simile and metaphor that Ruskin is pointing out, but the implications of the visual image. Dante has observed leaves falling correctly and because of his perception of the motion of the leaves he is able to make a precise, therefore potent analogue with the motion of fallen souls. But Coleridge has used language to falsify the actuality of the phenomenon, by producing an ill-fitting overlay of associations which, as Ruskin points out, creates a morbid disparity between the visual image and the verbal rendering. The hectic motion of a leaf in wind is not "merry"; so Ruskin feels that the language loses power as it loses verbal accuracy. Ruskin is aware that the morbid effect may be intended, but even so he believes that a literary critic can make a qualitative distinction between Dante's superior clarity of diction and vision and the verbal distortion of "pure fact" produced by Coleridge.

Ruskin's sense of verbal accuracy and precision and his examples of literary exegesis are often astonishingly modern in the degree of attention to the text as text. Like Baudelaire, Ruskin insists that poetry must be read letter by letter, not simply word by word, and that each syllable, each separate accent

of sound, the look of each letter on the page goes into determining the final accuracy of reading. He wants the reader "to look intensely at words . . . and assure yourself of their meaning . . . letter by letter":

> For though it is only by reason of the opposition of letters in the function of signs, to sounds in the function of signs, that the study of books is called "literature," and that a man versed in it is called, by the consent of nations, a man of letters instead of a man of books, or of words, you may yet connect with that accidental nomenclature this real fact:—that you might read all the books in the British Museum (if you could live long enough), and remain an utterly "illiterate," uneducated person; but that if you read ten pages of a good book, letter by letter,—that is to say, with real accuracy,—you are for evermore in some measure an educated person.[34]

Ruskin follows up his definition of close textual reading with an example of his own reading of a passage from "Lycidas." The main point of the reading is to show how Milton has achieved a kind of absolute accuracy in diction; Ruskin's insistence on the precise adjustment of term to meaning is similar to Flaubert's aesthetic of "le mot juste." As a critic Ruskin's aim is to illuminate the words of the poem with a kind of letter by letter scrutiny. He takes the lines

> Enow of such as for their bellies' sake
> Creep, and intrude, and climb into the fold.

and points out the full significance of the three simple verbs, "creep, intrude, and climb" in this context:

> Never think Milton uses those three words to fill up his verse, as a loose writer would. He needs all the three;—especially those three, and no more than those— "creep," and "intrude," and "climb"; no other words would or could serve the turn, and no more could be added. For they exhaustively comprehend the three classes, correspondent to the three characters, of men who dishonestly seek ecclesiastical power. First, those who "creep" into the fold; who do not care for office, nor name, but for secret influence, and do all things occultly and cunningly, consenting to any servility of office or conduct, so only that they may intimately discern, and unawares direct, the minds of men. Then those who "intrude" (thrust, that is) themselves into the fold, who by natural insolence of heart, and stout eloquence of tongue, and fearlessly perserverant self-assertion, obtain hearing and authority with the common crowd. Lastly, those who "climb," who, by labour and learning, both stout and sound, but selfishly exerted in the cause of their won ambition, gain high dignities and authorities, and become "lords over the heritage," though not "ensamples to the flock."
> Now go on:—
> "Of other care they little reckoning make,
> Than how to scramble at the shearer's feast,
> Blind mouths—"[35]

What Ruskin is trying to show the reader is not simply the correct etymology of the words, but the fact that Milton's accuracy is based on an unclouded, clear vision of his subject. In the case of the broken metaphor of the blind mouths, the visualization of the words produces what Ruskin would call a "grotesque" image; but what Ruskin is interested in demonstrating is that the initial obscurity of the metaphor gives way to the clarity of literal truth. The grotesque and broken quality stops the reader and makes him focus more closely on the words, so that accurate reading reveals a precise meaning.

As Ruskin continues to expand on the full implication of specific words, he moves on to the phrase

> But swoln with wind, and the rank mist they draw

and his critical commentary almost begins to rival the verse in power of language, as Ruskin draws on his own verbal images to illustrate the richness of Milton's precision.

> But swoln with wind, and the rank mist they draw.

This is to meet the vulgar answer that "if the poor are not looked after in their bodies, they are in their souls; they have spiritual food."

And Milton says, "They have no such thing as spiritual food; they are only swollen with wind." At first you may think that is a coarse type, and an obscure one. But again, it is a quite literally accurate one. Take up your Latin and Greek dictionaries, and find out the meaning of "Spirit." It is only a contraction of the Latin word "breath" and an indistinct translation of the Greek word for "wind." The same word is used in writing, "The wind bloweth where it listeth"; and in writing, "So is every one that is born of the Spirit"; born of the *breath,* that is; for it means the breath of God, in soul and body. We have the true sense of it in our words "inspiration" and "expire." Now, there are two kinds of breath with which the flock may be filled,—God's breath, and man's. The breath of God is health, and life, and peace to them, as the air of heaven is to the flocks on the hills; but man's breath—the word which *he* calls spiritual—is disease and contagion to them, as the fog of the fen. They rot inwardly with it; they are puffed up by it, as a dead body by the vapours of its own decomposition. This is literally true of all false religious teaching; the first and last, and fatalest sign of it, is that "puffing up." Your converted children, who teach their parents; your converted convicts, who teach honest men; your converted dunces, who, having lived in cretinous stupefaction half their lives, suddenly awaking to the fact of their being a God, fancy themselves therefore His peculiar people and messengers; your sectarians of every species, small and great, Catholic or Protestant, of high church or low, in so far as they think themselves exclusively in the right and others wrong; and, pre-eminently, in every sect, those who hold that men can be saved by thinking rightly instead of doing rightly, by word instead of act, and wish instead of work;—these are the true fog children—clouds, these, without water; bodies, these of putrescent vapour and skin, without blood or flesh; blown bagpipes for the fiends to pipe with—corrupt, and corrupting.—"Swollen with wind, and the rank mist they draw."[36]

The potency of Ruskin's images—the blown bagpipes of putrescent vapor and skin—is a direct response to the evocative accuracy of Milton's language. Ruskin actually sees images embodied in each word, sees each word on the page as a condensation of potential visual images. But Ruskin's elaboration does not detract from the verse itself; instead he acts as a magnifying lens for the quality of the each word, deepening and expanding every square inch of Milton's text. As Ruskin himself emphasizes, this "true" reading is aimed at "clear sight," at seeing what the author sees and how he sees it; the personality of the critic should be transparent:

> We have got something out of the lines, I think, and much more is yet to be found in them; but we have done enough by way of example of the kind of word-by-word examination of your author which is rightly called "reading"; watching every accent and expression, and putting ourselves always in the author's place, annihilating our own personality, and seeking to enter into his, so as to be able assuredly to say, "Thus Milton thought," not "Thus *I* thought, in mis-reading Milton."[37]

Thus the critic's position, like the writer's, is related to Ruskin's ideal of *seeing clearly.* A writer with Ruskin's verbal sensitivity cannot be easily dismissed when he defines the greatest form of writing as based on a visual center. Ruskin believes that the greatest writers, like Dante and Milton, achieve greatness because their writing is an accurate recording, a precise rendition of a specific vision, whether an optical, physical seeing or the visionary sight of the mind; in either case, Ruskin feels, the power of the writer, like the power of the painter, is based on the ability to *see.* In a chapter entitled "The Naturalist Ideal" Ruskin tries to explain why the greatest art is based on seeing clearly and recording plainly; how things seen simply as they are, without the poetic addition of the pathetic fallacy, can acquire any degree of ideality. Ruskin again stresses the analogy between the "sister arts"; both writer and painter are subject to the rule of clear vision. Ruskin describes the highest level of art as:

> . . . the plain narration of something the painter or writer saw. Herein is the chief practical difference between the higher and lower artists; a difference which I feel more and more every day that I give to the study of art. All the great men see what they paint before they paint it,—see it in a perfectly passive manner,—cannot help seeing it if they would; whether in their mind's eye, or in bodily fact, does not matter; very often the mental vision is, I believe, in men of imagination, clearer than the bodily one; but vision it is, of one kind or another,—the whole scene, character, or incident passing before them as in second sight, whether they will or no, and requiring them to paint it as they see it; they not daring, under the might of its presence, to alter one jot or tittle of it as they write it down or paint it down; it being to them in its own kind and degree always a true vision or Apocalypse, and invariably accompanied in their hearts by a feeling correspondent to the words,—"Write the things *which thou hast seen* and the things which *are*."[38]

The test of reality is visual, and the test of great art is the ability to record the vision as precisely and clearly as possible. Ruskin, in defining The Naturalist Ideal, is of course aware of the difference between a photographic representation and an artist's visual experience: in a similar way he does not expect the plain transcription, whether in paint or words, of the artist's vision to be a simple mechanical process. The whole power of art rests in achieving clarity, which cannot be accomplished with spontaneous ease, either by the painter or the writer. One of the most important aspects of Ruskin's aesthetic based on clear vision is his realization that seeing clearly is not a natural or even a normal process. Instead *seeing clearly* is precisely the opposite of "natural" perception, as it must be learned through the education of the eye. As Ruskin announces early in *Modern Painters,* "the truth of nature is not to be perceived by the uneducated senses." It is exactly here that Ruskin's entire aesthetic departs from Romanticism. Ruskin does not believe that a painter or a poet is spontaneously able to perceive Nature; seeing clearly is an art which must be learned. The ability to see plain, clear "pure facts" is an ability that must be acquired; even if the artist has an innate visionary power the power must be trained, exercised and developed. As Ruskin puts it, there is an immense qualitative difference between the "uneducated senses," left in a state of nature, and the sensory responses which have been refined by the process of training. In terms of sight, Ruskin insists that the degree of difference is the difference between an "infinite" vision and virtual blindness:

> The first great mistake that people make in the matter, is the supposition that they must see a thing if it be before their eyes. . . . And what is here said, which all must feel by their own experience to be true, is more remarkably and necessarily the case with sight than with any other of the senses, for this reason, that the ear is not accustomed to exercise constantly its function of hearing; it is accustomed to stillness, and the occurrence of a sound of any kind whatsoever is apt to awake attention, and be followed with perception, in proportion to the degree of sound; but the eye, during our waking hours, exercises constantly its function of seeing; it is its constant habit; we always, as far as the bodily organ is concerned, see something, and we always see in the same degree, so that the occurrence of sight, as such, to the eye, is only the continuance of its necessary state of action, and awakes no attention whatsoever, except by the particular nature and quality of the sight. And thus, unless the minds of men are particularly directed to the impressions of sight, objects pass perpetually before the eyes without conveying any impression to the brain at all; and so pass actually unseen, not merely unnoticed, but in the full, clear sense of the word, unseen.[39]

Again Ruskin is emphasizing the physical range of sight as a process; the span between seeing nothing and seeing the "things which are" is accomplished through a long evolution, leading the eye to see past habit, emotional distortion, intellectual rhetoric and into the third phase of vision described in "The Pathetic

Fallacy," a vision in which things are seen with the optical precision of a painter.
Ruskin refers to this type of clear vision as "innocence of the eye"; but far from
being an inborn innocence, it is an innocence that is learned through unlearning
visual habits:

> The perception of solid Form is entirely a matter of experience. We *See* nothing but
> flat colors; and it is only by a series of experiments that we find out that a stain
> of black or gray indicates the dark side of a solid substance, or that a faint hue indi-
> cates that the object in which it appears is far away. The whole technical power of
> painting depends on our recovery of what may be called the *innocence of the eye;*
> that is to say, of a sort of childish perception of these flat stains of color, merely as
> such, without consciousness of what they signify,—as a blind man would see them if
> suddenly gifted with sight.

> For instance: when grass is lighted strongly by the sun in certain directions, it is
> turned from green into a peculiar and somewhat dusty-looking yellow. If we had
> been born blind, and were suddenly endowed with sight on a piece of grass thus
> lighted in some parts by the sun, it would appear to us that part of the grass was
> green, and part a dusty yellow (very nearly of the color of primroses); and, if there
> were primroses near, we should think that the sunlighted grass was another mass of
> plants of the same sulphur-yellow color. We should try to gather some of them, and
> then find that the color went away from the grass when we stood between it and the
> sun, but not from the primroses; and by a series of experiments we should find out
> that the sun was really the cause of the color in the one,—not in the other. We go
> through such processes of experiment unconsciously in childhood; and having once
> come to conclusions touching the signification of certain colors, we always suppose
> that we *see* what we only know, and have hardly any consciousness of the real
> aspect of the signs we have learned to interrupt. Very few people have any idea
> that sunlighted grass is yellow.

> Now, a highly accomplished artist has always reduced himself as nearly as possible
> to this condition of infantine sight. He sees the colors of nature exactly as they are,
> and therefore perceives at once in the sunlighted grass the precise relation between
> the two colors that form its shade and light. To him it does not seem shade and
> light, but bluish green barred with gold.[40]

Ruskin's blind man suddenly gifted with sight would have a primal kind of inno-
cence that reduces the world to purely visual facts. Like Baudelaire's imaginary
artist—convalescent in "Le Peintre de la Vie Moderne," the blind man achieves a
level of intensity based on "nouveauté." Baudelaire describes a similar state of
visual innocence as being the condition of an artist "toujours, spirituellement à
l'état du convalescent." The state of perpetual convalescence, the continuation
of childlike freshness, the absence of dulling habit produce the same ideal of
visual perception for Ruskin and Baudelaire: continual optical ecstasy. But
neither Ruskin nor Baudelaire confuses this innocence of the eye with "natural"
vision. As Ruskin points out in "The Pathetic Fallacy," the most natural kind of
seeing, the first degree, is simply the habitual use of the eye, which amounts, in

fact, to seeing nothing. The second level is the poetic-associational method of only half observering what is seen and half projecting an immediate response which distorts the visual stimulus. The third level, the clear vision of plain facts which corresponds with "innocence of the eye," is more sophisticated and less "natural" than the poets' confusion of self with external objects. To see innocently is an art in itself; it is not a spontaneous process but requires the education of the senses. Again the painter serves as a model for the poet, because his art requires the ability to perceive the plain facts, the objective "aspects" of visual phenomena. In *Art and Illusion*, Gombrich uses Ruskin's description of the innocent eye to mark a major change in the history of perception. As Gombrich points out, what Ruskin means by the innocent eye is not to see like a Wordsworthian child of nature, but to see with the trained eye of a painter:

> Ruskin's description itself indicates that the painter can achieve the feat of looking at the visible world while ignoring its meaning only by expelling one interpretation through another. His artist introduces an alternative meaning which is so obvious that it easily eludes description. He sees the meadow, not like an innocent child in terms of light and shade, but like a painter in terms of pigments, green and sulfur yellow. . . . Of course the painter must interpret nature in terms of paint, for how else could he get it on the canvas? But when we say that he must also learn to see it in terms of paint, this may have some interesting consequences that may help us to see the story of visual discoveries in fresh light.[41]

Ruskin's description of this infantine sight is strikingly similar to Baudelaire's description of the "plaisir primitif" of the initial view of Delacroix's canvases. Baudelaire is able to see the painting in terms of pure form and color, in the same way Ruskin is able to see Nature in terms of paint. In both cases the primitive component is the ability to decompose the "subject," of the painting or the natural scene, into purely visual facts. There is a component of artifice involved in this process of "reduction," which is freely admitted by Baudelaire and implicit in Ruskin. The painter must learn to see Nature in terms of its translation into paint; Nature is seen as raw material to be composed and ordered by the eye of the artist. The power of "reducing" Nature to visual facts, is like the power of the child to construct the world from the basis of a sensory *tabula rasa*, which has not been veiled with habit or covered with associations. Ruskin, like Baudelaire, emphasizes that the artist must make a conscious effort to return to the state of visual innocence. As Ruskin puts it, the artist "recovers" innocence of the eye; after a long apprenticeship at his craft he returns to childlike vision with full consciousness of how to use it. In discussing the value of "childishness or innocent susceptibility" Ruskin says:

> When we first look at a subject we get a glimpse of some of the greatest truths about it . . . as we look longer still we gradually return to our first impressions, only with

a full understanding of their mystical and innermost reasons; . . . It is thus eminently in this matter of color. Lay your hand over the page of this book—any child or simple person looking at the hand and book, would perceive, as the main fact of the matter, that a brownish pink thing was laid over a white one. The grand artist comes and tells you that your hand is not pink, and your paper is not white. He shades your fingers and shades your book, and makes you see all manner of starting veins, and projecting muscles, and black hollows, where before you saw nothing but paper and fingers. But got a little farther, and you will get more innocent again; you will find that, when "science has done its worst, two and two still make four"; and that the main and most important facts about your hand, so seen, are, after all, that it has four fingers and a thumb—showing as brownish pink things on white paper.[42]

Baudelaire similarly finds that the artist as a child has already begun to see in terms of paint, but only by "returning" to innocent perception with the control and will and technique of an adult artist is the value of childlike pictorial vision able to be utilized and turned into works of art:

Well, convalescence is like a return to childhood. The convalescent enjoys, to the highest degree, like the child, the faculty of being vividly interested in things, even the most trivial in appearance. Let us return, if it is possible, by a retrospective effort of the imagination, towards our youngest, our earliest impressions, and we will recognize that they have a singular relationship to the impressions, so vividly colored, that we received later following a physical illness, provided that this illness had left, our mental (spirituelles) faculties, pure and intact. The child sees everything in its newness; he is always intoxicated. Nothing more resembles what one calls inspiration, than the joy with which the child absorbs form and color. I will dare to go even further; I affirm that inspiration has some rapport with congestion, and thought every sublime thought is accompanied by a nervous convulsion, more or less strong, which reverberates even into the brain. The man of genius has solid nerves; the child's are feeble. With the one, reason has taken a considerable place; with the other, sensibility occupies almost the total being. But genius is nothing more than *childhood recovered by will,* childhood endowed now, in order to express itself, with virile organs and an analytic mind which permits the genius to order the sum of material amassed involuntarily. It is to this profound and joyous curiosity that one must attribute the fixed and animally ecstatic eye of children before the new, whatever it is, face or landscape, light, gold, colors, shimmering materials, enchantment of beauty enhanced by cosmetics. One of my friends said to me one day, that when he was very little, he watched his father shaving, and that he contemplated with astonishment mixed with delight, the muscles of the arm, the gradation of color of the skin nuanced with pink and yellow, and the bluish network of veins. The painting of exterior life had already penetrated him with respect and seized his brain. Already form obsessed him and possessed him. Predestination revealed itself precociously early. The *damnation* had taken place. Do I need to add that this child is a famous painter today?[43]

This process of "recovering" innocence, "l'enfance retrouvée à volonté," involves a balance between optical purity and the willpower of the artist. As

Ruskin says in "The Pathetic Fallacy," in discussing the third power of vision, in which feeling is subordinated to "pure fact":

> A poet is great, first in proportion to the strength of his passion, and then, that strength being granted, in proportion to his government of it.[44]

Baudelaire also finds the relationship of passion to control the distinguishing aspect of Delacroix that separates him from the weaker class of Romantic artists, like Musset. According to Baudelaire, Delacroix "was passionately in love with passion, and coldly determined to find the means to express passion in the most visible manner."[45] Delacroix is Baudelaire's prototype for the highest type of artistic genius which always manifests this "double caractère":

> Une passion immense, doublée
> d'une volonté formidable, tel était
> l'homme.[46]
>
> (An immense passion doubled with a
> formidable will; such is the man.)

Both Ruskin and Baudelaire see the function of the will as refining upon Nature, purifying vision. The concept of willed vision is not limited to Turner or Delacroix, but applies to all great writers as well as to all great painters. The will of the artist is the force of consciousness; without the will art would be a matter of unthinking production, purely "mechanical" for Ruskin, like photography, and "purement végétale" for Baudelaire, as uncontrolled as the rank overproduction of Nature. The addition of the concept of consciousness of process separates both Ruskin and Baudelaire from Romantic doctrine based on the idea of art derived spontaneously from natural sources of inspiration. To be conscious of the process of seeing, to be conscious of the stages and degrees of perception, alters the process of seeing and perceiving by introducing the component of will and control. Baudelaire's dandy believes that he can will his own existence into shape through his constant awareness of the process of "being"; thus a willed "consciousness" of self modifies the act of living at every moment. In a similar way Ruskin's consciousness of the process of seeing adds a new dimension to sight; the innocent eye is conscious of being innocent. When Ruskin wills himself to see the "pure facts" of Nature he tries to clarify his vision by consciously reducing the element of "self" which interposes between viewer and object. He controls the degree of clarity by pushing the eye beyond its normal boundaries and limitations. In a sense this consciousness of process helps determine how and what Ruskin is able to see, but the final goal is to make the eye transparent, to will the personal self away, to will the self absorbed into the perceived object, to purify consciousness so that it coincides with what is seen. On the contrary,

when Wordsworth "half creates" what he sees in Nature, the perception is created by an unedited emotional response. Perception is controlled by emotion, and while the stimulus remains, the consciousness of the sensory process itself is forgotten, lost in the exploration of the poet's feelings and psychology. While Wordsworth turns to the personal self, the interiorized perception of himself, "the poet," Ruskin places himself in reverent subjection to the painter's vision of the endless, external world and the process of seeing that world with increasing, magnifying, accelerating clarity.

When we return to the naturalist ideal it is apparent that Ruskin intends for both painter and poet to attain "ideality" through the clear perception of "pure facts":

> And the whole power, whether of painter or poet, to describe rightly what we call an ideal thing, depends upon it being thus, to him, not an ideal, but a real thing. No man ever did or ever will work well, but either from actual sight or sight of faith . . .[47]

What Ruskin means by "sight of faith" is in fact a kind of acute mental vision that approaches physical actuality, but that aspect of the naturalist ideal will be discussed further on. What Ruskin is trying to justify is how the close observation of visible facts can yield a "moral" meaning, how "the art which represents things simply as they are, can be called ideal at all."[48] The key to the concept of the naturalist ideal is that the natural object is in itself a sufficient ideal, but the ability to perceive the object in its true state involves a certain "mental arrangement." As Ruskin puts it, the naturalist ideal is "naturalist because studied from Nature and ideal because it is mentally arranged in a certain manner."[49] The first level of mental arrangement for Ruskin is the mental reorganization necessary in order to see with an "innocent eye." The eye must be brought through two phases of education, both of which involve a recognition of psychological conditioning: first the mental habits which govern optics must be "cleared" and second, the automatic confusion of feeling with seeing must be distinguished into separate components. When the idea of the "innocent eye" is applied to writing, it is apparent that recording "plain facts" is not a spontaneous operation, but requires its own degree of artifice. The writer who attempts to capture "reality," to make the ideal manifest in "things as they are" must use a great deal of art to simplify and exalt plain fact at the same time. In *Modern Painters* Ruskin often begins the process of cleansing the senses by writing in a basic style that approaches scientific precision—a kind of optical prose that is used primarily to make the reader see what he *doesn't* see, because of visual habits. The reader is thus introduced to reading about the significance of "pure facts" on a stylistic level that is as plain as possible.

For Ruskin, perception begins with an awareness of the physical mechanism of the eye itself. He tries to make the reader understand, with minutely

scientific prose, the processes involved in seeing. His arguments are often supple-
mented and reinforced with actual scientific proofs: simple experiments, home-
made instruments, graphs, diagrams and charts which train the reader's
"innocent eye" to register the various information provided by the "science of
aspects." In trying to show how "the eye like any other lens" adapts its focus
Ruskin asks the reader to:

> Look at the bars of your window-frame, so as to get a clear image of their lines and
> form, and you cannot, while your eye is fixed on them, perceive anything but the
> most indistinct and shadowy images of whatever objects may be visible beyond.
> But fix your eyes on those objects, so as to see them clearly, and though they are
> just beyond and apparently beside the window-frame, that frame will only be felt
> or seen as a vague, flitting, obscure interruption to whatever is perceived beyond it.

Or again in illustration of the same principle, he suggests that the reader

> Go to the edge of a pond, in a perfectly calm day, at some place where there is
> duckweed floating on the surface—not thick, but a leaf here and there. Now, you
> may either see in the water the reflection of the sky, or you may see the duckweed;
> but you cannot, by any effort, see both together.[50]

The impact of these demonstrations is to shake loose the reader's visual habits
so that Ruskin can reconstruct the world of visible facts for him. The impact of
the prose is to shatter the reader's complacency with disarming simplicity. The
writing is unadorned, and yet it makes the visual world seem intensely new, by
limiting the focus to plain facts and dispensing with all other rhetoric. Ruskin's
descriptive powers are used on this first level of scientific plainness to clear the
visual ground, to eliminate the preconceptions of habit and attune the eye to
the subtleties of the visual manifold. Ruskin frequently modulates from this
plain prose to a more elaborate descriptive effort, without ever abandoning the
grasp of precise visual data. In this case the simple visual phenomenon of the
mutual cancellation of surface and depth perception is used to form the basis for
a more complex passage which Ruskin attempts a full rendering of his percep-
tion of this visual effect in Turner's painting:

> Hence it appears, that whenever we see plain reflections of comparatively distant
> objects, in near water, we cannot possibly see the surface, and vice versa; so that
> when in a painting we give the reflections with the same clearness with which they
> are visible in nature, we presuppose the effort of the eye to look under the surface,
> and, of course, destroy the surface, and induce an effect of clearness which, perhaps,
> the artist has not particularly wished to attain, but which he has found himself forced
> into, by his reflections, in spite of himself. And the reason of this effect of clearness
> appearing preternatural is, that people are not in the habit of looking at water with
> the distant focus adapted to the reflections, unless by particular effort. We invariably,
> under ordinary circumstances, use the surface focus; and, in consequence, receive

nothing more than a vague and confused impression of the reflected colors and lines, however clearly, calmly, and vigorously all may be defined underneath, if we choose to look for them. We do not look for them, but glide along over the surface, catching only playing light and capricious color for evidence of reflection, except where we come to images of objects close to the surface, which the surface focus is of course adapted to receive; and these we see clearly, as of the weeds on the shore, or of sticks rising out of the water, etc. Hence, the ordinary effect of water is only to be rendered by giving the reflections of the margin clear and distinct (so clear they usually are in nature, that it is impossible to tell where the water begins); but the moment we touch the reflection of distant objects, as of high trees or clouds, that instant we must become vague and uncertain in drawing, and, though vivid in color and light as the object itself, quite indistinct in form and feature. If we take such a piece of water as that in the foreground of Turner's *Chateau of Prince Albert,* the first impression from it is,—"What a wide surface." We glide over it a quarter of a mile into the picture before we know where we are, and yet the water is as calm and crystalline as a mirror, but we are not allowed to tumble into it, and gasp for breath as we go down,—we are kept upon the surface, though that surface is flashing and radiant with every hue of cloud, and sun, and sky, and foliage. But the secret is in the drawing of these reflections. We cannot tell when we look at them and for them, what they mean. They have all character, and are evidently reflections of something definite and determined; but yet they are all uncertain and inexplicable; playing color and palpitating shade, which, though we recognize in an instant for images of something, and feel that the water is bright, and lovely, and calm, we cannot penetrate nor interpret: we are not allowed to go down to them, and we repose, as we should in nature, upon the lustre of the level surface. It is in this power of saying everything, and yet saying nothing too plainly, that the perfection of art here, as in all other cases, consists.[51]

As Ruskin clearly indicates, the quality of the painted surface has "said something." A certain "truth of Nature" has been perceived by the educated senses, and transmitted from painter to writer to reader, but the "truth" has no element of the morally didactic, no particular emotional associations. The "truth" which has been made so impressive by Ruskin's language is a purely visual truth, "a pure fact," and what Ruskin is asserting by focussing his verbal energy on Turner's "surface," is that pure perception has a value in itself.

But this perception, unattached to a poetic psychology, is not as simple as it seems. The perception of the natural laws of reflection is neither natural nor automatic; as Ruskin reminds us throughout *Modern Painters,* true perception is impossible for the "uncultivated eye." True perception, or "seeing clearly" is the result of training; seeing the "facts" of reflection is already an artistic process, a process which involves subordinating the "natural" impulse of the self to impose a psychological meaning on the visual facts. In the same way Baudelaire's ability to see Delacroix's painting first of all as pure color harmony involves a subordination of the natural impulse to look for the subject or narrative content. In both cases the cleansing of sight, removing the conventional or habitual interpretation, is a negative and positive process at the same time; as

content is "reduced" to visual facts, the facts themselves become more promi-
nent, rich, intense, clear and self-sufficient. For a poet like Wordsworth, reduc-
ing content to visual "aspects" would seem a negative process; for a poet like
Valéry, who comes later in the course of Symbolism, the ability to attain "pure
perception," unmediated by the poet's personality, would seem a positive
goal.[52]

As Ruskin tries to show in his description, Turner's ability to record plain
fact in paint is not simple or spontaneous either. His art is in getting down the
record of the optical experience with as little rhetoric as possible. Compared
to the landscapes of Claude and Poussin, who served Turner as early models,
Turner's mature method is closer to the stated aim of the Impressionists: to
paint only what the eye can see. Turner moved beyond the literary conventions
of the "picturesque," beyond the formal rules of composition and coloring
suggested by the Academy, to paint according to his own rigorous standard of
optical truth. Turner discarded the conventions that governed painting more
completely than any of his contemporaries. Constable may have refused to
paint grass the color of a brown fiddle, but Turner, according to the critics,
painted scenes that were totally unrecognizable. In fact Turner chooses subjects
that are progressively more abstract, especially seascapes, painted at sea, as
Ruskin emphasizes, which are primarily large spaces of air and water, containing
spaces for light. As the subject of Turner's painting is purified, as the subject
becomes light itself, Turner seems to feel obliged, in the late canvases, to include
allegorical figures, almost indistinguishable, which people the bottoms and
corners of the pictures, overwhelmed by the masses of light and color which
are the true "subject." But as Ruskin points out, these seemingly abstract paint-
ings of light effects are based on an absolute accuracy to optical fact. Ruskin
relates the incident of Turner strapping himself to a mast in order to see as
clearly as possible the magnificently abstract spectacle of a major storm at sea,
which he renders in the painting "Snowstorm: Steamboat Making Signals." As
John Rosenberg puts it, Turner's "radical fidelity" was misinterpreted by his
critics, who called this painting a "mass of soapsuds and whitewash."[53] Turner's
fidelity is *radical:* the idea of painting exactly what the eye sees strikes at the
root of historical artistic convention by uncovering a new level of optical purity
open to the educated eye. The "radical fidelity" of the snowstorm at sea was too
extreme for the critics; the scientific naturalism is so acute that it seems to
pass over into its opposite and become expressionistic, mere "soapsuds and
whitewash." But it is not only in such extreme examples that Turner's radical
fidelity seems new; in Ruskin's passage above on the *Chateau of Prince Albert,*
the whole interest is in a simple *flat* surface, and the way the reflections are
painted so that they appear precise and obscure at the same time. Turner goes
beyond the Romantic *range* of landscape which is usually governed by human
associations. In the *Chateau of Prince Albert,* the subject of broken light and flat

surface is much closer to the Impressionist choise of a visual field than to Constable's meadows, streams, and pastures. But Turner actually goes beyond the Impressionists, beyond Monet's "Nympheas" in reducing the subject of a painting to light itself, light filling space and reflecting from surfaces. As Ruskin is the first to see, Turner's "science of aspects" is radical in its approach to landscape; Turner's optical precision is "modern" in comparison to the conventions of poetic association that condition Romantic ideas of landscape, which are just as removed from "pure facts" as the classical formulations of Claude or Poussin. Ruskin feels that a painter like Constable tends to distort landscape, like Wordsworth or Coleridge, by his own projections of what harmonious scenery *ought* to look like, rather than painting from the facts like Turner. In a section on "Finish" in *Modern Painters* 3, Ruskin uses Constable as a foil for Turner (having overused Claude, he feels), in comparing the rendering of tree trunks. Constable, Ruskin says, is a perfect example of a "weak imagination"; he paints the tree the way he *thinks* it should look, while Turner, with stronger powers, dares to paint what is actually there.

> It is worth while to turn back to the description of the uninventive painter at work on a tree [Vol. II. chapter on Imaginative Association, p. 11], for this trunk of Constable's is curiously illustrative of it. One can almost see him, first bending it to the right; then, having gone long enough to the right, turning to the left; then, having gone long enough to the left, away to the right again; then dividing it; and "because there is another tree in the picture with two long branches (in this case there really is), he knows that this ought to have three or four, which must undulate or go backwards and forwards." &c., &c.
>
> Then study the bit of Turner work: note first its quietness, unattractiveness, apparent carelessness whether you look at it or not; next note the subtle curvatures within the narrowest limits, and, when it branches, the unexpected, out of the way things it does, just what nobody could have thought of its doing; shooting out like a letter Y, with a nearly straight branch, and then correcting its stiffness with a zig-zag behind, so that the boughs, ugly individually, are beautiful in unison. (In what I have hereafter to say about trees, I shall need to dwell much on this character of unexpectedness. A bough is never drawn rightly if it is not wayward, so that although, as just now said, quiet at first, not caring to be looked at, the moment it is looked at, it seems bent on astonishing you, and doing the last things you expect it to do.) But our present purpose is only to note the finish of the Turner curves, which, though they seem straight and stiff at first, are, when you look long, seen to be all tremulous, perpetually wavering first, are, when you look long, seen to be all tremulous, perpetually wavering along every edge into endless melody of change. This is finish in line, in exactly the same sense that a fine melody is finished in the association of its notes. [54]

As Ruskin tries to point out, the only difference between Constable and Claude is that the Romantic painter uses freer brush strokes; the difference between both and Turner is the difference between painting according to mental conventions and painting according to the precise observation of the trained eye.

Ruskin tries to make the reader see that Turner's precision, his respect for optical fact, makes his painting both more accurate and more sublime, more natural and more ideal, than the work of either Constable or Claude, in which the painter's ideas of form are imposed over the pure visual facts themselves.

Ruskin's fascination with plain optical data is reflected in his description of Turner's flat surface in the *Chateau of Prince Albert* passage. The passage of prose has the same kind of deceptive simplicity as the painting it describes; Ruskin has cultivated a particular kind of "innocence" as a writer that enables him to translate "pure facts" into words and concentrate the reader's interest in the visual "aspects" alone. Just as there is art and training involved in seeing and painting with an innocent eye, there is a corresponding verbal art in recording plain fact, without shifting the center of attention back to the observer. In a recent study on Ruskin, by Patricia Ball,[55] there is a comparison made between a typical Romantic descriptive passage in Dorothy Wordsworth's journals of the Falls at Shaffhausen and Ruskin's account. As Ms. Ball points out, Dorothy's description almost immediately converts the spectacle into her own response; she departs from precise observation to concentrate on her emotions of "awe and fear." Ruskin's description, however, manages to condense the feeling of awe into the visible aspects alone; the mass and volume of water, the velocity and depth of the plunge are facts that speak for themselves. The technique of subordinating the spectator's emotions, of making the visible facts "speak," is far more complex than the more natural impulse to *state* the emotional response. Ms. Ball's study goes on to show that Hopkins specifically apprenticed himself to Ruskin's techniques, by keeping notebooks in which he attempted to record his impressions of Nature as accurately as possible in prose. Ms. Ball's book confirms the findings of a major study on the development of poetic imagery from Romanticism past Ruskin: Josephine Miles' "The Pathetic Fallacy in the Nineteenth Century." What Miss Miles so precisely documents is the progressive movement towards greater accuracy and precision in poetic imagery, which, she feels, is partially the result of the poets' response to Ruskin's optical criteria. The influence of Ruskin's demand for precision is more diffuse in poetry than in painting, where his ideas are taken quite literally by Holman Hunt and the Pre-Raphaelite Brotherhood. But whether Ruskin specifically causes the movement towards objectivity in poetic description, or whether he simply reinforces a dominant trend, there is no doubt that his optical prose contributes to the change. At the end of the century, for example, T.E. Hulme's call for "scientific" dryness, for "precise description," is exactly the kind of criterion that Ruskin had established for poetry in *Modern Painters*. When Hulme describes the artist, he echoes Ruskin both in tone and substance:

> I always think that the fundamental process at the back of all the arts might be represented by the following metaphor. You know what I call architects' curves—

flat pieces of wood with all different kinds of curvature. By a suitable selection from
these you can draw approximately any curve you like. The artist I take to be a man
who simply can't bear the idea of that 'approximately.' He will get the exact curve of
what he sees whether it be an object or an idea in the mind.[56]

The criterion of exactness is for Hulme, as well as Ruskin, an aesthetic goal to
be achieved by a skilled writer; in both cases the concept of precision is based
on a visual model for the verbal image. As Hulme puts it, poetry "always en-
deavors to arrest you and to make you continuously see a physical thing, to
prevent you gliding through an abstract process." This is of course directly
parallel to Ruskin's definition of the naturalist ideal which applies to literature
as well as painting; the aim is to make the reader see clearly, to see the ideal
aspect of things as they are, and the generalization or abstraction of the "specific
character" of experience is prevented by the fact that, for Ruskin, all great
artists rely on visible reality as a foundation; "whether actual sight or mental
sight," the result is the same. Thus Dorothy Wordsworth glides into an abstract
process when she ceases to look at the waterfall and begins to narrate her emo-
tional response. But when Ruskin glides into Turner's painting of the *Chateau of
Prince Albert,* he concentrates his verbal skill on visual particulars, and elevates
plain fact to poetry without abandoning the accuracy of his optical focus.

First of all there is a certain complexity added to Ruskin's descriptive
prose, because the object being described is in itself a description; Ruskin is
writing about the translation of a natural landscape into paint. The object to
be seen clearly, in this case, is another work of art, which itself embodies an act
of perception. But curiously, as Ruskin tends to see Nature in terms of painting,
there is very little difference in the technical qualities of his prose, whether the
object is landscape, painting or architecture. The difference is that if the object,
as in this case, is a painting, Ruskin endeavors to see it clearly as a transposi-
tion into paint; the "innocent eye" of the art critic is trained to see a painting as
a representation and as medium at the same time, to see the subject and the
rendering simultaneously. Ruskin's prose is often a complex recognition of the
overlay of art on art: in the passages on reflection, the *Nottingham Castle,* or
the *Chateau of Prince Albert,* Ruskin is writing about Turner's perception and
the translation of this perception into paint, and at the same time he is trans-
lating his own perception of the relationship between these components into
words. Thus seeing a painting clearly is a complex operation and recording it
plainly even more so.

Ruskin realizes that the painter can never represent all there is to see in
Nature in any given space, on the more limited scale of his canvas; similarly the
art critic can never translate the fullness of a painting into words (Chapter 1,
pp. 14-16). Just as the painter's eye is selective, just as Turner manages, in the
Chateau of Prince Albert, to suggest the full complexity of reflections in water
by masterful brushstrokes, Ruskin's verbal art consists in rendering his

impression of a painting, or a landscape, with selected details. But Ruskin's selection, his arrangement of words, his art of prose is governed by the same law he applies to the painter and the poet; render the vision clearly, accurately with as little interference from "self" as possible. A major aspect of Ruskin's fidelity to his own law of precision is the fact that he is minutely aware of the various spatial and temporal components that go into making an "impression." For Ruskin, visual impressions are never static; instead they are treated as a perceptual process, a movement in time from an initial view, through various stages, to a final resting place. The movement is not in fact stopped; Ruskin simply allows the eye to turn away. As he says throughout *Modern Painters,* WE NEVER SEE ANYTHING CLEARLY, and the process of seeing more clearly is an infinite continuation. Ruskin tends to select an arbitrary span, a particular segment along the curve of perception, which he follows with accuracy; the culmination of the act of seeing is not so much an exhaustion of the visual field as it is a recognition of overabundance.

In the *Chateau of Prince Albert* passage Ruskin's impression begins with an overall, initial view, a "first impression" of the wideness of the surface. Then Ruskin immediately begins to animate the act of perception by using active verbs to carry the motion of seeing forward, as the observer is carried by Turner's methods into the frame.

> We glide over it a quarter of a mile into the picture before we know where we are, and yet the water is as calm and crystalline as a mirror, but we are not allowed to tumble into it, and gasp for breath as we go down . . .

Before the reader, in fact, knows where he is, on the lake in front of the Chateau, or in Turner's painting, Ruskin manages to activate the process of seeing so that it acquires the same physical actuality as rowing into the lake. Ruskin imputes depth to the canvas ("we are not allowed to tumble into it") in order to emphasize the effect of flatness that Turner has achieved. Ruskin moves back and forth between Nature and the canvas with bewildering rapidity, by deliberately using words with multiple points of reference. The "surface" is at first painted, but as we glide over it the surface is transformed into water, which we are in danger of falling through, until rescued by Turner, whose ability to keep the painted surface looking flat returns Ruskin, with the reader, back to the surface of the canvas. Ruskin intentionally tries to keep the boundary between Nature and art in fluctuation, because his experience of the painting is just as real and concrete to him as the visual experience of three-dimensional landscape. For Ruskin perception is not a detached look from outside, but involves a penetration of the object perceived, which in this case amounts to a sense of entering into the canvas. Just as the reader is acquiring a sense of location, of having been taken through the painting to the actual lake, Ruskin establishes again a definite position outside the canvas.

. . . we are kept upon the surface, though that surface is flashing and radiant with every hue of cloud, and sun, and sky, and foliage. But the secret is in the drawing of these reflections. We cannot tell when we look at them and for them, what they mean.

Ruskin moves back into the painting again in his description, by reactivating the painted surface, so that imperceptibly the reader is made to feel that Turner's canvas is in motion, "playing colour and palpitating shade," and he is again faced with real water and real uncertainty as to the nature of the reflections. Part of Ruskin's technique is to emphasize the present tense of the visual experience ("though we recognize them in an instant") and to keep the reader aware of the continual activity involved in seeing. In this case Ruskin has followed the curve of perception from the initial view of the flat surface through a number of separate observations which contrast surface and depth, stillness and motion in order to concentrate on the perpetually changing reflections. Ruskin tries to show that Turner's skill is so great that the painted reflections seem to move and hover on the verge of distinctness, fade back into vagueness, constantly appear to "flash" with different colors; the visual precision in this case is the ability to record a continuously changing spectacle in paint and the effect of Ruskin's prose is simply to point out the kinetic effect of Turner's painting. But the passage finally ends with the reader "resting" on the painted surface, as he would on the "natural" surface; the perception of the activity of the reflections is replaced by the feeling of the overall flatness again, the wide "lustre of the level surface." The perception which has moved from reflections to surface could easily move back again, but Ruskin chooses to end the passage with a visual "rest" on the original vision of wideness and flatness, only expanded to include the perception of the opposite qualities of the agitated reflections. Ruskin's "impression" is the sum total of this process of perception.

The perceptual process is the organizing structure of the description; instead of trying to enumerate the total number of visible facts that go to make up a painting, a landscape, or a building, Ruskin uses language to approximate the visual experience, the precise rhythm of seeing that goes into making up an "impression." For Ruskin, all visual impressions, including his own perceptions of landscape or architecture, are modelled on the perceptual process implicit in viewing a painting; as in the description of the *Chateau of Prince Albert* there is an initial, simultaneous "first impression," then a temporal movement through particular details culminating in a final point of stasis. Ruskin's perception includes an awareness of the condensation of time into space, the implicit movement frozen in the canvas, which is reactivated by the eye of the observer. This perceptual model is used to organize the otherwise endless process of seeing more clearly; an impression for Ruskin involves choosing a selected span and an arbitrary degree of clarity. But the significant factor for Ruskin is that an

impression is a *clear* rendering, a *clear* reception of the object. The verbal rendering is disciplined by the same law that pertains to painting: no projection or interpretation; render the "pure facts" as plainly as possible.

This point is important because it distinguishes Ruskin's type of impressionism from the frequent implication of the word to mean a personal idiosyncratic view; for Ruskin an impression is as impersonal as possible; the observer becomes a clear lens for the intensification of the object. In reading Ruskin's descriptive prose, it is helpful to keep this "clear," "scientific" side of his impressionism in mind. As an example of slight confusion over this fact, Robert Stange has written a short analysis of the position of the prose of art criticism in relation to the artifact, and lumps Ruskin and Pater together as "impressionists." Stange argues that in Ruskin's description of Tintoretto's "The Massacre of the Innocents" the "subject" of the description is Ruskin's response, not the painting itself and that because Ruskin animates the painting, with motion and sound, he is making it literary, a kind of "impressionistic" narrative; a separate artifact. Stange is right in identifying the "subject" of the passage as Ruskin's impression, but he oversimplifies, I feel, in suggesting that this impression is independent of the artifact it describes; he does not seem aware of Ruskin's aim, to render his impression of the painting as clearly and precisely as possible. Stange interprets Ruskin's rhythmic prose account of the "action" in the painting to mean that the description has departed from the "formal" aspects of the painting and converted it into "literature":

> Ruskin does not offer an account of the formal elements of the painting; instead he concentrates on its affective aspects and provides the reader with cues to an emotional response. He pointedly ascribes to the work precisely those features which are impossible to painting: literary comparison, movement in space, extension in time, and even sound.[57]

Stange omits to supply the full context of the quotation and thereby refers to Ruskin's verbal techniques, without allowing them their full implication. Ruskin is using Tintoretto's painting as an example of the "imagination penetrative," the power of the painter or poet to seize the inner truth of a subject. In this case Ruskin is trying to show that Tintoretto achieves his full horrific power, by deliberately *not* painting facial expressions, but relying solely on the rhythmic organization of the figures, the overall effect of the banded shadows, and the contrast of motion with a still point as central focus. Stange entirely misses the visual basis for the description and the fact that Ruskin's rendition of the "narrative" is written with an awareness of its pictorial nature. Ruskin prefaces the passage, which indeed classifies as a set piece, a purple panel, with this comment:

I have before alluded, Sect. I. Chap. XIV., to the painfulness of Raffaelle's treatment of the massacre of the innocents. Fuseli affirms of it that, "in dramatic gradation he disclosed all the mother through every image of pity and of terror." If this be so, I think the philosophical spirit has prevailed over the imaginative. The imagination never errs, it sees all that is, and all the relations and bearings of it, but it would not have confused the mortal frenzy of maternal terror with various development of maternal character. Fear, rage, and agony, at their utmost pitch, sweep away all character: humanity itself would be lost in maternity, the woman would become the mere personification of animal fury or fear. For this reason all the ordinary representations of this subject are, I think, false and cold: the artist has not heard the shrieks, nor mingled with the fugitives, he has sat down in his study to twist features methodically, and philosophize over insanity. Not so Tintoret. Knowing or feeling, that the expression of the human face was in such circumstances not to be rendered, and that the effort could only end in an ugly falsehood, he denies himself all aid from the features, he feels that if he is to place himself or us in the midst of that maddened multitude, there can be no time allowed for watching expression.[58]

Ruskin's passage that follows is indeed literature, but literature controlled by the analogy to painting and conditioned by the attempt to energize visual perception. In this case Ruskin is dealing with the painting of a religious historical subject, rather than a landscape, so there is, in fact, already a "story" behind the painting. In describing a painting that has built-in literary content, Ruskin avoids a simple reliance on "story" and tries to underline the pictorial facts of Tintoretto's rendition. The most salient facts for Ruskin are the renunciation of facial expression and the subordination of emotive elements to the chiaroscuro, the overall relation of masses and colors, and the specific positioning of figures. As Ruskin has said a few paragraphs previously, Tintoretto's

> . . . intensity of imagination is such that there is not the commonest subject to which he will not attach a range of suggestiveness almost limitless, not a stone, leaf, or shadow, nor anything so small, but he will give it meaning and oracular voice.[59]

In "The Massacre of the Innocents" the very absence of expression in the faces is significant, and all of the overt bloodshed has been subtly transferred into the ominous red shadows:

> . . . there is no blood, no stabbing or cutting, but there is an awful substitute for these in the chiaroscuro. The scene is the outer vestibule of a palace, the slippery marble floor is fearfully barred across by sanguine shadows, so that our eyes seem to become bloodshot and strained with strange horror and deadly vision; a lake of life before them, like the burning sea of the doomed Moabite on the water that came by the way of Edom; a huge flight of stairs, without parapet, descends on the left; down this rush a crowd of women mixed with the murderers; the child in the arms of one has been seized by the limbs, she hurls herself over the edge, and falls head down most, dragging the child out of the grasp by her weight;—she will be dashed dead in a second: two others are farther in flight, they reach the edge of a deep river,—the water is beat into a hollow by the force of their plunge;—close to us is the great

struggle, a heap of the mothers entangled in one mortal writhe with each other and the swords, one of the murderers dashed down and crushed beneath them, the sword of another caught by the blade and dragged at by a woman's naked hand; the youngest and fairest of the women, her child just torn away from a death grasp and clasped to her breast with the grip of a steel vice, falls backwards helplessly over the heap, right on the sword points; all knit together and hurled down in one hopeless, frenzied, furious abandonment of body and soul in the effort to save.[60]

After setting up the overall impression, Ruskin begins to describe the individual positions of the figures, and in moving around the canvas, down the main diagonal, into the background and then into foreground again, he suggests the complicated rhythm of the relation of masses. As Ruskin accounts for the various figures, he describes them in the present tense, as indeed Tintoretto has poised them on the verge of things about to happen, actions caught at mid-point. Again Stange takes the "series of active verbs" to imply that painting has been converted into literature: the active verbs "suggest a frenzied movement in space which the writer has supplied to Tintoretto's canvas . . . It may be unnecessary to point out that . . . Ruskin has endowed a painting with the function that Lessing reserved for poetry—the power of depicting action in time." The interpretation of Lessing is too restrictive; surely anyone who has looked at a large Tintoretto would not imagine painting to be incapable of producing a sense of motion, even violent movement. Ruskin has not supplied a literary element to the canvas which was not there before; he is simply trying to convey the process of perception, his impression of the energetic activity, an effect that Tintoretto has painted into the picture. What Lessing has actually said is that painting is inherently spatial, and literature temporal; therefore painting will always be working with or against the limitation of space, and Ruskin's literary rendering of the painting reflects the tension between motion and stasis that is so dominant an aspect of Tintoretto's style. Ruskin's use of the present tense shows his awareness of Tintoretto's effort to freeze the figures at significant moments: the two women in the background just barely "reach the edge of a deep river,— the water is beat into a hollow by the force of their plunge." Tintoretto, like Turner, has the power to state a temporal condition within the static confines of his art. For Ruskin's trained eye, Turner's landscapes are so refined that a single curve in the painting of a stream can describe its temporal extension beyond the frame:

> . . . Turner seizes on these curved lines of the torrent (which) tell us how far the torrent has been flowing before we see it . . . thus the moment we see one of its curves over a stone in the foreground, we know how far it has come and how fiercely.[61]

In describing a painting with a narrative subject like the *Massacre of the Innocents* Ruskin shows restraint by staying with the exact "frame" of the narrative

that Tintoretto has frozen, by stating the visible facts as they are seen in the present tense of painting. Ruskin only passes beyond the visible facts once, when he attempts to sum up the effect of the whole group of actions taken together, the complex horror of this rhythmic mass of "frenzied" humanity. The effect which goes beyond the frame is purely Ruskin's imagination, shrieks and rending marble, but he returns immediately from this departure, to highlight the visual focal point of the entire composition, a static, expressionless shadow, a heap of clothes, which is, for Ruskin, a crowning instance of Tintoretto's ability to endow the insignificant with an "oracular voice."

> Their shrieks ring in our ears till the marble seems rending around us, but far back, at the bottom of the stairs, there is something in the shadow like a leap of clothes. It is a woman, sitting quiet,—quite quiet—still as any stone, she looks down stead-fastly on her dead child, laid along on the floor before her, and her hand is pressed softly upon her brow.[62]

The final visual "rest" in the description corresponds to the point of greatest intensity in the composition. The static figure is more emblematic of grief than the still writhing mothers: the lack of motion serves as the point of culmination for the rhythm that Ruskin has been describing, and the verbal rendering follows the principles of pictorial organization. Far from departing from the "formal elements" of the painting, Ruskin has duplicated those formal aspects in verbal art, so that the composition of his paragraph follows the perceptual process that Tintoretto has built into his canvas.

Ruskin's "impression" of the painting is an attempt to be clear, precise and intense at the same time: to magnify the effect of the painting without departing from the "pure facts" contained on the canvas. The breathless rhythm of the passage describing the furious activity of the massacre reflects a visual rhythm, things happening simultaneously all over the canvas in the present tense, not the narrative rhythm of a story unfolding in time. As this activity clears away to reveal the motionless woman in the background, Ruskin imi-tates Tintoretto's design by using the still figure as the focal point in his para-graph, which casts a retrospective organization over the previous words as the entire effort at animation is resolved into stasis. Again it is important to empha-size the context of Ruskin's verbal painting; it is used as an example of the "imagination penetrative," the power of the artist to get the center of his material, to grasp it and see it from the inside out. This ability to pierce through to the "central fiery heart," "the very inmost soul" is Ruskin's measure of the true artist, whether painter or writer:

> It may seem to the reader that I am incorrect in calling this penetrating, posses-sion-taking faculty, imagination. Be it so, the name is of little consequence; the faculty itself, called by what name we will, I insist upon as the highest intellectual

power of man. There is no reasoning in it, it works not by algebra, nor by integral calculus, it is a piercing, Pholas-like mind's tongue that works and tastes into the very rock heart, no matter what be the subject submitted to it, substance or spirit, all is alike, divided asunder, joint and marrow, whatever utmost truth, life, principle, it has, laid bare, and that which has no truth, life, nor principle, dissipated into its original smoke at a touch. The whispers at men's ears it lifts into visible angels. Vials that have lain sealed in the deep sea a thousand years it unseals, and brings out of them Genii.

Every great conception of poet or painter is held and treated by this faculty. Every character that is so much as touched by men like Aeschylus, Homer, Dante, or Shakespeare, is by them held by the heart; and every circumstance or sentence of their being, speaking, or seeming, is seized by process from within, and is referred to that inner secret spring of which the hold is never lost for an instant; so that every sentence, as it has been thought out from the heart, opens for us a way down to the heart, leads us to the centre, and then leaves us to gather what more we may . . . [63]

Just as the painter seizes the "ruling form" of objects by penetrating to the interior, understanding the form from the inside out, the writer who "sees the heart and inner nature" will be infallibly more powerful in recording his vision than the writer who only observes in a detached way, who doesn't work from inside" his subject. As Ruskin points out, there are corollary aspects to the distinction between the imagination which penetrates to the interior, and "fancy" which merely observes from the outside—corollary aspects which have to do with time. An "essential difference" between imagination and fancy is that:

. . . the imagination being at the heart of things, poises herself there, and is still, quiet, and brooding; comprehending all around her with her fixed look, but the fancy staying at the outside of things, cannot see them all at once, but runs hither and thither, and round and about to see more and more, bounding merrily from point to point, and glittering here and there, but necessarily always settling, if she settle at all, on a point only, never embracing the whole. [64]

. . . Now these differences between the imagination and the fancy hold, not only in the way they lay hold of separate conceptions, but even in the points they occupy of time, for the fancy loves to run hither and thither in time, and to follow long chains of circumstances from link to link; but the imagination, if it may, gets hold of a moment or link in the middle that implies all the rest, and fastens there. [65]

The fancy is sequential and moves, on the outside, from "link to link," but the imagination, poised in the center, is able to "embrace the whole" simultaneously. Not surprisingly Ruskin illustrates this point with examples from painting, the art that most clearly exemplifies totality and simultaneity, but Ruskin is also using the definition to cover writers, and he has already provided examples of the way the imagination of Dante or Shakespeare seizes on significant "moments" which "imply all the rest." Ruskin begins his illustration of the

temporal aspect of the "imagination penetrative" by describing Turner's "Jason," which depicts a single coil of the dragon and dispenses with the usual rendition of a dragon seen "from head to tail." Ruskin affirms that Turner has "concentrated" more "dragon-power . . . into one moment" than other artists are able to do with the full panoply of "vulture eyes, serpent teeth, forked tongue, fiery crest, etc."[66] Ruskin's final example of the power of the imagination to condense the whole "into one moment" is his verbal rendition of *The Massacre of the Innocents*. Ruskin feels that Tintoretto has expressed it with the figure of the static, featureless woman in the background; this one point condenses and "implies all the rest." The genius of Tintoretto has penetrated the "heap of old clothes," used the insignificant as imaginative center, the still "heart" of the painting on which the entire composition is poised and which comprehends "all the rest" simultaneously.

For Ruskin, as for Baudelaire, painting is a model for formal "wholeness" and simultaneity, but for neither critic does the concept carry with it the connotation of frozen stasis. Ruskin clearly shows the "facts" of looking at a painting taking place in time; but the "moment" of stasis implies a condensation of temporal movement, the final still point implies its own opposite, rhythmic visual activity. Part of the meaning of "wholeness" for Ruskin and "totalité" for Baudelaire is the ability to perceive the kinetic aspects of an instantaneous form, the movement within the perceptional "moment." Ruskin, in *Praeterita,* gives us a perfect example of this kind of perceptual process which has rhythm in time while it retains spatial "wholeness" or "totalité." In his autobiography, Ruskin records his own personal discovery of the new world of "pure facts," his discovery of the visual self-sufficiency of the object. The experience, which comes to Ruskin with the force of revelation, with the same visual intensity that dazzles the eye of Baudelaire's artist-convalescent, occurs at Fountainbleau, after a night of illness. In the passage Ruskin refers back to an earlier and similar experience which is placed on a few paragraphs back in *Praeterita,* an incident that happened on the road to Norwood:

> . . . One day on the road to Norwood, I noticed a bit of ivy round a thorn stem, which seemed, even to my critical judgment, not ill "composed"; and proceeded to make a light and shade pencil study of it in my grey paper pocket-book, carefully, as if it had been a bit of sculpture, liking it more and more as I drew. When it was done, I saw that I had virtually lost all my time since I was twelve years old, because no one had ever told me to draw what was really there! All my time, I mean, given to drawing as an art; of course I had the records of places, but had never seen the beauty of anything, not even of a stone—how much less of a leaf![67]

This discovery of "what was really there" is not fully understood until it is reinforced at Fountainbleau:

... I put my sketch-book in pocket and trotted out, though still in an extremely languid and woe-begone condition; and getting into a cart-road among some young trees, where there was nothing to see but the blue sky through thin branches, lay down on the bank by the roadside to see if I could sleep. But I couldn't and the branches against the blue sky began to interest me, motionless as the branches of a tree of Jesse on a painted window.

Feeling gradually somewhat livelier, and that I wasn't going to die this time, and be buried in the sand, though I couldn't for the present walk any farther, I took out my book, and began to draw a little aspen tree, on other side of the cart-road, carefully ...

Languidly, but not idly, I began to draw it; and as I drew, the languor passed away: the beautiful lines insisted on being traced,—without weariness. More and more beautiful they became, as each rose out of the rest, and took its place in the air. With wonder increasing every instant, I saw that they "composed" themselves, by finer laws than any known of men. At last, the tree was there, and everything that I had thought before about trees, nowhere.

The Norwood ivy had not abased me in that final manner, because one had always felt that ivy was an ornamental creature, and expected it to behave prettily, on occasion. But that all the trees of the wood (for I saw surely that my little aspen was only one of their millions) should be beautiful— ... this was indeed an end to all former thoughts with me, an insight into a new silvan world.[68]

As the drawing of the tree progresses, Ruskin's perception of the form is intensi-fied and his level of visual clarity is increased, along with his "wonder," every instant. But Ruskin has elongated the temporal span by imposing "slow motion" on a process that is virtually instantaneous. The form of the tree is revealed suddenly, during the course of the drawing, and after this "ruling form" has been seen, its literal ramifications are traced out with accelerated speed. As Ruskin describes the process in another instance, there is a transformation of the object, an instantaneous visual transformation so that the "form flashes out" and the object is seen in its essence. Ruskin reconstructs the perceptual process of a hypothetical gothic architect, who moves from seeing nothing to seeing a "ruling form," a sudden visual switch of figure and ground. Ruskin is writing about a "radical" historic change in Gothic architecture:

... and I have been careful in pointing out the peculiar attention bestowed on the proportion and decoration of the mouldings of the window at Rouen, as compared with earlier mouldings, because that beauty and care are singularly significant. They mark that the traceries had *caught the eye* of the architect. Up to that time, up to the very last instant in which the reduction and thinning of the intervening stone was consummated, his eye had been on the openings only, on the stars of light. He did not care about the stone; a rude border of moulding was all he needed, it was the penetrating shape which he was watching. But when that shape had received its last possible expansion, and when the stone-work became an arrangement of graceful and parallel lines, that arrangement, like some form in a picture, unseen and accidentally developed, struck suddenly, inevitably, on the sight. It had literally not been seen before. It flashed out in an instant, as an independent form. It became a feature of the work.[69]

In the same way Ruskin suddenly sees the form of the aspen tree a form that had literally been invisible to him before. The revelation has only taken a "moment," but the process of perception continues to deepen, and the object is transformed without changing in outline. The imagination has penetrated the object, seized the form from within, so that the observer disappears into the object, lost in the wonderful self-sufficiency of the aspen tree or the pattern made by the window molding. It is precisely this aspect of Ruskin's visual perception, "that penetrating, possession-taking power of the imagination which (is) the very life of man considered as a seeing creature" that Floris Delattre[70] compares to Henri Bergson's concept of metaphysical intuition. Delattre sees that Ruskin's "observation direct de la nature extérieure" is a way of seeing "l'essence même des choses, sous des apparences visibles." For Delattre the most significant aspect of Ruskin's perception is the "faculté de se fondre dans l'objet étudié, de lui devenir intérieure" so that the observer can "plonge au coeur même de son sujet, de la saisir par le centre." This "saisir immédiate," like Bergson's concept of consciousness, gives an "approfondissement de l'expérience." The observer has "un coincidence" with the external world which enables him to see "dans la matière même sa participation à la spiritualité." The process of seeing the object clearly is indeed an "approfondissement" which transforms the object from plain fact to symbol; the aspen tree has become "ideal" and yet remains "natural," it retains all its specificity and particularity—it is only one of millions of trees in the forest—and yet it flashes into essential form. The modulation from fact to symbol is like a flash, an instantaneous change in perception, and yet it has a temporal component, as the object seems to "deepen," to grow more intense, to become more clearly and simply itself. There is a simultaneous awareness of change, movement, happening all at once to the object and to the observer. To borrow Delattre's word, Ruskin experiences a coincidence with the aspen tree—the observer is absorbed into the process of seeing so that the loss of self is simultaneous and coincidental with the intensification of the object. This sense of the instantaneous deepening of reality, of form flashing out, is not only similar to Bergson's intuition, but also close to Baudelaire's concept of the "surnaturel," to Hopkin's "inscape," to Joyce's "epiphanies," to the "moments" of perception in which "symbolic meaning descends" in Virginia Woolf, to the "moments" of sensation in Proust and in Pater. All of these experiences of momentary revelation are characterized by "wholeness," a metaphysical change in everything at once, and the model for this experience is visual transformation, a sudden new sight that makes the ordinary visionary. In the experience of seeing the aspen tree for Ruskin or tasting the madeleine for Proust, there is a deepening of the object or sensation, without losing the physical particularity, spiritualization of matter that leaves the object intact. The "wholeness" of the aspen tree is intensified and clarified, the natural object becomes an "adequate symbol."

For Ruskin, at the time of the revelation of the aspen tree, the visual self-sufficiency of the object is predicated upon a sense of the Divine pervading Nature. In the next paragraph he says that the insight into the aspen tree expands to include all nature:

> Not silvan only. The woods, which I had only looked on as wilderness, fulfilled I then saw, in their beauty, the same laws which guided the clouds, divided the light, and balanced the wave. "He hath made everything beautiful, in his time," became for me thenceforward the interpretation of the bond between the human mind and all visible things . . .[71]

But the religious underpinning is added *after* the account of the visual experience, and as Ruskin grew away from his Calvinistic faith, his sense of the Divine was difffused so widely that it ceased to figure in his aesthetics, except in the sense that art itself is a kind of affirmation of man's better nature, a triumph over corruption. Part of the pull away from Nature-worship occurs because Ruskin is trying to extend his aesthetic definitions beyond landscape, so that his defense of Turner's optical precision is founded on a broader base, and Turner is included in a pantheon of artists, writers and painters, artists that Ruskin believes are representative of the highest imaginative achievement: Homer, Dante, Shakespeare, Tintoretto, Veronese, Turner and, for very particular reasons, Sir Walter Scott. If we remember, our discussion of imaginative "wholeness" began with Tintoretto's *Massacre of the Innocents,* and it is precisely this kind of detail, the insignificant heap of old clothes, that Ruskin perceives to be transformed by the artist into a powerful symbol. In his definition of the naturalist ideal Ruskin intends for the concept to cover all types of literature and painting—so that it applies equally to an aspen tree or a heap of old clothes. When he poses the question "how the art which represents things simply as they are, can be called ideal at all . . ." he answers with another example from Tintoretto.

> In Tintoretto's Adoration of the Magi, the Madonna is not an enthroned queen, but a fair girl, full of simplicity and almost childish sweetness. To her are opposed (as Magi) two of the noblest and most thoughtful of the Venetian senators in extreme old age,—the utmost manly dignity, in its decline, being set beside the utmost feminine simplicity, in its dawn. The steep foreheads and refined features of the nobles are, again, opposed to the head of a negro servant, and of an Indian, both, however noble of their kind. On the other side of the picture, the delicacy of the Madonna is farther enhanced by contrast with a largely-made farm-servant, leaning on a basket. All these figures are in repose: outside, the troop of the attendants of the Magi is seen coming up at the gallop.
> I bring forward this picture, observe, not as an example of the ideal in conception of religious subject, but of the general ideal treatment of the human form; in which the peculiarity is, that the beauty of each figure is displayed to the utmost, while yet, taken separately the Madonna is an unaltered portrait of a Venetian girl, the Magi

are unaltered Venetian Senators, and the figure with the basket, an unaltered market-woman of Mestre.

And the greater the master of the ideal, the more perfectly true in portraiture will his individual figures be always found, the more subtle and bold his arts of harmony and contrast. This is a universal principle, common to all great art. Consider, in Shakespeare, how Prince Henry is opposed to Falstaff, Falstaff to Shallow, Titania to Bottom, Cordelia to Regan, Imogen to Cloten, and so on; while all the meaner idealists disdain the naturalism, and are shocked at the contrasts. The fact is, a man who can see the truth at all, sees it wholly, and neither desires nor dares to mutilate it.[72]

Again for Ruskin the "wholeness" of conception is based on visual precision; just as Turner observes a radical fidelity to the pure facts of landscape, Tintoretto is radically accurate in basing a religious painting on actual portraiture. As Ruskin points out, both religious painting and landscape, both writing and painting derive their vitality from "actual sight." The criterion for reality, the test of ideality is visual:

> The whole power, whether of painter or poet, to describe rightly what we call an ideal thing, depends upon its being thus, to him not an ideal, but a real thing. No man ever did or ever will work well, but either from actual sight or sight of faith . . .[73]

Ruskin has to make an exception to his optical bias, to allow vision to mean either "in the mind's eye, or in bodily fact," in order to include all of the art which is not based on direct observation of Nature, into his concept of the naturalist ideal. For Ruskin, the visual reality, the ability to see the facts in the external world or in the imagination, is the guarantee of the "wholeness" of the artist's vision, and this "wholeness" implies a theory of modernity which parallels Baudelaire:

> And just because it is always something that it sees or believes in, there is the peculiar character above noted, almost unmistakable, in all high and true ideals, of having been as it were studied from the life, and involving pieces of sudden familiarity, and close specific painting which never would have been admitted or even thought of, had not the painter drawn either from the bodily life or from the life of faith. For instance, Dante's centaur, Chiron, dividing his beard with his arrow before he can speak, is a thing that no mortal would ever have thought of, if he had not actually seen the centaur do it. They might have composed handsome bodies of men and horses in all possible ways, through a whole life of pseudo-idealism, and yet never dreamed of any such thing. But the real living centaur actually trotted across Dante's brain, and he saw him do it.
>
> And on account of this reality it is, that the great idealists venture into all kinds of what, to the pseudo-idealists, are "vulgarities." Nay, venturing is the wrong word; the great men have no choice in the matter; they do not know or care whether the things they describe are vulgarities or not. They saw them: they are the facts of the case. If they had merely composed what they describe, they would have had it at

their will to refuse this circumstance or add that. But they did not compose it. It came to them ready fashioned; they were too much impressed by it to think what was vulgar or not vulgar in it. It might be a very wrong thing in a centaur to have so much beard; but so it was. And, therefore, among the various ready tests of true greatness there is not any more certain than this daring reference to, or use of, mean and little things—mean and little that is, to mean and little minds; but, when used by the great men, evidently part of the noble whole which is authoritatively present before them. Thus, in the highest poetry, as partly above noted in the first chapter, there is no word so familiar but a great man will bring good out of it, or rather, it will bring good to him, and answer some end for which no other word would have done equally well.

So a common idealist would have been rather alarmed at the thoutht of introducing the name of a street in Paris—Straw Street—Rue de Fouarre—into the midst of a description of the highest heavens. Not so Dante . . .

We may dismiss this matter of vulgarity in plain and few words, at least as far as regards art. There is never vulgarity in a *whole* truth, however commonplace. It may be unimportant or painful. It cannot be vulgar. Vulgarity is only in concealment of truth, or in affection.[74]

For Ruskin the great artist sees a "noble whole" or a "*whole* truth" which forms a total and inextricable unit; and the proof of the "wholeness" of the vision is the inclusion of vulgarities, of mean and little details, of "close specific painting," topical and local particularities, all precisely observed facts that authenticate the optical reality of the artist's imagination. The same concept of ideality that includes "vulgarity," that prompted Baudelaire to focus on the "mean" details of modern city life in *Les Fleurs du Mal*, is the quality that Ruskin finds in common among Homer, Dante, Tintoretto, and Turner. Ruskin expands his notion of Turner's specificity to include the whole spectrum of contemporary "facts," recorded at whatever time in history:

> Finally, as far as I can observed, it is a constant law that the greatest men, whether poets or historians, live entirely in their own age, and that the greatest fruits of their work are gathered out of their own age. Dante paints Italy in the thirteenth century; Chaucer, England in the fourteenth; Masaccio, Florence in the fifteenth; Tintoret, Venice in the sixteenth;—all of them utterly regardless of anachronism and minor error of every kind, but getting always vital truth out of the vital present.

> . . . it is, not because Shakespeare sought to give universal truth, but because, painting honestly and completely from the men about him, he painted that human nature which is, indeed, constant enough,—a rogue in the fifteenth century being, at heart, what a rogue is in the nineteenth and was in the twelfth; and an honest or a knightly man being in like manner, very similar to other such at any other time. And the work of these great idealists is, therefore, always universal; not because it is *not portrait,* but because it is complete portrait down to the heart, which is the same in all ages . . . Thus Tintoret and Shakespeare paint, both of them, simply Venetian and English nature as they saw it in their time, down to the root; and it does for all time . . .[75]

Ruskin uses the portrait as a metaphor for the embodiment of the ideal in the particular. He says in discussing portraiture:

> No right ideal can be reached by any combination of feature nor by any moulding and melting of individual beauties together; but there is a perfect ideal to be wrought out of every face around us. No face can be ideal which is not a portrait.[76]

Baudelaire also sees that each individual is a complex whole containing his own "idéale":

> Telle main veut tel pied; chaque epidermé engendre son poil
>
> Chaque individu est un harmonie . . .
> Chaque individu a donc son idéale.[77]

The concept of portraiture, representing an ideal wrought out of specifics, is the basic metaphor for Baudelaire's description of modernity:

> La modernité, c'est le transitoire, le fugitif, le contigent, la moitié de l'art dont l'autre moitié est l'éternel et l'immuable. Il y a eu un modernité pour chaque peintre ancien: la plupart des beaux portraits qui nous restent de temps antérieures sont revêtus des costumes de leur époque. Ils sont parfaitement harmonieux, parce que le costume, la coiffure et même le geste, le régard et le sourire (chaque époque a son port, son régard, son sourire) forment un tout d'une complète vitalité.[78]

For Baudelaire, as for Ruskin, modernity is a way of examining the world with fresh eyesight, a way of discovering beauty or ideality in things as they are. As a poet Baudelaire finds a new beauty in the clutter and debris of contemporary life, his poetry admits vulgarities and objects considered ugly by academic standards of taste. Baudelaire has the ability to transform "le spectacle, si ordinaire qu'il soit" into a symbol; this transforming power which changes insignificant facts into a symbolic whole is precisely the same power that Ruskin ascribes to Homer, Dante, Tintoretto, and Turner; the ability to draw out the "ideal" aspect out of plain facts. Homer's art consists in seeing his subject so clearly that he goes to the "heart" and gives us an image which is ideal because it is drawn with visual specificity: Achilles is represented cutting up pork-chops for Ulysses. Dante's vision of paradise is so "whole" and complete it includes an actual street name, borrowed from contemporary Paris. In the same way Tintoretto is able to use a real Venetian girl to represent the madonna, or endow the insignificant heap of clothes with symbolic intensity. And Turner, the original model for the naturalist ideal, can transform the same debris and decay of modern life that appeals to Baudelaire into ideal landscape. In the "Two Boyhoods" Ruskin writes:

Hence, to the very close of life, Turner could endure ugliness which no one else, of the same sensibility, would have borne with for an instant. Dead brick walls, blank square windows, old clothes, market-womanly types of humanity—anything fishy and muddy, like Billingsgate or Hungerford Market, had great attraction for him; black barges, patched sails, and every possible condition of fog.

You will find these tolerations and affections guiding or sustaining him to the last hour of his life; the notablest of all such endurances being that of dirt. No Venetian ever draws anything foul; but Turner devoted picture after picture to the illustration of effects of dinginess, smoke, soot, dust, and dusty texture; old sides of boats, weedy roadside vegetation, dunghills, straw-yards, and all the soilings and stains of every common labor.

And more than this, he not only could endure, but enjoyed and looked for litter, like Covent Garden wreck after the market. His pictures are often full of it, from side to side; their foregrounds differ from all others in the natural way that things have of lying about in them. Even his richest vegetation, in ideal work, is confused; and he delights in shingle, debris, and heaps of fallen stones. The last words he ever spoke to me about a picture were in gentle exaltation about his St. Gothard: "that litter of stones which I endeavored to represent."[79]

Turner's subjects are precisely the kind of mud that Baudelaire felt deserved transmutation into alchemical gold: Turner doesn't select "picturesque" detail, he sees everything as a "whole," as Ruskin emphasizes, "rejecting nothing," so that he takes the "dead brick walls" the "dinginess" and "the dung" as part of his visual field—"le spectacle si ordinaire qu'il soit"—which is transformed into symbol, the natural spectacle seen as "ideal." Thus modernity depends upon accepting the "wholeness" of the visual field and in recording this field as precisely as possible. This is why, in a chapter "On Modern Landscape," Ruskin announces his prediction that "modern art," that is post-Romantic, will be characterized by *seeing*. It is in this context that Ruskin makes his comprehensive statement:

> . . . the greatest thing a human soul ever does in this world is to see something, and tell what it *saw* in a plain way. Hundreds of people can talk for one who can think, but thousands can think for one who can see. To see clearly is poetry, prophecy, and religion—all in one.[80]

The implications of seeing clearly and recording plainly have been explored in this essay, but there is still more to be said in relation to Ruskin's "prophecy" of the modern tendency towards seeing as a touchstone for literature. What Ruskin sees clearly, as a critic, is that the predominance of "feeling" is played out. He divides literature into "Thinkers and Seers" and affirms that "Seers are wholly the greater race of the two."[81] Having "cast metaphysical writers out of our way" Ruskin proceeds to place romantic poetry under another category of "sentimental literature" which is "second rank" compared to Seers:

Again: the mass of sentimental literature, concerned with the analysis and description of emotion, headed by the poetry of Byron, is altogether of lower rank than the literature which merely describes what it saw. The true Seer always feels as intensely as any one else; but he does not much describe his feelings. He tells you whom he met, and what they said; leaves you to make out, from that, what they feel, and what he feels, but goes into little detail. And, generally speaking, pathetic writing and careful explanation of passion are quite easy, compared with this plain recording of what people said or did, or with the right invention of what they are likely to say and do; for this reason, that to invent a story, or admirably and thoroughly tell any part of a story, it is necessary to grasp the entire mind of every personage concerned in it, and know precisely how they would be affected by what happens; which to do requires a colossal intellect; but to describe a separate emotion delicately, it is only needed that one should feel it oneself; and thousands of people are capable of feeling this or that noble emotion, for one who is able to enter into all the feelings of somebody sitting on the other side of the table. Even, therefore, when this sentimental literature is first rate, as in passages of Byron, Tennyson, and Keats, it ought not to be ranked so high as the Creative; and though perfection, even in narrow fields is perhaps as rare as in the wider, and it may be as long before we have another In Memoriam as another Guy Mannering, I unhesitatingly receive as a greater manifestation of power the right invention of a few sentences spoken by Pleydell and Mannering across their supper-table, than the most tender and passionate melodies of the self-examining verse.[82]

What Ruskin clearly indicates here is a preference for the external world of the novelist, full of specific and particular facts, over the "self-examining" verse of the poet. Again the narrative art of Scott, or Homer, or Dante is characterized by visual "wholeness"; the writer must simultaneously "grasp the entire mind of every personage" in the story. For Ruskin, this ability to see the "whole" spectacle is superior to the "narrow field" of lyric introspection. Ruskin's prediction is in fact borne out by the rise of the status of the novel, and the general predominance of the novel as a form in the late nineteenth and early twentieth centuries, in the same way that poetry was a predominant form in the late eighteenth and early nineteenth centuries.

Ruskin's other prediction indicates the complex relation between painting and prose which is embodied in Ruskin's writing itself.

. . . the greatest painters or painter of modern times will in all probability be devoted to landscape principally; and farther, because in representing human emotion words surpass painting, but in representing natural scenery painting surpasses words, we may anticipate also that the painter and poet (for convenience' sake I here use the words in opposition) will somewhat change their relations or rank in illustrating the mind of the age; that the painter will become of more importance, the poet of less; and that the relations between the men who are the types and first fruits of the age in word and work,—namely Scott and Turner,—will be, in many curious respects, different from those between Homer and Phidias, or Dante and Giotto.[83]

The principle point is, of course, highly debatable, but whether or not painting has taken the lead from literature, it is certainly true that painting has taken a more central position in the aesthetic pantheon, from the 1850s into the twentieth century than it held during the Romantic period. To borrow Ruskin's phrasing, the "relations of rank" between the Impressionists, Symbolists, Cubists, and Surrealists and their literary counterparts has been very different than the relation between Constable and Wordsworth, or Corot and Lamartine. Partly due to the aesthetic climate established by Ruskin, modern writers have felt the significance of painting as a sister art in a more direct way than any time since the eighteenth-century version of pictorialism. Ruskin's version of pictorialism is that writing should resemble painting in the ability to record and "idealize" plain, visible facts: the opposition that Ruskin sets up is the identification of poetry with emotion and painting with "pure facts." Ruskin's prediction is again accurate in a diffuse sense—that much of modern literature is influenced by the analogy to painting, and by concepts translated from painting into literary equivalents, which are so vividly exemplified in Ruskin's own prose. Ruskin's influence is felt, with various degrees of directness, in the impulse towards precision in poetic imagery, in Hopkins, Pound, Hulme, in the general ideas behind Imagism. But Ruskin's major impact is in the realm of prose and the following chapters of this book will rest on the point of contact between Ruskin and the emerging form of the modern novel in Pater and Proust. Ruskin's writing about visual sensations, precise impressions, the process of seeing sets the background for narrative writing which is based on the character's impressions and sensations, rather than structured according to plot and action. But Ruskin not only contributes to the aesthetic climate, he provides specific examples of prose which is geared to recording impressions, prose which imitates a visual model and attempts to energize the act of perception and make it synonymous with moral consciousness.

One of Ruskin's most famous verbal pictures, the description of a Highland landscape in the final volume of *Modern Painters,* is specifically designed to convey a visual impression that has a moral component, a meaning that goes beyond pure sense experience to the full consciousness of perception: Ruskin carefully separates this kind of vision on the one hand, from didactic "morality," and on the other, from the simple "picturesque," the attempt to look at the scene, like Uvedale Price's hypothetical aesthete, only in terms of light and color "variously modified." Ruskin is writing an anti-picturesque landscape, a verbal description which points to the limitations of the "picturesque" as interpreted by a Highland preacher, who tends to see only "what these religious persons call 'the bright side of things,' that is to say, on one side of them only, when God has given them two sides, and intended us to see both."[84] In his description Ruskin attempts to make the reader see both sides simultaneously; the moral aspect of perception is fused into visible facts, the facts constitute an

immediate language, and the "whole" picture becomes an integrated symbol that cannot be paraphrased. The act of perception rendered in language is a recognition of the "reciprocal action between the intensity of moral feeling and the power of the imagination."[85] The imagination, for Ruskin, as we have seen, is condensed into vision, whether physical or mental. In this case Ruskin's Highland landscape is drawn from physical memory and reconstructed by mental sight. But the visual and moral components are reciprocal; the picture cannot be decomposed into sensory notation or didactic message; seeing, for Ruskin, implies a fusion of both at once. The following quotation includes the "whole" verbal picture, and then Ruskin's commentary about the significance of its "wholeness":

> Now a Highland scene is, beyond dispute, pleasant enough in its own way; but, looked close at, has its shadows. Here, for instance, is the very fact of one, as pretty as I can remember—having seen many. It is a little valley of soft turf, enclosed in its narrow oval by jutting rocks and broad flakes of nodding fern. From one side of it to the other winds, serpentine, a clear brown stream, drooping into quicker ripple as it reaches the end of the oval field, and then, first islanding a purple and white rock with an amber pool, it dashes away into a narrow fall of foam under a thicket of mountain ash and alder. The autumn sun, low but clear, shines on the scarlet ash-berries and on the golden birch-leaves, which, fallen here and there, when the breeze has not caught them, rest quiet in the crannies of the purple rock. Beside the rock, in the hollow under the thicket, the carcass of a ewe, drowned in the last flood, lies nearly bare to the bone, its white ribs protruding through the skin, raven-torn; and the rags of its wool still flickering from the branches that first stayed it as the stream swept it down. A little lower, the current plunges, roaring, into a circular chasm like a well, surrounded on three sides by a chimney-like hollowness of polished rock, down which the foam slips in detached snow-flakes. Round the edges of the pool beneath, the water circles slowly, like black oil; a little butterfly lies on its back, its wings glued to one of the eddies, its limbs feebly quivering; a fish rises and it is gone. Lower down the stream, I can just see, over a knoll, the green and damp turf roofs of four or five hovels, built at the edge of a morass, which is trodden by the cattle into a black Slough of Despond at their doors, and traversed by a few ill-set stepping-stones, with here and there a flat slab on the tops, where they have sunk out of sight; and at the turn of the brook I see a man fishing, with a boy and a dog—a picturesque and pretty group enough certainly, if they had not been there all day starving. I know them, and I know the dog's ribs also, which are nearly as bare as the dead ewe's; and the child's wasted shoulders, cutting his old tartan jacket through, so sharp are they.[86]

> Truly, this Highland and English hill-scenery is fair enough; but has its shadows; and deeper coloring, here and there, than that of heath and rose.
>
> Now, as far as I have watched the main powers of human mind, they have risen first from the resolution to see fearlessly, pitifully, and to its very worst, what these deep colors mean, wheresoever they fall; not by any means to pass on the other side looking pleasantly up to the sky, but to stoop to the horror, and let the sky, for the present, take care of its own clouds. However this may be in moral matters, with which I have nothing here to do, in my own field of inquiry the fact is so; and all

great and beautiful work has come of first gazing without shrinking into the darkness. If, having done so, the human spirit can, by its courage and faith, conquer the evil, it rises into conceptions of victorious and consummated beauty. It is then the spirit of the highest Greek and Venetian Art.[87]

What Ruskin means by the act of perception which clarifies the darker colors, which extends clarity into the shadows, is both a moral and aesthetic affirmation; "gazing without shrinking into the darkness" is the ultimate degree of honesty in an aesthetic based on seeing clearly. Ruskin admits the final inability to penetrate the darkness, the element of death, because compared to some imaginary and angelically pure absolute of clarity, man's perceptions are like a "dark and broken mirror." The attempt to see clearly does not dispel darkness but simply casts illumination on the darker "facts" of existence, so that both the light and dark sides are seen in relation together. Ruskin introduces the whole chapter with a simple statement that "religious" landscape, the kind of pious pantheism of the Highland preacher, is both morally and visually false "because its first assumption is false, namely that the natural world can be represented without the element of death."[88] In the sentimental picturesque, the "absolute fact of corruption" as well as "the elements of decay, danger, and grief in visible things were always disregarded."[89] Thus in order to make his landscape "whole," Ruskin tries to show both dark and light aspects simultaneously. The same visual acuity which clarifies the "clear brown stream" and "the purple and white rock with an amber pool" is used to reveal intense details such as the dog's ribs and the cloth of the jacket frayed from the boy's shoulder blades. Optical truth and moral truth are inseparable; *not* to see clearly, like the Highland preacher, is a distortion, a wilful selection, a projection—in any case, a departure from "pure facts" and "whole truth" of modern landscape.

In referring to this passage in his book on Ruskin's aesthetics, Landow mentions that the descriptive technique is like a "camera eye," but in fact the structure is closer to Ruskin's usual animation of the perception of a painting than it is to a cinematographic pan. The passage opens with a pictorial perception of the "whole" landscape, seen as a unit. The first impression gives way to following the details of the brown stream past the purple rock to the small waterfall under the trees. With no change of tone or rhythm, Ruskin introduces the sight of the decaying carcass, and then, employing verbal resources to re-create a perceptual process that would necessitate an infinitely complex montage by the camera eye, he focusses on the "white ribs protruding through the skin, raven-torn; and the rags of its wool still flickering from the branches that first stayed it as the stream swept it down." The visual similarity of "white ribs" and "rags of wool" is reinforced by the sound of the phrasing, and the suggested action, protruding, flickering, tearing and sweeping, unites the stream, the birds, and the carcass into a still image of the natural process of corruption, much like the seething corpse in Baudelaire's "La Charogne." After the

description of the carcass Ruskin slips into the present tense of his picture—the butterfly with glued wings is suddenly gone. But within this pictorial present, Ruskin does not allow himself to glide at will; his position as observer is fixed within the frame; he "can just see, over a knoll, the green and damp turfs" and the muddy yard which form the background of the picture. Finally the whole description comes to a visual rest in the group of the man, the boy and the dog—and in this final rest there is an effect of increasing clarity, like a camera close-up, which focusses on the child's jacket shoulders. Like the insignificant heap of old clothes in Tintoretto's *Massacre,* the tartan jacket becomes the trivial detail which provides a central point of intensity for the entire composition. The temporal movement of the stream gives way to the temporal stasis of the group and Ruskin makes them seem even more frozen and static by suggesting that they have been standing still all day long. Ruskin steps out of the spatial "frame" of the passage in order to tell us a fact which changes the perception of the figures. He adds a dimension of moral knowledge when he adds time to the picture; the figures have been fishing all day because they are starving. There is a perceptual rhythm to the passage that is similar to Ruskin's description of *The Massacre of the Innocents;* as soon as he departs from the pictorial space into narrative, to register the action of the massacre or the near immobility of the fishermen, he immediately returns to locate the additional information in a visual detail on the canvas, and changes back from a narrative to a pictorial method. Here, the fact of starvation, the element of death, Ruskin believes, should be apparent in the "pure facts" themselves; if the perception of the scene is accurate enough, the sum total of "visible truth" will be revealed. In this case, the weight of time, the circumstances of poverty, encroaching necessity, the inevitability of decomposition, the temporal pull of death are all condensed into the final visual image of the frayed jacket: as the focus of the paragraph sharpens, the increase in clarity reveals the moral and temporal "aspects" hidden in the visual field. The emotion of the passage, the pathos, has been concentrated into *visibilia,* to borrow terminology from the tradition of *ut pictura; poesis.* There is no projection of despair onto the beautiful aspects of nature; the golden light, scarlet berries, and purple rock are seen clearly "as they are," not distorted by the sympathy that Ruskin feels for the human figures. On the other hand, Ruskin's clear vision of the "whole" scene does not edit out the darker coloring, the visible evidence of death and decay which coexist with natural loveliness, so that the dark and light sides of the picture, the temporal and spatial "aspects," are rendered simultaneously. Because the vision is complete and precise, perceived and recorded as a "whole truth," the scene is raised to the level of the naturalist ideal.

The tonality of Ruskin's "Modern Landscape," with its juxtaposition of corruption and starvation, is closer to Baudelaire than to Wordsworth. Baudelaire's vision is frequently centered on the "facts" of decomposition, sickness,

disease, poverty, deformity, misery and vice—the imperfect side of existence which is summed up in the word "spleen," the ordinary and often repulsive spectacle which is transformed by the poet into the "idéale" world of art. The ideal that Baudelaire discovers in "modernité" is based on inclusion, taking in the *entire* spectacle, accepting all the evil, ugliness, and brutality that exist in the state of nature into the world of the book. In both *Les Fleurs du Mal* and *Spleen de Paris* Baudelaire stresses "evil" in order to draw beauty out of the more horrifying aspects of existence, to include even the most degrading facets of human nature within the aesthetic realm. Ruskin intends for his Highland scene to exemplify a similar power, the ability "to gaze without shrinking into the darkness," to include the facts of death and evil within the "wholeness" of the naturalist ideal. The Highland scene is an illustration, for Ruskin, of his concept of the grotesque, which is an extension or redefinition of the naturalist ideal. When the "wholeness" of the vision of the naturalist ideal, which comprehends the trivial, mean, and vulgar, is widened to include death, decay, and evil, Ruskin names this greater breadth of vision the "grotesque ideal" or "noble grotesque." Ruskin feels that the grotesque is the natural condition of "seeing man"; the effort to see clearly involves a recognition of the "Divine terror" and "horror" in the universe, and because it is difficult for man to face the "pure fact" of evil,[90] there is an inevitable distortion in the apprehension of any major "truth," due to the imperfect nature of man's perceptions, his incapacity to attain absolute clarity. In *The Stones of Venice* Ruskin uses a complex optical metaphor to explain the grotesque:

> Now observe in this matter, carefully, the difference between a dim mirror and a distorted one; and do not blame me for pressing the analogy too far, for it will enable me to explain my meaning every way more clearly. Most men's minds are dim mirrors, in which all truth is seen, as St. Paul tells us, darkly; this is the fault most common and most fatal; dulness of the heart and mistiness of sight, increasing to utter hardness and blindness; Satan breathing upon the glass, so that if we do not sweep the mist laboriously away, it will take no image. But, even so far as we are able to do this, we have still the distortion to fear, yet not to the same extent, for we can in some sort allow for the distortion of an image, if only we can see it clearly. And the fallen human soul, at its best, must be as a diminishing glass, and that a broken one, to the mighty truths of the universe round it; and the wider the scope of its glance, and the vaster the truths into which it obtains an insight, the more fantastic their distortion is likely to be, as the winds and vapours trouble the field of the telescope most when it reaches farthest.
>
> Now, so far as the truth is seen by the imagination in its wholeness and quietness, the vision is sublime; but so far as it is narrowed and broken by the inconsistencies of the human capacity, it becomes grotesque: and it would seem to be rare that any very exalted truth should be impressed on the imagination without some grotesqueness in its aspect . . .[91]

Thus clear vision involves a perception of the inevitable distortion; the "noble grotesque" is a "whole" that includes imperfection, a vision reflected

in "a dark and broken mirror." The grotesque is a recognition of the fact that sublime wholeness can only be approximated, that man can only achieve a broken whole, a partial clarity; but as Ruskin points out, even though man's perception is like a flawed and rippled mirror, it is the *only* mirror and without it there is nothing but darkness. Therefore Ruskin concludes that the grotesque is an ultimate test of greatness in art; he finds that all of the figures in his Pantheon of the naturalist ideal also exhibit an awareness of the broken quality of the human condition and express this quality through the grotesque, a composite of opposites, beauty and corruption, the ludicrous and the terrible, fused into a unified vision.

> From what we have seen to be its nature, we must, I think, be led to one most important conclusion; that wherever the human mind is healthy and vigorous in all its proportions, great in imagination and emotion no less than in intellect, and not overborne by an undue or hardened pre-eminence of the mere reasoning faculties, there the grotesque will exist in full energy. And accordingly, I believe that there is no test of greatness in periods, nations, or men, more sure than the development, among them or in them, of a noble grotesque; and no test of comparative smallness or limitation, of one kind or another, more sure than the absence of grotesque invention, or incapability of understanding it. I think that the central man of all the world, as representing in perfect balance the imaginative, moral, and intellectual faculties, all at their highest, is Dante; and in him the grotesque reaches at once the most distinct and the most noble development to which it was ever brought in the human mind. The two other greatest men whom Italy has produced, Michael Angelo and Tintoret, show the same element in no less original strength, . . . in Tintoret, ruling the entire conceptions of his greatest works to such a degree that they are an enigma or an offence, even to this day, to all the petty disciples of a formal criticism. Of the grotesque in our own Shakespeare I need hardly speak, nor of its intolerableness to his French critics; nor of that of Aeschylus and Homer, as opposed to the lower Greek writers; and so I believe it will be found, at all periods, in all minds of the first order.[92]

Throughout his discussion of the grotesque, Ruskin adds Spenser to his usual group of Homer, Dante, Shakespeare, Tintoretto, and Turner because *The Faerie Queen* is so rich in the particular medieval type of grotesque that Ruskin discovered through architectural sculpture. In a chapter on the "Grotesque Ideal" Ruskin defines the literary grotesque in terms of a composite visual image, which he illustrates with an example from Spenser:

> A fine grotesque is the expression, in a moment, by a series of symbols thrown together in bold and fearless connection, of truths which it would have taken a long time to express in any verbal way, and of which the connection is left for the beholder to work out for himself; the gaps, left or overleaped by the haste of the imagination, forming the grotesque character.
>
> For instance, Spenser desires to tell us, (1) that envy is the most untamable and unappeasable of the passions, not to be soothed by any kindness; (2) that with

continual labor it invents evil thoughts out of its own heart; (3) that even in this, its power of doing harm is partly hindered by the decaying and corrupting nature of the evil it lives in; (4) that it looks every way, and that whatever it sees is altered and discolored by its own nature; (5) which discoloring, however, is to it a veil, or disgraceful dress, in the sight of others; (6) and that it never is free from the most bitter suffering, (7) which cramps all its acts and movements, enfolding and crushing it, while it torments. All this it has required a somewhat long and languid sentence for me to say in unsymbolic terms,—not, by the way, that they are unsymbolical altogether, for I have been forced, whether I would or not, to use *some* figurative words; but even with this help the sentence is long and tiresome, and does not with any vigor represent the truth. It would take some prolonged enforcement of each sentence to make it felt, in ordinary ways of talking. But Spenser puts it all into a grotesque, and it is done shortly and at once, so that we feel it fully, and see it, and never forget it. I have numbered above the statements which had to be made. I now number them with the same numbers, as they occur in the several pieces of the grotesque:—

 "And next to him malicious Envy rode
(1) Upon a ravenous wolfe, and (2.3.) still did chaw
 Between his cankred teeth a venemous tode
 That all the poison ran about his jaw.
(4.5) All in a kirtle of discolord say
 He clothed was, y-paynted full eies;
(6) And in his bosome secretly there lay
 An hatefull snake, the which his tail uptyes
(7) In many folds, and mortall sting implyes."

 There is the whole thing in nine lines; or, rather, in one image, which will hardly occupy any room at all on the mind's shelves, but can be lifted out, whole, whenever we want it. All noble grotesques are concentrations of this kind, and the noblest convey truths which nothing else could convey; and not only so, but convey them, in minor cases with a delightfulness, in the higher instances with an awfulness,—which no mere utterance of the symbolised truth would have possessed, but which belongs to the effort of the mind to unweave the riddle, or to the sense it has of there being an infinite power and meaning in the thing seen, beyond all that is apparent therein, giving the highest sublimity even to the most trivial object so presented and so contemplated.[93]

Ruskin's definition has all the characteristics of the Symbolist version of a symbol: a "whole thing" composed of a number of symbols that cannot be expressed in an ordinary "verbal" way, it cannot be paraphrased because it is a "whole" that includes "gaps" so that the act of connecting all the parts is left up the "beholder." The "series" of images are condensed into a "moment" of perception; the temporal flow of literature is concentrated into a single "image" which can be "lifted out whole." Like the Symbol, Ruskin's grotesque is based on the model of visual perception, a view of the simultaneous relationship between parts and "gaps," all taken together at once. In a brilliant insight Ruskin answers the question that arises for the next half century in literary criticism about the discursive aspect of the symbol: the symbol, or the

grotesque, cannot disclose itself to paraphrase because it is a perception that encompasses more than it states. "The thing seen" has an infinite power of revealing further levels of clarity, further relations between parts, further mental activity in "unweaving the riddle." Ruskin specifically opposes the concentrated image-making power of language to "mere utterance"; the verbal image continues to radiate meaning while utterance or discourse exhausts itself in the effort to be comprehensive in a linear fashion. As Ruskin tries to demonstrate in his Spenser exegesis, the enumeration of the qualities of Envy in discourse, "in ordinary ways of talking," is "long, tiresome . . . a prolonged enforcement," while the grotesque has the immediacy and wholeness of a visual image, and is presented "all at once, so that we feel it and see and never forget it." The symbol, the grotesque, the concentrated image, allows the mind the "sense of infinite meaning" because, as statement, it is incomplete, constructed with built-in gaps—so that it continues to reverberate with new meaning. The "whole" is always more than the list of parts—as Ruskin tries to show by numbering his discourse—because the whole allows for recombination, weaving and unweaving the riddle of the "thing seen."

If we apply this refined definition of the grotesque back to Ruskin's Highland scene, it shows us more about the way he structures perception in prose. The movement in the picture is from an overall first view, through a series of details, to a final close-up focus on the frayed jacket; but imposed over this progressive intensification is a pattern of unstated relations between parts that gives the passage a spatial unity. There is a kind of counterpoint between the flow of the visual experience in time, and the implicit moral "gaps" between the elements of the "thing seen" as a whole. On second glance, one notices that the picture is built on the juxtaposition of images of corruption and starvation: the carcass of the ewe is rotting uselessly while the human figures need food. In a similar way there is an underlying series of links between the carcass of the ewe, caught unaware in the flood, and now half decomposed, the butterfly with wings hopelessly glued together, who is presently gone before our very eyes, swallowed by the fish, who in turn, will probably soon be caught by the fisherman, and the group of man, boy and dog, who will undoubtedly succumb to the pressure of starvation, who are subject, in their turn, to being swallowed up in the natural cycle of decay and mortality, the temporal process which is being described by the successive details of the picture. But at the end of the series, Ruskin suddenly returns to the beginning by comparing the dog's ribs and the boy's shoulders to the bones of the dead ewe. "I know them, and I know the dog's ribs also, which are nearly as bare as the dead ewe's, and the child's wasted shoulders cutting his tartan jacket through, so sharp are they."[94] This final link emphasizes the cyclical aspect of the natural process, but it also points out the incongruities, the senselessness, and the random waste of Nature. The boy's "wasted shoulders" are so sharp from hunger, that they cut through the tartan jacket, almost the way the ewe's "white ribs . . . protrud[e] through the skin."

The boy and the ewe are subjected to the same conditions of waste and chance, and the brutality of the image of the frayed jacket, cut through by sharp bone, is reinforced by the parallel with the protruding ribs. There is also a suggestion of further waste and greater irony in the fact that the "rags of wools" flickering on the tree are the very material needed for a new jacket, in the same way the carcass would have been potential food. It is precisely this process of unweaving the riddle that gives the passage energy: as the images continue to modify each other in new combinations, the verbal picture, as a "whole," deepens and darkens. There is an incalculable unity to the passage which results from all the symbolic details being "thrown together" in the mind of the beholder: a phrase like "raven-torn," the image of water like "black oil," the background view of the muddy slough trodden by the cattle are all contributing elements to the total picture, which acts like Spenser's lines on Envy to form a "concentration" composed of symbols and gaps, which are all perceived together, in a "moment" of time.

Ruskin, like Baudelaire, transforms the ordinary spectacle, with its dark coloring of death, waste, and despair into poetry. But when we return to Ruskin's general aesthetic pronouncement that the greatest thing a human soul ever did is to see something clearly and tell what it saw in a plain way, it is apparent that this poetry of plain fact is more complex than it sounds theoretically. The Highland scene fulfills the criteria of the naturalist ideal, because it is studied from nature, in this case Ruskin's mental vision of a precisely seen imaginary landscape, and ideal because "mentally arranged in a certain manner." The mental arrangement is a complicated structure; first the premise of a static picture, then a temporal movement into the picture, following a visual sequence, and finally a perception of the spatial unity of the passage, which is established by the reciprocal effect of all the images working together. The mental arrangement is a deliberate act of composition, so that the structure of the verbal rendering duplicates the process of visual perception. Ruskin has the idea of spatial unity in mind when he says: "Composition may be best defined as the help of everything in the picture by everything else." He uses the word "invention" as a synonym for true composition which is characterized by the total integration of parts into a whole:

> Now invention in art signifies an arrangement, in which everything in the work is thus consistent with all things else, and helpful to all else.
> It is the greatest and rarest of all the qualities of art. The power by which it is effected is absolutely inexplicable and incommunicable; but exercised with entire facility by those who possess it, in many cases even unconsciously.
> In work which is not composed, there may be many beautiful things, but they do not help each other. They at the best only stand beside, and more usually compete with and destroy, each other. They may be connected artificially in many ways, but the test of there being no invention is, that if one of them be taken away, the others are no worse than before. But in true composition, if one be taken away, all the rest are helpless and valueless. . . .

Also in true composition, everything not only helps everything else a little, but helps with its utmost power. Every atom is in full energy; and all that energy is kind. Not a line, nor spark of color, but is doing its very best, and that best is aid. The extent to which this law is carried in truly right and noble work is wholly inconceivable to the ordinary observer, and no true account of it would be believed.

True composition being entirely easy to the man who can compose, he is seldom proud of it, though he clearly recognizes it. Also, true composition is inexplicable. No one can explain how the notes of a Mozart melody, or the folds of a piece of Titian's drapery, produce their essential effect on each other. If you do not feel it, no one can by reasoning make you feel it. And, the highest composition is so subtle, that it is apt to become unpopular, and sometimes seem insipid.

The reader may be surprised at my giving so high a place to invention. But if he ever come to know true invention from false, he will find that it is not only the highest quality of art, but is simply the most wonderful act or power of humanity. It is pre-eminently the deed of human creation; otherwise, poetry.[95]

Ruskin begins the discussion with picture and ends with poetry: the kind of pictorial unity in which all parts "help" each other simultaneously is extended as a model for all forms of artistic unity. The verbal poetry of Ruskin's Highland scene depends upon pictorial unity; if the image of the ewe is removed, or the image of the boy's sharp bony shoulders, the composition is destroyed. Even particular words—"the bones *protruded* through the skin," the "*wasted* shoulders"—are essential to the total unity of the passage.

This concept of pictorial composition, or its verbal equivalent, is another example of the complexity of Ruskin's aesthetic, which is based on Nature, but Nature rearranged. Ruskin calls this pictorial unity "sacred invention" because it is the power of giving "life" or "energy" to the work of art. He distinguishes between unimaginative composition, which is mere "watchmaking," putting parts together in a mechanical way, and "true composition," which gives the work a "choral harmony," an intensity and vitality due to the total fusion or "helpfulness" of all the parts: "intensity of helpfulness—completeness of depending of each part on all the rest." This pictorial unity is based on a natural metaphor: the tree with its complexity of branches and roots is an example of interdependence in Nature, like the Fountainbleau aspen which "composes" itself, but as Ruskin repeatedly states, the artist can never render the "fullness" of nature. Therefore the act of composition is a way of duplicating the wholeness of nature, by translating it into another "whole" invented by the artist, which reflects the total unity of the natural world on a limited scale. At every turn Ruskin handles the complex aesthetic relation between art and nature with subtle ease: first of all art is necessary in order to perceive the ",pure facts" of Nature; the innocent eye must be trained and educated to see clearly. The naturalist ideal is based on the perception of wholeness in Nature, but the artist must mentally arrange his vision, which often involves rearrangement of "pure fact," in order to record this wholeness clearly and plainly in paint or in words. Ruskin calls this ability to recompose the unity of Nature *invention* because he

is fully aware of the possible implications of his aesthetic of "pure fact": for Ruskin the power of a work of art is not in the simple, mirror-like reflection of the visible facts of Nature, but in translating these facts into an invented form which reproduces the impression made by those facts, on the artist, as accurately as possible. Ruskin is emphasizing the tremendous creative power involved in recording plain facts, and Turner serves again as a model for "invention formal." The capacity to invent implies wholeness of vision, "an absolute grasp of the whole subject." As Ruskin points out, Turner's grasp of the whole canvas, like Veronese's, is the same, whether he works from the basis of washes over the whole canvas or proceeds "inch by inch":

> It is all the same to him whether he grounds a head, and finishes it at once to the shoulders, leaving all round it white; or whether he grounds the whole picture. His harmony, paint as he will, never can be complete till the last touch is given; so long as it remains incomplete, he does not care how little of it is suggested, or how many notes are missing. All is wrong till all is right.[96]

Just as Baudelaire sees a relation between Delacroix's technical ability, his grasp of the *totalité* of the canvas, and his ability to control and discipline his "passion," Ruskin also connects true compositional unity with the subjugation of emotion:

> The whole picture must be imagined, or none of it is. And this grasp of the whole implies very strange and sublime qualities of mind. It is not possible, unless the feelings are completely under control; the least excitement or passion will disturb the measured equity of power; a painter needs to be as cool as a general; and as little moved or subdued by his sense of pleasure, as a soldier by the sense of pain. Nothing good can be done without intense feeling; but it must be feeling so crushed, that the work is set about with mechanical steadiness, absolutely untroubled, as a sur-geon—not without pity, but conquering it and putting it aside—begins an operation.[97]

To see the vision clearly is to see it whole—but in order to translate this vision into a painted or written record, the artist must calm his intensity into coolness and preserve a detachment that allows him to keep the entire composition in focus at once. Far from acting as a mirror, the artist is a clear but reductive lens. The innocent eye, purified of emotional distortion, is still unable to encompass the universal "wholeness" so that the image transmitted through the lens is re-composed on a smaller scale in the work of art. The grotesque is an honest recognition of this reductive aspect, but the whole power of the artist lies in his ability to invent or compose a form that transmits the vision with as little dis-tortion as possible. Ruskin ends his discussion of composition with a statement as paradoxical as Yeats' "artifice of eternity"—"only truth can be invented":

As wholeness and wholesomeness go together, so also sight with sincerity; it is only
the constant desire of, and submissiveness to truth, which can measure its strange
angles and mark its infinite aspects; and fit them and knit them into the strength of
sacred invention.

Sacred, I call it deliberately; for it is thus, in the most accurate senses, humble
as well as helpful; meek in its receiving, as magnificent in its disposing; the name it
bears being rightly given to invention formal, not because it forms, but because it
finds. For you cannot find a lie; you must make it for yourself. False things may be
imagined, and false things composed; but only truth can be invented.[98]

As an example of how the artist invents truth, Ruskin discusses Turner's process
of mentally arranging Nature in a chapter entitled "Turnerian Topography."
What Ruskin is trying to demonstrate in this chapter is the difference between
the photographic reproduction of a landscape and a painter's representation,
which, because it is invented, that is composed, can be more precisely true to
the actual visual experience than a simple mirror image. Ruskin shows that the
visual "impression" of a place is conditioned by a number of factors that lie
outside the presumed frame. He is contrasting false composition, dictated by
academic rules, to true composition or invention, as evidenced in Turner:

But the artist who has real invention sets to work in a totally different way.
First, he receives a true impression from the place itself, and takes care to keep hold
of that as his chief good; indeed, he needs no care in the matter, for the distinction
of his mind from that of others consists in his instantly receiving such sensations
strongly, and being unable to lose them; and then he sets himself as far as possible
to reproduce that impression on the mind of the spectator of his picture.

Now, observe, this impression on the mind never results from the mere piece
of scenery which can be included within the limits of the picture. It depends on
the temper into which the mind has been brought, both by all the landscape round,
and by what has been seen previously in the course of the day; so that no particular
spot upon which the painter's glance may at any moment fall, is then to him what,
if seen by itself, it will be to the spectator far away; nor is it what it would be, even
to that spectator, if he had come to the reality through the steps which Nature has
appointed to be the preparation for it, instead of seeing it isolated on an exhibition
wall. For instance, on the descent of the St. Gothard, towards Italy, just after passing
through the narrow gorge above Faido, the road emerges into a little breadth of
valley, which is entirely filled by fallen stones and debris, partly disgorged by the
Ticino as it leaps out of the narrower chasm . . .

There is nothing in this scene, taken by itself, particularly interesting or im-
pressive. The mountains are not elevated, nor particularly fine in form, and the
heaps of stones which encumber the Ticino present nothing notable to the ordinary
eye. But, in reality, the place is approached through one of the narrowest and most
sublime ravines in the Alps, and after the traveller during the early part of the day
has been familiarized with the aspect of the highest peaks of the Mont St. Gothard.
Hence it speaks quite another language to him from that in which it would address
itself to an unprepared spectator . . .

Any topographical delineation of the facts, therefore, must be wholly incapable of arousing in the mind of the beholder those sensations which would be caused by the facts themselves, seen in their natural relations to others. And the aim of the great inventive landscape painter must be to give the far higher and deeper truth of mental vision, rather than that of the physical facts, and to reach a representation which, though it may be totally useless to engineers or geographers, and, when tried by rule and measure, totally unlike the place, shall yet be capable of producing on the far-away beholder's mind precisely the impression which the reality would have produced, and putting his heart into the same state in which it would have been, had he verily descended into the valley from the gorges of Airolo.[99]

Ruskin is insisting that the precise visual impression is automatically more than the topographical delineation, because the static moment represented by the picture is part of a temporal experience which flows up to the point framed, and the section of landscape inside the frame is connected, organically, to all of its surroundings—so that an "impression," like a grotesque, is a "concentration," into a "moment," into a "whole image" of more than is "apparent therein." Just as Ruskin's perception of the group of figures in his Highland scene is conditioned by the length of time they have been standing still, Turner's impression of the valley is seen through eyes conditioned by the journey over the pass. The impression, in order to be accurate, must be reinvented, on canvas or in words, so that as a "whole" it includes the surrounding experience outside the frame. In this case Ruskin shows how Turner subtly changes the actual topography: he alters the scale of the mountains in the background to make them taller, he "overhangs" a cliff to make it resemble the chasm through which he has passed; in short, he condenses the whole visual process, which has unfolded in time, into the space of the picture by a delicate reinvention of the scene. But for Ruskin this is not a violation of "pure facts" but a higher, almost spiritual power of visual perception, which allows the artist to convey the impression more precisely to the beholder. In a long and detailed account Ruskin tries to show how Turner "holds fast" to his first impression while at the same time transforming the actual scene into an invented scene which corresponds more closely to the impact of the initial impression. As Ruskin demonstrates, the process is almost instantaneous, but in fact, is the result of several steps: other ideas, memories of other places, the images associated with the journey, "insensibly gather" around the first impression and "modify" it. What Ruskin finds surprising is that in changing the scene to produce the accurate impression, the artist's mind doesn't invent out of thin air, but appropriates memories and fits them into the composition of the actual scene itself:

The kind of mental chemistry by which the dream summons and associates its materials, I have already endeavored, not to explain, for it is utterly inexplicable, but to illustrate, by a well-ascertained though equally inexplicable fact in common chemistry. That illustration (8. of chapter on Imaginative Association, Vol. II) I

see more and more ground to think correct. How far I could show that it held with all great inventors, I know not, but with all those whom I have carefully studied (Dante, Scott, Turner, and Tintoret) it seems to me to hold absolutely; their imagination consisting not in a voluntary production of new images, but an involuntary remembrance, exactly at the right moment, of something they had actually seen.

Imagine all that any of these men had seen or heard in the whole course of their lives, laid up accurately in their memories as in vast storehouses, extending, with the poets, even to the slightest intonations of syllables heard in the beginning of their lives, and with the painters, down to the minute folds of drapery, and shapes of leaves or stones; and over all this unindexed and immeasurable mass of treasure, the imagination brooding and wandering, but dream gifted, so as to summon at any moment exactly such groups of ideas as shall justly fit each other: this I conceive to be the real nature of the imaginative mind . . .[100]

Thus even the process of reinventing the scene into an impression is based on precise vision, on accurate images stored in the mind of something that has actually been seen by the artist. Ruskin gives a stunning example of a cliff formation that Turner had drawn thirty years before, and which is used as the basic visual model for reforming the cliff in the St. Gothard, to reinforce the impression of the traversed chasm. The mysterious process of association, through which all the various elements come together, as Ruskin defines it in the chapter on imaginative association (mentioned above) operates with virtual simultaneity:

> Now, this operation would be wonderful enough, if it were concerned with two ideas only. But a powerfully imaginative mind seizes and combines at the same instant, not only two, but all the important ideas of its poem or picture, and while it works with any one of them, it is at the same instant working with and modifying all in their relations to it, never losing sight of their bearings on each other; as the motion of a snake's body goes through all parts at once, and its volition acts at the same instant in coils that go contrary ways.[101]

The whole scene is changed in Turner's mind as a whole—instantaneously reinvented, all the remembered pieces and new alterations working together at once to form the composition of the picture. According to Ruskin, this process is so inexplicable that the original impression is modified, in the artist's mind, almost in the act of perception itself: thus Turnerian topography is precisely "true" to the artist's vision, even if it reinvents topography. What Ruskin is trying to establish is that the artist's eye sees "pure facts" under their ideal aspect, the spiritual truth embodied in physical facts, and that therefore the innocent eye is a far more complex recording instrument than any scientific equipment for recording topography:

> . . . all mathematical, and arithmetical, and generally scientific truth, is in comparison, truth of the husk and surface, hard and shallow; and only the imaginative truth

is precious. Hence, whenever we want to know what are the chief facts of any case, it is better not to go to political economists, nor to mathematicians, but to the great poets; for I find they always see more of the matter than any one else: and in like manner those who want to know the real facts of the world's outside aspect, will find that they cannot trust maps, nor charts, nor any manner of mensuration; the most important facts being always quite immeasurable, and that (with only some occasional and trifling inconvenience, if they form too definite anticipations as to the position of a bridge here, or a road there) the Turnerian topography is the only one to be trusted.[102]

We have seen an example of Ruskin's verbal invention in his Highland scene, which is a mental picture composed of the numerous associations of sights and incidents of his visits to Scotland; Ruskin even follows the passage with a diary account of a meeting with an impoverished cress-gatherer who was one component of the final vision. But in turning to Ruskin's description of real places, it is easy to see how he modifies actual facts in order to give the reader the greater truth of impression, and incorporates Turnerian topography into prose. One of Ruskin's most famous set pieces of description is his contrast between a hypothetical English cathedral and St. Mark's in Venice. The two parts of the description are parallel in rhythm and in structure, but the effects that Ruskin produces are as different in style as English Gothic and Byzantine architecture. Ruskin is not attempting a "topographical" rendition of architecture; he does not try to give a full delineation of the primary structural components of a building. Rather, he tries to record his experience of seeing the building, his "impression" of the work of architecture, which is composed of more elements than could be recorded by a photograph, an elevation, and a floor plan. For Ruskin each building is unique because it is related to a particular surrounding environment, rooted to its geographical location, connected to the composition of the earth where it is built, with its own specific "color of time," produced by the climate's weathering and staining of the stone. He often encourages the reader to approach a building following a certain route, not in the spirit of a tourist guide, but in an effort to get him to see it from a number of successive points of view. Thus he advises that the church at Abbeville be reached by taking a particular path across a meadow and through the town, and he even recommends catching the light on the towers in the late afternoon. Proust, who followed Ruskin's suggested approach to Amiens, understood exactly the significance of the experience:

> Ruskin does not separate the beauty of cathedrals from the charm of the countryside from which they emerge, so that everyone who visits them tastes again in the particular poetry of the countryside and in the memory, cloudy or golden, the afternoon that he spent there.[103]

It is precisely this "poésie particulière" that Ruskin attempts to condense into his descriptions of buildings; just as Turner's view of St. Gothard valley is influenced by the route he has taken, Ruskin attempts to include the perceptual process leading up to the sight of a cathedral as part of the whole visual experience. Thus the double panel description of the English Cathedral and St. Mark's begins in each case with a narrative approach to the building through its surroundings, which leads up to a stopping point, where narrative sequence is replaced by spatial organization, and the "impression" of the building itself is rendered in terms of pictorial unity. The first panel of the description, like Ruskin's Highland scene, is drawn from a mental picture, a composite but particular vision, an act of associative imagination which "invents" a specific cathedral out of all the accurate memories of the English churches that Ruskin has seen. In describing the hypothetical approach to the English Cathedral, Ruskin brings the reader through the main gate and past the houses of the close at an "ambling" pace, giving a sense of smoothly flowing time by presenting an orderly sequence of details. When the observer's motion halts and his sight is directed to the facade of the cathedral, the sense of time and rhythmic structure are changed:

> And so, taking care not to tread on the grass, we will go along the straight walk to the west front, and there stand for a time, looking up at its deep-pointed porches and the dark places between their pillars where there were statues once, and where the fragments, here and there, of a stately figure are still left, which has in it the likeness of a king, perhaps indeed a king on earth, perhaps a saintly king long ago in heaven; and so higher and higher up to the great mouldering wall of rugged sculpture and confused arcades, shattered, and grey, and grisly with heads of dragons and mocking fiends, worn by the rain and swirling winds into yet unseemlier shape, and coloured on their stony scales by the deep russet-orange lichen, melancholy gold; and so, higher still, to the bleak towers, so far above that the eye loses itself among the bosses of their traceries, though they are rude and strong, and only sees like a drift of eddying black points, now closing, now scattering, and now settling suddenly into visible places among the bosses and flowers, the crowd of restless birds that fill the whole square with that strange clangour of theirs, so harsh and yet so soothing, like the cries of birds on a solitary coast between the cliffs and sea.[104]

The front of the church is a more organized visual field than the random sights along the walk, and Ruskin uses one long continuous sentence to describe his "impression" of the facade. The sentence is broken into three sections by the two heavy rhythmical pauses occurring at the two semi-colons, followed by a repeated phrase (" . . .; and so higher . . .; and so higher still . . ."). These divisions correspond to the three major architectural units Ruskin is describing, the portals, the clerestory, and towers, which are separated by string-courses as the sentence is by semi-colons. Within the framework of this sentence, Ruskin varies the rhythm with repetition (". . . the likeness of a king, perhaps indeed a

king on earth, perhaps a saintly king long ago in heaven") and accelerates our sense of time. The eye gradually frees itself from the limitations of the spatial structure as it moves up the building, and there is a corresponding quickening of the perceptual process. Finally the architectural details become indistinct and Ruskin's vision moves off the towers to the birds, accurately described as "a drift of eddying black points, now closing, now scattering and now setting suddenly. . . ." The rhythm accelerates again here to correspond to the birds' greater mobility in space. Then Ruskin switches suddenly away from the visible to the sound of the birds, and from this sound he moves into purely imaginary space, and a suspended moment in time, as he ends with the image of the "birds on a solitary coast between the cliffs and the sea."

In his *Anatomy of Criticism,* Northrop Frye discusses a particular type of syntax which is found in long sentences, where clause is piled on clause, until the reader loses the sense of sequential relation. Frye calls this a "containing sentence" because it acts as a spatial container for all the numerous elements which compose it—elements which are related to each other in a non-linear fashion. Ruskin's single sentence is a container of this type; the images in the sentence, the fragments of statues, the mouldering wall, the heads of dragons and fiends, the black birds, the solitary coast, are all combined into a verbal picture that represents more than is "apparent" in the facade of the church. The passage has extraordinary power of condensation as well as the kind of compositional unity in which all parts "help" each other to the utmost. Ruskin manages to suggest the entire geographic conditioning of Northern Gothic—the dark, grey, black coloration which is related to the swirling mists and rain, the dark and solitary imagination which sees grotesque demons embodied in the trees and stones of the forest, the whole aesthetic temperament which results from the "bleak" climate is rendered with verbal nuance. The passage then is like a "fine grotesque" in that all of the images simultaneously modify each other; and this effect of pictorial wholeness is accomplished, while at the same time the sentence imitates the spatial structure of the object described, and follows the temporal process of accelerating perception which is precisely described as moving with greater speed as the eye goes from the clear details at the bottom of the church to the indistinct forms at the top, finally carried away by the drifting birds to an imaginary stasis.

One of the earliest and most perceptive critics of Ruskin's poetic prose was Frederic Harrison, who points out that the extraordinary length of Ruskin's sentences is one of the prominent aspects of his style. Harrison, like Frye, realizes that one effect of a long sentence is that the reader loses himself and is "carried away by its . . . rhythm":

> We know the sentence is too long, preposterously, impossibly sustained—200 words and more—250, nay 280 words without a single pause—each sentence with 20, 50, 60 commas, colons, and semicolons—and yet the whole symphony flows on with

such just modulation, the images melt so naturally into each other, the harmony of tone and the ease of words are so complete, that we hasten through the passage in a rapture of admiration.[105]

This sense of release, of rapture is exactly what Ruskin is attempting to make the reader feel in the second panel of the description, the verbal picture of St. Mark's. Again he begins with the approach to the building, glimpses of balconies, flowers, shops, madonnas and candles, all seen in passing through the alley leading up to the piazza. The rhythm is more hectic than in the corresponding English approach, because the visual assault of Venice is more kinetic and lively than the quiet English scene. Then Ruskin tries to give the sense of an optical explosion, a sudden and intense energizing of sight, as the "great light" of the piazza bursts on the eyes and space seems to compose itself into a vast symmetry. Ruskin tries to capture the absolute initial impression of St. Mark's, before the eye has had time to sort out its various forms, so that it appears as "a multitude of pillars and white domes, clustered into a long low pyramid of coloured light." This is St. Mark's, seen as it might be represented by Turner, in the background of a painting, a clear, yet indistinct mass of color and light. Ruskin's description is optically precise—if the eye were absolutely innocent, and could register the actual instant of perception—the result would undoubtedly be closer to Ruskin's "pyramid of coloured light" than to any notation of the five domes or the horses on top. As in Turnerian topography, the first impression serves as a basis for the following stages of perception, for the instantaneous process of gathering associations and visually composing the scene. After the initial impression, the description continues to waver between clarity and confusion:

> . . . beyond those troops of ordered arches there rises a vision out of the earth, and all the great square seems to have opened from it in a kind of awe, that we may see it far away;—a multitude of pillars and white domes, clustered into a long low pyramid of coloured light; a treasure-heap, it seems, partly of gold, and partly of opal and mother-of-pearl, hollowed beneath into five great vaulted porches, ceiled with fair mosaic, and beset with sculpture of alabaster, clear as amber and delicate as ivory,—sculpture fantastic and involved, of palm leaves and lilies, and grapes and pomegranates, and birds clinging and fluttering among the branches all twined together into an endless network of buds and plumes; and in the midst of it, the solemn forms of angels, sceptred, and robed to the feet, and leaning to each other across the gates, their figures indistinct among the gleaming of the golden ground through the leaves beside them, interrupted and dim, like the morning light as it faded back among the branches of Eden, when first its gates were angel-guarded long ago. And round the walls of the porches there are set pillars of variegated stones, jasper and porphyry, and deep-green serpentine spotted with flakes of snow, and marbles, that half refuse and half yield to the sunshine, Cleopatra-like, "their bluest veins to kiss"—the shadow, as it steals back from them, revealing line after line of azure undulation, as a receding tide leaves the waved sand; their capitals rich

with interwoven tracery, rooted knots of herbage, and drifting leaves of acanthus and vine, and mystical signs, all beginning and ending in the Cross; and above them, in the broad archivolts, a continuous chain of language and of life—angels, and the signs of heaven, and the labours of men, each in its appointed season upon the earth; and above these, another range of glittering pinnacles, mixed with white arches edged with scarlet flowers,—a confusion of delight, amidst which the breasts of the Greek horses are seen blazing in their breadth of golden strength, and the St. Mark's lion, lifted on a blue field covered with stars, until at last, as if in ecstasy, the crests of the arches break into a marble foam, and toss themselves far into the blue sky in flashes and wreaths of sculptured spray, as if the breakers on the Lido shore had been frost-bound before they fell, and the sea-nymphs had inlaid then with coral and amethyst.[106]

The eye is lost in the profusion of rich detail, in the wealth of interlocking imagery; Ruskin's imagination simultaneously throws together a multitude of associations, oriental opulence, lists of jewels and rare stones and precious metals, surrounding and enveloping the Christian references, which become syntactically intertwined with the overwhelming pagan sensuality. Ruskin's passage is an invention, a composition designed so that all parts work together to form an inextricable whole, but as Ruskin has put it, only the truth can be invented, and it is the true complexity of his impression that he is trying to record as accurately as possible. Part of the accuracy is rendering the visual confusion of a spectacle like St. Mark's—the eye is overpowered and oscillates between particular detail and overall form. Ostensibly the description is moving up the building, progressing through architectural divisions as in the English cathedral, but in fact Ruskin had obliterated the sense of spatial organization with the notation of imagery, which unfolds in a "continuous chain" from the beginning to the end of the passage; the five vaulted porches and the archivolts are less important than the "endless network" of decorative detail. Again the verbal rendering is true to the "pure facts" of the architecture, as the divisions in English Gothic are quite clear, while St. Mark's is, as Ruskin describes it, a "confusion of delight." But even in the midst of this interlaced confusion, when Ruskin seems to be getting most metaphorical, he suddenly returns the reader, with vibrant clarity, to precisely observed fact:

> . . . and marbles, that half refuse and half yield to the sunshine, Cleopatra-like, "their bluest veins to kiss"—the shadow, as it steals back from them, revealing line after line of azure undulation, as a receding tide leaves the waved sand.[107]

The receding shadow, revealing the delicate blue veins in the marble, is a detail that has optical truth, but Ruskin uses it, simultaneously, to introduce the image of Cleopatra, who replaces the Virgin, and provides a focal point for the under-current of voluptuousness in the passage, as well as to bring in the sea, the tide, and the shore which, as he has told us in the first chapter of *The Stones of*

Venice, are the governing elements in the development of Venetian architecture. Thus again everything helps everything else, and as the passage continues this effect is reinforced, as Ruskin seems to move from the third power of vision described in "The Pathetic Fallacy," the vision of things as they are, to the rare fourth power, in which the observer stands so overmastered by his vision that his language becomes "obscure and wild in metaphor." Ruskin closes the passage by moving into imaginary space, as in the description of the English sea-coast, but in the St. Mark's ending, the sense of accelerating perception finally breaks into a "wild" metaphor—a vision of the crests of the marble arches, transformed into moving waves of water, which are frozen in time, incrusted by sea-nymphs, flashing continually in the space of the ecstatic moment. This final metaphor consolidates the pagan and ocean imagery introduced in the Cleopatra analogy and brings the whole mounting rapture of perception to a point of intense, vibrating stasis.

But characteristically Ruskin does not leave the reader hanging in the ecstatic moment—he moves on to show the "darker colouring" in his picture of St. Mark's. In a kind of second look at the church Ruskin sees the disparity between the aesthetic delight of the architecture and the moral brutality of the life which passes in front of it:

> And in the recesses of the porches, all day long, knots of men of the lowest classes, unemployed and listless, lie basking in the sun like lizards; and unregarded children,— every heavy glance of their young eyes full of desperation and stony depravity, and their throats hoarse with cursing,—gamble, and fight, and snarl, and sleep, hour after hour, clashing their bruised centesimi upon the marble ledges of the church porch. And the images of Christ and His angels look down upon it continually. . . .[108]

As John Rosenberg has pointed out, there is a subtle exchange of qualities, of hardness and vulnerability, between the "unregarded" children with their "stony" eyes and the "bruised" coins which they toss down on the stone ledges of the porch. This added picture, superimposed over the initial splendor of St. Mark's, gives the whole section the unity of the grotesque, which incorporates the element of evil into the composition. As Ruskin says in the follow-up to his Highland scene, if the artist has the power to outface evil, to include it within the "wholeness" of his vision, then he is working in the spirit of the "highest Greek and Venetian art." One of the major lessons that Ruskin took from his study of Venice was an understanding of the pagan realism of the city and its art, its ability to accept the mixed aspects of existence, the playful and the awesome, the coexistence of the godlike and the human, the intermingling of the material and the spiritual, which approximates the Greek sense of humanity, with gods moving freely and literally among mortals. Ruskin contrasts this Venetian realism with the Christian art of the rest of Italy.

Throughout the rest of Italy, piety had become abstract, and opposed theoreti-
cally to worldly life; hence the Florentine and Umbrian painters generally separated
their saints from living men. They delighted in imagining scenes of spiritual perfect-
ness;–Paradises, and companies of the redeemed at the judgment;–glorified meetings
of martyrs;–madonnas surrounded by circles of angels. If, which was rare, definite
portraitures of living men were introduced, these real characters formed a kind of
chorus or attendant company, taking no part in the action. At Venice all this was
reversed, and so boldly as at first to shock, with its seeming irreverence, a spectator
accustomed to the formalities and abstractions of the so-called sacred schools. The
madonnas are no more seated apart on their thrones, the saints no more breathe
celestial air. They are on our own plain ground–nay, here in our houses with us. All
kinds of worldly business going on in their presence, fearlessly; our own friends and
respected acquaintances, with all their mortal faults, and in their mortal flesh, look-
ing at them face to face unalarmed: Nay, our dearest children playing with their pet
dogs at Christ's very feet.[109]

This bold and shocking realism, Ruskin feels, is most perfectly exemplified
in the paintings of Veronese. Ruskin shows that one of Veronese's primary
compositional methods is to create a chain of importance in the picture, ranging
from the central figure, holy, supernatural, legendary, the Madonna, or a saint,
or Solomon, down past a series of figures who are progressively more occupied
with the material world than the central figure, and ending with a dog, which is
totally unimpressed by the holiness or solemnity of the occasion. In the painting
at Dresden of Veronese's own family being presented to the Madonna, in their
own house, as Ruskin emphasizes, there is absolutely no sense of incongruity
registered by the family. The older members are honored by the presentation,
but not overwhelmed, and the younger members are either shy or uninterested
while the dog, "the last link in the chain of lowering feeling . . . cannot under-
stand how the Madonna got in the house; nor . . . why she is allowed to stay,
disturbing the family . . . and he is walking away much offended."[110] Ruskin
has defined the grotesque in *The Stones of Venice* as a double awareness of the
"ludicrous and the terrible" and in Veronese he finds this consistent realism
that embraces the whole spectacle, that attempts "to represent things as they
were likely to have occurred, down to the trivial or even ludicrous detail."[111]
His central illustration of this principle is Veronese's "Solomon and the Queen
of Sheba":

This picture is at Turin, and is of quite inestimable value. It is hung high; and the
really principal figure–the Solomon, being in the shade, can hardly be seen, but is
painted with Veronese's utmost tenderness . . . This column of noble shade is curious-
ly sustained. A falconer leans forward from the left-hand side, bearing on his wrist a
snow-white flacon, its wings spread, and brilliantly relieved against the purple robe of
one of the elders. It touches with its wings one of the golden lions of the throne, on
which the light also flashes strongly . . .[112]

The group opposite, of which the queen forms the centre, is also painted with Veronese's highest skill; but contains no point of interest bearing on our present subject, except its connection by a chain of descending emotion. The Queen is wholly oppressed and subdued; kneeling, and nearly fainting, she looks up to Solomon with tears in her eyes; he, startled by fear for her, stoops forward from the throne, opening his right hand, as if to support her, so as almost to drop the sceptre. At her side her first maid of honor is kneeling also, but does not care about Solomon; and is gathering up her dress that it may not be crushed; and looking back to encourage a negro girl, who, carrying two toy-birds, made of enamel and jewels, for presenting to the King, is frightened at seeing her Queen's fainting, and does not know what she ought to do; while lastly, the Queen's dog, another of the little fringy-paws, is wholly unabashed by Solomon's presence, or anybody else's; and stands with his fore legs well apart, right in front of his mistress, thinking everybody has lost their wits; and barking violently at one of the attendants, who has set down a golden vase disrespectfully near him.[113]

Ruskin almost copies this compositional method in his picture of St. Mark's, which moves down from the aesthetic ecstasy of the visual splendor, to the trivial and realistic detail of the gambling children who look completely away from the church and all it represents, and who, while the religious statues look down on them, are looking only at their centesimi on the pavement. But Veronese's chief quality, his lightness of touch, is something that Ruskin is too inherently Protestant to duplicate. Venice presents Ruskin with a deep conflict; he respects Veronese's ability to outface evil with cheerfulness, but is unable to fully accept the pagan implications. He says that

. . . the mind of Veronese, (is) capable of tragic power to the utmost . . . but by habitual preference, exquisitely graceful and playful, religious without severity, and winningly noble; delighting in slight, sweet, every day incident, but hiding deep meanings underneath it.[114]

One of the deeper meanings hidden in the "wholly realistic . . . Venetian mind" is that "sensual passion in man was, not only a fact, but a Divine fact" (M.P. V, 227). It is the "breadth and realism" of the spirit of Venice that accepts sensuality, materiality, as an integral part of experience. Ruskin accurately perceives that the most dominant aspect of Venetian painting is the refinement of color—and he realizes that the sensuous delight in color for its own sake, although it seems pagan, is actually based on the Venetians' realistic sense of religion—religion mixed with everyday life. Thus he sees that the Venetian capacity to accept the grotesque, the blending of disparate elements into the whole of life, is connected to their appreciation of and abstract delight in color:

We may be deeply thankful for this peculiar reserve of the Gothic grotesque character to the last days of Venice. All over the rest of Europe it had been strongest

in the days of imperfect art; magnificently powerful throughout the whole of the thirteenth century, tamed gradually in the fourteenth and fifteenth, and expiring in the sixteenth amidst anatomy and laws of art. But at Venice, it had been received when it was elsewhere in triumph, and it fled to the lagoons for shelter when elsewhere it was oppressed. And it was arrayed by the Venetian painters in robes of state, and advanced by them to such honour as it had never received in its days of widest dominion; while, in return, it bestowed upon their pictures that fulness, piquancy, decision of parts, and mosaic-like intermingling of fancies, alternately brilliant and sublime, which were exactly what was most needed for the development of their unapproachable colour-power.[115]

Ruskin connects the Venetian love of color to the mosaic-like composition of the grotesque, because there is an implicit double awareness in the handling of color: the Venetian painters are simultaneously religious and sensual. Ruskin, with slight irony, points out that the "Venetians delight . . . in more massive and deep colour than other religious painters. They are especially fond of saints who have been cardinals because of their red hats, and they sunburn all their hermits into a splendid russet brown." He understands the dual aspect in the Venetian temperament, which allows them to combine material pleasure with religion, in such a way that the artist can paint for the "colour's sake" without being profane:

> No Venetian painter ever worked with any aim beyond that of delighting the eye, or expressing fancies agreeable to himself or flattering to his nation. They could not be either unless they were religious. But he did not desire the religion. He desired the delight.
>
> The Assumption is a noble picture, because Titian believed in the Madonna. But he did not paint it to make anyone else believe in her. He painted it because he enjoyed rich masses of red and blue, and faces flushed with sunlight.[116]

There is still a hint of reservation here, in endorsing the *purely pictorial* value of Titian's color, and it is only in a footnote, towards the very end of *The Stones of Venice,* that Ruskin takes a definitive stand on the sensual aspect of color:

> Nothing is more wonderful to me than to hear the pleasure of the eye, in colour, spoken of with disdain as "sensual," while people exalt that of the ear in music. Do they really suppose the eye is a less noble bodily organ than the ear,—that the organ by which nearly all our knowledge of the external universe is communicated to us, and through which we learn to wonder and to love, can be less exalted in its own peculiar delight than the ear, which is only for the communication of the ideas which owe to the eye their very existence? . . .[117]

When Ruskin finds himself defending the pleasure component in Venetian art, it is the culmination of an internal process that began long before his study of Venice. As he tells us in *Praeterita,* his life is distinguished from others by the

intensity of his visual curiosity: he feels the pleasure and "desire of the eyes" so strongly that he describes himself "eating" his way into a Turner watercolor "touch by touch." Ruskin's aesthetic is partially based on an attempt to justify his optical hunger: the "innocent eye" is a way of subduing the self, transforming the self into a clear lens for recording the "pure facts" of Nature. But as Ruskin feels God withdrawing from Nature, the act of perception becomes an end in itself. Ruskin comes to think of seeing as illumination as well as "refraction," man as the "sun of creation," man as the "light of the world," the "eye itself becoming a Sun." Seeing is the process of relating man to Nature, mutually "energizing" both. As long as man takes "delight . . . through himself as the sun of creation, not as *the* creation" he stands in his "due relation . . . to other creatures and inanimate things—as made for him and he for them," a relation of reciprocity. This shift in Ruskin's mind, his sense of man's new centrality, changes, in a subtle way, the relation of art to Nature: Ruskin begins defending Turner's truth in a Wordsworthian spirit, a "religion of nature," but the effect that Ruskin has on his public, is founding a "religion of beauty," a "religion of art," a religion based on "Nature *as painted by* Turner." This shift can be traced through Ruskin's gradual acceptance of art for its own sake, not in the rarefied sense of the nineties, but as representing the highest form of human activity. Part of this change, as suggested earlier in this essay, is the result of moving beyond the landscape art of Turner to an understanding of the Venetian painters, especially Tintoretto and Veronese: the change can be seen most emphatically in Ruskin's progressive appreciation of "colour for its own sake." Several times throughout *Modern Painters* Ruskin explains that the essential aspect of the art of painting is the ability to use color: ". . . painting . . . is distinctly the art of colouring, not of shaping or relating. Sculptors or poets can do these, the painter's own work is to colour."[118]

> Hence as I have said elsewhere, the business of a painter is to paint. If he can colour, he is a painter, though he can do nothing else; if he cannot colour, he is no painter, though he may do everything else.[119]

Ruskin felt that the painter's eye should be trained to see the interdependence of color harmonies in nature, the reciprocal effect of tonal values, which is the basis of subtlety in coloring, so that if one part of the harmony is off, the whole is destroyed ("if that be wrong, all is wrong.") Like Baudelaire, Ruskin compares color harmony to music, and gradually he begins to think of coloring as an abstract art in itself, which can be disassociated from the representational subject. He compares the "delicate ear [which] rejoices in the slightly and more modulated passages of sound" to the "eye exquisitely keen and clear" which observes "grey films of shade and wandering rays of light" which would be missed by a "less educated sense." Ruskin continues

> In painting, this progress of the eye is marked always by one consistent sign—its
> sensibility, namely, to effects of gradation in light and colour, and habit of looking
> for them, rather even than for the signs of the essence of the subject . . . the more it
> is cultivated the more of light and colour it will perceive, the less of substance.[120]

Thus the more innocent the eye becomes, the more educated, the more it sees in terms of light and color, the less in terms of subject. This progression, not surprisingly, is exactly parallel to Turner's development as a painter—he tends to refine his "subject" more and more, so that in his final paintings the subject is simplified into light and color itself, perceived as luminous gradation. Ruskin follows this aspect of Turner's art and continually uses the analogy to music to explain it: he refers to Turner's color as "visible melody," "visible music" and compares his painting to Beethoven, with the "varying and blending of colours" as the equivalent of "melody and harmony." In *The Elements of Drawing* Ruskin discusses Veronese's use of color so specifically in terms of melody and dominant notes that he illustrates his point by translating Veronese into actual musical scales. Ruskin makes an explicit connection between music, painting, and abstraction in *The Stones of Venice:*

> We are to remember, in the first place, that the arrangement of colours and lines is
> an art analogous to the composition of music, entirely independent of the represen-
> tation of facts. Good colouring does not necessarily convey the image of anything
> but itself. It consists in certain proportions and arrangements of rays of light, but not
> in likenesses to anything. A few touches of certain greys and purples laid by a
> master's hand on white paper, will be good colouring; as more touches are added
> beside them, we may find out that they were intended to represent a dove's neck,
> and we may praise, as the drawing advances, the perfect imitation of the dove's neck.
> But the good colouring does not consist in that imitation, but in the abstract qualities
> and relations of the grey and purple.[121]

But just as Turner's abstraction is based on precise observation of the external world, Ruskin never abandoned completely his dedication to the subject in painting, the "pure facts" from which the color abstraction is derived. He thought that the "abstract value" of painting gained depth, and acquired a kind of spiritual focus, when it was united with the "imitative power." The great masters of color, Turner and Veronese, accomplish both feats at the same time; Veronese can put down two dots of color that form an abstract harmony when seen close up, but stepping back a few feet, the color dots "compose" a precise representation of the visual effect of a pearl.

When Ruskin's sense of color is transferred into literature, his love and delight in color for its own sake becomes more pronounced. In one of Ruskin's stranger critical judgments, he elevates Scott to the chief modern landscape poet, the literary equivalent of Turner, primarily because Scott uses pure color notation in poetry. Ostensibly the reason for preferring Scott to Wordsworth is

the lack of pathetic fallacy, but the aspect of Scott's poetry that Ruskin underlines is his ability to capture an image with "two strokes of colour" or "two dashes of Tintoret's favorite color."[122] Ruskin praises Scott's use of "Turnerian colour" and he will frequently analyze an entire passage of verse, strictly in terms of the "exquisite colour chord given":

> It begins with purple and blue; then passes to gold, or cairmgorm colour (topaz); then to pale grey, through which the yellow passes into black; and the black through broken dyes of lichen, into green.[123]

Ruskin notes, in *Praeterita,* that he himself always tends to see first in color, before he sees forms and lines. He often makes notations of scenes in his diary in terms of the relation of color masses:

> the great valley of level cornfield; half smooth close to the ground, yet yellow and warm with stubble; half, laden with sheaves; the vines in massy green above, with Indian corn, and the rich brown and white cottages in the midst of them.[124]

His description of a thunderstorm in the Apennines is like a color painting in motion:

> A heavy rain cloud, stealing the blue sky inch by inch, till it had left only a strip of amber-blue behind the Apennines, the near hills thrown into deep dark purple shade; the snow behind them, first blazing—the only strong light in the picture—then in shade, dark against the pure sky; the gray above, warm and lurid—. . . below, a copse of willow coming against the dark purples, nearly pure Indian yellow, a little touched with red.[125]

Ruskin obviously took a strong private delight in these color passages, which are difficult for an average reader to follow, unless he is sensitized to responding to pure color. Many of Ruskin's notations, like Turner's color sketches which served as working studies for his paintings,[126] while based on an actual scene, become almost entirely abstract. Thus his description of the Rhône turns into a melodic color harmony progressing from actual pigments to symbolic, imaginary color:

> through bright day and lulling night, the never pausing plunge, and never fading flash, and never hushing whisper, and while the sun was up, the ever answering glory of unearthly aquamarine, ultramarine, violet blue, gentian blue, peacock blue, river of paradise blue, glass of a painted window melted in the sun. . . .[127]

Color becomes both a visible and a spiritual quality for Ruskin; after losing his Protestant faith, he fuses his displaced religion into aesthetic equivalents through the metaphors of his own "invented" science of aspects. He explains that

"purity of colour is dependent on the full energizing of the rays that compose it." This purity is connected with "spirituality, for the essential characteristic of matter is its inertia, whence by adding to it purity or energy we may in some sense spiritualize even matter itself." It is in this refined sense that Ruskin calls color "divine" and sees it as a concrete equivalent of "love" and the "life force," as the "purifying or sanctifying element of material" beauty. Ruskin feels that Turner of all artists reaches the most abstract level of color in painting and also the most sacred. Ruskin observes that

> the peculiar innovation of Turner was the perfection of colour chord by means of scarlet . . . Nor was it only in seeing this colour in vividness when it occurred in full light that Turner differed from preceding painters. His most constructive innovation as a colourist was his discovery of the *scarlet* shadow.

Ruskin goes on to explain that

> this scarlet colour—or pure red, intensified by expression of light,—is, of all three primitive colours—that which is most distinctive. Yellow is of the nature of simple light: blue, connected with simple shade: but red is an entirely abstract colour.[128]

Red acquires a sort of autonomy in Ruskin's private system: "Scarlet is absolute colour, standing alone [and] is more sacred than all the rest; colour generally, but chiefly the scarlet used with the hyssop in the Levitical law, is the great sanctifying element of visible beauty inseparably connected with purity and light."[129]

It is in this exalted sense, color as a spiritualization of matter, that Ruskin returns to see again Veronese's *Solomon and the Queen of Sheba* in the episode of his "unconversion" at Turin. He relates his feeling of sudden horror at the mean-spirited sermon given by a Waldensian preacher in a "suburban chapel" and his flight from this "stale rhetoric" to see Veronese's painting, which marked the definitive end of his Protestant faith:

> Myself neither cheered nor greatly alarmed by this doctrine, I walked back into the condemned city, and up into the gallery where Paul Veronese's "Solomon and the Queen of Sheba" glowed in full afternoon light. The gallery windows being open, there came in with the warm air, floating swells and falls of military music, from the courtyard before the palace, which seemed to me more devotional, in their perfect art, tune, and discipline, than anything I remembered of evangelical hymns. And as the perfect colour and sound gradually asserted their power on me, they seemed finally to fasten me in the old article of Jewish faith, that things done delightfully and rightly were always done by the help and in the Spirit of God.[130]

Ruskin's departure from the church leads him, at this point in his life, not to the consolation of mountains and streams, but to the museum. Instead of turning to Nature, he turns to a painting to give him the sense of spiritual

plenitude; and he turns to Veronese's painting, not because of its capacity to reflect Nature, but in the enjoyment and acceptance of its material beauty, the abstract power of color to purify and delight at the same time. Ruskin's paragraph reflects the spirit of Veronese's composition, even though the "subject" itself is not even mentioned—and the painting is rendered only in terms of pure "glowing" color. Veronese's painting is a mixed whole, composed of the trivial and the sublime, Solomon and the dog. In the same way Ruskin mixes the warm air, the military music, and the glowing color of Veronese: the syntax gives equal prominence to all three sensuous aspects which are combined together in a perceptual "moment," which symbolizes for Ruskin his final acceptance of the "wholeness" of life. The "grotesque" unity of the spiritual and material aspects of existence, which Ruskin had learned to see through Venetian art, is expressed in the fusion of Veronese's color with the band music, blended together in the warm air, a composite delight that seems more religious to Ruskin than any religion that attempts to isolate the soul from its pleasure in visible and material beauty.

Chapter 3

Proust and the Metaphor of Painting

One of the most famous scenes in the vast expanse of *A la recherche du temps perdu* is the death of Bergotte; the manner of Bergotte's death is carefully designed by Proust so that it serves as a point of crystallization, a point around which multiple themes, ideas, and images converge and unite to form a central aesthetic statement, which prefigures the more extended aesthetic credo interlaced with the novelistic action at the "matinée des Guermantes" in *Le Temps retrouvé*. The death of Bergotte supplies the reader with the first hint of the aesthetic triumph which is realized by Marcel at the end of the novel; the theme of art resurrecting the artist is sounded for the first time as Bergotte succumbs to the attacks of his malady at the Vermeer exhibition. The relationship of art, death, life, and time, which is briefly and succinctly stated in the narrator's comments on the death of his "idolized" writer, becomes the major preoccupation of the last section of the novel, where the balancing effect of art against time is expanded, amplified, and illuminated from every angle. The death of Bergotte serves as a germ for the conclusion of the novel in the same way the "madeleine" episode is the germ which unfolds into the recaptured past of Combray.

As Elizabeth Bowen has astutely observed, there are only two instances through *A la recherche* of the narrator stepping into another persona:[1] the primary instance is the entire section of the first volume, "Un amour de Swann," which, as has often been pointed out, is almost detachable from the main body of the book as a separate novel; the other, shorter, and therefore more anomalous instance is the scene of Bergotte's death. One possible explanation for the fact that the narrator abandons Marcel's perspective and writes the scene from inside the character of Bergotte, is that Proust changes the function of Bergotte in the story at the point of his death. In the first two volumes Bergotte represents an imaginary writer, one of a triumvirate of imaginary artists, including Elister the painter and Vinteuil the musician, who operate as aesthetic guides and models for the young Marcel. Through the course of the novel the narrator gradually becomes disenchanted with Bergotte, and no longer responds to the magic of his "silvery" style. Bergotte's death, however, reinvests him with aesthetic depth and power—he himself transcends the sterility of his last years

during the confrontation with the painting of Vermeer. Coincidentally, the narrator's faith in the lasting power of Bergotte's art is reconfirmed. The pattern of Marcel's relationship to Bergotte, from initial enthusiasm and enchantment through disillusion to final reaffirmation parallels the longer span of development of the narrator's own literary vocation. When Marcel writes his youthful passage on the steeples of Martinville he is convinced of his literary ability— a conviction which he loses as the novel continues, until he finally gives up his ambition to become a writer completely and decides to return to the empty world of society and attend, out of boredom, the "matinée" of the Princesse des Guermantes. During the final series of revitalizing sensations, the feeling of his own sterility gives way to a sudden realization of the almost transcendent nature of the "true" literary vocation. His faith in art and in himself as an artist is reconfirmed at the same time. The revelation is triggered by the experiences of involuntary memory, the doubling of present sensations which overlay similar moments in Marcel's past. This experience of simultaneous existence in two moments in time reveals the key which unlocks Marcel's inner life; he discovers that there is an "essence" common to both moments, confined to neither, that he has entered a privileged mental space which is outside time, the vantage point he has been striving to attain for the writing of his novel, which, as he suddenly understands, must be designed to make time visible. But the entire action at the "matinée des Guermantes" is built on another overlay of experience: the narrator's revelation of his vocation doubles the revelation granted to Bergotte in the moment of his death. Proust has constructed the novel so that Bergotte's experience is the corresponding and prefiguring example of the narrator's ultimate vision of himself as a writer. The "idolized" master and the narrator share a coincidence of feeling: although there is no specific doubling in time, the second revelation (of Marcel) is implicitly an overlay of the first: Bergotte's understanding of the relationship of his writing to Vermeer's painting contains the essential metaphor which unfolds in the consciousness of Marcel at the end of the novel. The analogy of writing to painting is a condensed way of expressing the complex of ideas that Marcel unravels in his long discourse on aesthetics at the "matinée des Guermantes": ideas that pertain to the relationship of space and time, that differentiate between life experienced in lineal aridity and life experienced in temporal depth, between the novel as a sequence of events and the novel which achieves the spatial unity of painting, the novel which presents the reader with simultaneous perceptions of various "layers of time."

The incident of Bergotte's death is one of the clearest examples of autobiography transposed into fiction. Proust himself risked death in an effort to leave his famous room and attend an exhibition of Dutch painting at the Jeu de Paume. Peter Quennel describes the journey:

. . . in 1921, about 24 May, instead of following his customary procedure and going
to sleep as soon as day broke, he rose early and despite an alarming attack of vertigo,
managed to travel across Paris to the Jeu de Paume, where he visited an exhibition
of Dutch pictures that included Vermeer's *View of Delft*. It was 'the most beautiful
picture in the world' he decided; and, having seen it, and gazed with his usual pas-
sionate intensity on a 'little patch of yellow wall'–the detail that had so delighted
Bergotte–he lunched at his old haunt, the diningroom of the Ritz, and slowly
struggled home to bed.

From this adventure he derived his magnificent description of the death of
Bergotte–one of the three great creative intelligences, Bergotte the novelist, Elstir
the painter and Vinteuil the composer, evolved by Proust from his personal recollec-
tions of a variety of modern artists. In *A la Recherche du temps perdu,* except for
his mother and grandmother, they are the only characters who escape reproach–
intercessory spirits in whom the author came to believe, as Balzac had believed in
Bianchon, the famous physician of the Comédie Humaine to whose professional skill
he appealed upon his death-bed. On his own deathbed, Proust remarked that, having
himself reached the same condition, he would like to enlarge his account of his
imaginary novelist's final hours; and, when he had dictated the passage to Celeste, he
said that the result was 'very good'. Then, 'I must stop,' he added, 'I can't do any
more.' Some manuscripts were scattered across the bed-clothes; and, during his
agony, Celeste noted that his hands were plucking feverishly at the tumbled pages.[2]

The entire episode was written as a separate unit and inserted into the manu-
script of *La Prisonière* at a later date, and as Quennel points out, the revision of
this section of the book was absolutely the last work of Proust's career as a
writer. The personal nature of the episode itself–as well as the deathbed revi-
sion–reinforces the connection between Proust and Bergotte. Instead of treating
Bergotte consistently, like Elstir and Vinteuil, as a model artist, Proust identifies
his own fate with that of his imaginary writer and in describing his death, the
novelist allows himself to merge with his character. The narrator momentarily
becomes Bergotte, a fusion which never takes place between Marcel and either
Vinteuil or Elstir. The incident is therefore related to the narrator of *A la
recherche* in a different way than the passage describing Marcel's immersion in
the world of Elstir's studio, or his introduction into the world of Vinteuil's
music. Bergotte's visit to the museum, while not an actual part of Marcel's past,
takes on the quality of remembered experience. Although the experience be-
longs to another character, it is as central to Marcel's development as the made-
leine episode or the Vinteuil sonata, and like these passages, it is one of the
primary keys that guide the reader through the aesthetic structure of the book,
before the final retrospective summing up of *Le Temps retrouvé.* The death
scene is prepared for by a description of Bergotte's life during the preceding
several years; we find out that, like Proust, ". . . for years Bergotte had ceased to
go out of doors" but that, unlike Proust, during this period Bergotte has ceased to
write, which reinforces his similarity with the narrator, who has given up litera-
ture. The spiritual shock that Bergotte receives from his perception of Vermeer's

painting, a shock which reawakens his aesthetic faith, is parallel to the shocks
that Marcel receives from his experiences of involuntary memory at the Guer-
mantes reception. As Proust points out throughout the novel, the feeling of
pure sensation, produced by the overlapping of the present and the past, is
similar to the feeling induced by works of art: the joy of tasting the madeleine
is qualitatively the same as the joy produced by the reappearance of the "petite
phrase" of Vinteuil's sonata or the perception of the stylistic "color" of Ber-
gotte's phrases. This distinction is probably rooted in Baudelaire, who finds
that the state of involuntary grace, the experience of "surnaturel" reality which
comes unexpectedly from outside, is similar to the controlled experience of the
"surnaturel" produced by the artist. The central idea that Proust is trying to
convey in Bergotte's confrontation with Vermeer is the release from ordinary
perception, a sudden sense of depth and intensity, which like Baudelaire's 'sur-
naturel' perception, involves a vertiginous plunge into a new and richer space.
This idea, in the first paragraph of the death scene, carries the renewed vision
from painting to writing:

> An attack of uraemia, by no means serious, had led to his being ordered to rest.
> But one of the critics having written somewhere that in Vermeer's *Street in Delft*
> (lent by the Gallery at The Hague for an exhibition of Dutch painting), a picture
> which he adored and imagined that he knew by heart, a little patch of yellow wall
> (which he could not remember) was so well painted that it was, if one looked at it
> by itself, like some priceless specimen of Chinese art, of a beauty that was sufficient
> in itself. Bergotte ate a few potatoes, left the house, and went to the exhibition.
> At the first few steps that he had to climb he was overcome by giddiness. He passed
> in front of several pictures and was struck by the stiffness and futility of so artificial
> a school, nothing of which equalled the fresh air and sunshine of a Venetian palazzo,
> or of an ordinary house by the sea. At last he came to the Vermeer which he remem-
> bered as more striking, more different from anything else that he knew, but in which,
> thanks to the critic's article, he remarked for the first time some small figures in blue,
> that the ground was pink, and finally the precious substance of the tiny patch of
> yellow wall. His giddiness increased; he fixed his eyes, like a child upon a yellow
> butterfly which it is trying to catch, upon the precious little patch of wall. "That is
> how I ought to have written," he said. "My last books are too dry, I ought to have
> gone over them with several coats of paint, made my language exquisite in itself,
> like this little patch of yellow wall." Meanwhile he was not unconscious of the
> gravity of his condition. In a celestial balance there appeared to him, upon one of
> its scales, his own life, while the other contained the little patch of wall so beautifully
> painted in yellow. He felt that he had rashly surrendered the former for the latter.
> "All the same," he said to himself, "I have no wish to provide the 'feature' of this
> exhibition for the evening papers."[3]

One of the major components of the scene is the role played by the unnamed
art critic: the main point of the critical article is apparently the self-sufficiency
of the "petit pan de mur jaune," which seen by itself, is like a separate and
precious work of art. Because Vermeer's "View of Delft" is Bergotte's personal

icon, he is astonished to find that there are aspects of his adored canvas that he has never perceived. Proust had written to a friend in 1921, "since I saw the *View of Delft* I knew that I had seen the most beautiful painting in the world." The text implies that Bergotte also thinks of the painting as a supreme example of the art, a painting which symbolizes the aesthetic value of all "true" painting. Because the *View of Delft* is so close to an aesthetic absolute for Bergotte, he risks everything to go and see it again under the new light cast by the art critic. The critic's words offer Bergotte a form of spiritual grace, a state of aesthetic beatitude which revives the author's spirit, while the effort of perception kills his body; *grâce à l'article du critique* Bergotte is able to see for the first time the small figures in blue, that the sand is pink, and the "petit pan de mur jaune (the little patch of yellow wall)." This new perception reaffirms Bergotte's faith in the power of art; even a painting that he knows by heart can reveal new aspects, a new dimension of depth, a sense of perpetual renewal. And it is specifically the words of the art critic that direct Bergotte to this illumination and inadvertently cause his death. The unnamed art critic is charged with a heavy responsibility; he serves as a spiritual guide for Bergotte, opening for him a new realm of perception, while ultimately, simultaneously, acting as his usher into the region of death.

The relationship of the unnamed art critic to Bergotte is modelled on the relationship of Ruskin to Proust himself. After abandoning the manuscript of *Jean Santeuil,* in a state of spiritual dryness, Proust turned to his work as translator and critic of Ruskin, work that energized and vitalized his forces as a novelist. Ruskin, through his writing on visual art and the process of seeing, gave Proust a new sense of vision which was transferred directly into literature. The best account of Proust's relationship to Ruskin is Proust's own commemorative tribute, *En mémoire des églises assassinées.* In defining his debt to Ruskin, in explaining the impact of Ruskin's words on himself, Proust formulates, on a small scale, the primary components of the aesthetic vision which unifies *A la recherche. En mémoire des églises assassinées* is divided into three sections; in the first, "Journées en automobile" Proust makes an initial sketch of the experience of seeing three steeples collapsed into one, as the trajectory of the automobile takes him through successive points of view, which becomes the "clochers de Martinville" passage in *Du Côté de chez Swann.* The second section, "Journées de pèlerinage," is a discussion of Ruskin's aesthetic in general terms, with alternating translation from *La Bible d'Amiens* and critical comments. The third section, "John Ruskin—La Mort des cathédrales" is focussed on the narrative account of Proust's own "pèlerinage Ruskiniene (Ruskinian pilgrimage)" to see a tiny sculpture or the facade of Rouen cathedral, an episode which condenses his relationship to Ruskin into a single adventure, an adventure which closely resembles the journey of Bergotte to see the "petite pan de mur jaune."

Proust, perhaps, or rather undoubtedly already fictionalizing his pilgrimage,

claims to have been reading a particular page from *The Seven Lamps of Architecture* at the time of Ruskin's death: "I confess that in rereading this page at the moment of Ruskin's death, I was taken with a desire to see the little figure about whom he spoke." Proust quotes the passage, "une page très caratéristique de Ruskin," which describes an extremely small sculpted figure in the corner of one of the decorative quatrefoils on the porch of Rouen cathedral. The context in Ruskin is a defense of the nature of gothic, the workman's freedom to create original, though crude, expression. Proust emphasizes, throughout the entire passage, the minute size of the sculpture:

> He speaks of a little figure of a few centimeters, lost in the thousands of minuscule figures on the porch of the bookstalls at the cathedral of Rouen.

> The upper creature on the left is biting something, the form of which is hardly traceable in the defaced stone—but biting he is; and the reader cannot but recognize in the peculiarly reverted eye the expression which is never seen, as I think, but in the eye of a dog gnawing something in jest, and preparing to start away with it: the meaning of the glance, so far as it can be marked by the mere incision of the chisel, will be felt by comparing it with the eye of the couchant figure on the right, in its gloomy and angry brooding. The plan of this head, and the nod of the cap over its brow, are fine; but there is a little touch above the hand especially well meant: the fellow is vexed and puzzled in his malice; and his hand is pressed hard on his cheek bone, and the flesh of the cheek is *wrinkled* under the eye by the pressure. The whole, indeed, looks wretchedly coarse, when it is seen on a scale in which it is naturally compared with delicate figure etchings; but considering it as a mere filling of an interstice on the outside of a cathedral gate, and as one of more than three hundred (for in my estimate I did not include the outer pedestals), it proves very noble vitality in the art of the time.[4]

Proust changes Ruskin's text in one important respect: he translates as, "si on le compare à des delicates gravures," what in Ruskin reads, "when it is seen on a scale in which it is naturally compared with delicate figure etchings." Ruskin is alluding to his own engraved drawing of the crude little figure, which naturally appears different in the engraving which accompanies the text than it does on the facade of the cathedral itself. Proust is aware of the engraving in the library edition: as he points out later in the passage, Ruskin has emphasized the importance of the little figure by illustrating it:

> Ruskin, who among the very few prints which illustrate his book, gave one to him because he was a present and durable part of his thought.[5]

But Proust discovers, when he goes to Rouen itself, that the difference in scale between the engraving and the cathedral is overwhelming: he feels the hopelessness of trying to see the tiny sculpture in the confusion of images and lights and shadows that form the intricate and dazzling facade of the north porch.

And I went to Rouen, as if obeying a thought from a will, and as if Ruskin in dying had in some way entrusted the poor little figure to his readers, the figure to whom he had given life in writing about him and who had just lost forever, without knowing it, the one who had done as much for him as the original sculptor. But when I drew near the immense cathedral and stood in front of the porch where the saints warmed themselves in the sun, farther up (higher) the galleries where the kings were radiating light, up to the supreme altitudes of stone which I thought were uninhabited and where here also a sculpted hermit lived in isolation, letting the birds rest on his forehead, while, there, a group of apostles listened to the message of the angel who was landing next to them, folding his wings, under the flight of pigeons who were flapping theirs, and not far from a character who receiving a child on his back, turned away his head with a brusque and secular gesture: when I saw arrayed before the portals or leaning from the balconies of their towers all of these hosts of stone of the mystic city breathing in the sun or the morning shadow, I understood that it would be impossible to find among this superhuman race a figure of only a few centimeters. I went, however, to the porch of the bookstalls. But how to recognize the little figure among the hundreds of others? All of a sudden, a young sculptor of talent and future, Mme. Yeatman, said to me "Look, there is one that resembles him." We looked a little lower—and there he was. He didn't even measure ten centimeters.[6]

Proust almost gives up the search, when, miraculously, his eyes fasten onto the image of the little creature, barely ten centimeters in size, whom he is able to pick out of the multitude of "surhumain" figures. The act of seeing the little sculpture, of lifting it out of the "cité mystique," of focussing on something so insignificant in the overabundant visual field, seems impossible to Proust, and yet, because of the acuity of Ruskin's vision, the little figure springs out of the host of other sculpture, and comes to life again in Proust's eyes:

He was crumbling and yet his expression was still there, the stone kept the hole which gave form to the pupil and which gave him the expression which made me recognize him. The artist, dead for centuries, had left there, among thousands of others, this little person who died a little each day, and who had been dead for a long time, lost in the middle of the crowd of others, forever. But he had put him there. One day, a man for whom there is no death, for whom there is no material infinity, no oblivion, a man who, casting the void far from himself, the void which oppresses us all, to pursue the goals which dominated his life, so numerous that he was not able to attain them all (whereas ourselves seemed to lack goals), this man came and in these waves of stone where each lacy form seemed to resemble the others, seeing in that all the laws of life, all the thoughts of the soul, naming them with their names, he said 'Look, it is this, it is that.' As on the day of Judgment, which was represented not from there, he made heard in his words like the trumpet of the archangel and he said "Those who have lived, will live, matter is nothing." And, indeed, similar to the dead, who not far from the figured tympanum, awakened by the trumpet of the archangel, rising, having taken their form, recognizable, living, lo and behold the little figure came to life and refound his glance, and the Judge said "You have lived, you will live." For him, he is not an immortal judge, his body will die, but that does not matter. As if he were not to die he accomplishes his immortal task, not thinking

about the size of the thing which takes up his time, and having but one life to live, he spends several days before one of ten thousand figures on a church. He drew it. It corresponded to the ideas which agitated his mind, careless about approaching old age. He drew him, and he wrote about him. And the harmless and monstrous little figure will have been resurrected, against all hope, from this death which seems more total than the others, this death which is disappearance in the bosom of the infinity of the numbers, and under the levelling of resemblances, but from which genius is also quick in pulling us. In finding it there one can't help being touched. He seems to live and to look around or rather he seems to be caught by death in his very act of looking, like the Pompeiians whose gestures remain interrupted. And it is a thought of the sculptor, indeed, which has been seized here, in its gesture immobilized in stone. I have been touched in finding him there; nothing dies then which has lived, no more the thought of the sculptor than the thought of Ruskin.[7]

Proust emphasizes the components of chance and time in Ruskin's encounter with the little figure; it is only because a particular man, Ruskin, whose whole life has been a training to see minutely, has come along and noticed the averted eye and wrinkled cheek of the little man in the bottom of the quatrefoil, distinguished it "dans ses vagues de pierres où chaque écume dentelée paraissait ressembler aux autres," that the work of the unknown artist is rescued from oblivion. Time is presented as the destructive element, eating away at the little figure, who dies a little every day, while Ruskin, by seeing it and drawing it and writing about it, restores it to life. Proust stresses the immense span of time crossed by the act of perception; Ruskin's vision obliterates the span of time; the little figure is resurrected through Ruskin's words, just as, at the end of time, all figures rise simultaneously, whatever their temporal location, at the sound of the archangel's trumpet. This aesthetic resurrection, as Proust implies, is "close" to the Last Judgment; as he says in *Le Temps retrouvé,* ". . . l'art est ce qu'il y a de plus réel, la plus austère école de la vie, et le vrai Jugement dernier" (III, p. 880). Whatever the artist's intentions or efforts, he is ultimately *judged* by his ability to give a concrete form to his individual vision. In this case Ruskin's "criticism" is creative; like the creator, Ruskin gives new life to things by pulling them out of the void, which he strenuously ignores, and restores them by the act of naming. In naming the little figure with the paragraph of text, Ruskin, as critic, performs an aesthetic act, equal to but different from the original manual activity of the sculptor. Proust's paragraph ends by equating the "pensée de Ruskin" with the "pensée du sculpteur"; Ruskin has done as much for the poor little creature "in speaking of him" as the first sculptor. Ruskin's writing is a second creation, which abolishes the force of Time, and renews the vitality of the original aesthetic impulse, by re-seeing it and giving it a new form in language.

The complexity of Proust's account gathers as he concludes: his "tendresse" for the little figure increases and he begins to "tutoyer" the little man. His intimacy is partially due to the pathetic crudeness of the sculpture; it is

"un pauvre petit monstre," it is ugly, almost uninteresting, insignificant, grotesque. Proust notes in another part of the essay Ruskin's penchant for focussing on the insignificant detail in the paintings of Tintoretto; part of the impact of the little figure is the individuality expressed in even such a rough and minor detail of the cathedral porch. Proust understands that Ruskin's "religion of beauty" is not based on a sense of aesthetic hierarchy; Ruskin devotes both text and illustration to a bit of minor work, in which he discovers the same aesthetic value, the same artistic spirit, that is evident in a more famous example of medieval sculpture, such as the *Vierge Dorée* of Amiens, surrounded by her "parure des aubépines." In *Due coté de chez Swann,* Marcel notices that one facet of the "esprit de Guermantes" is the tendency to seize hold of the insignificant details in a work of art: Swann tells the narrator that he doesn't believe in the "hierarchie" of the arts, enunciating the word, as Marcel observes, with vocal quotation marks, as another aspect of the Guermantes style is to underplay serious opinions. But the Guermantes sophistication, which shuns the obvious in favor of the unnoticed, which glorifies the trivial in order to abash the less initiated, is the mask for a deeply held conviction on the part of the narrator, who also specifically renounces the hierarchy of the arts in *Le Temps retrouvé.* We learn that the novel which is about to be written (and which we have just read) is to be constructed like an unfinished cathedral, or like a dress. Proust intentionally doubles his metaphor in order to deflate his own rhetoric; the vast structure of the book can also be compared to the dressmaker's art, in piecing together effects, in creating an illusion of wholeness. As Proust continues he stretches his aesthetic "hierarchy" to include cooking, so that his novel can be likened to the creation of Françoise, the *boeuf mode,* a perfection of simplicity produced by using the best ingredients and letting them simmer and blend together. The point of the metaphors is to emphasize the concreteness of the work of art—to pull the aesthetic idealism back down to the level of the physical sensations from which it springs. The joy of escaping time is ultimately rooted in the taste of the madeleine, the feel of the unequal paving stones or the texture of the starched napkin; the route to transcendance lies *through* the material aspects of existence. In returning to Proust's Ruskinian pilgrimage, the relation of matter to spirit is intricately stated in the episode of discovering the little figure. The sculpture is embodied materially in the most permanent form possible, stone; but even the stone is subject to the action of Time. As Proust states it, the stone, the medium through which the sculptor's "pensée" is given form, is ultimately immaterial, as it is in the process of returning to dust, but the intercessory "spirit" of Ruskin has given another form to the little figure by resurrecting it in words:

> In meeting him (the little figure) there, which was necessary to Ruskin, who among so few prints which illustrate his book has given him one, because it was for

him an ever present and durable part of his thought, and which was pleasant to us because Ruskin's thought is necessary to us, guide to our own thought which has met his on the way, we felt in a state of mind closer to the artist's who sculpted the tympanum of the Last Judgment and who thought that the individual (and what is most particular in a person, in an intention) does not die and remains in the memory of God and will be resurrected.—At the call of the angel each dead body finds himself remaining in the same place, when we thought he had been turned to dust for a long time. At Ruskin's call, we see the smallest figure which frames a minuscule quatrefoil resurrected in his form, looking at us with the same look which seems to be contained in only a millimeter of stone. Without doubt, poor little monster, I would not have been strong enough among the billions of stones of the cities to find you, to discover your figure, to find again your personality, to call you, to make you live again. But it is not because infinity or number or void which oppresses us are so strong; it is because my thought is not strong enough. To be sure you had nothing in you that was truly beautiful. Your poor face that I would never have noticed doesn't have a very interesting expression, even though of course, it has, like all people, an expression that no one else ever had. But since you lived enough to continue to look with that same oblique glance and to be noticed by Ruskin and after he had spoken your name, so that his readers could recognize you—do you live enough now—are you loved enough now? And one cannot help thinking of you with a special tenderness, although you don't have an air of "goodness" about you, but because you are a living creature, because during such long centuries you have been dead without hope of resurrection, and because you have been resurrected. And one of these days perhaps some other person will come to find you on your porch, looking with tenderness at your wicked, oblique expression which has been resurrected, because what came out of thought can alone fix another thought one day, which in its turn has fascinated ours. You were right to remain there unlooked at, being disintegrated. You could expect nothing from matter where you were only "nothingness." But the small ones have nothing to fear, nor dead ones. Because at times the Spirit visits the earth; on his passage the dead bodies arise and the small forgotten figures find their look and fix the look of the living who for them shun the living who don't live and go search for life only where the Spirit has shown it to them, namely in stones, which are already dust and which are still, at the same time, thought.[8]

What Proust is trying to show is that the original "spirit" of the sculptor that informed the stone is not lost; after a long lapse of time the spirit is extracted from the stone through Ruskin's perception, just as the original world of childhood sensations connected with Combray is not lost, but hidden for a long time within the narrator, who re-extracts the "lost" time from the taste of the madeleine dipped in tea. Spirit is enclosed in matter, but conversely matter can be spiritualized through the consciousness of the observer. The actuality of Combray is potentially lost until the narrator by chance rediscovers it; in a similar way the little figure at Rouen has virtually disappeared until it is reseen by Ruskin: in both cases the spiritual reality owes its potential resurrection to the physical substance which contains it—the stone, the tea-cake—but this preserving substance is liable to decay, likely to be absorbed by Time, unless

the saving act of re-spiritualizing takes place. A corollary aspect in both examples is the conversion of experience into literature. The evanescent taste of the madeleine is captured and fixed by the "rings of style" that Proust uses to enclose the sensation in permanent form. In equating Ruskin's text with the stone figure, Proust implies that words have a concreteness, a substantiality, equal to and perhaps superior to that of the stone itself. Because of the multi-plication of books in print, the little figure has a better chance of continuing its spiritual existence through Ruskin's words than it does in weathering the years at Rouen, where the millimeter of indentation that creates the expression of the eye is in constant danger of disappearing. This idea of the concreteness of language is coupled with the idea of a second creation; Ruskin's prose has a value "indépendante de la beauté de cette statue," the spirit which resurrects has transformed the little figure from "poussière" back to "pensée" by giving a second life in a literary text. This second creation, as Proust maintains, has equal value with the first, as well as the advantage of a new form which is more immune to Time. But Proust, unlike Mallarmé, makes no claim to the absolute transcendance of *le livre:* after a long discussion of the power of litera-ture to "save" experience from disintegration in *Le Temps retrouvé,* Proust finally admits, in a footnote, that books too, as physical objects, are subject to the destruction of Time, and that his own novel, which preserves his individual vision, will also at some point in the future "die" just as his body will, when the final copy returns to dust.

But to return to the Bergotte-Vermeer episode, it is immediately clear that the journey of the writer to see the "petit pan de mur jaune" in the *View of Delft* is similar in its basic components to Proust's Ruskinian pilgrimage to see the little figure at Rouen. Both journeys are prompted and inspired by critical writing; the effect of the unnamed art critic on Bergotte parallels the impact of Ruskin's criticism on Proust. Bergotte and Proust both undertake an act of confirmation; the experience of seeing described in the literature of art criti-cism is tested against the material reality of the stone at Rouen and the precious substance of yellow paint in Vermeer's *View of Delft.* In both episodes there is an emphasis on the apparent insignificance of the artifact; the "petit homme" and the "petit pan de mur jaune" are each small unnoticed details, small parts of the whole work, the painting, the cathedral porch, in which they remain frag-ments until they are given coherence and self-sufficiency through the words of the art critic. Bergotte discovers that the "petit pan" is a work of art in itself, an entirel new "oeuvre" within the painting he knows by heart; Proust discovers the aesthetic integrity of the little sculpture, isolated by Ruskin's perception from the waves of stone that compose the Rouen facade. In both instances, the dis-covery of the aesthetic wholeness of the fragment is also a discovery of the power of art to transcend time. Bergotte is spiritually rejuvenated by his percep-tion of the new aspect of the *View of Delft,* which is materially there for him to

see, long after the death of Vermeer, not as a memory of his own recollected sight of the painting, but an entirely new and "present" vision contained within the substance of the paint on the canvas itself. Just as the little figure at Rouen is recreated through Ruskin, Bergotte himself is resurrected through Vermeer and the art critic.

The similarity of the two episodes creates an effect of mutual illumination: both aesthetic pilgrimages, taken together, help to interpret a fundamental aspect of Proust's thinking about art, the idea of overlay. If the Rouen episode is broken down into primary elements, a whole series of overlays emerges. The original artist, the sculptor, has created the original artifact, the "petit homme" with a wrinkled cheek and malicious eye; then another artist, Ruskin, happens along to re-see the original artifact, and by writing about the experience of perception, creates a second artifact, the literary text, which is based on and overlays the first. Then a third artist, Proust, discovers the second artifact, Ruskin's text, and attempts, personally, to lay the literary experience back over the original artifact, by going to see the little sculpture himself with Ruskin's words in mind. From this encounter a third artifact is created, Proust's text, which is specifically based on correlating the previous two: in Proust's account the literary text and sculpture are balanced, given equal value, and the core of his own experience is the realization of this balance. Without the critical text, the original artifact would have been invisible to Proust; with the text, it is impossible not to see the little sculpture through Ruskin's eyes. Proust's experience is composite, half sculpture, half words. Ruskin's writing overlays and energizes the original work of the sculptor in such a way that the two artifacts become inseparable for Proust. The only access to the stone figure is through the literary overlay, and the verbal text gains depth when it is brought, by Proust, to life again, as he recreates Ruskin's experience of seeing for himself. The final artifact, Proust's account, is therefore added as another "couche"; a future visitor to Rouen, looking for the little figure, will be recreating Proust's recreation of Ruskin's recreation of the original "spirit" which shaped the stone.

This might seem to be an overly complex schematization of the pilgrimage, except for the fact that from the beginning of *A la recherche,* Proust introduces the idea of overlay in every way possible. In the overture, Marcel describes the magic lantern which projects the figures of Geneviève de Brabant and Golo over the walls, curtains and doorknob of his room. The transparent medium, the magic light from the slides, moves fluidly and independently across the objects which serve as its screen; not only is the projected overlay magic, but it functions to change the surface on which it rests, and the room itself is transformed for Marcel through the action of superimposing images on the walls. The effect of overlay destroys the force of habit—and the room is no longer a familiar sanctuary for Marcel, but open, alien space. In an entirely different key, Marcel refers to his grandmother's attempt to introduce several "thicknesses" of art

between himself and the mechanical "vulgarity" of photographs. Instead of giving him photos of famous works of architecture, she prefers to give him a photographic copy of a painting of a building—or, if possible, an etching of a painting of a building. Thus, Marcel is buffered, by three layers of art, from contact with mere machine-copies.

The grandmother's preoccupation is a hint of Marcel's own obsession with doubling, tripling, thickening, multiple layers of experience. Proust gives the reader a full explanation of the significance of overlay in the passage on the steeples of Martinville. The description of the three steeples, seen from a moving automobile, which is used as the preface to the Ruskin articles, and which Proust in this first account compares to a Turner painting, is used again as the conclusion to "Combray," this time seen from the rapid carriage of Dr. Percepied. In the original version Proust describes the two steeples suddenly "joined" by a third, as collapsing together to form a single unit, and then "multiplying" again into three, and finally separating into the two steeples together with the third moving away to resume its proper distance. The episode itself is a graphic illustration of visual overlay as well as optical illusion, an aspect of painting that Proust identifies with Turner and Elstir. In the novel, however, he concentrates on the sight produced by the three steeples seen together as a unit, and omits the collapsing effect, which is used in another and more complex way in connection with depth in Time. The context in the novel is important: the Martinville passage is used as the conclusion to the first section of the novel because it gives the narrator his first concrete realization of his aim to become a writer, and it connects up with the Bergotte episode as well as the final discovery of the literary vocation in *Le Temps retrouvé*. The narrator is feeling impotent; he cannot discover a philosophical basis for writing. Instead he turns to sensations—sights and smells in particular—and tries to penetrate the significance hidden in "impressions," feeling all along that this sensory explanation could never serve as a foundation for literary work. He collects sensations, tries to preserve them in his memory and unlock their meaning for himself, but the sensations disappear as rapidly as they arrive. Finally he is determined to study an "impression," to force himself to persevere until the secret is drawn out. While riding in the carriage with Dr. Percepied, he sees the three steeples come together, and immediately attempts to write down the phrase, which is the form within himself, that "corresponds" to the impression produced by the steeples. The whole passage is prefaced by a reference to Baudelaire and the "correspondance" between the senses and reinforced by comparing Baudelaire's synaesthetic metaphor to certain passages from *Lohengrin* or certain paintings by Carpaccio. The framework of an overlay of aesthetic experience is already suggested; in this case the overlay is similar to the Ruskin episode at Rouen, literature over architecture. Marcel learns that by writing down his impression, he has given a new form to evanescent experience, and for the first time, instead

of losing his sensation, he captures it in his piece of prose. The prose is obviously bad; pretentious, inflated, adolescent, but part of the intention of the passage is to contrast the stylistic difference between the young Marcel and the present narrator. There is a curious effect produced by the two texts juxtaposed in the novel; the initial description the reader encounters, which forms part of the ostensible present in the novel, is a pared-down version of the description in the book on Ruskin. It is followed by a second account, in italics, the recovered artifact supposedly written in the past by the young Marcel, in which Proust takes all the hyperbolic elements of his past "Ruskin" version and exaggerates them. The juxtaposition, in itself, points out the layers of time involved: the original experience, recorded at a later date by the mature narrator, is better than the second version which it precedes in the novel, while the second version, in overlaying the first, which it antedates, brings the reader to an abrupt sense of time elapsed.

In the original "Ruskin" version Proust describes the final swing of the automobile in front of the cathedral, as having the effect of precipitating time:

> The steeples having remained for such a long time unreachable by the effort of our car which seemed to be sliding vainly on the road always at the same distance from them, it was only in the last seconds that the speed of the whole totalized time became appreciable.[9]

All of the totalized time that has elapsed is made abruptly clear in the final movement of the automobile which is suddenly in front of the cathedral porch. This precipitated time, the sense of temporal solidity, is, of course, the missing key in Marcel's experience in the novel. It is not until the end of the book that Marcel discovers the true secret of sensations in allowing him a vantage point outside the temporal flux, an escape into the double space of moments which overlay each other. Proust naturally leaves the Martinville episode incomplete— as the final revelation of the narrator's literary vocation and its relation to layers of time must be deferred to *Le Temps retrouvés.* But as an epilogue to the Martinville passage, on the final page of the "Combray" section, Proust provides a clue to the idea of temporal overlay, in terms that parallel the spatial overlay of the three steeples collapsed together in the "Ruskin" version. The narrator says:

> And so I would often lie until morning, draming of the old days at Combray, of my melancholy and wakeful evenings there; of other days besides, the memory of which had been more lately restored to me by the taste—by what would have been called at Combray the 'perfume'—of a cup of tea; and, by an association of memories, of a story which, many years after I had left the little place, had been told me of a love affair in which Swann had been involved before I was born; with that accuracy of detail which it is easier, often, to obtain when we are studying the lives of people who have been dead for centuries than when we are trying to chronicle those of our

own most intimate friends, an accuracy which it seems as impossible to attain as it seemed impossible to speak from one town to another, before we learned of the contrivance by which that impossibility has been overcome. All these memories, following one after another, were condensed into a single substance, but had not so far coalesced that I could not discern between the three strata, between my oldest, my instinctive memories, those others, inspired more recently by a taste or 'perfume,' and those which were actually the memories of another, from whom I had acquired them at second hand—no fissures, indeed, no geological faults, but at least those veins, those streaks of colour which in certain rocks, in certain marbles, point to differences of origin, age, and formation.[10]

The three strata of memory that are fused together, like the three steeples that seem to form a single spire, are not fully understood until the end of the novel when Marcel is able to look back through the multiplied layers of his life, telescoped together into a single substance.

Returning again to the scene of Bergotte's death, we can see the parallel with Ruskin at Rouen in terms of overlay. The art critic has provided a second artifact, the literary text, which Bergotte uses as a magnifying lens for his new vision of the *View of Delft*. In using this lens Bergotte is able to see something which he had literally never seen before. Just as Ruskin's optical prose has the effect of giving the reader new sight, removing the blindness of habit, and educating the eye to see what had been invisible, the function of the unnamed art critic is to remove Bergotte's habitual "idea" of the *View of Delft* and to confront him with the precious substance of the "petit pan de mur jaune." What Bergotte sees in the "petit pan" is the technique of overlay in operation: the successive "couches de couleur" that Vermeer has laid over the canvas create the sensation of depth, "profondeur," and richness which gives the "petit pan" the self-sufficiency of a separate "oeuvre d'art chinois." But the technique of overlay that Bergotte sees in the painting is taken a step further as Bergotte applies the visual principle to literature: the idea of aesthetic overlay is introduced—painting over literature—which is the true essence of the revelation. Bergotte wants to copy Vermeer, to translate the "couches de couleur" into a literary equivalent, to make his phrases themselves, the verbal matter, precious like the paint. Proust is fusing two separate ideas in the analogy of writing to painting; first that the part, a section of a novel, a paragraph, a sentence, a metaphor, should have self-sufficiency and second, that this self-sufficiency can be achieved through technical refinement, the reworking of the material with successive stylistic changes, until it has depth, substantiality, concreteness like the "petit pan de mur jaune."

The metaphor of painting is central to Proust; he uses it in the most general way in the Bergotte episode to underline the tangibility of words. The words of the art critic have revealed the layers of colored paint to Bergotte, who turns from painting back to literature, by comparing the substance of the paint to the materiality of language. Just as Proust equates Ruskin's words

with the stone sculpture at Rouen, Bergotte dreams of approximating the physicality of paint in his own verbal art. Although the concept of "tangible" language was diffused by Symbolist writers in France during the 1880s and 1890s, Proust goes farther back for his own points of reference. He specifically compares Baudelaire and Ruskin as two writers who savor the physical properties of words. In his translation of Ruskin's *Sesame and Lilies,* Proust comments on Ruskin's precise exegesis of Milton's metaphor of "blind mouths" (see Chapter 2, pp. 87-88):

> . . . Ruskin is intoxicated in finding at the heart of each word its hidden sense, antique and delicious. A word is for him the gourd filled with memory of which Baudelaire speaks. Even outside of the beauty of the sentence in which it is placed (and there begins the danger) he venerates the word. And if one misunderstands what it contains (in using it falsely) he cries sacrilege (and in that he is right). He is astonished by the secret virtue which exists in a word, he marvels over it; in pronouncing this word in the most commonplace conversation, he notes it, repeats it, shouts it. By that he gives to the most simple things, a dignity, a grace, an interest, a life which made those who approached him prefer his conversation to practically all others. But from the point of view of art one can visualize the dangers for a writer less gifted than he: words are beautiful in themselves but we count for nothing in their beauty. There is no more merit for a musician to employ a mi than a so; therefore, when we write we must consider words at the same time as works of art of which we must comprehend the deepest signification and of which we must respect the glorious past and as simple notes which only acquire value (in relation to us) through the position which we give to them and by the rapports of reason or emotion which we construct between them.[11]

Proust sees that Ruskin, like Baudelaire, is attracted to the mysterious savor of words, their hidden essence, their unaccountable presence as objects "beaux en elles mêmes." But he also points to the danger of this kind of particularity, the tendency to focus too closely on the individual unit, and to forget the reciprocal effect of words on each other, their *relative value,* which Baudelaire so often describes. But as Proust implies, Ruskin's genius prevented him from falling into the trap of "idolizing" words, so that his works have a universality that absorbs his minute attention to language in a larger purpose.

An extension of the notion of concrete language is the idea of the book as a physical object. Proust was probably familiar with the doctrine of Mallarmé and the Symbolists—*le livre* as a special kind of magical object—but again he returns to Ruskin as an earlier and less transcendental source for the same idea. In *Sesame and Lilies,* Ruskin makes the same distinction that Mallarmé does between "les mots de la tribu" and the language of art, but in terms of true books as opposed to "books of the hour." Ruskin is trying to differentiate between speech and writing, between talking to friends and contemporaries who supply us with news of the day, and the "company" of writers locked in "those plainly furnished and narrow ante-rooms, our bookcase shelves." Ruskin

is arguing that a large number of books are no more than printed talk, as ephemeral as everyday conversation.

> For all books are divisible into two classes, the books of the hour, and the books of all time. Mark this distinction—it is not one of quality only. It is not merely the bad book that does not last, and the good one that does. It is a distinction of species. There are good books for the hour, and good ones for all time; bad books for the hour, and bad ones for all time.
> . . . Our friend's letter may be delightful, or necessary, today: whether worth keeping or not, is to be considered. The newspaper may be entirely proper at break-fast time, but assuredly it is not reading for all day. So, though bound up in a volume, the long letter which gives you so pleasant an account of the inns, and roads, and weather, last year at such a place, or which tells you that amusing story, or gives you the real circumstances of such and such events, however valuable for occa-sional reference, may not be, in the real sense of the word, a "book" at all, nor, in the real sense, to be "read." A book is essentially not a talking thing, but a *written* thing; and written, not with a view of mere communication, but of permanence. The book of talk is printed only because its author cannot speak to thousands of people at once; if he could, he would—the volume is mere multiplication of his voice. You cannot talk to your friend in India; if you could, you would; you write instead: that is mere conveyance of voice. But a book is written, not to multiply the voice merely, not to carry it merely, but to perpetuate it. The author has something to say which he perceives to be true and useful, or helpfully beautiful. So far as he knows, no one has yet said it; so far as he knows, no one else can say it. He is bound to say it, clearly and melodiously if he may; clearly at all events. In the sum of his life he finds this to be the thing, or group of things, manifest to him;—this, the piece of true knowledge, or sight, which his share of sunshine and earth has permitted him to seize. He would fain set it down for ever; engrave it on rock, if he could; saying, "This is the best of me; for the rest, I ate, and drank, and slept, loved, and hated, like ano-ther; my life was as the vapour, and is not; but this I saw and knew: this, if anything of mine, is worth your memory." That is his "writing"; it is, in his small human way, and with whatever degree of true inspiration is in him, his inscription, or scrip-ture. That is a "Book."[11]

Just as Mallarmé contrasts *le livre* with the newspaper, Ruskin distinguishes between print, as the multiplication of a voice, and print as the medium for recording an individual vision in perpetuity. The implication of the passage anticipates the Symbolist concept of the book as a transcendental object: for Ruskin a "Book" is written down as if engraved on rock; it is a solid, permanent document meant to be read and re-read and read again as it contains an un-limited store of information. Proust transposes this whole section of *Sesame and Lilies* into the first volume of his novel; Swann is discussing journalism with Marcel's aunts who continue to make oblique and baffling references to the appearance of Swann's name in "Le Figaro." Swann replies to tante Céline:

> "The fault I find with our journalism is that it forces us to take an interest in some fresh triviality or other every day, whereas only three or four books in a lifetime

give us anything that is of real importance. Suppose that, every morning, when we tore the wrapper off our paper with fevered hands, a transmutation were to take place, and we were to find inside it—oh! I don't know; shall we say Pascal's *Pensées*?" He articulated the title with an ironic emphasis so as not to appear pedantic. "And then, in the gilt and tooled volumes which we open once in ten years," he went on, shewing that contempt for the things of this world which some men of the world like to affect, "we should read that the Queen of the Hellenes had arrived at Cannes, or that the Princess de Leon had given a fancy dress ball. In that way we should arrive at the right proportion between 'information' and 'publicity.' "[13]

But Proust, in a sense, resolves the conflict that Swann feels between writing for the "hour" and writing for "all time." All of the momentary sensations experienced by Marcel, all of the trivial details of the parties at the Verdurin *Salon*, at Mme de Ste-Euverte's, at the Princesse des Guermantes, are fitted together in a novel, a "book for all time," which is recorded in a form that approaches permanence, like the stone of a cathedral, but which is nevertheless ultimately as fragile as the fabric of a dress. The permanence of literature, the preservation of an individual vision, is a major theme in the novel, which brings us back once again to the metaphor of the Vermeer painting.

Painting, for Proust, not only supplies the writer with an analogy for concreteness, but an analogy that pertains to form and total vision as well. To explore the metaphor revealed to Bergotte through Vermeer and the art critic, it is necessary to examine a key passage that connects Vermeer with music, literature, and the imaginary painter Elstir. Marcel is trying to explain to Albertine the spiritual reality contained in the "petit phrase" of Vinteuil's sonata, which reappears in the septet:

It is not possible that a piece of sculpture, a piece of music which gives us an emotion which we feel to be more exalted, more pure, more true, does not correspond to some definite spiritual reality. It is surely symbolical of one, since it gives that impression of profundity and truth. Thus nothing resembled more closely than some such phrase of Vinteuil the peculiar pleasure which I had felt at certain moments in my life, when gazing, for instance, at the steeples of Martinville, or at certain trees along a road near Balbec, or, more simply, in the first part of this book, when I tasted a certain cup of tea.

Without pressing this comparison farther, I felt that the clear sounds, the blazing colours which Vinteuil sent to us from the world in which he composed, paraded before my imagination with insistence but too rapidly for me to be able to apprehend it, something which I might compare to the perfumed silkiness of a geranium. Only, whereas, in memory, this vagueness may be, if not explored, at any rate fixed precisely, thanks to a guiding line of circumstances which explain why a certain savour has been able to recall to us luminous sensations, the vague sensations given by Vinteuil coming not from a memory but from an impression (like that of the steeples of Martinville), one would have had to find, for the geranium scent of his music, not a material explanation, but the profound equivalent, the unknown and highly coloured festival (of which his works seemed to be the scattered fragments,

the scarlet-flashing rifts), the mode in which he 'heard' the universe and projected it far beyond himself. This unknown quality of a unique world which no other composer had ever made us see, perhaps it is in this, I said to Albertine, that the most authentic proof of genius consists, even more than in the content of the work itself. "Even in literature?" Albertine inquired. "Even in literature." And thinking again of the monotony of Vinteuil's works, I explained to Albertine that the great men of letters have never created more than a single work, or rather have never done more than refract through various mediums an identical beauty which they bring into the world.[14]

This passage is rich to overabundance in "correspondances": Marcel's own impressions, Martinville and the madeleine, are equated with the sensations produced, in an organized fashion, by works of art and at the same time the various forms of art, literature, music, painting are equated on the basis of their similar function; a work of art in whatever form serves as a lens for distilling the essence of the artist's vision and projecting this "monde unique" into the universe outside the artist himself. The work of art captures the light of another world, the spiritual reality that lies within and beyond the artist at the same time, and makes it visible to others. Thus music is described in terms of painting—the septet is colored scarlet. It serves, like literature, to refract Vinteuil's musical vision and project it into the outer world, just as the sonata had refracted this same vision and projected it into another form. As Michel Butor has pointed out, there are internal references within the descriptions of the sonata and the septet which correspond to similar terms used in depicting Elstir's imaginary painting, *Le Port de Carquethuit*. Butor argues that Proust has intended for the painting to function as a prism which refracts the sonata into the septet, so that the coloration of Vinteuil's earlier work is expanded, as it passes through the lens of Elstir's "world," into the new coloration of the septet. Proust himself underlines the change: "Le rougeoyant septuor différait singulièrement de la blanche sonate." But whether or not Proust intended this specific effect, it is clear that he intends to overlay music with analogies to painting (the septet is also related to Bellini and Mantegna), to overlay painting with analogies to literature (Elstir's canvas is described in terms of Symbolist metaphor), and to compare literature to all the other arts, major and minor, in order to establish the concrete spiritual reality that lies behind and connects all forms of aesthetic experience. As J.M. Cocking has noted, the most dominant of these analogies is the comparison of literature to painting, and as the novel progresses, painting replaces music as the aesthetic form best suited to explain the structure of Proust's thought and serve as the model for his book.

In following up the connection between Vermeer and Vinteuil, we must continue with Marcel's conversation with Albertine. He asks her about a comment that she has made concerning the "world" of Vermeer's painting:

You told me that you had seen some of Vermeer's pictures, you must have realised that they are fragments of an identical world, that it is always, however great the genius with which they have been recreated, the same table, the same carpet, the same woman, the same novel and unique beauty, an enigma, at that epoch in which nothing resembles or explains it, if we seek to find similarities in subjects but to isolate the peculiar impression that is produced by the colour. Well, then, this novel beauty remains identical in all Dostoievski's works.[15]

What Marcel is trying to show Albertine is the essential similarity between painting and literature: Vermeer's canvases are all fragments of a larger "world" which is bound together, not only by identical "subjects," but more importantly by the "color" of his style; in a parallel way the beauty of Dostoevsky's novels lies in their stylistic essence—the color of his vision. Marcel differentiates between "Les idées de tableaux" in Dostoevsky, which are generally stupid, and the coloration of his world, which is the secret unity of his work:

As, in Vermeer, there is the creation of a certain soul, of a certain colour of fabrics and places, so there is in Dostoievski creation not only of people but of their homes, and the house of the Murder in *Crime and Punishment* with its dvornik, is it not almost as marvellous as the masterpiece of the House of Murder in Dostoievski, that sombre house, so long, and so high, and so huge, of Rogojin in which he kills Nastasia Philipovna. That novel and terrible beauty of a house, that novel beauty blended with a woman's face, that is the unique thing which Dostoievski has given to the world, and the comparisons that literary critics may make, between him and Gogol, or between him and Paul de Kock, are of no interest, being external to this secret beauty. Besides, if I have said to you that it is, from one novel to another, the same scene, it is in the compass of a single novel that the same scenes, the same characters reappear if the novel is at all long.[16]

Albertine asks Marcel to explain an earlier comment about "le côté Dostoievsky de Mme de Sévigné" and Marcel replies:

What I meant was that Mme. de Sévigné, like Elstir, like Dostoievski, instead of presenting things in their logical sequence, that is to say beginning with the cause, shews us first of all the effect, the illusion that strikes us. That is how Dostoievski presents his characters. Their actions seem to us as misleading as those effects in Elstir's pictures where the sea appears to be in the sky. We are quite surprised to find that some sullen person is really the best of men, or vice versa.[17]

By the end of the passage Vermeer has been included in a family of artists, comprised of the very real and very different writers, Dostoevsky and Mme de Sévigné, as well as Prousts' imaginary artists, Vinteuil and Elstir. The family resemblance is based on two related concepts. First that an artist's work constitutes a total "oeuvre," "un monde," and that any piece of the whole will reflect the coloration of the total vision in the part. Thus a single novel by Dostoevsky, a scene in a novel, the description of a room, like a single painting

by Elstir or Vermeer, or a fragment of a painting like the "petit pan de mur jaune," will contain the same essence or color that characterizes the vision as a whole. The second family trait is the tendency to represent the effect before the logical cause is known; in short, to place sensory knowledge before intellectual knowledge. "Color" precedes "subject," style is more intrinsic than content, effect goes before causal explanation. Proust fuses these two family traits together in his definition of *style as vision,* but in order to see verbal color as Proust sees it, it is necessary to look at the family traits one at a time.

First of all, Proust is trying to establish the significance of the fragment and its ability to reflect a larger whole. He compares the reappearance of "phrases-types" in Vinteuil's music with the repeated motifs in Elstir's painting:

> And yet these so widely different phrases were composed of the same elements, for just as there was a certain universe, perceptible by us in those fragments scattered here and there, in private houses, in public galleries, which were Elstir's universe, the universe which he saw, in which he lived, so to the music of Vinteuil extended, note by note, key by key, the unknown colourings of an inestimable, unsuspected universe, made fragmentary by the gaps that occurred between the different occasions of hearing his work performed . . .[18]

All of the fragments together hint at the existence of a "univers insoupconné" from which they derive. Each artist, as Proust says, is the citizen of an unknown country to which he attempts to return through his works. This unknown country is the spiritual reality which is the source for all his endeavors at realization. As the artistic process is refined, the work approaches the visionary reality more completely:

> When his vision of the universe is modified, purified, becomes more adapted to his memory of the country of his heart, it is only natural that this should be expressed by a general alteration of sounds in the musician, as of colours in the painter.[19]

Thus the "petit phrase" of Vinteuil's sonata is a reflection, on a small scale, of the vast universe of Vinteuil's unknown country; the septet is an expansion of this same vision which reveals the contours of the country with greater precision. The main point for Proust is that even a fragment, a small piece of a work or true art, has the power to open up a new universe, to give concrete form to a whole "monde" that would otherwise be lost with the death of the artist. The young Marcel delights in particular phrases in Bergotte's writing that seem to have a stylistic similarity; even before he understands the meaning of the words, he responds in an almost physical way to the "color" of Bergotte's phrases. In these special phrases, the essence of Bergotte's vision is revealed directly to Marcel, just as Swann is able to feel the direct impact of Vinteuil's universe through the fragment of the "petit phrase" alone. Towards the end

of *Le Temps retrouvé* Proust makes a final pronouncement that equates litera-
ture and painting on the basis of style as vision:

> For style is for the writer, as for the painter, a question, not of technique but of
> vision. It is the revelation—impossible by direct and conscious means—of the quali-
> tative differences in the way the world appears to us, differences which, but for art,
> would remain the eternal secret of each of us. Only by art can we get outside our-
> selves, know what another sees of his universe, which is not the same as ours and the
> different views of which would otherwise have remained as unknown to us as those
> there may be on the moon. Thanks to art, instead of seeing only one world, our
> own, we see it under multiple forms, and as many as there are original artists, just
> so many worlds have we at our disposal, differing more widely from one another
> than those that roll through infinite space, and years after the glowing center from
> which they emanated has been extinguished, be it called Rembrandt or Vermeer,
> they continue to send us their own rays of light.[20]

A writer's words, like the painting of Vermeer, continue to send their own par-
ticular color, the unique light and vision of an individual universe, across the
void of Time. This metaphor, of an extinguished star, technically dead, but
whose light is still traveling across space, which Proust applies to Rembrandt and
Vermeer, is a metaphor which he takes from and applies to Ruskin himself who
had used it as an epitaph for Turner. In "En mémoire des églises assasinées"
Proust says of Ruskin:

> Dead, he continues to shed light on us, like those extinguished stars from which the
> light is still reaching us, and one could say of him what he said at the death of
> Turner: "It is through these eyes, closed forever at the bottom of the tomb, that
> generations who are not yet born will see nature."[21]

Vermeer, Ruskin, Turner: again a family of artists who illustrate for Proust the
miraculous power of paint or print to transmit an individual vision across the
intervening density of Time.

Because Proust sees the power of even a fragment to send out rays of
light from the unknown country of art, he emphasizes the smallness of the
containers of aesthetic revelation. Throughout the novel, the key to the "univers
insoupçonné" is hidden in small things: the taste of the madeleine, the feel of
the starched napkin and the uneven paving stone are normally minute sensations,
which however, because of the wealth of time condensed into the insignificant
objects, are capable of expanding into whole worlds of recollected experience.
Similarly, the "petit phrase" for Swann, the "petit pan de mur jaune" for
Bergotte, like the "petit homme" for Ruskin at Rouen, are examples of a new
universe contained within something small and previously insignificant. Ruskin
sees the entire Gothic aesthetic, the medieval "universe" expressed in the little
figure, Bergotte rediscovers the reality of aesthetic experience in the "petit pan"

and Swann is reminded of the transcendental world of art when he hears the "petit phrase." But Proust uses Swann as a cautionary figure, a failed artist, who like Bergotte and Marcel, is offered an experience of rejuvenation, which he refuses to complete. When Swann first encounters the "petit phrase" in Vinteuil's sonata, he singles it out as a fragment, a portion of the whole like the "petit pan," which forms a unit of music in Swann's mind, a unit that Proust equates with an "image." This "moment" of music, lifted out of the temporal flow of the sonata, takes Swann above his normal level of aesthetic appreciation, and places him on the edge of a transcendent realm. Because the fragment is a magical condensation of the essence of the artist's universe, it has the power to remind Swann of the real existence of the other world of art. Swann hears the "petit phrase"when it reappears in the septet: like Ruskin's encounter with the little figure it is by chance that Swann rediscovers the key to perception; the "petit phrase" like the "petit homme" is the secret object which contains a vision that was temporarily lost. But when Swann hears the phrase again, and feels himself rising above the lost time that has passed since he first heard the sonata at the Verdurin "Salon," his response should be to prove his revived faith in art by working at his own art of criticism, and writing the book on Vermeer that he has been planning to write for years. But Swann allows the revelatory "moment" to sink back into the abyss of Time, and instead of becoming an artist himself by writing on Vermeer, he returns to society and the effect generated by the "petit phrase" is dissipated. Swann could have been the unnamed art critic who, like Ruskin, turns criticism into creative work, and supplies Bergotte with a new vision of Vermeer. Bergotte himself goes a step further than Swann; after the revelation of the "petit pan" he plans to start writing again in a new way, but dies before he can carry out his imitation of the painter's technique. It is finally Marcel who profits from the momentary revelations of the paving stone and the starched napkin and turns the vision of his own life lived in Time into a novelistic work of art.

When we go back to the second family trait, the Dostoevsky side of Mme de Sévigné, we are taken more immediately to the metaphor of painting. Proust is describing a particular literary technique, the presentation of sensory effects before the intellectual reason for these effects is given, and he uses a comparison to the painting of Elstir to illustrate his point. Thus Proust moves from Vermeer to Dostoevsky and Mme de Sévigné, and then compares their literary technique back to the imaginary canvas that he has invented to exemplify the aesthetic of painting, *Le Port de Carquethuit,* which is analyzed in terms of literary metaphor. As J.M. Cocking points out, Proust decided at a later date to expand the section on the "world" of Elstir's studio in *A l'ombre de jeunes filles en fleur* because the metaphor of painting served his ultimate purposes better than the musical theme introduced in the first volume with Vinteuil's sonata:

Albert Feuillerat has pointed out, after examining the proofs of the pre-war un-
printed edition of this part of the book, that most of the account of the main Elstir
episode was added as an afterthought; yet the ideas it conveys fit most wonderfully
into the existing structure and improve both the pattern and the coherence. Again
they are selected for a special purpose. It is useless to expect from Proust a complete
aesthetic of painting or even of Impressionism, which is the kind of painting Proust
obviously has in mind here. He is concerned to stress his favourite points; to use some
very particular observations on painting to support his view of literature and to
suggest, at the same time, that his view of literature fits into a comprehensive view of
all modes of art. In fact, this more lately elaborated passage supports the main con-
clusions of *Le Temps retrouve* in greater detail than the passages on Vinteuil and
music, many of which belong to the period when Proust's general plan was not clear
enough to force its pattern on experience. In writing of Elstir's painting Proust knows
more exactly what he is trying to demonstrate, and the evidence is marshalled and
presented accordingly. Elstir is often said to be based on the French impressionist
painters, and different critics favour different names; what is too often forgotten—
though it has been clearly enough demonstrated—is that much of the material of this
episode is worked up from suggestions Proust noted in his study of Ruskin. Behind
his comments we can see Ruskin's writing on mediaeval architecture, Ruskin's
remarks on Turner, and Turner's remarks as reported by Ruskin or by Robert de la
Sizeranne who wrote a book introducing Ruskin's 'religion of beauty' to the
French.[22]

As Cocking also notes, the bulk of the Elstir material is more directly related
to Proust's work on Ruskin and Ruskin's writing on Turner than it is to the
numerous French Impressionist painters who have been suggested as the models
for Elstir. Marcel's introduction to the universe of painting actually begins
with a Baudelairian metaphor; Elstir's studio is an alchemical laboratory for
the transformation of the world into various rectangles of canvas; the physical
nature of the medium is emphasized as well as the transcendent action of re-
cording a particular vision, and the relationship between reality and the rec-
tangles of canvas opens up a new "poetical" understanding for Marcel. Proust
gives a full scale rendition of an imaginary rectangle of canvas, Elstir's *Port de
Carquethuit,* which, like Ruskin's descriptions of a Turner painting, is organized
around a perceptual process. Just as, in the *Chateau of Prince Albert* passage,
Ruskin tries to make the reader see the flat surface and the flashing reflections
in alternation, Proust tries to make the reader see the transposition of terrestrial
and marine elements. The whole point of the composition is the way in which
the painter has refused to draw an absolute line of demarcation between the sea
and the land, so that houses appear to float, boats resemble buildings, air and
water intermingle, to produce an optical illusion which is based on the visual
facts themselves. Proust compares this metamorphosis of elements to the fusion
that takes place between the components of a metaphor in language: the simi-
larity is that, in paint or in words, the phenomenon is perceived in a new light,
reinvented in terms of the artist's vision. Just as Proust had compared Ruskin to

the creator in giving names to things, like the little figure at Rouen, he compares Elstir to God the Father:

> Naturally enough, what he had in his studio were almost all seascapes done here, at Balbec. But I was able to discern from these that the charm of each of them lay in a sort of metamorphosis of the things represented in it, analogous to what in poetry we call metaphor, and that, if God the Father had created things by naming them, it was by taking away their names or giving them other names that Elstir created them anew. The names which denote things correspond invariably to an intellectual notion, alien to our true impressions, and compelling us to eliminate from them everything that is not in keeping with itself.
>
> But the rare moments in which we see nature as she is, with poetic vision, it was from those that Elstir's work was taken.[23]

Elstir, like Ruskin, gives things new names by removing the veil of habitual sight: the vision that Proust describes in *Le Port de Carquethuit* is precisely the same as Ruskin's innocent eye—the ability to see the world without intellectual or emotional distortion—to see with an eye educated to disregard conventions of representation. Elstir's genius is his ability to paint a scene with visual purity, undisturbed by prior intellectual knowledge:

> Now the effort made by Elstir to reproduce things not as he knew them to be but according to the optical illusions of which our first sight of them is composed, had led him exactly to this point; he gave special emphasis to certain of these laws of perspective, which were thus all the more striking, since his art had been their first interpreter.[24]

Elstir's paintings produce a certain effect, primarily and directly, and then, later, the reason can operate to untangle the visual puzzle, which is only puzzling because the optical truth that Elstir records is based on "innocent" vision—seeing things as they actually appear to the eye. It is this same preference for truth of the senses, as opposed to intellectual knowledge, that Proust points out in relating a story about Turner in one of his Ruskin articles. While Turner is painting a ship off the coast of England, a naval officer, watching him work, objects to the fact that Turner has left the hatchcovers out of the picture. Turner admits that he knows perfectly well that the ship has hatchcovers: "Yes, said Turner, I know that, of course, but my business is to draw what I see, not what I know."[25] As Proust goes on to describe Elstir, it is in terms that correspond exactly to the Turner incident; Elstir deliberately strips himself of "every intellectual concept" when he sits down to paint, so that when face to face with reality, his eye will be a clear lens for perceiving visual effects. As Proust catalogues the effects in Elstir's painting, the parallels with Ruskin's descriptions of Turner increase. Elstir's canvases are studies of the illusions produced by winding rivers, bays, inlets, reaches of water enclosed by land, all

of which reflect the general law stated in *Le Port de Carquethuit,* that the effect
on the eye is a more important aspect of landscape, or seascape, than a rational
topography. The whole list reads like Ruskin's chapter of *Modern Painters,* "Of
Water, as Painted by Turner." And Proust in his notebook reminder to himself
plans to fill the Balbec episode with "Turneresque seas." One particular painting
that Proust describes produces the same illusion that Ruskin points to in
Turner's *Nottingham Castle* (see p. 80) where the reflection of the castle in
water has equal value with the reality. As Ruskin describes the relationship, the
reflected image is like an entire separate painting within the painting (com-
parable in this respect to the "petit pan" in the *View of Delft.*) In Elstir's
version, the reflection is an equal counterpart to the principal image of the
castle, thus forming a perfect circle:

> a castle crowned with a tower appeared as a perfect circle of castle prolonged by a
> tower at its summit, and at its foot by an inverted tower, whether because the excep-
> tional purity of the atmosphere on a fine day gave the shadow reflected in the water
> the hardness and brightness of the stone, or because the morning mists rendered the
> stone as vaporous as the shadow.[26]

Elstir's painting is almost a "mirage," just as Turner's "Nottingham" records
an optical illusion based on the transposition of light and dark values and the
startling reversal of these values when reflected in the water. The last painting in
the catalogue of Elstir is a mountain scene that Proust uses twice again in his
book as a specific metaphor. At this point in the novel the painting is described,
but its significance as a symbol is not underlined:

> (And since Elstir's earliest work belonged to the time in which a painter would make
> his landscape attractive by inserting a human figure), on the cliff's edge or among the
> mountains, the road, that half human part of nature, underwent, like river or ocean,
> the eclipses of perspective. And whether a sheer wall of mountain, or the mist blown
> from a torrent, or the sea prevented the eye from following the continuity of the
> path, visible to the traveller but not to us, the little human personage in old-fashioned
> attire seemed often to be stopped short on the edge of an abyss, the path which he
> had been following ending there, while, a thousand feet above him in those pine-
> forests, it was with a melting eye and comforted heart that we saw reappear the
> threadlike whiteness of its dusty surface, hospitable to the wayfaring foot, whereas
> from us the side of the mountain had hidden, where it turned to avoid waterfall or
> gully, the intervening bends.[27]

The general outline of the painting is based on the successive reappearance of
the road, and the intervening space which blocks it temporarily from view.
When this painting reappears the second time, Elstir's version is specifically
related to Turner, and connected tangentially to "an exhibition of Dutch paint-
ing." Marcel is looking out of his window in Paris at the Hôtel des Guermantes
across the courtyard, and he sees in the series of windows, an analogy to a group

of Dutch paintings, all related by a spiritual family resemblance, just as in another part of the novel, he discovers in a roomful of Elstirs, that the paintings reflect the spiritual unity of the painter's vision, rather than a number of different "subjects." But when Marcel observes the valets de chambre running up and down steps, reappearing on different floors, he is reminded of an Elstir, or a Turner painting of St. Gothard pass, with a traveller reappearing simultaneously at different sections of the continuous but visually broken road:

> And then also, the extreme proximity of the houses, with their windows looking opposite one another on to a common courtyard, makes of each casement the frame in which a cook sits dreamily gazing down at the ground below, in which farther off a girl is having her hair combed by an old woman with the face, barely distinguishable in the shadow, of a witch: thus each courtyard provides for the adjoining house, by suppressing all sound in its interval, by leaving visible a series of silent gestures in a series of rectangular frames, glazed by the closing of the windows, an exhibition of a hundred Dutch paintings hung in rows [juxtaposés].

> When its large paned windows, glittering in the sunlight like flakes of rock crystal, were thrown open so as to air the rooms, one felt, in following from one floor to the next the footmen whom it was impossible to see clearly but who were visibly shaking carpets, the same pleasure as when one sees in a landscape by Turner or Elstir a traveller in a mail-coach, or a guide, at different degrees of altitude on the Saint-Gothard.[28]

Marcel sees the glass rectangles of the windows, like the rectangles of Elstir's canvases, as a number of juxtaposed Dutch pictures at an exhibition, but as he continues to look, he detects a new rhythm, which organizes the rectangles vertically, as if they were all included in the *same* painting. As the passage continues, Marcel turns from the "paysage Turnerien" to his relationship with the "moral" landscape of the Guermantes. The overlay effect is intentional and complex: the references to Vermeer, Turner, and Elstir overlap throughout the novel, so that Proust can base Marcel's final realization of his literary vocation on a variety of inter-related metaphors. When Marcel begins to see his life in layers of Time, he sees his past as a landscape which is "au moins double." In these "paysages rêvés dont la juxtaposition quadrillait ma vie" he becomes aware of the simultaneous existence of people in various temporal spaces. He thinks of himself as having travelled through this dream landscape, meeting and abandoning "ces amis momentanées." But looking back retrospectively, the "moments" appear to be side by side: he sees Gilberte's shadow cast over the church at Combray and at the same time cast over the "allée" in the Champs-Elysées. Finally Marcel is able to view all the separate pieces of his life as a single composition, each juxtaposed "moment" bathed in its own "color," all forming a mosaic-like whole. Like the exhibition of Dutch paintings, or the roomful of Elstirs, the different rectangles of Time reflect the spiritual unity of Marcel's life.

This ultimate vision is expressed in a metaphor that places Marcel in the position of the traveller in the Elstir-Turner mountain landscape. Marcel compares himself, as a novelist, to a painter:

> The mind also has its landscapes which it is allowed to contemplate only for a moment. I had lived like a painter climbing a road overlooking a lake, which is hidden from his eyes by a curtain of rocks and trees. Through a breach he catches sight of it, has it all before him, takes out his brushes. But already night is coming on when painting will be impossible, the night on which day will never dawn![29]

The writer, like the painter, has arrived at a pinnacle, from which the entire landscape, previously seen only in momentary glimpses, is finally visible as a whole. From this vantage point in space, the painter is able to record the total landscape, just as the novelist, having reached a similar point in relation to Time, is able to begin his vast effort at unified composition. But the writer and the painter, like Bergotte in front of Vermeer, are threatened by the element of Time that has just been traversed in arriving at the top of the mountain. The revelation for Marcel, of the spatial unity of his elapsed life, is accompanied by a fear, that like Bergotte, he will die before the revelation can be put to work. If he can write about his life, giving form to temporal flux, through "couches superposées," he will complete the task that Bergotte had set for himself, to translate the layers of color in Vermeer into a literary equivalent. In order to discuss the full implications of the metaphor of painting, it is necessary to go back to the technique of presenting effect before knowledge that connects Elstir to the "côté Dostoevsky de Mme de Sévigné."

In painting, the concept is clearly related to Turner's method of painting only what the eye can see, but Proust is not interested in isolating sensory knowledge from the rest of the human organism, but in discovering the relationship between the intellect and the "état d'âme" produced by physical sensations. As soon as Proust has presented the Turner side of Elstir, the eye innocent of knowledge, he turns to the Ruskin side of his imaginary painter, which is manifested in his vast learning and his keen intellect. When Proust describes Elstir stripping himself of knowledge in front of the canvas, he goes on to show that this is a deliberate act on the part of a mind that is full of critical perceptions about the arts:

> The effort made by Elstir to strip himself, when face to face with reality, of every intellectual concept, was all the more admirable in that this man who, before sitting down to paint, made himself deliberately ignorant, forgot, in his honesty of purpose, everything that he knew, since what one knows ceases to exist by itself, had in reality an exceptionally cultivated mind.[30]

Elstir, who talks botany like Ruskin to the young Marcel as he paints, is also the source for an impassioned lecture on medieval architecture and sculpture; the

painter's critical insights help Marcel to see the beauty which he has been in-
capable of seeing for himself as the proximity of the church to shops and houses
blinds him to its true features. Elstir's energetic recreation of the action taking
place on the sculptured front of the church, is directly modelled on Ruskin's
present-tense accounts of medieval architecture: like Ruskin, Elstir moves from
narrative to formal elements and back to iconography again until he has summed
up the sculptured spectacle as a "whole gigantic poem full of theology and
Symbolism. . . ." The episode concludes with another reminder of Ruskin at
Rouen: Marcel has been unable to see the oriental aspect of the church, which
Elstir demonstrates to him with a photograph of a detail that he could not
distinguish in the profusion of sculpture on the church itself:

> And he did indeed shew me, later on, the photograph of a capital on which I saw
> dragons that were almost Chinese devouring one another, but at Balbec this little
> piece of carving had passed unnoticed by me in the general effect of the building
> which did not conform to the pattern traced in my mind by the words, 'an almost
> Persian church.'[31]

Like Ruskin's engraving of the little figure, Elstir's photograph brings the
Chinese dragons into visibility: without the eye of the critic, the sculpture would
be lost in Marcel's visual field.

The presentation of Elstir is divided into two phases which correspond to
Turner and Ruskin, the painter and then the critic. In actual fact the compo-
nents are mixed in Proust's mind; Turner is a model for Elstir in terms of
Ruskin's interpretation of his painting, just as Ruskin's writing about painting is
itself inevitably conditioned by Turner's example. But Proust divides Elstir into
two aspects, sensation and intellect, because this double phase, this two-beat
rhythm, mirrors the process that is typical of all of Marcel's key experiences;
first a moment of pure sensation followed by an intellectual analysis of the
effect produced. To take a small example, we can look at Proust's sentence
describing an auditory phenomenon that occurs to Marcel while sitting in
Aunt Léonie's room:

> A little tap at the window, as though some missile had struck it, followed by a
> plentiful, falling sound, as light, though, as if a shower of sand were being sprinkled
> from a window overhead; then the fall spread, took on an order, a rhythm, became
> liquid, loud, drumming, musical, innumerable, universal. It was the rain.[32]

The pattern of sound is minutely described, the accelerating rhythm carries the
reader through a perceptual process that culminates with an explosion of knowl-
edge, as the mysterious noise is suddenly identified as the rain. The sentence
follows the curve of sensation with precision; the unidentified sound is carefully
rendered in terms of effect which precedes the intellectual process of identifying

the cause. Proust's sentence is therefore the literary equivalent of the Turner-Elstir technique of presenting the effect first; as Proust says of *Le Port de Carquethuit,* after experiencing the confusion between the land and the sea, the reason comes after to compose the water into a "single element" and distinguish it from the shore, just as, in this case, the reason comes after to conceptualize the pattern of sound as rain. Proust's immediate model for this literary technique is neither Dostoevsky or Mme de Sévigné, but once again, Ruskin. As J.M. Cocking puts it:

> He showed Proust exactly how certain works of art could be said to reflect the inner and transcendent life. Proust turned from *Jean Santeuil* to the study and translation of Ruskin because, as he wrote, he sometimes felt that he was piling up ruins, like Casaubon in *Middlemarch.* Ruskin taught him how to set about a real building. He showed him how familiar things become strangely interesting when they are resolved into their complex details, and provided the example of a style in which such details are precisely noted. He suggested a way of according to the dull world of natural experience a prestige reflected from the more satisfactory and exciting world of art, or of viewing the world with a humorous sense of its contrast with a world of art which some of its features recall.
>
> Ruskin's influence is reflected in Proust's minute account of Aunt Léonie's dried lime-flowers, of the rise and change of feeling, of motives, of how milk looks as it comes to the boil.[33]

Ruskin's minute and precise descriptions of visual facts, his ability to follow the process of a perception coming into being, his microscopic accuracy are the literary qualities that provided Proust with an example, in writing a book based on sensation. The account of the madeleine dipped in lime flower tea, perhaps the most classic passage in all of *A la recherche,* is specifically Proustian because of the verbal precision lavished on the almost intangible taste, and the delineation of the psychological effects released through the physical sensation. The passage, like Ruskin's paragraphs which trace a visual perception, follows the progress of the sensation through its various stages, from its beginning, with the mysterious rush of joy, to the end, when Marcel is trying to discover intellectually the cause behind the overwhelming effects produced. Just as Ruskin's prose acts as a magnifying lens for visual experience, Proust uses the same verbal techinques to intensify the sensation of taste, so that through his efforts at scrupulous particularization, every nuance of change in the span of perception is enriched in the process of writing about it. It is not surprising that Proust uses Elstir's painting as a metaphor for his own verbal art of recording sensations; as Elstir is drawn from Turner, and Ruskin's style is based on aesthetic concepts derived from Turner's painting, and Proust's style is partially derived from Ruskin, the metaphor is brought full circle. Ruskin and Proust both find in painting a model for a perceptual process which is transmitted into literature, and because painting is such a comprehensive metaphor for Proust,

he includes Bergotte and Vermeer, along with Ruskin and Turner, and himself and Elstir, as another example of the fertile interchange between the arts.

In the Bergotte-Vermeer confrontation Proust supplies a hint, but only a hint, of the structural concept of superposition. The metaphor of the "couches de couleur" which make up the "petit pan de mur jaune" contains within it the concept of overlay which Proust returns to later in *Le Temps retrouvé* when painting is used as a metaphor for total design, but at this point in the novel Bergotte sees in painting an analogy for the materiality of language, the formal coherence of the fragment, and the general idea of stylistic "color" and finish. The metaphor is handled in the same key that Proust uses to apply terms from painting to Flaubert's style in his *Contre Ste-Beuve* essay. When Proust describes Flaubert's sentences as "vast mirroring surfaces," he is trying to point out the result of Flaubert's polishing of language, his ability to cull and select words and fit them together to create the "substance spéciale" of "la phrase." Flaubert's language is a special substance, like the precious matter of Vermeer's yellow paint, because he has purified the words of the tribe, and converted ordinary reality into an aesthetic whole characterized by a *uniform* verbal refinement. Every sentence, every clause, every word, is consciously placed and this results in "la verité de la peinture de langage." When Proust, in another essay, defines Flaubert's position as a literary innovator, he bases his judgment on Flaubert's "originalité grammaticale" which he compares to a change in color in the history of painting:

> He (Flaubert) can make one comprehend the role of certain painters in the history of art who changed the use of color (Giotto, Cimabue). And the revolution in vision—in the representation of the world which flows—or is expressed—through his syntax, is perhaps as great as that of Kant in moving the center of the knowledge of the world to the soul.[34]

Proust sees Flaubert's use of the imperfect as a total change in vision, comparable to a philosophic shift or a breakthrough in painting. He may or may not have known that Flaubert himself thought of his stylistic originality in terms of painting: in his notebooks Flaubert refers to the various sections of his novels as "tableaux," because he is attempting to give internal unity to each part, to treat each unit in terms of the reciprocal relations between people, actions, background, and images.[35] But Proust definitely understands the "tableaux" aspect of Flaubert's work; he emphasizes the fact that both character and action are subordinated to the world of language:

> When the painting was purely material, things acted there as characters. . . . If it was a painting of people, to demonstrate explicitly that it is only a picture, a detail which has no bearing on the action, which showed that the action had been described like a painting, when we don't know if this little spot is not equally as important as this gesture, this line was added.[36]

What Proust is defining in Flaubert is the fact that the essence of his vision is contained in formal elements: the syntactical arrangement that gives equal prominence to images and actions transforms the novel into a "surface" of words that can be read like a painting. It is precisely the same approach to literature that Marcel brings to Bergotte: Marcel becomes aware of the "phrases-types" in Bergotte's writing, which have a characteristic rhythm, a tonal similarity, a repeated cadence. The actual subject of the "phrase" is totally irrelevant to Marcel; what he searches out is the "color" of Bergotte's style, the concrete and physical traits that distinguish his sentences from those of any other writer. Bergotte is apparently trying to recapture this essential color, or to invent a new and richer color, when he sees the Vermeer painting. The implication is that like Flaubert, he will polish and varnish his sentences until the words become a "substance spéciale" like the precious matter of the yellow paint. But within this idea of style as vision, stylistic color as essence, is a related concept that pertains to the way this essence is perceived. In an article on literary criticism, Proust links stylistic color in painting and in literature with the experience of escaping Time. He is referring again to the family resemblance between the canvases of a painter ("he" refers to Proust as a young man):

> . . . between two paintings by the same painter, he perceives the same sinuosity of profile, the same piece of material, the same chair, showing something in common between the two pictures: the predelection and the essence of the painter.* [the asterisk refers to Proust's footnote on himself] *What there is in one painting by a painter cannot nourish him, nor in one book by a writer, nor in a second painting by an artist, a second book by a writer. But if in the second painting or the second book, he sees something which is not in the second or the first, but which is in some way between the two, in a sort of ideal painting, which he sees being shaped in spiritual matter outside the canvas, he receives his nourishment and begins to exist and to be happy. Because to exist and to be happy are one and the same. And if between this ideal painting and this ideal book, which are each sufficient to make him happy, he finds a higher link again the joy increases again. If he discovers between two paintings by Vermeer . . . [37]

Perhaps the reason that Proust trails off after writing the name Vermeer, is that he realized that he had just written the central statement of his aesthetic, and that it would take the whole structure of *A la recherche* to embody the correspondences and connections suggested by this footnote. The idea of stylistic color is carried to a metaphysical degree: the essence of the painter's or the writer's vision is a quality that transcends the individual manifestations—it is located somewhere *beyond* the two canvases, *beyond* the two phrases that partially embody it. Proust, of course, uses exactly the same formula in *Le Temps retrouvé* to explain the significance of the double moments of sensation: when Marcel feels the starched napkin at the Guermantes reception, he is transported *beyond* Paris, but he does not simply return to Balbec, the location of his

first encounter with this particular sensation. Instead he moves into a quasi-magical space, which is neither Paris nor Balbec, but the space produced by the doubling of sensation, which is beyond both "moments," a space outside the confines of Time. Thus, in the novel, Marcel's experiences of the essence contained in Bergotte's sentences, in Elstir's paintings, and in the "petit phrase" which appears in Vinteuil's sonata and septet and transcends both, are all preparatory experiences for the revelation of the essence of his own life which exists, in reality, beyond Time, just as the essence of the artist's vision exists in a realm beyond the concrete examples of his work. As Proust continues in his footnote, he imagines an even higher essence that can be obtained by doubling an ideal book with an ideal painting, and seeing the visionary "color" that unites the two. In the novel, of course, this correlation takes place between Marcel's idolized writer, Bergotte, and the ideal painter, Vermeer. It is not far-fetched, therefore, to see the "couches de couleur" in the *View of Delft* as a hint of the concept of doubling, or overlay, or superposition that is the key to the composition of *A la recherche.*

The structure of *A la recherche* has been discussed by a multitude of critics, but among the various interpretations there is almost universal agreement that between the formlessness of *Jean Santeuil* and the complex design of *A la recherche,* Proust discovered some idea of organization. As Proust was working on his Ruskin translations between his first and second attempts at writing a novel, several critics have looked to Ruskin, not only as a model for the perceptual style, but as an example of a particular kind of unity through apparent disorder. It is significant therefore, that in Proust's first footnote to his translation of *Sésame et le lys,* he underlines the "secret plan" and retrospective order of Ruskin's book.

> This epigraph ("You shall each have a cake of sesame and ten pound." Lucian: *The Fisherman*), which did not appear in the first edition of *Sesame and Lilies,* projects like a supplementary ray, which only comes to touch the last sentence of the speech, but which illuminates retrospectively everything preceded. Having given his speech the symbolic title of Sesame (Sesame of the Arabian Nights—the magic word which opens the door of the thieves' cave—being the allegory for the reading which opens the door of its treasures where the most precious wisdom of man is enclosed—books), Ruskin is delighted to take back the word Sesame in itself and without further occupying himself with the two meanings here (Sesame in Alibaba and in reading) and he is delighted to insist on its original meaning (Sesame seed) and to embellish it with a quotation from Lucian which creates a play on words in making vividly appear under the conventional signification which the word has for the oriental story teller and in Ruskin, its primordial meaning. In reality Ruskin thus elevates by a degree this symbolic signification of his title since the quotation from Lucian reminds us that Sesame is already removed from its signification in the *Thousand and One Nights* and hence the sense it has as the title of Ruskin's speech is an allegory of an allegory. This quotation clearly shows from the start the three meanings of the word Sesame, *reading* which opens the doors to wisdom, the magic

word of Ali Baba, and the magic seed. From the beginning Ruskin unfolds his three themes and at the end of the speech he will blend them inextricably in a final sentence where the tonality of the beginning will be heard in the final accord (Sesame Seed), a sentence which will borrow from the three themes (or rather five, the two other being, the treasures of kings taken in the symbolic sense of books, then dealing with the kings and their different sorts of treasures, a new theme introduced toward the end of the speech) an extraordinary richness and fullness. On the quotation from Lucian itself the library edition gives a commentary which would only seem exact to me if this citation served as an epigraph to the Gardens of Queens and not to the Treasures of Kings. In compensation—it notes (and this is very interesting) the admiration of Ruskin (witness of which is a pencilled note on a copy of the book) for a passage from *The Birds* of Aristophanes where la Huppe in describing the simple life of the birds says that they have no need of money and feed themselves on sesame. I believe simply that Ruskin, partially by this idolatry of which I have often spoken, delighted thus in going to adore a word in all of the fine passages in the great authors in which it figures. The idolator, our contemporary, to whom I have compared Ruskin, frequently puts up to five epigraphs at the head of a single play. Ruskin would have put successively up to five at the head of *Sesame* and if he opted at last for that of Lucian, it was without doubt because it was more removed than the others from the import of his speech. It was, because of that, more new, more decorative, and in rejuvenating the sense of the word Sesame, it clarified, indeed, the diverse symbols. No doubt, moreover, it would have brought him to connect the treasures of wisdom with the charm of a frugal life and it would have brought him to give to his advice for individual wisdom the scope of maxims intended for social well-being. This last intention makes itself clear toward the middle of the talk. But it is precisely the charm of Ruskin's work that there are between the ideas in the same book, and between the various books, links which he does not show, which he hardly appear an instant, and which he has, moreover, perhaps woven as an afterthought, but which are never artificial, however, since they are always drawn from the substance always identical to itself of his thought. The multiple but constant preoccupations of this thought, that is what assures his books a unity more real than the unity of composition, which is generally absent, one must admit.

I see that in the note placed at the end of the speech, I thought I was able to identify up to seven themes in the last sentence. In reality, Ruskin arranges here one next to another, mixes, manoeuvres and makes shine altogether the various principle ideas or images which have appeared with some disorder during the course of the speech. That is his procedure. He passes from one idea to another without any apparent order. But in reality the fantasy which leads him follows profound affinities which impose on him, in spite of himself, a superior logic. So that at the end he finds that he has obeyed a sort of secret plan, unveiled at the end, which imposes retrospectively an order over the total ensemble and makes it apparent that it has been magnificently graduated up to this final apotheosis.[38]

There can be no doubt that what Proust discovers in writing this footnote is the secret plan of his own book. The aspect of Ruskin's plan that appeals to Proust is the fact that it is hidden until the end, when the secret design emerges and casts a retrospective order back over the entire composition. The "superior logic" of this plan is that it allows for fluidity, digression, and disorder along the way. And within this apparent chaos, the writer is in total control, building

up an internal structure that is "magnifiquement étagé jusqu'à cette apothéose finale." The resemblance to the design of *A la recherche* is too precise to be ignored. As Jean-Yves Tadie comments on Proust's footnote, he sees a direct correspondence between Ruskin's plan and *A la recherche:*

> Thus the first pages of Combray, taking the place of the Ruskinian epigraph, must be connected to the final pages of *Le Temps retrouvés,* and the secret plan of *A la Recherche* does not appear fully until the end, imposing on the reader a gigantic, retrospective look, a reading which is always double. The novel keeps the charm of apparent disorder which marked the first works, but this novel hides a secret and admirable order.[39]

Tadie confirms Proust's intention to connect beginning and end, as Ruskin has done with his epigraph and conclusion, by citing a letter that Proust wrote to Bernard Cremieux:

> One will not be able to deny the construction when the final page of *Le Temps retrouvés,* written before the rest of the book, fits itself back exactly over the first page of Swann.

Proust's image of the last page closing back over the first is perhaps the ultimate expression of the principle of overlay in the novel, but although many critics have emphasized the circularity of the novel's form, Proust is not attempting to create a perfectly symmetrical structure. The appeal of Ruskin's plan is the combination of apparent disorder with hidden unity: it is this kind of aesthetic balance that Proust refers to in comparing his novel to an unfinished medieval cathedral. The structure of the cathedral is asymmetrical, huge, composed of innumerable parts which can be seen in an infinite number of relations to each other. The entire building has a unified plan, but the plan is barely perceptible due to the vastness of the construction. Proust's book is closer to the form of a cathedral, than to a perfect geometrical figure: the design is spread out over such a vast area, that is only occasionally visible before the end; the reader moving from chapel, to apse, to nave has no conception of what the building might look like seen from above. Proust felt that Ruskin's entire work, the library edition, was like a Bible full of correspondences, and since he sees cathedrals as Bibles through Ruskin's writing, the metaphor of book as cathedral is again composite. Proust's gigantic "oeuvre," like Ruskin's, is unified through diversity and abundance: the total number of connections, relations, and correspondences in both cases is almost incalculable. In another footnote to Ruskin, Proust outlines his activity as a critic that again prepares the way for his own work as a novelist. He attempts to correlate and cross-reference his translation of *Le Bible d'Amiens* with all of the rest of Ruskin's work, supplying with his footnotes a sort of "caisse de resonance" for reflecting the total unity of Ruskin's diverse books and essays:

In the course of this study, I have quoted so many passages from Ruskin drawn from his books other than *The Bible of Amiens;* here is the reason. To read only one book by an author, that is to have only one meeting with this author. Well, in chatting with someone one time, one can discern in him certain singular traits. But it is only by their repetition in varied circumstances that one can recognize them as characteristic and essential. For a writer, as for a musician and a painter, this variation of circumstances which permits one to discern by a sort of experimentation the permanent traits of character is the variety of works. We find in a second painting, a second book, the particularities which the first time we might have believed to belong as much to the subject treated as to the writer or the painter. And from the connection of different works we disengage the common traits of which the assemblage composes the moral physiognomy of the artist. In putting a note at the bottom of the passages quoted in the *Bible of Amiens,* each time that the text awakens by analogy, even far off, the memory of other works of Ruskin, and in translating in the note the passage which had returned to my mind, I tried to permit the reader to place himself in the position of someone who would find himself not in the presence of Ruskin for the first time, but who having already had previous conversations with him would, in his words, recognize what in him is permanent and fundamental. Thus I tried to provide the reader with an improvised memory in which I had deposited memories of other books of Ruskin—a sort of resonating chamber [caisse de resonance] where the words from the *Bible of Amiens* would be able to take on reverberation in awakening in it fraternal echoes. But to the words of *The Bible of Amiens* these echoes no doubt will not respond, just as it happens in a memory which has created itself, from these unequally distant horizons, habitually hidden from our sight and of which our life itself has measured day by day the various distances. They will not have, in order to come rejoin the present word the resemblance to which has attracted them, to cross the resistant sweetness of that interposed atmosphere which has the very length of our life and which is all the poetry of memory.[41]

The footnote again slides imperceptibly into the substance of the novel. The concept of stylistic color, of characteristic essence, discovered in the repetition of works, is applied to Ruskin, and extended to comprehend painting and music as well as literature. And in the final sentences of the paragraph, the diverse fragments of a central vision, represented by works of art, are suddenly transformed into the parts of "our life itself," and the critical activity of pulling together references is changed into the activity of fitting memories to the present, and unifying life by crossing the atmosphere interposed between ourselves and our past.

What Proust accomplishes in creating a "caisse de resonance" with his cross-references to Ruskin's other books, is to make the fragment, *Le Bible d'Amiens,* reflect the total unity of Ruskin's work as a whole. It is a preparatory exercise for writing *A la recherche* because it shows Proust a technique for correlating all the multiple aspects of Marcel's life, so that each fragment of *A la recherche* will reflect the overall writing of the novel. There is a kind of gap between the reader's experience and Marcel's: the reader, along with Proust, is aware of the correlations and correspondences building up before Marcel himself

is able to see the retrospective unity of his life lived in Time. The reader is placed
in the position of critic, cross-referencing the novel as it unfolds, long before
Marcel sees the correspondences. The main reason for this gap is the artificial
delay required to make Marcel's final experience absolutely clear: Marcel is lost
in the multiplicity of events until the final involuntary memories precipitate his
sense of Time as a solid substance. In order to achieve the effect of precipitation,
Marcel must be kept blind to the numerous hints supplied for the reader, which
define the pattern of doubled sensation which Marcel perceives at the end as a
sudden revelation. The reader therefore anticipates the conclusion; the secret
plan of the novel is apparent before the final sensations bring it into definite
form in Marcel's consciousness. Throughout the novel, Marcel's privileged
moments give the reader a vertical lift above the horizontal flow of the narrative.
If Marcel is the painter, travelling to the top of the mountain towards a final
view of the entire landscape, the reader is always a few steps ahead, watching
Marcel's progress. At many points, Proust gives the reader an elevated "point de
repère," from which the relation of parts, images, and themes can be seen in
overview. In Bergotte's death scene, for example, Proust condenses all the ana-
logies of writing to painting that are scattered throughout the novel: when this
central analogy is expanded it touches on Marcel's earlier relationship with
Bergotte, his subsequent encounter with Elstir, and the connection between
both artists and Vinteuil, it draws on all the references to Vermeer and his
connections with Vinteuil, Elstir, Turner, and Swann, as well as summing up the
major themes of the material nature of art, the chance encounter with revela-
tion, the aesthetic transcendance of Time, the wholeness of fragmentary experi-
ence, the smallness of the container for visionary essence, and the 'other'
universe embodied in a concrete work of art. The ramifications of the episode
extend endlessly to all parts of the novel.

The scene points forward, in a special way, to the conclusion of the novel
because it underlines the metaphor of painting. The references to painting in-
crease in frequency during the final aesthetic exposition in *Le Temps retrouvé,*
because Proust sees in painting a form that condenses time into a spatial unit.
The object of Marcel's literary quest is to discover a form that will make Time
visible. He feels defeated by temporal flow, as the important "moments" of his
life seem to disappear in the sequential order of Time, and all he can salvage
with his intellectual memory is a random collection of juxtaposed images, seen
as fragments, like snapshots, placed side by side. When his involuntary memory
operates, it is to superimpose a present sensation over a past moment, and the
true density of Marcel's life emerges. The "moments" are not lost, but actually
exist, and can be resurrected to form a single substance with the present: the
action of superposition is reciprocal; past and present mutually cover each
other to produce a double layer of experience which is located outside the
boundaries of Time. This principle of superposition creates a new order which is

not based on causal sequence or random juxtaposition—all of Marcel's life is "telescoped" into a single, unified picture, layered in depth. Marcel actually *sees* time in an optical sense:

> From all these aspects, an affair like the one I was attending was something far more precious than a picture of the past; it offered me, as it were, all the successive pictures separating the past from the present, which I had never seen, and, better yet, the relationship of the past to the present. It resembled what used to be called 'an optical view,' but of the years, the view not of a monument but of a person placed in the distorting perspective of Time.[42]

This optical view of Time expands to cover all experience, not just the moments of involuntary memory. The view through layers of Time gives every aspect of experience a new resonance, a temporal thickness that corresponds to the spatial density of the layers of yellow paint. Marcel's whole life, or in other terms, the whole novel, acquires a total retrospective unity which is the literary equivalent of the painter's simultaneous form. Like the landscape seen from the top of the mountain, the novel seen from Marcel's final vantage point, encompasses a pictorial unity in which every element in the composition is perceived in relation to everything else; the entire field of words is visible as a massive entity.

Of course, for Proust, as for Baudelaire, the application of pictorial unity to literature is theoretical. The simultaneous view of all the parts of *A la recherche*, reciprocally related, can only be approximated. For this reason Proust supplements the metaphor of painting with the analogy of the cathedral. The theoretical unity of the novel is offered as a potential absolute; the reader is invited to survey the whole novel retrospectively, like the novelist-painter at the top of the mountain, but the total scope of the view is virtually unlimited. The reader's actual view of the novel is closer to the visual experience of the cathedral, which is always incomplete, the total structure only seen in glimpses, interpolated from the mass of details. The pictorial view of the novel can be imagined more easily than it can be obtained. But in the Bergotte-Vermeer episode, Proust implies that absolute pictorial unity is only theoretical for painting as well; the Vermeer canvas is perpetually new for Bergotte, therefore perpetually incomplete. The new aspects of the painting, the rose-colored sand, the figures in blue, the yellow wall, are elements that reconstitute the overall unity of the *View of Delft*. Therefore the novel, like the painting, while totally unified, will always yield a new vision to an observant eye. The form is an organized container for an infinite process of discovery.

It is this same feeling of continual discovery that Proust experiences in attempting to correlate Ruskin's work. As Proust states it, the index to the library edition is an image of perpetual novelty:

> Only in consulting the indexes of the different works of Ruskin, does the perpetual novelty of the quoted works, even more the disdain of a knowledge which he has

used once and more often its total abandonment, give the idea of something more than human, or give the impression that each book constitutes a new man who has a different knowledge, not the same experience, in short, another life.[43]

Proust thinks of Ruskin's cathedral-like work as inexhaustible; the total number of topics, images, buildings, paintings, and poems that are woven into the fabric of his writing creates a "richesse inépuisable." The critic has an unlimited number of correlations to draw from in making his "caisse de resonance"; the reader finds that the richness and density of the vision is continually open to a new reading, and Ruskin's work is always unfinished. It is the unfinished aspect of *A la recherche* that forms the basis for Gilles Deleuze's description of the novel as a machine for producing sensations. The interpretation of Deleuze, which is primarily based on medieval signs, suggests various concepts that can be fitted to the terms of this essay. First Deleuze takes Proust's claims for the materiality of language quite literally; taken literally, the novel as concrete substance embodies the process of superposition, correlation, correspondence, and gives this process a physical field in which to operate. When an experience occurs to Marcel, it is transformed into the medium of words, concretely recorded as text, so that when the experience is repeated a second time, it exists not only in Marcel's consciousness, but is present for the reader as an overlay of text on text; thus the experience in the verbal world of the novel produces the same effect on the reader that the experience, in life, has produced on Marcel. Because the reader's experience of the novel is wider than the narrator's, because of the gap between Marcel and the reader, the double rhythm already mentioned, the novel functions as a machine capable of producing other sensations for the reader than those specifically noted by Marcel. The novel is therefore perpetually unfinished—each reader experiencing the possible effects of the machine differently. Proust himself points out this quality of the book when he describes it as an optical instrument which reflects each reader to himself:

> In reality, each reader reads only what is already within himself. The book is only a sort of optical instrument which the writer offers to the reader to enable the latter to discover in himself what he would not have found but for the aid of the book. It is this reading within himself what is also in the book which constitutes the proof of the accuracy of the latter and *vice versa*—at least to a certain extent, for any discrepancy between the two texts should often be laid to the blame of the reader, not the author.[44]

If we take the metaphor of the machine and combine it with the notion of a double rhythm, we can see that Marcel's key experiences provide the reader with a model for perception. When Marcel feels the present moment of the taste of the madeleine superimposed over Aunt Léonie's room at Combray, he gives the reader a pattern for discovery. Once the reader is fully immersed in the

verbal "univers" of the novel, once tuned into the system, he can find his own correspondences, independent of Marcel, between the words, phrases, images, and ideas, that Proust has used to make his text into a "caisse de resonance." Proust has expanded the metaphor of the layers of yellow paint, so that his "style" is built up with layers of corresponding terms, colored with verbal echoes, parallel images, endless reverberations, until the novel acquires the "tenébreuse et profond unité" that Proust had so much admired in Baudelaire. Marcel, for example, is not specifically aware of the link between the flower images in the novel; but Proust has supplied a large-scale "correspondance" for the reader who finds the same botanical images used to describe the adult world of homosexuality in the "overture" to *Sodomme et Gomorrhe* that had been used to depict the innocent sexuality of Marcel and Gilberte in the first volume. Or again, the reader is able to see beyond Marcel, and connect the saving act of Mlle. Vinteuil's friend, who preserves, fortuitously, Vinteuil's fragile and cryptic pages of music and makes them available to the world at large, to the chance intervention of the "petit phrase" in Swann's life, or the chance intervention of the art critic who directs Bergotte to Vermeer, or to Marcel's chance moments of sensation which resurrect his past, and finally to the fragility of Marcel's own book, which is like Vinteuil's musical pages, subject to the chance neglect and erosion of Time. The sensation of discovery, of detecting an overlay of words or images, gives the reader a new insight into the dense unity of the novel.

In constructing the novel as a resonant network of correspondences, Proust brings the whole process to bear on the image of Mlle de Saint-Loup, who stands before Marcel at the final Guermantes reception, like a silent portrait. Marcel sees in her the total resolution of the threads of his life, which "radiate" out from her in all directions. In a long paragraph he traces out all the "transversal" lines that are united in her single person: as the daughter of Robert and Gilberte she represents a fusion of the "côté de Swann" and the "côté des Guermantes." As this connection ramifies, it includes Swann and Odette, Combray, Balbec, Gilberte and the Champs Elysées, Albertine, Vinteuil and as the relations multiply Marcel is aware that the lines extend to *all* parts of his life, even those that seem most remote. As he concludes his "portrait" of Mlle de Saint-Loup, he says:

> But it is even more true that life is ceaselessly weaving other threads between human beings and events, that life crosses these threads with one another and doubles them to make the weft heavier, so that, between the tiniest point in our past life and all the other points, a rich network of memories leave us only the choice of which road to take.[45]

Thus each minor point in life is connected by a *réseau* (network) to everything else, just as in the verbal *réseau* of the novel, every detail connects to the rest of the text.

Proust uses the portrait of Mlle de Saint-Loup, much as Baudelaire and Ruskin had used the metaphor of the portrait, to express the ideal embodied in the particular. Marcel sees the ideal unity of his life mirrored in the image of a very real and individual little girl. Just as Proust understands that the visionary essence of an artist transcends his individual works, but can only be seen *through* the concrete examples, Marcel is able to see through the physical form of Mlle de Saint-Loup to the *réseau* of moments she represents for him. As J.M. Cocking points out, the tendency to see ideality in terms of particulars is characteristic of the late nineteenth century, but Proust's most immediate references are Baudelaire and Ruskin:

> Proust is . . . stating his conviction of the transcendence, universality and unique-
> ness of the work of every great artist. These were things he had felt, and perceived
> more sharply when he read, in *Sesame and Lilies,* Ruskin's statement that beauty is
> an absolute existing outside individuals though perceived by each artist in an irre-
> ducibly individual form. He might equally have found the paradox implied in Baude-
> laire's *Salons;* Baudelaire, too, claimed that beauty is eternal and absolute but ex-
> pressed by every age and country in its own way.[46]

Baudelaire and Ruskin both tried to see the ideal aspects in "modernité"; all phenomena, perceived in their complete particularity, as potentially ideal. It is in this sense that Proust uses the portrait of Mlle de Saint-Loup; as an individual, seen under the light of her total relation to Marcel, she represents an ideal condensation of the network of his life into a single figure. Just as Baudelaire and Ruskin see the whole spirit of an age condensed into a painter's portrait, Proust, as a novelist, tries to imitate the painter's ability to make a general statement in a particular form. As Proust emphasizes in *Le Temps Retrouvé,* what comes naturally to the painter is often difficult for the writer:

> The writer envies the painter; he would like to take sketches and notes—he is ruined
> as a writer if he does so. But when he writes, there is not a gesture of one of his
> characters, not a single nervous mannerism or intonation that was not suggested to
> him by his memory; there is not a single fictitious name of a character under which
> he could not write the names of sixty persons he has actually seen, one of whom
> posed for the grimace, another for the monocle, this one for the anger, that one for
> the becoming movement of the arm, and so on. And then the writer realises that, if his
> dream of being a painter could not come true in a conscious and intentional manner,
> it has happened to come true anyhow, and the writer finds that he, too, has been
> making a sketchbook without knowing it. And just as the painter needs to study
> many churches in order to paint one, even more so must the writer who wishes to
> acquire volume, substance, generalness, literary reality, study many human beings for
> a single sentiment.[47]

Thus Proust feels that "la réalité littéraire" depends upon the writer's ability to condense generality and volume into the particulars that make up his imaginary

universe. Proust's main technique for achieving this volume is the use of the *réseau* which is exemplified by the portrait of Mlle de Saint-Loup. As each fragment, each detail of his novel is related through verbal ties to everything else, each particular reflects the generality, the unity, the voluminous scope of the total vision. This relationship is underscored in the last sentence of the madeleine episode, where Proust balances the "vast structure of recollection" against the tiny and impalpable drop of the tea's essence which contains it. Just as the drop of tea is a condensation of Combray, each fragment of the novel is a potential point of access to a vision of its vast structure. Proust emphasizes the fact that the point of access can be anything; even a trivial and insignificant detail like the feel of the starched napkin which resurrects Balbec, can open up a whole system of correspondences. For the reader of the novel, with wider latitude than Marcel, the endless network of the book provides innumerable points of access, so that at any moment, a detail will suddenly flash with light reflected from a whole field of correspondences, separated from each other by the spatial vastness of the text, but reunited, across the volumes and pages, by the common essence which Proust has incorporated into his book and which permeates every part. The reader's time, elapsed while reading the novel, is reorganized, like Marcel's, in moments of perception in which the vast structure of Proust's vision is unified as a solid substance.

The ability of the fragment to condense a vast structure, to reflect a vision larger than itself, returns us to the metaphor of the fragment of yellow paint on Vermeer's canvas. In this little patch of layered paint, Bergotte sees not only a reflection of the larger vision represented by the totality of Vermeer's work, but an even larger essence, the transcendant realm of spirit, to which Vermeer's painting provides a point of access. Just as the "petit pan" is a condensation of the "essence" of Vermeer, this "essence" is in itself only a fragment of the "other world" of spirit, which is the common source of all artistic endeavor. As Bergotte continues to meditate on the "petit pan," his convulsions augment in intensity, and he dies in front of the *View of Delft*. The narrator speculates on the imperative nature of revelation, and the concrete existence of the spiritual world, opened up through works of art:

> He repeated to himself: "Little patch of yellow wall, with a sloping roof, little patch of yellow wall." While doing so he sank down upon a circular divan; and then at once he ceased to think that his life was in jeopardy and, reverting to his natural optimism, told himself: "It is just an ordinary indigestion from those potatoes; they weren't properly cooked; it is nothing." A fresh attack beat him down; he rolled from the divan to the floor, as visitors and attendants came hurrying to his assistance. He was dead. Permanently dead? Who shall say? Certainly our experiments in spiritualism prove no more than the dogmas of religion that the soul survives death. All that we can say is that everything is arranged in this life as though we entered it carrying the burden of obligations contracted in a former life; there is no reason inherent in the conditions of life on this earth that can make us consider ourselves

obliged to do good, to be fastidious, to be polite even, nor make the talented artist
consider himself obliged to begin over again a score of times a piece of work the
admiration aroused by which will matter little to his body devoured by worms, like
the patch of yellow wall painted with so much knowledge and skill by an artist who
must for ever remain unknown and is barely identified under the name Vermeer. All
these obligations which have not their sanction in our present life seem to belong to
a different world, founded upon kindness, scrupulosity, self-sacrifice, a world entirely
different from this, which we leave in order to be born into this world, before per-
haps returning to the other to live once again beneath the sway of those unknown
laws which we have obeyed because we bore their precepts in our hearts, knowing
not whose hand had traced them there—those laws to which every profound work
of the intellect brings us nearer and which are invisible only—and still!—to fools.
So that the idea that Bergotte was not wholly and permanently dead is by no means
improbable.[48]

As Proust constructs the situation, Bergotte actually gives his life for a percep-
tion of this other world, which is entirely different from this one; through
Vermeer he re-enters a spiritual reality which he plans to reconstitute in the
concrete form of his own words. Bergotte comes to feel, in the moment of his
death, that the vision is worth the sacrifice of his life. Proust had first identified
this aesthetic transcendentalism in Ruskin and in similar terms:

> But this beauty to which he (Ruskin) found he had consecrated his life was not
> conceived by him as an object of pleasure made to charm him, but a reality infinitely
> more important than life, for which he had given his.[49]

What Proust is trying to work out in his study of Ruskin is the paradox of
spirit and matter: the beauty of works of art, which Ruskin has made into a
religion, is inevitably contained in material substance. As Proust sees, Ruskin's
spiritual aesthetic never becomes intellectually or metaphysically abstract, but
remains firmly rooted in concrete experience. For Ruskin, a work of art is
a physical medium for a spiritual essence which expands beyond its borders,
just as in *A la recherche,* the physical sensations of taste, touch, smell, and
sight are the medium through which Marcel comes in contact with the deeper
reality and unity of his life. In his conclusion to "Journées de pelèrinage"
Proust attempts to reconcile Ruskin's materialism with his religion of art.
Ruskin's spirit, Proust says, has given new value to concrete objects that are as
perishable as we are; through Ruskin's perception we see the essential aspect of
things that had previously been hidden:

> The object to which such thought as Ruskin's applies itself and from which it is in-
> separable is not immaterial, it is spread out here and there over the surface of the
> earth. It is necessary to go find it there where it is located, at Pisa, at Florence, at
> Venice, at the National Gallery, at Rouen, at Amiens, in the mountains of Switzer-
> land. Such thought which has an object other than itself, which is realized in space,

which is not infinite and free, but limited and subjugated, which is incarnated in bodies of sculpted marble, in snowy mountains, in painted visages, is perhaps less divine than pure thought. But it adds increased embellishment to our universe, or at least to certain individual parts, named parts of the universe, because it touched them, and because it initiated us to them and obliges us, if we wish to understand them, to love them.

And it was thus, in effect: the universe gained all of a sudden an infinite value to my eyes. And my admiration for Ruskin gave such an importance to the things he made me love, that they seemed to me charged with a value greater even than life. It was in circumstances in which I believed my days numbered; I left for Venice in order to be able, before dying, to approach, to touch, to see incarnated, in the sinking palaces, but still roseate and standing, the ideas of Ruskin on domestic architecture of the middle ages. What importance, what reality, to the eyes of someone soon to leave this earth could a city, so special, so localized in time, so particularized in space as Venice have and how could these theories of domestic architecture which I could study there and which I could verify on living and concrete examples become part of these "truths which dominate death, prevent one from fearing it, and make us almost love it." It is the power of the spirit to make us love a beauty which we feel more real than ourselves, in things which are to the eyes of others as particular and perishable as ourselves.[50]

Proust feels that the experience that comes from seeing through Ruskin's eyes is the equivalent of an "état de grâce": the discipline of recreating the thought of a "maître" is liberating, because the concrete objects which embody a genius like Ruskin's, the snowy mountains and painted faces, reflect our own personal vision back to us. Just as Ruskin's perception spiritualizes the matter it touches, all artistic vision is a projection, an overlay of spirit on concrete substance, which reflects "le génie," the spirit, back again. Proust's own aesthetic is intensified through Ruskin, as Ruskin's thought "realized in space" has the capacity to reveal Proust to himself, just as Proust's novel reflects the vision of each individual reader.

Proust takes up the same concept of the function of art, in the preface to his translation of *Sésame et les lys*. He is describing the effect of transfiguration that takes place when a landscape is painted:

What makes them appear different to us and more beautiful than the rest of the world is that they bear on them like an intangible reflection the impression they have given to genius, and which we would see, as singular and as despotic, moving over the indifferent and submissive face of all the countries they might have painted. This appearance with which they charm and deceive us, and beyond which we would like to go, is the very essence of that thing without thickness, so to speak—mirage fixed on a canvas—that a vision is. And that mist which our eager eyes would like to pierce is the last word of the painter's art. The supreme effort of the writer as of the painter succeeds only in partially raising for us the veil of ugliness and insignificance which leaves us indifferent before the universe.[51]

Again the writer's supreme effort, like the painter's, is to lift the veil of insignifi-
cance and give us a new vision, the value of which lies in its "irreducible"
individuality. The actual landscape is unimportant compared to the particular
vision with which it is seen. Proust once again emphasizes the materiality of the
container for the "essence"; the vision of the artist is arrested like a mirage on a
canvas which is virtually without thickness, a two dimensional object, a mere
layer of pigment, simple physical substance. Proust, of course, re-uses these
components in the Bergotte-Vermeer scene, where the writer must imitate the
painter in giving a form to his vision, a form which is as concrete and physical as
the substance of yellow paint, and which, paradoxically, acts as a container for
the essence of spiritual reality.

In the Bergotte-Vermeer episode there is a curious reflection of images
that appear in Ruskin's description of his religious unconversion at Turin in
front of Veronese's *Solomon and Sheba.* As Bergotte is walking into the exhi-
bition, he compares the profundity of Vermeer with the sterility of lesser
artists whose paintings "ne valait pas les courants d'air et de soleil d'un palazzo
de Venise." The balancing of "inutile" art against the warm air and sunlight of
Venice is reminiscent of Ruskin's balancing of useless religion against the warm
breeze and military music that float into the palazzo at Turin, where he is look-
ing at the abstract and glowing color of Veronese's painting, much in the same
way that Bergotte is looking at the fragment of yellow paint in Vermeer. Al-
though the location is changed to Venice, Ruskin's symbolic city, the episodes
are related by deeper parallels than the verbal echo. At Turin, Ruskin renounces
his Protestant faith for the religion of art, and his new faith is founded, not on
the "subject" or "noble ideas" of Veronese's painting, but on a realization of the
sensuous power of color alone. Ruskin's new spiritual aesthetic is based on the
concrete aspects of the painting; he sees that the handling of color, by itself,
expresses the essence of Veronese's vision, which is deep but lighthearted,
secular and religious at the same time. Veronese's glowing color is a metaphor
for Ruskin's aesthetic religion, just as the precious matter of Vermeer's yellow
paint is a metaphor for the spiritual reality that Bergotte discovers through
the painted surface.

Pater and the Structure of the Moment

Walter Pater occupies a curious position in literary history that makes his work serve as a central pivot for the essays in this book: like Proust, he inherits the vast aesthetic world of Ruskin's thought and transforms it into his own system. Again like Proust, Pater's interpretation of Ruskin is subtly altered by the addition of ideas primarily derived from Baudelaire. The system that Pater creates is the English equivalent of French Symbolism: Pater forms the transition between Ruskin's "spiritual" aesthetic and the aesthetic climate of the nineties which was permeated with borrowings from France. But the climate that nourished Oscar Wilde also nurtured Henry James, and in James we can seen a direct link back to Ruskin's aesthetic morality, a link which is established through Pater's transformation of Ruskin's thought. Although Wilde make Pater's *The Renaissance* his "golden book," just as Des Esseintes had turned a book of Mallarmé's poetry into a sacramental object, Pater himself was at a loss to explain how his system had been diluted into the flamboyant and superficial aestheticism of the mauve decade. The true complexity of Pater's system is expanded and amplified in the novels of Henry James, just as the values of French Symbolist poetic theory are given novelistic form in the work of Marcel Proust.

Because of the wealth of correlations, this chapter will attempt to focus directly on Pater's work. The parallels with Proust are almost too numerous to trace out, as the synthesis of Ruskin and Baudelaire in both writers frequently results in mysteriously identical situations. For example, in Pater's "The Child in the House" he emphasizes the reciprocal relationship between the "soul" of the child and the concrete envelope of sensations which surround him, which is symbolized by the "house." The "inextricable" relationship of person to place is the same relationship that Proust constructs with Marcel at Combray, where the "reciprocité des échanges . . . entre personnes et lieux" that Poulet underlines[1] is given full expression. Pater is trying, like Proust, to account for the "tyranny of the senses," to explain why the "revelation" that comes through "physical impressions" seems to contain a metaphysical reality. The culminating example of a remembered sensation that glows with spiritual overtones is the sight of a

red hawthorn that seems to be "absolutely the reddest of all things"[2] and which Pater connects with the old Red of Venetian painting. With or without the correlation of Marcel's meditation on the pink and white hawthorns at Combray, *the similarity is essential.* Pater and Proust both describe the process of growing up as a function of sensation, sensation attached to the particularity of place, concrete experience influencing spiritual development, and the whole mass of concepts that relate to the idealization of the concrete, can be felt in both writers in terms of the mixed impact of Ruskin and Baudelaire. Proust aligns himself with Baudelaire because of correspondences, while Pater emphasizes the conscious control of the artist-dandy, but both writers take Baudelaire's concept of language as a tangible medium to its furthest extension, and consider the literary text as metaphysically real and concrete, anchoring this metaphysical dimension in the analogy of writing to painting. And for Pater, as well as Proust, Ruskin provided the meticulous training of the senses·which forms the basis of his aesthetic view of life. Because of the commonality of sources, we can see Pater's system and his attempt to embody this system in novels and essays as analogous to the aesthetic system of *A la recherche.* But Pater's major attempt at a novel, *Marius the Epicurean,* lacks the breadth and range of Proust's work: there is no Dickensian element in *Marius,* nothing of George·Eliot or of the *Arabian Nights,* none of the true novelistic diversity that fills in the aesthetic structure of *A la recherche. Marius* is closer to the philosophic presentation of aesthetic ideas in *Le Temps retrouvé* than it is to the rest of the novel. Although Proust and Pater were both trying to write novels based on *sensation* as the primary unit of experience, Proust depicts Marcel's sensations seen against the full panorama of the social and sexual life of the times, while Pater restricts the scope of his novel to a discursive theorem, barely adorned with the trappings of fiction. *Marius* lacks the Gothic roughness of *A la recherche,* the Ruskinian order achieved through variety and multiplicity. While Proust's system is submerged throughout most of the novel, in Pater's work the system is unfolded with precision, chapter by chapter. Because of the tight application of his literary theory in practice, and the refined coherence of the system, Pater is actually closer in spirit to Mallarmé than to Proust, as an English exponent of Symbolism.

Several critics have made brief comments linking Pater to French Symbolism, remarks usually left in the state of a suggestion.[3] Edmund Wilson, for example, makes a direct comparison between Pater and Mallarmé, but fails to develop his implication. He simply states:

> I have said that the battle of Symbolism was never properly fought out in English; but there was one writer in England who played a role somewhat similar to that of Mallarme in France. Walter Pater was, like Mallarmé, a man of much intellectual originality who, living quietly and writing little, had a profound influence on the literature of his time. More nearly than anyone else, he supplied, in his literary criticism, an English equivalent to the Symbolist theory of the French.[4]

Wilson seems to be alluding to the temperamental affinity between the two writers, and in both cases the shy, retiring, scholarly attitude has aesthetic consequences: their work is deliberately refined and obscure, meticulously constructed so that it has a high degree of polish and condensation and is "cloistered" from the vulgar world of journalism. There may have been a direct contact between the two writers when Mallarmé came to Oxford in 1894 to deliver a lecture. After leaving Oxford, Mallarmé idealized the life of the don as a perfect existence for the scholar-artist, removed from the world at large, enclosed in a purely mental environment. Arthur Symons reports Mallarmé commenting on Pater as "Le prosateur ouvragé par excellence de ce temps." Whether or not an actual meeting took place, Mallarmé, at least, was aware of the similarity of his and Pater's efforts to consciously "work" prose into a new medium. The deeper parallel that Wilson implies beneath the cloistered temperaments, is the fact that Pater developed a literary theory comparable to Mallarmé's concept of language as substantial reality in itself. Because Baudelaire is the ultimate source for Mallarmé, as well as for Proust and Pater, in the attempt to concretize words, it is hardly surprising that the various formulations bear a family resemblance. The striking parallel between Pater and Mallarmé is the way in which language, handled as a physical and sensuous medium, is used to convey profoundly abstract and intellectual propositions. Most of Pater's work falls into the genre of poetic criticism, the poet using other works of art as the subject of his poetry. Pater's essays, like Mallarmé's "poèmes en prose," are essentially lyrical arguments that combine a dense poetic language with an intricate process of thought. The subtlety of the essay form for Pater lies in the flexibility of prose, a medium which is traditionally adapted to the presentation of ideas, but which in Pater's "modern" usage is able to convey the sensory impact of ideas directly as well as the intellectual impact of images and sensations. Prose for Pater, as for Mallarmé, fuses the magical and discursive powers of language.

In the following discussion of Pater, Mallarmé will be used as a "point de repère" to situation Pater in the context of Symbolism, but the treatment of Mallarmé will necessarily be incomplete, introduced only as a means to comparison. Only the larger correlations with Baudelaire, Ruskin, and Proust will be emphasized, assuming that the reader will use the larger framework to detect other correlations on his own. The chapter will be directed at illuminating Pater's codification of the literary theory of his time, just as Mallarmé, responding to similar influences in the air, constructed an organized theory of verbal art. Although the process of codification is systematic and coherent in Pater's work, it is not rigid, as it is based on the evanescent nature of the momentary sensation; Pater himself warns against the facile orthodoxy of a locked system, using Hegel and Comte as examples. Pater's own system is a perfect illustration of the delicate relation between Impressionism and Symbolism, which Cocking felt that Proust had never completely resolved:

> But even the intellectual conjuring tricks are stimulating and challenging, and
> they have been prompted by a genuine sense of correspondences which even Proust's
> intelligence has not been able to make manifest as clear intellectual relations; corre-
> spondences between that aspect of the expressive power of painting which Impres-
> sionism isolated and concentrated and that aspect of the expressive power of lan-
> guage which Symbolism isolated and concentrated.[5]

In a more explicit way than Proust, Pater connects the impression recorded by
the painter and the use of the impression or image in literature. The impression
of the painter and the symbol of the writer are based on the same model—the
structure of the moment of sensation. In both cases time is arrested and replaced
with spatial organization, all parts viewed with theoretical simultaneity. In order
to show the relation between impression and symbol, we will proceed directly
to Pater's concept of the moment of sensation, the interaction of consciousness
with the concrete manifold, and the use of painting as a metaphor for literary
form.

Pater's aesthetic criticism is based on the same approach to experienced
which underlies *Modern Painters:* the attempt to look directly at things as they
are. Like Ruskin, Pater objects to generalizations about art or life because he
feels that statements in abstract terms are not true to "the precise meaning" of
actual experience or "the precise texture of things."[6] His stated aim is

> To define beauty, not in the most abstract but in the most concrete terms possible,
> to find not its universal formula, but the formula which expresses most adequately
> this or that special manifestation of it, is the aim of the true student of aesthetics.[7]

The word "concrete" becomes a key term in Pater's aesthetic, and in many of
its implications it is similar to Ruskin's concept of the particular. By examining
the extended meanings of the term "concrete," we can see how Pater's thought
is based on Ruskin's and also note the significant departures that the disciple
makes from the master.[8]

First of all, Pater's effort to define beauty in the concrete is an attempt
to find the special quality of each phenomenon, to see each object as unique:
"the function of the aesthetic critic is to distinguish, to analyze, to separate
from its adjuncts, the virtue by which a picture, a landscape, a fair personality
in life or in a book, produces this special impression of beauty . . ." (Pater,
The Renaissance (London, 1914), p. vii. Hereafter cited as *Ren*) Already in the
first few pages of the preface to *The Renaissance,* Pater introduces a major
change from Ruskin's attempt to focus his perception on the distinct qualities
of the object. Pater unobtrusively shifts the emphasis from seeing "the object
as in itself it really is" to "knowing one's impression as it really is." Thus the
impression or sensation (the terms are used interchangeably) replaces the object
as the focus of study. Pater has lost Ruskin's sustaining sense of reality in the

outer world; the only reality he can find, at first, is within the individual mind. While Ruskin's powers of observation are used to illuminate the object, for Pater "the observation of facts more precise and minute . . . the power of distinguishing and fixing delicate and fugitive detail"[9] is directed inward to illuminate the observer's impression. The special qualities of a work of art or an object exist only in a reflected version in the impression that they create. The primary question for Pater's aesthetic critic is "what is this song or picture, this engaging personality presented in life or in a book, to *me*?" (*Ren.*, p. viii). Thus the ability for refined perception in Pater is essentially a passive faculty; it makes the observer receptive to more varied, complex, and subtle impressions. The relationship between the precise discrimination of the object and the precise nature of the individual impression is expressed in Pater's description of Botticelli:

> To him, as to Dante, the sound, the colour, the outward image or gesture, comes with all its incisive and importunate reality; but awakes in him, moreover, by some subtle law of his own structure, a mood which it awakes in no one else, of which it is the double or repetition, and which it clothes, that all may share it, with visible circumstance. (*Ren.*, p. 54)

Pater's sense of refinement and discrimination is more acute than Ruskin's and is carried to an infinitesimal degree. While Ruskin was sensitive to the particular qualities of objects and the changing effects of time, he did not systematically disintegrate experience into the smallest possible spatial and temporal quantities as Pater does. Pater's schema of the world is represented by a stream[10] or a river which is in constant motion and is divisible. At first "experience seems to bury us under a flood of external objects" and then these are further decomposed into basic components such as "colour, odour, texture" which exist in the mind of the observer (whereas for Ruskin and Pound, as Davie says, "colour inheres in the object." After the object has been reduced to a number of sensations, these impressions are further divided into temporal units. As each impression or sensation is

> limited by time, and that as time is infinitely divisible, each of them is divisible also; all that is actual in it being a single moment, gone while we try to apprehend it, of which it may ever be more truly said that it has ceased to be than that it is. To such a tremulous wisp constantly re-forming itself on the stream, to a single sharp impression, with a sense in it, a relic more or less fleeting, of such moments gone by, what is real in our life fines itself down. It is with this movement, with the passage and dissolution of impressions, images, sensations, that analysis leaves off—that continual vanishing away, that strange, perpetual weaving and unweaving of ourselves. (*Ren.*, pp. 235-36)

Thus this personal, momentary sensation is the primary unit of experience for Pater. This configuration represents the point of intersection of three variables,

each of which is unique: the peculiar temperament of the observer, the particular object, and the moment in time in which they came together. This conjunction is present in the description of experience in *The Renaissance*.

> Every moment some form grows perfect in hand or face; some tone on the hills or the sea is choicer than the rest; some mood of passion or insight or intellectual excitement is irresistibly real and attractive to us,–for that moment only. (*Ren.*, p. 236)

Although his concept of the moment or the sensation[11] changes and deepens throughout his career, the basic formula remains the same: as it is phrased in *Marius*, knowledge begins with "the momentary sensible apprehension of the individual."[12] The same configuration is present no matter which of the three elements is used as a focus: the "moment" is always described as replete with sensation and is related back to the experience of a particular artist or aesthetic critic, the "sensation" is always understood as momentary and subjective, and Pater's observers always apprehended life as a series of separate, distinct "impressions," as in his description of Goethe, "to whom every moment of life brought its contribution of experimental, individual knowledge; by whom no touch of the world of form, colour, and passion was disregarded."[13]

This cult of the concrete sensation, besides emphasizing the particularity of experience, also keeps the aesthetic critic close to the physical texture of life. Just as Ruskin thought that knowledge began with the perception of visible reality, so Pater believed that knowledge began with sense experience; and the proof of reality becomes the physical immediacy of the sensation, whether of sight, touch, smell, or sound. At the beginning of his career Pater emphasizes the physical in opposition to (and at the expense of) metaphysical considerations. In the Coleridge essay, for example, he deplores his tendency to "change the colour or curve of a rose leaf for that . . . colourless, formless, intangible being–Plato put so high."[14] In *The Renaissance* he feels that "the desperate effort to see and touch" is enough and ther is hardly "time to make theories about the things we see and touch" (*Ren.*, p. 237). In a similar way, at the beginning of his aesthetic education, Marius had tried "to live in the concrete." His philosophy had been to: "Trust the eye: Strive to be right always in regard to the concrete experience: Beware of falsifying your impressions" (*Marius*, p. 139). He felt that it was "reassuring after so long a debate about the rival *criteria* of truth, to fall back upon direct sensation . . ." (*Marius*, p. 79). Although Pater may seem to be reducing life to a merely sensuous existence, this is not his intention. He was always aware of the fusion of physical existence with the spiritual life, so that a sensation, for him as for the French Symbolists, is always connected to an "état d'âme." The use that Pater makes of these connections will be discussed later in the chapter in relation to his prose style. At this

point it is enough to show that Pater deepened his concept of the physical concrete to include the possibility of metaphysical analogues, thus making his cult of the sensation into a sort of religion.

His original rejection of "unprofitable metaphysical questions" is not so much a denial of the spiritual dimension in life as it is an insistence on direct, tangible experience. Just as Ruskin saw that a natural object can become symbolic without losing its particularity, so Pater realized that his impressions could provide a point of access to deeper reality without losing their physical immediacy. Pater's attempt to keep a degree of physical awareness in his consciousness of things is in many ways comparable to the French Symbolist cult of the *sensation*. In "The Child in the House" Pater explains his temperamental bias for transforming all experience into terms of sensation:

> In later years he came upon philosophies which occupied him much in the estimate of the proportion of the sensuous and the ideal elements in human knowledge, the relative parts they bear in it; and, in his intellectual scheme, was led to assign very little to the abstract thought, and much to its sensible vehicle or occasion. Such metaphysical speculation did but reinforce what was instinctive in his way of receiving the world, and for him, everywhere, that sensible vehicle or occasion became, perhaps only too surely, the necessary concomitant of any perception of things, real enough to be of any weight or reckoning, in his house of thought. There were times when he could think of the necessity he was under of associating all thoughts to touch and sight, as a sympathetic link between himself and actual, feeling, living objects; a protest in favour of real men and women against mere gray, unreal abstractions. . . .[15]

Pater therefore seems to be more interested in the sensation a thought or idea produces in the mind, than in the idea itself. He wants ideas to have the simplicity and directness of a physical sensation. Thus, in *Marius,* he discusses the "moments intent with sensation, and a kind of knowledge which, in its vivid clearness, was like sensation. . . ." (*Marius,* p. 153) or again, speaking of Marius:

> . . . he would at least fill up the measure of that present with vivid sensations, and such intellectual apprehensions as in strength and directness and their immediately realized values at the bar of an actual experience, are most like sensations.[16]

For Pater, as for Proust and Elstir, *sensation* takes precedence over *knowledge;* he tries to present the effect of an idea before the actual core of contact is realized. For this reason Pater uses the stylistic resources of "modern" prose to convey the "aura of visible loveliness about ideas," an aura which is felt directly before the intellectual grasp takes place. Pater, theoretically at least, does not describe an object, an idea, a work of art in abstract terms, but attempts to give the tangible and direct impression it makes on his mind, so that the physical act of apprehension is the basis of mental operation, *meaning* contained within

the aura of sensation. This attempt to convey ideas in terms of their physical impact is difficult, and Pater usually resorts to a complex and extended structure in order to make the sensation of an idea apparent; in the essays on "Leonardo" and "Giorgione," for example, the *whole* essay is needed to embody a single, primary impression. Mallarmé felt this difficulty in his attempt to create a new poetic language which would be able to "peindre non la chose, mais l'effet qu'elle produit." This statement is closely parallel to Pater's stated literary goal, described in his essay on "Style," "to give not fact but the imaginative sense of fact." To paint, not things, not facts, but the sensation produced by things and facts, involves both Pater and Mallarmé in a search for new verbal structures that go beyond naming and describing. Mallarmé discovered, like Pater, that he needed the whole structure of a poem or poetic essay, operating as a unit, to convey the complex aura that surrounds a single experience or idea.

In *Marius* Pater begins to develop the notion of sensation as a type of primary, pure consciousness. In *The Renaissance* he sees the momentary sensation as the ultimate point of contact with experience before the self vanishes into the flow of space and time. Pater believes that sensation is intent with a consciousness of self because it is a moment of intense, real being rescued from the flux. In the "moment" the consciousness is aware of itself. As Pater says, "painting, music, and poetry" are the "Romantic" or "modern" arts because in their "exquisite intervals" they embody "the consciousness brooding with delight over itself" (*Ren.*, p. 21). In *The Renaissance* he speaks of the moment yielding "multiplied consciousness"; in *Marius* he begins to see that pure sensation is a sort of consciousness of the moment itself. Marius' attempt "to live in the concrete" (*Marius,* p. 94) is defined as "grasping the sensation, the consciousness of the present" (*Marius,* p. 88); the New Cyrenaicism is an effort "to miss no detail of realized consciousness in the present" (*Marius,* p. 85). Living in the present moment comes to have a metaphysical significance for Marius as it is a way of transcending time, of existing in what Pater calls the "mystic Now."[17] Thus Pater's cult of sensation leads him in the same direction as Marcel Proust, who, as Guy Michaud says, was "en quête de le temps pure et la sensation pure."[18] Pater has an intimation of the same idea of a moment of pure being as Proust, who is also aware that a physical sensation such as the taste of the madeleine experienced in a moment of time can be a point of access to another plane of reality.

The moment of pure being in Proust also brings with it the consciousness of a permanent self, which lies deeper than the series of changing identities which constitute the fluid continuum of everyday life. For Pater, the "moment" also contains the intuition of a "better self." This perception of a second self is due to the fact that the consciousness turned inward seems to divide the self into an observer and an observed double. Pater's aesthete, like Baudelaire's dandy, is a *homo duplex* who watches himself live and is conscious of the way he

experiences life. This self-consciousness produces a feeling of detachment in Pater which it does not in Baudelaire; a quality Pater calls *umbratilis,* because it casts a shadowed light over experience. Marius maintains a type of double vision, looking at experience in the present and also as if seen retrospectively; he thus becomes the spectator of his own life while he lives it. Like Baudelaire, Pater uses this "strenuous self-consciousness" as a type of controlled discipline to convert life into an art. He is particularly interested in conscious attention to the elements of ritual in life which give it a sort of formal beauty: Pater therefore stresses the observance of traditinal manners and gestures. In characters such as Marius or Emerald Uthwart he praises the studied reserve, the practiced quiet, the tact which go to make up the scholarly demeanor, which sounds as if it were based on the English public school ideal of a scholar-gentleman. In "Diaphaneité," Pater points out that the moral life of the artist is not spontaneous but is the result of rigorous training.[19] The scholar must practice a strict discipline of "abstinence, strenuous self-control, *ascesis*" (*Marius,* p. 15). Thus, in a curious way, Pater's description of the scholar-dandy[20] reverts back to the original source for the dandy, which was the English gentleman. In France in the 1840s the impeccable manners and calm aloofness of the upper-class Englishman became the fashionable pose to strike in polite society, and it was from this French interpretation of the "gentleman" that Baudelaire took his original notion of the dandy which he converted into his concept of the artist.

Perhaps the major difference between the attempts of Baudelaire and Pater to live with conscious control is that Baudelaire is able to digest a greater range of experience and is acutely aware of all that happens to him, while Pater tries to consciously edit his moments, discarding what seems to him unpleasant. The aim of his "elaborately developed self-consciousness" (*Marius,* p. 151) is to "live life of varied yet select sensation" (*Marius,* p. 99). Pater's selectivity is initially an attempt to exclude what is evil or ugly from the vision of life, whereas Baudelaire was able to confront these elements directly. Marius' program for living a conscious, controlled existence is designed to banish from his mind the image of the serpent which he saw in a dream at the temple of Aesculapius. Another dream figure advises him to be temperate if "thou wouldst have all about thee like the colours of some fresh picture, in a clear light" (*Marius,* p. 20). Marius interprets this dream as an aesthetic and moral imperative, combining traditional English virtues with a very un-English refinement of the senses:

> To keep the eye clear by a sort of exquisite personal alacrity and cleanliness, extending even to his dwelling place; to discriminate ever more and more fastidiously, select form and colour in things from what was less select; to meditate much on beautiful visible objects . . . to avoid jealously, in his way through the world, everything repugnant to sight. . . . (*Marius,* p. 20)

This passage shows clearly how the moral qualities of the scholarly temperament are directed towards aesthetic ends.[21] As Anthony Ward points out, this attempt to control the quality of vision by limiting experience is properly called a "picturesque view" of life.[22] Pater tries to put a frame around certain "clauses of experience" which not only encloses the moment or sensation within, but cuts it off from what is outside.

For Pater, the power of transforming everyday life into a heightened or purified experience, as if it were art, is dependent upon this principle of selectivity. Marius learns

> the art of so reliving the ideal or poetic traits, the elements of distinction, in our every day life—of so exclusively living in them—that the unadorned remainder of it, the mere drift or *debris* of our days, comes to be as though it were not. (*Marius,* p. 23)

Whereas Baudelaire remains agonizingly conscious of even the debris in life, Pater's art of living is an attempt to forget *ennui,* not to transform it. The scholar aesthete controls his consciousness of life so that he refines his experience, by heightening certain moments and obliterating others. Again Pater uses a pictorial vocabulary to describe this process:

> Detached from him, yet very real, there lay certain spaces of his life, in delicate perspective, under a favorable light; and somehow, all the less fortunate detail and circumstance had parted from them. (*Marius,* p. 88)

Living life as an art always detaches Marius from reality. Pater's double view of life tends to separate experience from himself, to frame it in the past and give it a retrospective completeness: Baudelaire's dual consciousness, however, makes life seem acutely present and results in a sharp close-up of forms. Pater sacrifices the complexity of experience in order to give it the same sort of form or formal perfection as a work of art: Marius' life seems like "the reading of a Romance to him" (*Marius,* p. 14) and his "existence, from day to day, came to be like a well executed piece of music . . ." (*Marius,* p. 86).

Perhaps the contrast between Baudelaire's dandy and Pater's scholar is most evident in Pater's interpretation of Baudelaire's theory of modernity. The whole discussion in the "Modernity" chapter of *Gaston de Latour,* of how the "true classic is always of the present" is based directly on Baudelaire's ideas.[23] For example, Pater describes "a poetry which boldly assumes the dress, the words, the habits, the very trick of contemporary life, and turned them into gold"[24] which echoes Baudelaire's metaphor for the power of art to transform mud into gold. Again Pater uses Baudelaire's *exact* words in explaining the "latent poetic rights of the transitory, the fugitive, the contingent." There is an oblique acknowledgment of source in the last page of the chapter, as Pater

makes reference to "the flowers of evil" in a brief mention of the possibility of profane elements in his cult of beauty. Pater interprets the significance of modernity in literature as the power of making the reader aware of the poetic elements in the life around him, so that he sees his experience in terms of art. Again Pater's description of the process involves a pictorial ordering and selection:

> It [modernity] had been a lesson, a doctrine, the communication of an art,—the art of placing the pleasantly aesthetic, the welcome elements of life at an advantage, in one's view of it, till they seemed to occupy the entire surface. . . .[25]

The concept of modernity, which is theoretically a justification of living in the present, paradoxically again has the effect of distancing experience for Pater:

> It took possession of the lily in one's hand, and projecting it into the visionary distance, shed upon the body of the flower the soul of its beauty.[26]

Pater's conscious control of experience is not only a process of limitation and arrangement, it is also an attempt to intensify his consciousness of the "select" moments of sensation. Although Pater realizes that this selectivity involves a "sacrifice of a thousand possible sympathies" (*Marius,* p. 153) and that the ability to make "certain moments . . . highly pitched, passionately coloured" involves a "narrow perfection" (*Marius,* p. 154), he never abandons his concept of the concrete. He tries to discover some validity for experience within the physical sensation of the particular moment. Marius' "aesthetic education" involves a "dexterous training of capacity" for sensation; this "expansion and refinement of the powers of reception" is intended to make the "actual moments, as they passed . . . yield the utmost" (*Marius,* p. 84). As was mentioned earlier, this sensory refinement, for Pater, seems to lead to a state of pure consciousness. He describes the way in which the aesthetic scholar must train himself in order to attain complete directness of sensation. In the Cyrenaic "antimetaphysical metaphysic":

> Abstract theory was to be valued only just so far as it might serve to clear the tablet of the mind from suppositions no more than half realizable, or wholly visionary, leaving it in flawless evenness of surface to the impressions of an experience, concrete and direct. (*Marius,* p. 81)

The aim of Marius' training is "to be absolutely virgin towards such experience, by ridding ourselves of such abstractions as are but the ghosts of bygone impressions. . . ." After this discipline,

> He would be sent back . . . to experience, to the world of concrete impressions to things as they may be seen, heard, felt by him; but with a wonderful machinery of observation, and free from the tyranny of mere theories.[27]

As Pater explains it, the end of this cultivation of sensuous experience is not pleasure, but "Insight" (*Marius*, p. 81) or "mulitiplied consciousness" (*Ren.*, p.139). This consciousness includes not only a great awareness of the "aspects of things" but also a greater awareness of the self perceiving:

> to be occupied with the aesthetic or imaginative side of things, is to be in real con-
> tact with those elements of his own nature, and of theirs which are matter of the
> most real kind of apprehension. (*Marius*, p. 155)

The way that Pater relates this insight to the world beyond the individual, and expands the "moment of consciousness" beyond the act of physical perception is almost completely through a system of correspondences.[28] He uses a vocabulary pertaining to spiritual experience when describing his physical view of life, which suggests the possibility of greater significance. For example he says that "in the visionary reception of everyday life [Marius] was the seer, more especially of a revelation in colour and form" (*Marius*, p. 32). He intimates that physical vision could be expanded to "beatific vision" and that the perfecting of the sense of sight leads to "a blessedness of vision" (*Marius*, p. 85). Pater consistently refers to his aesthetic approach to life as a religious attitude:

> Such manner of life might come even to seem a kind of religion—an inward, visionary
> mystic piety, or religion, by virtue of its effort to live days 'lovely and pleasant' in
> themselves, here and now, and with an all sufficiency of well being in the immediate
> sense of the object contemplated. . . . (*Marius*, p. 85)

The scholarly dedication involved in the pursuit of sensation, the control and ascetic restraint necessary for refining the receptive powers make it seem to Marius that "the devotion of his days to the contemplation of what is beautiful [is] a sort of perpetual religious service." Perhaps the similarity that Pater found between the aesthetic calling and the religious life was the element of ritual common to both, which gives a certain formal order to experience.

The various threads of thought we have been discussing—the analogies between aesthetic and religious experience, the relationship between consciousness of objects and consciousness of self—are all brought together in the "expanded moment" of vision which Marius has in the Roman campagna. Here the conjunction of clearness in the temperament of Marius and clarity in the physical light produces a moment of insight. This moment completely fulfills the aims of the Cyrenaic education and refers back to the passage describing the perfected power of reception. As Marius rides out into the country he is "wholly" in possession of "that flawless serenity" (*Marius*, p. 176) which echoes the "flawless evenness of surface" which is described as the goal of the well-trained mind. The moment transpires under "the even veil of lawn-like white cloud" which

casts a "broad, shadowless light" (*Marius*, p. 177); this physical light functions
like the metaphorical "dry light" (*Marius*, p. 81) of the Cyrenaic temperament
in that it illuminates evenly without distortion or emphasis. In "the peculiar
clearness of one privileged hour" (*Marius*, p. 180) he experiences a pure sensa-
tion of being. His double consciousness, which has enabled him to be the spec-
tator of his own life, now functions to give him an intuition of his own self: "he
enjoyed a quite unusual sense of self-possession—the possession of his own best
and happiest self." (*Marius*, p. 176) He sees that this double of himself had
always been inside him; and he connects this idea of a second self with a sort of
corresponding divine companion on the other side of the veil. Pater thus comes
closest to grasping spiritual reality by discovering the innermost self: "he passed
from that mere fantasy of a self not himself, beside him in his coming and going,
to a divination of a living and companiable spirit at work in all things . . ."
(*Marius*, p. 179). Marius' discovery is that the self has the power of consciously
shaping the spiritual vision, in the same way the aesthete controls his physical
vision. The equation of will with vision then links the two types of consciousness
we have been discussing—consciousness as perception and consciousness as
control. In this prolonged moment of consciousness his awareness of the exter-
nal world and his awareness of self become fused: Marius has an insight which
springs him out of his subjectivism as he realizes that "actually his very self" is
connected to "the great stream of physical energy without it" and to "the great
stream of spiritual energy within." He sees that he himself as well as the material
world are both "reflections in that one indefectible mind" that "more vigorous
consciousness [where things] might subsist forever" (*Marius*, p. 180). Pater's
initial formulation of experience, the impression in the consciousness of the
individual, serves as a model for this final *correspondance* in which reality is
described as a reflection in the consciousness of God.

In *Marius* this expanded moment is the real climax of the novel: although
the whole course of his life is leading towards some "ampler vision" it never
comes within the pages of the book.[29] The experience in the Campagna remains
the point of greatest intensity, the moment of greatest "fullness of life" in
Marius's career: "Himself—his sensations and ideas—never fell again precisely
into focus as on that day . . ." (*Marius*, p. 180). Marius' experience is refined to
a single focus, his life condensed to a quintessential moment. This tendency to
reduce a complex structure to a single form is typical of Pater and reflects
another aspect of this theory of the momentary sensation, which is to regard
each moment as unique, separate from the flow, self-contained. The "single,
sharp impression" (*Ren.*, p. 196) detaches itself from the rest of experience
through its intensity:[30] the "moment intent with sensation" or the sensation
which has "fullness" both give a sense of completeness. We have already noted
that Pater tries to locate a deeper (or higher) reality within the boundaries of
an isolated moment in an individual mind, in the same way that Ruskin finds

ideality within the outline of the particular object. But Ruskin's atomistic view of the world is sustained by an underlying principle of unity: the distinct particulars are ultimately connected and form an interlocking whole. For Pater, however, the momentary sensations remain disconnected; he treats experience as if it were composed of discrete, discontinuous units. The moment becomes a sort of microcosm for Pater; there is no attempt to link up moments or sensations; each one seems to be as potentially complete as another.

We have seen in Marius how the moment can have a sort of psychological completeness within the consciousness of the individual. In *Plato and Platonism*, Pater gives a definition of this feeling of completeness in relation to the object, rather than the observer, although an observer is implied and, as always, the act of perception takes place in a "single moment of vision." He describes the way in which a natural object, such as a seashell, can have an inherent aesthetic significance:

> By its juxtaposition and co-ordination with what is ever more and more not *it,* by the contrast of its very imperfection, at this point or that, with its own proper and perfect type, this concrete and particular thing has, in fact, been enriched by the whole colour and expression of the whole circumjacent world, concentrated upon, or as it were at focus in, it. By a kind of short-hand now, and as if in a single moment of vision, all that, which only a long experience, moving patiently from part to part, could exhaust, its manifold alliance with the entire world of nature, is legible upon it, as it lies there in one's hand.[24]

Thus the object, like Marius' moment of consciousness, represents a single point of focus, and is defined as a self-contained form against the background of everything which is not it. Again the difference from Ruskin is apparent: for Ruskin an object has its own completeness but it also exists in relation to others; in Pater the object is complete because it is perceived as a single, unique form. This condensation is the equivalent of generalization for Pater, who imposes his own characteristic interpretation on Plato's doctrine of ideality:

> Generalization, whatever Platonists, or Plato himself at mistaken moments may have to say about it, is a method, not of obliterating the concrete phenomenon, but of enriching it, with the joint perspective, the significance, the expressiveness of all other things besides.[31]

Pater, like Ruskin, is looking for a way of attaching an ideality to experience without abandoning his tangible hold on things: the seashell, while it becomes, for a moment, the focal point of the entire world, is still physically close and real, "as it lies there in one's hand."[32]

The description of the "concrete phenomenon" and "the concrete and particular thing" in these sections from *Plato and Platonism* underlines another implicit meaning of the word "concrete" in Pater's thought. Besides connoting

particularity and physicality, it is also used to indicate the quality of discreteness or self-containedness which Pater finds in the aesthetic object. "Concrete" also means "a mass formed by concretion or coalescence of separate particles of matter in one body."[33] In the "Giorgione" essay Pater seems to underline this slightly unusual usage with his phrase "wholly concrete" in order to describe the wholeness or completeness of the moment. The definition of the moment here contains the same elements as the definition of the object in *Plato* or the definition of consciousness in *Marius;* in all three instances there is a condensation of experience into a single, whole unit. Giorgione's painting:

> presents us with a kind of profoundly significant and animated instants, a mere gesture, a look, a smile, perhaps—some brief and wholly concrete moment—into which, however, all the motives, all the interests and effects of a long history, have condensed themselves, and which seem to absorb past and future in an intense consciousness of the present. Such ideal instants the school of Giorgione selects, with its admirable tact, from that feverish, tumultuously coloured world of the old citizens of Venice—exquisite pauses in time, in which, arrested thus, we seem to be spectators of all the fulness of existence, and which are like some consummate extract or quintessence of life. (*Ren.,* p. 150)

Giorgione's painting is such a perfect metaphor for describing the significant moment, because of all the arts that Pater studied as an aesthetic critic, painting is the form most suited for translating a moment of being into a work of art. The framed painting (which Pater claims that Giorgione originated) is a self-contained microcosm with its own unity of atmosphere, effectively separated by the boundary of the frame from everything outside it. Thus a painting operates as a single form and conveys an impression directly and immediately (although the observer may go back to look at a painting several times, the form itself implies a single viewing). In the beginning of the "Giorgione" essay, Pater makes a passing reference to Lessing's *Laocoön,* in which painting is specifically described as a spatial art as opposed to the temporal art of literature. But Pater sets up Lessing as a straw man, and introduces the distinction between art forms, only to show how the boundaries can be transgressed:

> But although each art has thus its own specific order of impressions, and an untranslatable charm, while a just apprehension of the ultimate differences of the arts is the beginning of aesthetic criticism, yet it is noticeable that, in its special mode of handling its given material, each art may be observed to pass into the condition of some other art, by what German critics term an Anders-streben—a partial alienation from its own limitations by which the arts are able, not indeed to supply the place of each other, but reciprocally to lend each other new forces. (*Ren.,* p. 110)

Because the arts can, in Baudelaire's phrase, lend each other new forces, literature, attempting to record moments of sensation, can approach the conditions of

painting. Painting is a type of static form, a spatial configuration which is perceived in an instant of time, and is therefore the closest formal equivalent to Pater's concept of the concrete moment of sensation. Pater always conceives of art in opposition to time; the aim of artistic activity is to stop the flow of experience. We have seen that Pater's art of living is picturesque because he attempts to live within certain select, framed moments cut off from the rest of life. This approach to experience also involves a pictorial concept of time: living in the expanded present and treating each moment as a self-sufficient entity is trying to live outside the flow of time. This accounts for Pater's peculiarly static concept of existence: in his narratives, life seems to be composed of a series of barely animated scenes or tableaux with no feeling of transition or motion between. (The tableau principle will be discussed fully in considering Pater's pictorial structure.)

Even though Pater asserts that "all art aspires to the condition of music" his discussion of the art of music in the Giorgione essay is singularly unmusical. Music is always described as if it took place in a moment of time, as if it were reduced to a single tone.[34] Pater refers to the "consummate moments" (Ren., p. 12) of music or the "perfect moments of music" (Ren., p. 150) as if there were one quintessential note, and he says that in the songs from Shakespeare's plays "the whole play seems to pass for a moment into an actual strain of music" (Ren., p. 158). He deemphasizes the temporal context of music and refines it to a single form heard in an instant of time. Giorgione's painting of music is so appealing to Pater, because it is able to image these single momentary notes. As Pater himself acknowledges: "Some of the most delightful music seems to be always approaching to figure, to pictorial definition" (Ren., p. 134). Thus "The Concert," according to Pater, represents the moment just before the "true interval" (Ren., p. 144) while in other Giorgione paintings people seem to be listening "to detect the smallest interval of musical sound, the smallest undulation in the air, or feeling for music in thought or a stringless instrument . . . the momentary touch of an instrument in the twilight, as one passes through some unfamiliar room, in a chance company." Pater's description of a single "moment" of music depicted in Giorgione's painting is comparable to Proust's use of the single "phrase" of Vinteuil's sonata which functions like an "image." Like Proust, Pater's aesthetic is ultimately a synthesis of concepts taken from music and painting and applied to literature. Although music provides an example of the complete fusion of form and content, painting is a more important metaphor for literary structure and organization. As we examine Pater's style more directly in the last section of the essay, we will see that painting supplants music as a central metaphor for Pater as it does for Proust.

In his discussions of sculpture in The Renaissance, Pater again reveals his bias towards painting. First of all he shows a general preference for Renaissance sculpture because of its concern with "individual expression" and "the special

history of the special soul," whereas Greek sculpture is based on "a system of abstraction which aimed always at the broad and general type, purging away from the individual of what belonged only to him, and of the mere accidents of a particular time and place" (*Ren.*, p. 67). Painting is better able to register these delicate nuances of expression than sculpture, so that sculpture is always indirectly striving after pictorial means. Sculptors must find a way to "etherealize" the matter they work with, such as getting "not colour, but the equivalent of colour" (*Ren.*, p. 65). Pater's appreciation of Tuscan low relief sculpture is based on the delicacy of its lines which are like drawing; these sculptors

> seek their means of delineation among those last refinements of shadow, which are almost invisible except in a strong light, and which the finest pencil can hardly follow. The whole essence of their work is *expression*, the passing of a smile over the face of a child, the ripple of the air on a still day over the curtain of a window ajar. (*Ren.*, pp. 64-65)

These evanescent, transitory nuances are more properly pictorial effects. As Pater points out in the "Giorgione" essay, in a paradoxical phrase, painting is able to "reproduce instantaneous motion." The painter has finer means than the sculptor to catch and still even the most fleeting phenomena. As Pater goes on to mention, the painter defeats the sculptor because he can present an object completely in a moment of time whereas sculpture must be walked around in order to see it completely. In Giorgione's painting there is "some momentary conjunction of mirrors and polished armour and still water, by which all the sides of a solid image are exhibited at once, solving that casuistical question whether painting can present an object as completely as sculpture" (*Ren.*, p. 150). Pater is referring to a specific challenge that was made to Giorgione, a particular type of set competition between the arts that was popular during the Renaissance. Giorgione defeats the sculptor's claim that painting is unable to condense a temporal sequence into a canvas, by presenting multiple views simultaneously. Pater himself uses the Giorgione essay as an example of literature's ability to achieve the simultaneity of painting. As we will see in examining the structure of the Leonardo and Giorgione essays, Pater is using his verbal art to imitate the model form of the painting under discussion. As Leonardo was the most famous contestant in the Renaissance *paragone* between painters and writers, and as Leonardo's principal argument is directed at the writer's inability to secure the total unity of the canvas, it is entirely appropriate that Pater uses his essays on painting to demonstrate the literary equivalent of a "single view."

Pater's study of painting has a much more complex effect on his concept of literature than on his interpretation of other arts. It is convenient to examine the relationship of painting to literature in Pater's work in the light of the Symbolist movement and its constant preoccupation with relationships between the

arts.[35] As was noted in Chapter 1, the concept of the interrelatedness of the various arts is based on the belief that they are all translations of some common transcendental experience. Thus art affords a spiritual enlightenment which is qualitatively different from the experience of everyday life. This tendency to separate art from life, to locate the experience of art outside time, results in what could be called the museum attitude to art. The museum is the logical extension of the framed painting. As Pater points out, it was during the Renaissance that painting was taken off the walls of building, disengaged from its function in public life, and enclosed in a frame as a self-sufficient artifact. From the Renaissance to the nineteenth century, framed paintings were primarily for the connoisseur who could afford them, where they at least maintained a close relationship to the lives of their owners by decorating the walls of their houses. The rise of the museum, with the establishment of the Louvre in the late eighteenth century in France and the National Gallery in England in the early nineteenth, returned painting to the public domain but set it apart from the life of society. The museum acts as a larger frame, making a boundary around the collection of artifacts it contains, so that a visit to a museum becomes a special, conscious act of appreciation. The nineteenth century brought another change in the relationship between art and society, which has been often documented.[36] As science undermined the established religion, art served a "fonction compensatrice"[37] as an alternate form of spirituality. Thus the museum not only tended to separate a work of art from society, but also to enshrine it. The museum fostered an attitude of hushed reverence for the artifact as a sort of sacred object, so that, as Gertrude Pelles says, "the museum became the chapel of the substitute religion of art."[38]

The artist saw himself not only opposed to the materialism of science but to the resultant unspirituality of the middle classes devoted to Progress.[39] The dandy is such a persistent figure for the artist throughout the Symbolist period because he is both a social and spiritual aristocrat. The aristocracy represented an enclave, separate from the mass of society, and gave the artist a sense of distinction from the *bourgeois* or the "normal man." The whole Symbolist or aesthetic movement is permeated with this anti-bourgeois bias, so that even the cult of sensation is built upon a sense of refinement, which has social as well as spiritual connotations. Verlaine's description of the *sensation,* for example, is directed against the debased Romanticism which had become the standard aesthetic of the middle classes:

> To be oneself, it is more than anything else to find and to express one's soul. Not the soul of the Romantics, that gross sentimentality of prostitutes, which comes out in trite commonplaces and degraded themes, in tirades à la Lamartine and in verses like a diarrhea of tears. The soul is something intangible, nuanced, composed of emotions, sensations, less than that even: an atmosphere, a tonality, an inarticulable tint.[40]

Although many writers cultivated aristocratic connections,[41] the class did not offer a sustaining relationship to the artist, so most writers and painters operated within small coteries. As the split between art and society widened, the artist made a virtue of separation and thought of himself as self-contained and his activity as autonomous. These coteries were like isolated social units within society at large, exerting all their influence through radiation rather than through interaction with the masses of people. It is characteristic of the period that the writers who became centers of coteries almost hid within society, rarely venturing forth from the confines of their rooms. Flaubert's alcove at Croisset, Pater's carefully decorated rooms at Brasenose, Proust's cork-lined room, and Mallarmé's apartment are all isolated chambers, protecting the artist from the flow of society around him.[42] All of these writers, while separating themselves from society at large, make a further distinction within themselves, between the everyday self and the deeper creative self which produces a work of art.[43] Life, in the usual sense of motion and activity, is stopped: Pater, for example, ventured forth once for a London season, and retreated to Oxford; Mallarmé made one trip to Oxford, where he found the life of the don the ideal existence for an artist, and retreated to his rooms on the Rue de Rome. Pater and Mallarmé represents the type of the Symbolist artist for whom the everyday self is unimportant. Within a static existence they try to live entirely as artists. The whole of life is taken up with the practice of their craft and life becomes a verbal adventure, the only action being the struggle with language.[44] This ascetic devotion comes to seem like a religious activity: Flaubert and Pater are both considered "martyrs" to their style, and Mallarmé's room where his *cénacle* gathered was called *la chapelle*. As was pointed out in the first chapter, as the "life" of the Symbolist artist becomes less important, the "work" becomes increasingly autonomous; the artist as man is absorbed into his creation.

There is a paradox involved in the Symbolist concept of the book as a self-contained artifact and at the same time as the intimate expression of the author's soul. This paradox is a result of the concept of the double nature of the artist: the everyday man is completely divorced from the work (this separation leads to the idea of the unobtrusive narrator) while the artist-self is transposed into the work through the intimate and pervasive means of style. It is upon this distinction that Pater makes his claim that the individual personal concept of style is not "a relegation of style to the subjectivity, the mere caprice of the individual, which must soon transform it into mannerism. The style, the manner would be the man, not in his unreasoned and really uncharacteristic caprices, involuntary or affected, but in absolutely sincere apprehension of what is most real to him. . . . If the style be the man, in all the colour and intensity of a veritable apprehension, it will be in a real sense 'impersonal.' "

The alienated nature of the artist had its effect on the concept of personal style, so that the language of art is consciously separated from the language of

everyday life. Pater attempted to refine language above the level of ordinary speech, much as Mallarmé tried to "purifier les mots de la tribu." In both cases the cultivation of an expressly artificial style is designed to cut literature off from mass culture. Mallarmé makes his poetry difficult and obscure, on purpose, in order to throw up a veil to hide his art from the common reader of journals and newspapers. Pater is also consciously writing for the "select few,"[45] and defines his approach as "the scholar writing for the scholarly."[46] He tries to incorporate "the hiddenness of perfect things" into his prose, and has a dread of being too obvious, which he considers a vulgarity. In his description of the "critical and self conscious" style, which he calls Euphuism in *Marius,* Pater again considers the occupation of the artist as a religious activity. Marius feels that "he should seek in literature deliverance from mortality" and that in his "fastidious sense of correctness in external form, there was something which ministered to the old ritual interest, still surviving in him; as if here were involved a kind of sacred service to the mother tongue." Again these statements are parallel to Mallarmé's notion of literature as "notre seul tâche spirituelle et notre seul réalité," and Pater himself made an explicit connection between his own idea of Euphuism and "the modern French Romantics" (*Marius,* p. 56). Anthony Ward notes that Euphuism is picturesque in its selectivity; it could also be said that the coterie style, like the museum, tended to put art into a special, separate category. Just as the museum acts as a substitute chapel, so Pater thinks of literature as well as "all other fine art" as a "refuge, a sort of cloistral refuge, from a certain vulgarity in the actual world . . . [and has] something of the uses of a religious 'retreat' " ("Style," p. 14).

The widening split between artist and society is particularly apparent in the realm of criticism. At mid-century Ruskin, for example, thought of his function as bridging the gap between the landscape artists and a public which knew nothing about art. His purpose was to educate all men to be artists. In 1848, Baudelaire, as well, thought of his role as a critic as a way of bringing culture to the unenlightened public. In a matter of a few years he was using his choicest invective to denounce the bourgeois "brute" and formulating a concept of art reserved for the spiritually elite. Pater as a Symbolist critic is almost unconcerned with the public at large: his impressions and appreciations are only for a refined circle of readers. While Ruskin is always actively engaged in a dialogue with the hypothetical reader, Pater is more interested in making each essay a perfect self-contained unit, which the reader can interpret as he will. Symbolism has often been described as mannerist art,[47] because it is self-consciously artistic and inward-looking. In mannerist forms, art often becomes its own subject: a work of art is used to make a conscious aesthetic statement, or to describe the process of artistic creation. Poets in the Symbolist tradition, such as Mallarmé or Wallace Stevens, write poems about writing poems. Symbolist criticism falls into this category of a work of art describing another work of

art. In France, starting with Baudelaire, and continuing with Mallarmé, Proust and Valéry, imaginative criticism has constituted an important genre. Pater's criticism is equally imaginative and consciously artistic: and even in his writing which is not specifically centered on a particular work, aesthetic problems and artistic modes of perception constitute the dominant subject. There is almost no distinction between his "critical" writings and fictional writing; the essays using real artists for subjects are just as much "Imaginary Portraits" as his own inventions, and in his two novels, *Marius* and *Gaston,* there are substantial passages of criticism and aesthetic statement worked into the text.[48] In *Marius* Pater treats the main character as a particular sort of aesthetic temperament in much the same way as he discusses Leonardo or Watteau: the main difference between the fiction and the essay is in length, and in the longer work Pater attempts to show the various stages of development in Marius' aesthetic consciousness.

Pater's criticism, which is focussed on particular works of art is a "translation" of the work, in the Baudelairean sense that if a work of art is a reflection or translation of a certain reality, then a work of imaginative criticism is a translation of the translation. Pater's portraits of artists are, like Baudelaire's description of a painted portrait, "l'individu redressé par l'individu." And just as Baudelaire sees that a portrait is a complicated "modèle" of the painter himself, so Pater's critical portraits always reflect Pater. In a description of Charles Lamb as critic, Pater points out the motivations of his own practice. He states that the critic is truly an artist, because while he pretends to act as a "humble ministrator" to a work of art he actually "creates" it for the reader. The critical act is also explained as a way of revealing the critic:

> the desire for self portraiture is, below all more superficial tendencies, the real motive in writing at all—a desire closely connected with that intimacy, that modern subjectivity, which may be called the Montaignesque element in literature. What he designs is to give you himself, to acquaint you with his likeness; but must do this, if at all, indirectly, being indeed always more or less reserved, for himself and his friends. . . .[49]

Thus we see again that Pater's "aesthetic criticism" manifests the Symbolist, inward-looking, double consciousness: not only does the discrimination of the qualities of a work of art lead to self-awareness, but the description of a work is also a description of the sensibility perceiving it. By placing Pater's work in the tradition of Symbolist criticism which is an art form itself, one begins to see that his essays are not loosely structured, subjective "impressions" but subtle and highly wrought compositions. Pater's criticism is based on the Symbolist assumption of the interrelationship between the arts—and the idea that work in one medium may "translate" a work in another. Perhaps Pater's most impressive essays are those dealing with painting: these essays represent the revival of

another mannerist art form, the genre of *ekphrasis* or the literary imitation of a work of plastic art. It is in these essays on painting that Pater's distinctive concept of literature finds its clearest expression. In the next section I plan to discuss in detail this concept of language, its relation to the art of painting, and the pictorial structure that Pater developed in his literature of art criticism.

First of all we will look at Pater's idea of language as a concrete medium which is based on his own idea of the concrete; all three of his connotations of the word are implicit; he thinks of words as physical, particular, and self contained. As he says in *Marius,* for a person of his temperament, "words are things."

In the "Giorgione" essay Pater makes the initial point that each art has its own particular quality due to the physical nature of the medium. Pater's interpretation of the medium of paint emphasizes the concrete aspect which is independent of subject; like Baudelaire in front of the abstract color of Delacroix, or Bergotte in front of Vermeer's yellow paint, or Ruskin confronted with the glowing color of Veronese, Pater sees painting first of all in terms of the physical matter of paint, "a space of color on the wall," "a space of sunlight." He defines "the true pictorial quality" as

> the inventive or creative handling of pure line and colour, which, as almost always in Dutch painting, as often also in the works of Titian and Veronese, is quite independent of anything definitely poetical in the subject it accompanies.

Thus the "poetic" quality of painting is in the "colouring—that weaving as of just perceptible gold threads of light through the dress, the flesh, the atmosphere, in Titian's Lace Girl—the staining of the whole thing with a new delightful physical quality." The painting then

> . . . must first of all delight the sense, delight it as directly and sensuously as a fragment of Venetian glass; and through this delight only be the medium of whatever poetry or science may lie beyond them, in the intention of the composer. In its primary aspect, a great picture has no more definite message for us than an accidental play of sunlight and shadow for a moment, on the wall or floor: is itself, in truth a space of such fallen light, caught as the colours are caught in an Eastern carpet, but refined upon, and dealt with more subtly and exquisitely than by nature itself.

Just as Pater reduces painting down to its primary aspect, the initial sensation given by the paint itself, so he thinks of words as the "elementary particles" of language which have their own direct, physical qualities. Pater's description of the scholarly view of the language underlies this concept of words as sensuous objects. The scholar-artist is

> a lover of words for their own sake, to whom nothing about them is unimportant, a minute and constant observer of their physiognomy . . . Currently recognizing

the incident, the colour, the physical elements or particles in words like *absorb, consider, extract,* to take the first that occur, he will avail himself to them, as further adding to the resources of expression. The elementary particles of language will be realized in colour and light and shade through his scholarly living in the full sense of them.[50]

This passage from the essay on "Style" written towards the end of his career, echoes a passage from one of his first publications, the imaginary portrait of "an English poet," who "having nothing else to live on, . . . extracted all they could yield from words, and his sense of them came to be curiously cultivated at all points." He comes to a revelation of "The English tongue . . . as a living spirit of mysterious strength and sweetness" and "written language came to form and colour as well as sound to him, exotic perfume almost."[51]

The concept of language is reflected in the larger unit of the book. As was mentioned earlier, Pater, like Mallarmé, thought of a book as a self-contained artifact, a physical object. Pater's description of the "golden book" in *Marius* has a distinct shape on the page and emphasizes the particular sensuous qualities of the manuscript.[52] It was

a gift to Flavian, as was shown by the purple writing on the handsome yellow wrapper, following the title. *Flaviane!* —it said

Flaviane!	Flaviane!	Flaviane!
Lege	Vivas!	Vivas!
Felicitur!	Floreas!	Gaudeas!

It was perfumed with oil of sandal wood and decorated with carved and gilt ivory bosses at the ends of the rollers.

Throughout Pater's writing, books are often endowed with these physical qualities. Thus in *Gaston de Latour* he describes an edition of Ronsard's *Odes* which

itself verily like nothing so much as a jonquil, in its golden-green binding and yellow edges and perfume of the place where it had lain—sweet, but with something of the sickliness of all spring flowers since the days of Prosephine. (*Gaston,* p. 66)[53]

Throughout his career of writing imaginative prose, Pater tried to use these sensuous qualities of words to achieve a direct, initial communication, which operates in conjunction with the denotative function of language. At times, however, the sensuous elements seem to take precedence over meaning. Anthony Ward's description of Pater's manuscripts is revealing:

Often a sentence is plotted out before the meaning of it, what it refers to, is made specific. Gaps are left in the larger structure and several alternative words, often

quite different in meaning, are written down above the gap, to be selected on grounds of their tonal qualities, rather than on grounds of their denotive meaning.

Pater thus takes the musical pattern literally as the "primary aspect" of his prose in this instance. More often the musical qualities of prose are used to reinforce the sense. As Saintsbury noted in his study of English prose rhythm, Pater's modulation of rhythm and tone are incredibly delicate and subtle. His effects are very quiet, but once the reader is attuned to the quietness, he is able to see the variety and nuance involved. One of Pater's mannerisms, as Saintsbury pointed out, is the use of catachresis, the slight diversion of a word from its normal sense. Such phrases as "green shadow," "delicate place," "solemn water," because of the unusual coupling of adjective and noun, tend to throw both terms into higher relief, so that they stand out from the surface of the writing. As Saintsbury points out "they affect rhythm, so powerfully, though so quietly, by the slight shock they give to the understanding."[54] This is the same sort of shock that is intended by the categorical leaps in diction described in Chapter 1 of this work as typical of Symbolist writing. Pater often uses nuances of diction to emphasize similar convictions about the *correspondances* between the senses, and between physical and spiritual reality: as he describes it, "the correspondences which exist between the different orders of living things, through which, to eyes opened, they interpret each other" (*Ren.*, p. 103). There are obvious effects of synaesthesia in phrases such as "cool sound" or "audible sunlight"[55] and jumps from one order of reality to another in descriptions such as the "country of pure reason" (*Ren.*, p. 137), the "miraculous white thorn blossom," or "the landscape of moral fact."[56] Pater often constructs phrases that emphasize the effect of the physical matter of the work of art on the "soul" of the beholder, as in the description of the way "colour [functions] as a spirit upon things" or poetry is able to "touch and cool the soul" *(Gaston)* or the way in which, in Giorgione's "Concert," "the very threads of the fine linen . . . fasten themselves on the memory." In the last example Pater uses literal and metaphorical meanings simultaneously, shifting only slightly from the idea of the painted threads to the idea of mental threads, in order to point out the imperceptible transition by which the physical canvas becomes a part of the inner spirit of the observer. This technique is similar to the polyvalent uses of words in Mallarmé; for example, he uses the phrase "rameau subtil" in a double context, referring to branches of trees and ramifications of thought, as well as to emphasize the evanescent nature of a perception which is both physical and mental.[57]

As Saintsbury points out, these changes in diction affect rhythm; the harmonious *sound* of Pater's sentence is counterpointed against the slight diversion of sense which causes a minute alteration in the rhythm of perception. By juxtaposing words not normally conjoined, Pater creates a texture in his prose which brings the physical properties of words into greater relief. The rhythmic pause

is used to focus attention on the sensuous qualities of words, their "colour" and "perfume," terms which Pater uses to describe the almost luminous aura which words possess and which expands beyond their denotative meaning. As he puts it:

> For to the grave reader words too are grave; and the ornamental world, the figure, the accessory form or colour or reference, is rarely content to die to thought precisely at the right moment, but will inevitably linger awhile stirring a long "brain-wave" behind it of perhaps quite alien associations.[58]

In treating words as "elementary particles," like the particles of paint that compose a canvas, Pater, like Baudelaire, manipulates words so that they interact reciprocally with other particles. Even in a subdued phrase, such as "solemn water," the effect produced is a result of mutual alteration which causes the phrase, as a unit, to stand out from the verbal surface. Pater uses a continuous sound pattern as well as a uniform syntax, to contain these delicate breaks in the texture of meaning. In the introduction to *The Renaissance,* he casually links the study of "lights, morals, number" in a series; in the "Giorgione" he expands another series to the point of metaphysical fantasy:

> Life itself is conceived as a sort of listening—listening to music, to the reading of Bandello's novels, to the sound of water, to time as it flies. (*Ren.,* p. 125)

This manipulation of the verbal surface is a direct reflection of his conviction about the nature of reality: Pater felt that spirit and matter are falsely opposed and that

> in our actual concrete experience the two trains of phenomena which the words *spirit* and *matter* do but roughly represent, play inextricably into each other. (*Marius,* p. 89)

As Pater explains in *The Renaissance,* the self is composed of "elements" which are completely fused with "natural elements" in the environment, so that there is a "modification of the tissues of the brain under every ray of light and sound. . . . Like the elements of which we are composed, the action of these forces extends beyond us: it rusts iron and ripens corn." "The Child in the House" is the history of a relationship of this sort, between the spirit of the child and his physical surroundings, which "become a part of the texture of his mind." Pater describes "the process of brain building by which we are, each one of us, what we are" and connects it to the influences of the actual house:

> In that half-spiritualised house he could watch the better, over again, the gradual expansion of the soul which had come to be there—of which indeed, through the

law which makes the material objects about them so large an element in children's lives, it had actually become a part; inward and outward being woven through and through each other into one inextricable texture—half, tint and trace and accident of homely colour and form, from the wood and bricks; half, mere soul-stuff, floated thither from who knows how far. (*Imaginary Portraits*, p. 16)

We see that Pater's combinations of the "elementary particles" of words correspond to the fusion of physical and spiritual "elements" he finds in the life of each individual.[59] The jumps from one order of reality to another implied in the phrase "half spiritualized house" or in the apposition of "bricks" to "soul stuff" are sustained by the even texture of the prose and reflect the "inextricable texture" of experience.

What Pater attempts is to give his writing a certain stylistic "color," like Proust and Bergotte, by making words more visible. The scholar-artist, as he says in the "Essay on Style," will be aware of the "latent colour and imagery which language as such carries with it" and the "latent figurative texture" of prose. The true artist in words will draw on this submerged wealth and use the physical quality of words to intensify meaning. As the true writer, according to Pater, is dealing not with fact, but the imaginative sense of fact, language must, of necessity, convey sensation as well as information. Words must create a tangible experience of the abstract idea they contain. For this reason Pater uses terminology from painting to describe the aspect of style that he names "soul": "soul" which is equated with "colour" is the ability to manifest a personal vision through the construction of a vocabulary, the choice of words, and the relation of these "elementary particles" in a unified way. The beauty of style for Pater, as for Proust, is a matter of truth to personal vision:

Truth! there can be no merit, no craft at all, without that. And further, all beauty is in the long run only fineness of truth, or what we call expression, the finer accommodation of speech to that vision within.[60]

Pater feels that the fullest realization of an individual style is an exact and economical transcription of the "vision within" in verbal form, and again he uses spatial metaphors to make his point:

. . . there will be an aesthetic satisfaction in that frugal closeness of style which makes the most of every word, in the exaction from every sentence of a precise relief, in the just spacing out of word to thought, in the logically filled space connected always with the delightful sense of difficulty overcome.[61]

This description of a verbal process in terms of spatial adjustment brings us to another aspect of Pater's concept of language as a concrete medium. Besides the attention to words as physical particles, composed of sound and shape,

having latent color and texture, Pater's notion of the concrete includes the idea of wholeness or self-contained autonomy. In treating words as "things," Pater, like Mallarmé, believes in the particular reality of the literary text, a reality which wavers between the physical existence of the printed page, and the metaphysical ability of language to transform experience into *form*. Pater expands Flaubert's concept of the unique word to apply to any verbal construction, so that in "literature as a fine art," each particular configuration of words has its own potential "absolute" quality. The metaphysical implication in Flaubert, that each word, as an entity, has a unique correspondence with reality, is amplified by Pater into a general statement:

> One seemed to detect the influence of some philosophic idea there . . . of some pre-existent adaptation, between a relative, somewhere in the world of thought and, its correlative somewhere, in the world of language—both alike rather in the mind of the artist, desiderative, expectant, inventive—meeting each other with the readiness of "soul and body reunited," in Blake's rapturous design. . .[62]

In the spatial description of the verbal process above, Pater implies that an exact design, a precise relief, can be obtained so that the writer must strive to approximate the absolute form which corresponds to the "vision within." Pater feels that the language is able to give form to the amorphous chaos of experience: in *The Renaissance* he speaks of the fluid, changing nature of sensations which the mind feels before they are given "the solidity with which language invests them." He often compares literary art with artisan's work, with artifacts made of gold or metal, or carved work like cameos or gems. These metaphors are used, not only to emphasize solidity, but to compare the clear, hard outlines of the artifact with the clarity or distinctness with which words fix the moment and enclose the evanescent impression. The literary form is considered a spatial unit, outside the flow of time; Marius attempts "to arrest certain clauses of experience [and] imprison the very perfume of the flowers" and Flavian tries "to arrest this or that little drop at least from the river of sensuous imagery rushing so quickly past him," and his literary technique has "a firmness like that of some master of noble metal work, manipulating tenacious bronze or gold" (*Marius,* p. 104). This ability of language to give tangible form and shape to experience is described as a truly creative act in Pater's account of Plato as a scholar of language. Plato has the power

> of sounding by words the depths of thought, a plastic power literally, moulding to term and phrase what might have seemed in its very nature too impalpable and abstruse to lend itself, in any case, to language. He gives names to the invisible acts, processes, creations, of abstract mind, as masterly, as efficiently, as Adam himself to the visible living creations of old. . .[63]

The theory of the unique word, or in Pater's expanded version, the unique verbal construction, is based on the idea of absolute precision, the exact adjustment of term to meaning. But in Pater we rarely find the sort of precision that makes Ruskin's prose so vivid. Perhaps the difference could best be illustrated by citing Pater's description of his own sort of accuracy. He is speaking about the concept of modernity in language, in which "no expression could be too faithful to the precise texture of things":

> Occupied so closely with the visible, this new poetry had so profound an intuition of what can only be felt, and maintained that mood in speaking of such objects as wine, fruit, the plume in the cap, the ring on the finger. And still that was no dubious or generalized form it gave to flower or bird, but the exact pressure of the jay at the window . . . [64]

In this passage Pater shifts the emphasis from "vision" to "feeling" and from the form of the object to the impression it gives, "the exact pressure of the jay at the window." As was mentioned earlier, Pater is like Mallarmé in attempting to present the sensation of a thing rather than the thing itself, whereas Ruskin's prose is directed towards illuminating the object itself. The fact that they focus, not on the solid world of objects, but on the evanescent inner world of consciousness explains why Pater's style may appear hazy, and Mallarmé's poetry seem vague, when they are both theoretically striving for precision. As Professor R.G. Cohn has pointed out, Mallarmé's poetry is initially obscure, but when the total design is apprehended, the "constellation" acquires an exactness and clarity. In a similar way, Pater's attempt to render sensation with precision is often dependent on larger perspectives than the close-up focus used by Ruskin. In the next section we will examine these larger structures and patterns in Pater's writing and see how they are based on a pictorial concept of literature.

The concept of structure brings us to the heart of Pater's essay on "Style." While sensitivity to the physical aspects of language is called "soul" and the use of these aspects "colour," the organization and structural elements of style are referred to as "mind" and again described with visual metaphors. What Pater tries to define is

> . . . that architectural conception of work, which foresees the end in the beginning and never loses sight of it, and in every part is conscious of all the rest, till the last sentence does but, with undiminished vigour, unfold and justify the first—a condition of literary art, which, in contradistinction to another quality of the artist himself, to be spoken of later, I shall call the necessity of *mind* in style. [65]

As Pater continues he links the theory of the unique word to the idea of a structure that operates as a total unit; on the small scale, on the level of a single

sensation, the right word becomes what it signifies, while on the larger scale, a long composition, treated as a whole unit, becomes what it signifies when it gives precise expression to the original sensation from which it springs:

> All the laws of good writing aim at a similar unity or identity of the mind in all the processes by which the word is associated to its import. The term is right, and has its essential beauty, when it becomes, in a manner, what it signifies, as with the names of simple sensations. To give the phrase, the sentence, the structural member, the entire composition, song, or essay, a similar unity with its subject and with itself;–style is in the right way when it tends towards that. All depends upon the original unity, the vital wholeness and identity, of the initiatory apprehension or view. So much is true of all art, which therefore requires always its logic, its comprehensive reason–insight, foresight, retrospect, in simultaneous action–true, most of all, of the literary art, as being of all the arts most closely cognate to the abstract intelligence. Such logical coherency may be evidenced not merely in the lines of composition as a whole, but in the choice of a single word, while it by no means interferes with, but may even prescribe, much variety, in the building of the sentence for instance, or in the manner, argumentative, descriptive, discursive, of this or that part or member of the entire design.[66]

What Pater is trying to establish is the necessity of organizing even a long composition so that it has the wholeness of a moment of sensation. As he says, "all depends upon the original unity, the vital wholeness and identity of the initiatory apprehension or view." The first view, the original sensation, although it may be multiple and complex, has the simultaneous unity of the moment; therefore the entire composition must reflect this initial unity and reduplicate it on the larger scale. Thus every word, every particle and fragment, must be considered in relation to the overall design which embodies the "simultaneous action" of the first view. The verbal structure expands from the germ of the original sensation, and maintains "unity with itself" by imitating the formal unity of a "moment." As Pater continues he mixes metaphors from all the visual arts, but he uses the metaphor of painting, painting refined into a "single . . . visual image," as an absolute structural ideal to be attained:

> For the literary architecture, if it is to be rich and expressive, involves not only foresight of the end in the beginning, but also development or growth of design, in the process of execution, with many irregularities, surprises, and afterthoughts; the contingent as well as the necessary being subsumed under the unity of the whole. As truly, to the lack of such architectural design, of a single almost visual, image, vigorously informing an entire, perhaps very intricate, composition, which shall be austere, ornate, argumentative, fanciful, yet true from first to last to that vision within may be attributed those weaknesses of conscious or unconscious repetition of word, phrase, motive, or member of the whole matter, indicating, as Flaubert was aware, an original structure in thought not organically complete. With such foresight, the actual conclusion will most often get itself written out of hand, before, in the more obvious sense, the work is finished. With some strong and leading sense of

the world, the tight hold of which secures true composition and not mere loose accretion, the literary artist, I suppose, goes on considerately, setting joint to joint, sustained by yet restraining the productive ardour, retracing the negligences of his first sketch, repeating his steps only that he may give the reader a sense of secure and restful progress, readjusting mere assonances even, that they may soothe the reader or at least not interrupt him on his way; and then, somewhere before the end comes, is burdened, inspired, with his conclusion, and betimes delivered of it, leaving off, not in weariness and because he finds himself at an end, but in all the freshness of volition. His work now structurally complete, with all the accumulating effect of secondary shades of meaning, he finishes the whole up to the just proportion of that ante-penultimate conclusion, and all becomes expressive. The house he has built is rather a body he has informed. And so it happens, to its greater credit, that the better interest even of a narrative to be recounted, a story to be told, will often be in its second reading. And though there are instances of great writers who have been no artists, an unconscious tact sometimes directing work in which we may detect, very pleasurably, many of the effects of conscious art, yet one of the greatest pleasures of really good prose literature is in the critical tracing out of that conscious artistic structure, and the pervading sense of it as we read.[67]

In this condensed paragraph, which is written towards the end of Pater's career, he describes an aesthetic ideal that conditions literature for the next several decades; when Joseph Frank "discovers" the concept of spatial form in 1922, it is precisely the same formulation that appears in Pater's essay on "Style." In both cases the key idea is that literature can escape its normal temporal succession and approximate the spatial simultaneity of a painting. This concept of form, which we have followed through Baudelaire, Ruskin, and Proust, is given its particular "modern" definition in Pater; the notion of writing with a second reading in mind, in writing in such a way that the total structure can be perceived in all its complexity in re-reading, is the peculiar domain of "modern" prose which Pater also names "conscious" prose because the reader's awareness of unified intention is incorporated into the actual structure of the work. This element of "conscious" artistry built into the text forms the background for Henry James, who elaborates on Pater's ideas and hands over to the twentieth century a whole terminology for the novel which grows out of Pater's concept of "Style."

We have seen how Pater bases his idea of literary form on the structure of the moment, so that a whole composition will have the immediacy and unity of a single sensation. The use of painting as a metaphor for this structure is obvious in general outline, but the subtleties that Pater draws from the analogy are more complicated. First of all the most direct equivalent of the moment or sensation is the pictorial image, which Pater gives the full weight and complexity of a symbol. In *The Renaissance* Pater establishes an identity between "impressions, images, sensations" by putting the three terms in sequence. We have noted how the unit of experience of Pater, whether expressed as moment, sensation, or object, acquires greater significance without becoming less concrete, how it

represents a condensation of vast areas of experience and yet remains a single self-contained form, distinct from everything not it. In a similar way Pater defines a symbol as "a single imaginable form" which condenses "a whole world of thoughts, surmises, greater and less experiences"[68] or as "a single form [which sums] up an entire world of complex associations." Perhaps Pater's most famous symbol is his version of the Mona Lisa as a sort of decadent Salomé figure. He uses the "single imaginable form" of the familiar painted face to stand as the symbol of the archetypical *femme fatale*.[69] Throughout the description he reiterates the idea that the whole experience of civilization is condensed into this one image and the Mona Lisa herself is the "symbol" of this idea. He is also careful to underline the fact that the "projected image" is a representation of an actual particular Florentine girl:

> Besides, the picture is a portrait . . . that there is much of mere portraiture in the picture is attested by the legend that by artificial means, the presence of mimes and flute players, that subtle expression was protracted on the face.

Pater also emphasizes the fact that the spiritual quality that the picture symbolizes is embodied in the physical concrete in the actual flesh of the real girl: "it is a beauty wrought out from within upon the flesh, the deposit, little cell by cell, of strange thoughts and fantastic reveries and exquisite passions." Thus, like Ruskin and Baudelaire, Pater uses the portrait as a metaphor for the universal contained within the concrete particular.

The portrait, representing a single form which subsumes a complex experience defined against the background of this experience, becomes a compositional device for Pater. The "Imaginary Portraits" are attempts to use a central figure to symbolize a particular moment in cultural history or a certain archetypical temperament. These portraits are pictorial in conception not only because they are based on the single form[70] but because they are static, as each temperament is presented as a fixed quantity, an unchanging identity which is illuminated from various angles.

In many of Pater's "portraits," the central figure is defined not only against a cultural background, but more particularly against an actual physical environment, a landscape or a house. In these pieces there is an effect of interpenetration between figure and background which is comparable to Pater's description of Giorgione's canvases where there is

> that balance, that modulated unison of landscape and persons—of the human image and its accessories—already noticed as characteristic of the Venetian school, so that, in it, neither personage nor scenery is ever a mere pretext for the other. (*Ren.*, p. 153)

"The Child in the House" is perhaps the classic example in Pater's writing of a portrait which focusses as much on the background of house and atmosphere as on the human subject.[71] Throughout Pater's work we find examples of still scenes which represent this relationship between a particular temperament and environment. Because Pater is concerned with the spiritual effluvium of the material surroundings, these scenes are often similar in tone to Symbolist poetry which is often described as solely preoccupied with the *genre* of "paysage—état d'âme." For example, in describing *Aucassin and Nicolette* Pater gives a joint picture of the scenery and the heroine (note the Symbolist touch, in "almost nameless colors"):

> There is a languid Eastern deliciousness in the very scenery of the story, the full-blown roses, the chamber painted in some mysterious manner where Nicolette is imprisoned, the cool brown marble, the almost nameless colours, the odour of plucked grass and flowers. Nicolette herself well becomes this scenery, and is the best illustration of the quality I mean—the beautiful, weird, foreign girl, whom the shepherds take for a fay . . . (*Ren.*, p. 21)

Even Pater's critical writing is often cast in this form. The essay on Dionysus is a portrait of the god and the Greek landscape as well: the god is the "symbol" of the vine culture, the "spiritual form" of the life of green things *(Greek Studies)*. In his essay on Ronsard in *Gaston,* Pater presents the poet and his poetry against the topography of the Loire valley. Throughout *Marius,* Pater uses double images of a figure and environment to illuminate each other. For example, there is an equation between Marius' mother, who is "the type of maternity," and the house, which gives "the reality of a concrete outline to the ideal of home": the house is considered the mother's "sanctuary," and she is the symbol of the whole atmosphere of the place. Throughout the chapter "White Nights" Pater uses parallel diction and imagery to link the figure and background together. Again, as Anthony Ward points out, Flavian becomes the symbol of Pisa for Marius who is susceptible to similar qualities in place and person. Marius also associates Cornelius with a particular "grave and austere" landscape outside of Rome:

> And for sentimental Marius, all this was associated by some perhaps fantastic affinity, with a peculiar trait of severity . . . which mingled with the blitheness of his new companion . . . and what was earnest, or even austere, in the landscape they had traversed together, seemed to have been waiting for the passage of this figure to interpret or inform it. (*Marius,* p. 97)

Finally at the end of the book Marius visits two different houses, which are very carefully described as they are completely expressive of their inhabitants, the Roman aesthete and the Christian matron. In quoting the hypothetical

mystical German writer, Pater restates his concept of the identity between soul and environment:

> The house in which she lives . . . is for the orderly soul, which does not live on blindly before her, but is ever, out of her passing experiences, building and adorning the parts of a many-roomed abode for herself, only an expansion of the body; as the body, according to the philosophy of Swedenborg, is but a process, an expansion, of the soul. For such an orderly soul, as life proceeds, all sorts of delicate affinities establish themselves, between herself and the doors and passage-ways, the lights and shadows, of her outward dwelling-place, until she may seem incorporate with it— until at last, in the entire expressiveness of what is outward and inward, no longer any distinction at all; and the light which creeps at a particular hour on a particular picture or space upon the wall, the scent of flowers in the air at a particular window, become to her, not so much apprehended objects, as themselves powers of apprehension and doorways to things beyond—the germ or rudiment of certain new faculties, by which she, dimly yet surely, apprehends a matter lying beyond her actually attained capacities of spirit and sense. (*Marius*, p. 194)

The language of the passage is extraordinarily Proustian, especially in the description of the power of the mind to go beyond itself, and the use of sense experience to explore uncharted areas of consciousness. Again it is clear that Pater is a forerunner of the lyrical novel, in his presentation of character as determined by the surrounding physical envelope, and his idea of the influence of random influences and early associations in shaping the self. Before Pater it would be hard to find an English novel in which character is defined in terms of sensation instead of action, whereas in *Marius the Epicurean: His sensations and ideas,* as the wording of the subtitle implies, Pater gave more prominence to sensations than to ideas or actions. As Marius states, "not what I do but what I am is alone important." This concept of character leads to the novels of Proust, James and Virginia Woolf, in which people are created through their perceptions, their consciousness of experience.

 The use of the portrait as Symbol, with the reciprocal presentation of figure and background, brings us around to Pater's method of fitting a symbol into a total design. Although Pater often uses the terms impression, sensation, image, and symbol interchangeably, there is no confusion in this identification, but rather a precise correspondence implied. If the moment of sensation is the primary unit of consciousness for Pater, he finds that the aesthetic form which reflects the unity and concreteness of the moment most directly is the painted image. The "impression" represented by a canvas is composed of multiple images unified, so that the painting maintains the *totalité de l'effet* of a single image, the single complex sensation produced by the "first view." As Pater uses the term symbol as the literary equivalent of "image," the verbal composition is likewise composed of many symbols, unified so that the total works becomes a symbol. The ideal painting and the ideal literary work will both duplicate on a

large scale the wholeness and simultaneity of the original moment in which the vision is conceived: the canvas operates like a single image, just as the verbal structure works like an expanded symbol. In order to see how Pater designs his prose composition so that "if you look closely, you can see a highly qualified matter brought into compass at one view" we will examine the procedure of the "Leonardo" and "Giorgione" essays.

The essay, or the variation on the essay which Pater calls an "imaginary portrait," are his preferred forms, because in the shorter span he can organize the entire composition so that it approximates a "single view." Pater's books tend to be composed of self-contained units, so that each essay in *The Renaissance,* or each imaginary portrait, is focussed on the unique temperament of *one* artist; in both cases the overall unity of the book is achieved only through the juxtaposition of the separate units. *Marius,* Pater's only real attempt to write a sustained composition, also tends to break down into discrete units, each chapter like a self-contained essay or portrait. Because of Pater's emphasis on the internal unity of each chapter, the action of the novel is dissolved into a succession of still pictures or *tableaux,* to borrow a term from Flaubert's notebooks. Just as Flaubert's famous "Comices Agricoles" in *Madame Bovary* is organized as a "spatial" unit, most of the chapters in *Marius* are not only spatial but static pictures. The most predominant form of *tableau* has already been discussed: the chapter which presents a combination figure-landscape; another type of picture is based on Pater's tendency to see life as ritual, so that there are many isolated masques or pageants within the book. A typical example would be the "White Nights" chapter which culminates with a pictorialized procession; Pater emphasizes the static nature of his *tableau* by describing, paradoxically, the procession moving "in absolute stillness," so that it appears fixed like the frieze on the Parthenon. There is a similar paradoxical contrast in the central chapter which contains the "expanded moment" in the Campagna, where Pater uses the fluidity of a waterfall as the image ". . . of immoveable rest." The contrast of motion and stasis is worked into the form of the novel, so that instead of moving forward, Marius' life appears as a number of mysteriously connected "moments." The design of the novel is intended to condense Marius' life into the single "expanded moment" in the Campagna, but Pater's ideal of simultaneity is dispersed by the length of the book.

In his essays, however, Pater attempts to realize a structure which will be the equivalent of a "single visible image." The general method of *The Renaissance* is to construct an overall design which is focussed on a single image. In the "Leonardo" and "Giorgione" essays, for example, there is a progressive narrowing and condensation of the topic: Leonardo at first is used to represent the Florentine spirit, just as Giorgione is "a sort of impersonation of Venice itself, its projected reflex or ideal, all that was intense or desirable in it crystallizing about the memory of this singular young man." These essays, like the

"portraits," are attempts to describe a single temperament. The temperament of the artist which sums up the cultural moment is then condensed into his work, and his paintings are then collapsed into one single type, as Pater traces common elements through all of them. Leonardo's canvases are described as all leading up to the image of the Mona Lisa, and each of the paintings in the school of Giorgione represents a similar moment of listening to music.[73]

In both cases the way the essay is focussed on the single image is through an accretion of associations, a building up of an intricate pattern of cross reference. This type of construction is similar to the way Pater uses clauses in his sentences, putting one complete clause behind another, until at the end of the sentence, they are all apprehended together at once. Northrop Frye describes this "pictorial style" of sentence construction in which all the elements of the sentence

> are fitted into a pattern, and as one point after another is made, there emerges not a linear process of thought but a simultaneous comprehension. What is explained is turned and viewed from all aspects, but it is completely there, so to speak, from the beginning. (Frye, *Anatomy of Criticism*, p. 267)

In the layer structure of the essay, the elements of the pattern separate in the same way, as they are condensed into the central image which brings the whole essay into focus simultaneously. Using the Leonardo essay for an example we can see how Pater constructs the network of association. First of all he uses a purposefully limited and selected vocabulary, so that, like a painter limiting his palette, he is able to "modulate one dominant tone." Thus we find words such as "delicate"or "faint" repeated so often they acquire a tonal quality as well as a denotative meaning. Pater uses these reiterated words in combination with so many other words which create diverse associations that the tonal quality permeates the whole texture of the writing, like the gold he describes worked throughout the fabric of Venetian painting. What Pater is attempting through the repetition of key words is to produce the unity of "atmosphere": he says in "Style," "as the painter in his picture, so the artist in his book, aims at the production by honorable artifice of a peculiar atmosphere." The honorable artifice in this case is the construction of a pattern of association, which has both musical and pictorial analogues. Pater's description of the painter's ability to "modulate one dominant tone," which is the model for his tonal repetition of words, occurs in the context of the "Giorgione" essay, centered on the painting of musical "moments." It is fairly clear that the continual use of words such as "clairvoyant," "delicate," and "faint" sets up a tonal unity in terms of sound, and that through the reinforcement of sound the qualities suggested by these words saturate the atmosphere of the essay. But it is also true that this repetition "colors" Pater's style, so that a visible pattern is also in operation. The key

words, like color tones on a canvas, are optically in relief for the reader, physical reminders of the pattern being shaped. Compared to the visible structure in Mallarmé, the "constellation" pattern of words "Un Coup de Dès" spaced out against the blanks on the white page, Pater's use of the visible aspect of language is subdued. But although submerged, Pater expects the shape of words as "things" as well as their sound to work together in unison. If language is to produce a tangible effect, all the physical properties of words must be utilized. The relation of the visual to the musical is obliquely summed up in the "Giorgione" essay: Pater says that the concrete aspects of literature and painting must be fused with the representational, so that as artistic mediums they reflect the inseparability of form and content found in music.

> Art, then, is thus always striving to be independent of the mere intelligence, to become a matter of pure perception, to get rid of its responsibilities to its subject or material; the ideal examples of poetry and painting being those in which the constituent elements of the composition are so welded together, that the material or subject no longer strikes the intellect only; nor the form, the eye or the ear only; but form and matter, in their union or identity, present one single effect to the "imaginative reason," that complex faculty for which every thought and feeling is twin-born with its sensible analogue or symbol.
> It is the art of music which most completely realises this artistic ideal, this perfect identification of form and matter. In its ideal, consummate moments, the end is not distinct from the means, the form from the matter, the subject from the expression; they inhere in and completely saturate each other; and to it, therefore, to the condition of its perfect moments, all the arts may be supposed constantly to tend and aspire. (*Ren.*, "Giorgione," p. 114)

Again it is the perfect "moments" of music that completely embody this ideal; because music, like literature, is a temporal art, it cannot serve Pater as a model for simultaneous unity. Thus, in the actual essay, the ideal form described is a painting of a moment of music—an ideal which combines the fusion of form and content with the structure of the single moment. We can see this ideal transposed into literature in the "Leonardo" essay, where the tonal color and the physical aspects of language are used to construct a pattern which operates like the "single view" of a painting.

We find that the Leonardo essay is built around two thematic developments which are designed to function as a *correspondance*, "to interpret each other"; these are the two deepest "Impressions" in Leonardo's brain, "the smiling of women and the motion of great waters." Pater keeps these two themes in relation throughout the essay; for example, in his description of Leonardo as an alchemist he says that he had the gift "of divining the sources of springs beneath the earth or of expression beneath the human countenance." Again in another set passage, in which the paragraph has the self-contained unity of a prose poem, he links all of Leonardo's paintings to the single type

of the woman seen against the background of moving water. He also points out that the faint quality of the light makes it seem as if underwater.

> Through Leonardo's strange veil of sight things reach him so; in no ordinary night or day, but as in faint light of eclipse, or in some brief interval of falling rain at daybreak, or through deep water.

In another passage Pater connects this idea of faintness with the subtle "clairvoyant" quality of the Leonardo type of woman, which makes her "a delicate instrument" for registering the "subtle forces of nature."

> It is as if in certain significant examples we actually saw those forces at their work on human flesh. Nervous, electric, faint always with some inexplicable faintness, these people seem to be subject to exceptional conditions, to feel powers at work in the common air unfelt by others, to become, as it were, the receptacle of them, and pass them on to us in a chain of secret influences. (*Ren.*, p. 111)

Just before he launches into the famous "purple panel"[74] on the Gioconda, Pater reminds us again that the image is set against "that circle of fantastic rocks, as in some faint light undersea." When he begins the actual description of the portrait within "the presence that rose thus so strangely beside the water," the reader is prepared for the subtle relationship that Pater is trying to sugest between the figure and the setting. The water becomes a symbolic element in the description and seems to represent the unconscious, the past, the whole mythic envelope which surrounds the actual person, and which she "interprets" and transmits through the clairvoyant awareness expressed in her smile. Besides the main pattern of words and associations already described, Pater incorporates several minor patterns into the essay which play into the final image: there are suggestions throughout the essay of something mysterious and predatory in the smile, "about the dainty lines of the cheek the bat flits unheeded" and parallel diction is used to link ocean glass, seaweed, and hair, again fusing the portrait and its watery background. When Pater finally presents the image of Lisa, the paragraph is like an iconic summation of the essay, the entire verbal structure condensed into a single "image":

> The presence that thus rose so strangely beside the waters, is expressive of what in the ways of a thousand years men had come to desire. Hers is the head upon which all "the ends of the world are come," and the eyelids are a little weary. It is a beauty wrought out from within upon the flesh, the deposit, little cell by cell, of strange thoughts and fantastic reveries and exquisite passions. Set it for a moment beside one of those white Greek goddesses or beautiful women of antiquity, and how would they be troubled by this beauty, into which the soul with all its maladies has passed! All the thoughts and experience of the world have etched and moulded there, in that which they have of power to refine and make expressive the outward form, the animalism of Greece, the lust of Rome, the reverie of the middle age with its spiritual

ambition and imaginative loves, the return of the Pagan world, the sins of the Borgias. She is older than the rocks among which she sits; like the vampire, she has been dead many times, and learned the secrets of the grave; and has been a diver in deep seas, and keeps their fallen day about her; and trafficked for strange webs with Eastern merchants: and, as Leda, was the mother of Helen of Troy, and, as Saint Anne, the mother of Mary; and all this has been to her but as the sound of lyres and flutes, and lives only in the delicacy with which it has moulded the changing lineaments, and tinged the eyelids and the hands. The fancy of a perpetual life, sweeping together ten thousand experiences, is an old one; and modern thought has conceived the idea of humanity as wrought upon by, and summing up in itself, all modes of thought and life. Certainly Lady Lisa might stand as the embodiment of the old fancy, the symbol of the modern idea.

What Pater has accomplished is an approximation of the formal impact of the painting which stands at the center of the essay, which is designed to collapse into a "single almost visible image." The verbal image, like the painted one, gives the reader the experience of theoretical simultaneity, a perception of the whole essay, condensed and unified into a single symbol. Pater's aim has been to convey his initial, complex sensation or impression of Leonardo's peculiar and unique "soul." Thus the whole essay, with its interlocking pattern focussed on the image of Lisa, is the necessary structure for conveying the sensation, and the unity of the essay duplicates the "vital wholeness" of Pater's first view. Pater has consciously constructed the essay so that it reflects the unity of his original vision of Leonardo, and so that, as a total symbol of that vision, the essay can be condensed into the symbolic portrait of Lisa, or rather into the paragraph that transposes that image into words. Through that paragraph, the "static design" of the essay can be seen retrospectively as a simultaneous whole, so that the essay, like a painting, which communicates directly in an instant of time, can "reach us by a kind of immediate contact." As Pater says in discussing Flaubert, the reader of "conscious prose" must recognize by "intuition and a sort of immediate sense" the rightness of a literary structure. Pater expects the reader of his Leonardo essay to "consciously trace out" the pattern of the essay as he reads, so that at the end, he will intuit the possibility of an "immediate" view of the whole work seen through the form of painting.

Notes

Introduction

1. M.H. Abrams, *The Mirror and the Lamp* (New York: Norton and Co., 1958), p. 50.

2. Jean H. Hagstrum, *The Sister Arts: The Tradition of Literary Pictorialism and English Poetry from Dryden to Gray* (Chicago and London: 1958), p. 32.

3. Ibid., p. 12.

4. Ibid., p. xxii.

5. See Chapter 1, pp. 30-35.

6. George Steiner, *After Babel* (New York: Oxford University Press, 1977), pp. 176-78.

7. Merleau-Ponty, *The Prose of the World* ed. Claude Lefort, translated by John O'Neill. (Evanston: Northwestern University Press, 1973), p. 14.

8. M.A. Ruff, *Baudelaire* (Paris: Hatier, 1966), p. 143.

9. Merleau-Ponty, *The Prose of the World,* pp. 63-64.

10. Harry Levin, *Contexts of Criticism* (New York: Atheneum, 1963), p. 32.

11. Wallace Stevens, from "The Relations between Poetry and Painting" in *The Necessary Angel* (New York, Knopf: 1951).

Chapter 1

1. Eugene Delacroix, *Journal,* translated by Walter Pach (New York: Crown Publishers, 1948), p. 336.

2. Ibid., p. 337.

3. Ibid., p. 646.

4. Charles Baudelaire, *The Mirror of Art; Critical Studies by Charles Baudelaire,* edited and translated by Jonathan Mayne (New York: Phaidon Publishers, 1955), p. 5.

5. Charles Baudelaire, *Baudelaire as a Literary Critic*, translated by Lois and Francis Hyslop (University Park, Pennsylvania: The Pennsylvania State University Press, 1964), p. 168.

6. M.A. Ruff, *Baudelaire* (Paris:Hatier, 1966), p. 143.

7. Delacroix, *Journal*, p. 545.

8. Ibid., p. 329.

9. Ibid., p. 421.

10. Ibid., p. 715.

11. Ibid., p. 369.

12. Ibid., p. 370.

13. Eugene Delacroix, *Journal*, ed. André Joubin (Paris: Librairie Plon, 1950), III, p. 429. (This entry appears in the supplement in the Journal and was not included in the English edition: this and all other translations which I have done myself were checked by Professor Claude-Marie Senninger at The University of New Mexico).

14. Delacroix, *Journal*, pp. 718-19.

15. Delacroix, ed. Joubin, III, pp. 375-76.

16. Delacroix, *Journal*, p. 437.

17. Baudelaire, *Baudelaire as a Literary Critic*, pp. 164-65.

18. Emeric Fiser, *Le Symbole littéraire, essai sur la signification du symbol chez Wagner, Baudelaire, Mallarmé, Bergson et Marcel Proust* (Paris: Librairie Joseph Corti, 1941), p. 50.

19. Baudelaire, *The Mirror of Art*, p. 306.

20. *Oeuvres complètes de Baudelaire*, ed. Yves Le Dantec et Claude Pichois (Paris: Bibliothèque de la Pleiade, Gallimard, 1961), p. xi.

21. Baudelaire, *The Mirror of Art*, p. 49. Cf. to Delacroix:

> I see in painters prose writers and poets. Rhyme, measure, the turning of verses which is indispensable and which gives them so much vigor, are analogous to the hidden symmetry, to the equilibrium at once wise and inspired, which governs the meeting or separation of lines and spaces, the echoes of color, etc. This thesis is easy to demonstrate, only one has need of more active organs and a greater sensibility to distinguish error, discord, false relationship among lines and colors, than one needs to perceive that a rhyme is inexact or that a hemistich is clumsily (or badly) hung. But the beauty of verse does not consist of exactitude in obeying rules, when even the most ignorant eyes see at once any lack of attention to them.

> It resides in a thousand secret harmonies and conventions which make up the power
> of poetry and which go straight to the imagination; in just the same way the happy
> choice of forms and the right understanding of their relationship act on the imagina-
> tion in the art of painting. (Delacroix, *Journal,* p. 153).

22. Ibid., p. 49.

23. Ibid., pp. 49-50.

24. Ibid., p. 50.

25. Ibid., p. 49.

26. Ibid., p. 51.

27. Baudelaire, *Baudelaire as a Literary Critic,* p. 199.

28. Baudelaire, *The Mirror of Art,* p. 310.

29. Ibid., p. 310.

30. Ibid., pp. 310-11.

31. Cf. Delacroix:

> As to the difference that there is between literature and painting in the matter of *the*
> *effect that may be produced by the sketch of a thought,* in a word, as to the impossi-
> bility of sketching in literature in such fashion as to describe a thing to the mind, and
> as to the strength that the idea may present, on the contrary, in a sketch or first note
> by a painter. Music is perforce in the same category as literature, and I believe that
> the difference between the arts of design and the others derives from the fact that the
> latter develop the idea only by offering impressions *one after the other.* Whereas
> four strokes of the brush or the pencil are enough to sum up for the mind the whole
> impression of a pictorial composition. (Delacroix, *Journal,* p. 372)

32. Baudelaire, *The Mirror of Art,* p. 312.

33. Ibid., p. 312-13.

34. Ibid., p. 315.

35. Ibid., p. 313.

36. Baudelaire, *Oeuvres complètes de Baudelaire,* p. 186.

37. *Oeuvres complètes de Baudelaire,* p. 598.

38. Baudelaire, *My Heart Laid Bare and other prose writings,* ed. Peter Quennel, tr. Norman
 Cameron (New York: Vanguard, 1951), p. 159.

39. George Saintsbury, *A History of English Prose Rhythm* (London: Macmillan, 1972), p. 425.

40. Baudelaire, *The Mirror of Art,* p. 45.

41. Marcel Raymond, *De Baudelaire au surréalisme* (Paris: Corti, 1966), p. 21.

42. Baudelaire, *Oeuvres complètes de Baudelaire,* p. 180.

43. Ibid., p. 37.

44. Baudelaire, *The Mirror of Art,* p. 315.

45. Ibid., p. 306.

46. As Baudelaire says in a section on criticism in the *Salon de 1846:*

> I sincerely believe that the best criticism is that which is both amusing and poetic: not a cold, mathematical criticism which, on the pretext of explaining everything, has neither love nor hate, and voluntarily strips itself of every shred of temperament. But, seeing that a fine picture is nature reflected by an artist, the criticism which I approve will be that picture reflected by an intelligent and sensitive mind. Thus the best account of a picture may well be a sonnet or an elegy.

> *The Mirror of Art,* p. 44.

47. Ibid., p. 213-14.

48. Baudelaire, *Oeuvres complètes de Baudelaire,* p. 112.

49. Ibid., p. 84.

50. Ibid., p. 253.

51. Ibid., p. 690.

52. Ibid., p. 70.

53. Mallarmé, *Variations sur un sujet, Penguin Poets,* ed. Anthony Hartley (Suffolk: Bungay, 1965), pp. 174-75.

54. Jean Pierre Richard, *Poésie et profondeur* (Paris: Editions du Seuil, 1955), p. 160.

55. Baudelaire, *The Mirror of Art,* pp. 315-16.

56. Baudelaire, *My Heart Laid Bare and other prose writings of Baudelaire,* pp. 110-11.

57. Ibid., pp. 164-65.

58. Baudelaire, *The Mirror of Art,* p. 215.

59. Baudelaire, *Baudelaire as a Literary Critic*, pp. 200-201.

60. Baudelaire, *My Heart Laid Bare*, p. 60.

61. Baudelaire, *Oeuvres complètes de Baudelaire*, p. 1313.

62. Marcel Proust, *On Art and Literature, 1896-1919*, Translated by Sylvia Warner (New York: Meridian, 1958), p. 132.

63. Baudelaire, *Baudelaire as a Literary Critic*, pp. 127-28.

64. Ibid., pp. 129-30.

65. Ibid., pp. 317-18.

66. Baudelaire, *Oeuvres complètes de Baudelaire*, p. 99.

67. Ibid.

68. Ibid.

69. Ibid.

70. Ibid.

71. Ibid.

72. Baudelaire, *The Mirror of Art*, p. 58.

73. Baudelaire, *Oeuvres complètes*, p. 40.

74. Ibid., p. 44.

75. Baudelaire, *Paris Spleen*, tr. by Louise Varèse (New York: New Directions, 1941), p. ix.

76. Baudelaire, *The Mirror of Art*, p. 215.

77. Baudelaire, *Baudelaire as a Literary Critic*, p. 296.

78. Baudelaire, *The Mirror of Art*, p. 85.

79. Ibid., p. 318.

80. Jean Hagstrum, *The Sister Arts* (Chicago, 1958), *passim.*

81. Baudelaire, *Oeuvres complètes*, p. 51.

82. Translated version on pp. 63-64.

83. Baudelaire, *Oeuvres complètes*, p. 254.

84. Ibid.

85. Ibid., p. 254.

86. Ibid.

87. Ibid., p. 254-55.

88. Ibid., p. 255.

89. Ibid.

90. Ibid., p. 79.

Chapter 2

1. John Ruskin, *Modern Painters* 4: 190 (New York: John Wiley & Sons, 1881).

2. Sam Hunter, *Modern French Painting* (New York: Dell, 1956) and Adrian Stokes, *Painting and the Inner World* (London: Tavistock, 1963).

3. Frederic Harrison, *John Ruskin* (New York: Macmillan, 1906), p. 62.

4. George Saintsbury, *A Short History of English Literature* (New York and London: Macmillan, 1929), p. 78.

5. Graham Hough, *The Last Romantics* (London: Methuen, 1961), p. xvii.

6. Ruskin, *Modern Painters,* 2: 12-13.

7. Ruskin, *The Stones of Venice,* 3: 174.

8. George Landow, *The Aesthetic and Critical Theories of John Ruskin* (Princeton, N.J.: Princeton University Press, 1971).

9. Ruskin, *Modern Painters,* 3: 262.

10. Christopher Hussey, *The Picturesque* (London: G.P. Putnam's Sons, 1927), p. 70.

11. Jean Hagstrum, *The Sister Arts* (Chicago and London: The University of Chicago Press, 1958), p. 162.

12. *The Genius of John Ruskin,* ed. John Rosenberg (Boston: Houghton Mifflin, 1963), p. 40.

13. Ruskin, *Modern Painters* 4: 58.

14. Ibid., 1: 193.

15. Ibid., 4: 59.

16. John Ruskin, *Praeterita*, ed. Cook and Wedderburn (London: Allen, 1908), p. xxii.

17. Ruskin, *Modern Painters* 5: 324.

18. Ibid., 3: 9.

19. Ibid., 1: xxiv.

20. Ibid., 1: xxxii.

21. Ibid., 1: xxxiii.

22. Ibid., 4: 31.

23. Ibid., 3: 307.

24. Ibid., 2: 190.

25. Ibid., 1: 177.

26. Ruskin, *Modern Painters*, 1:359-61.

27. Ibid., 1: 373-74.

28. Ibid., 5: 195.

29. From *A Dialogue on the Distinct Characters of the Picturesque and the Beautiful*, by Uvedale Price, cited in Christopher Hussey, *The Picturesque: Studies in a Point of View* (London, N.Y.: 1927).

30. Ruskin, *Modern Painters* 1: 52-53.

31. Ibid., 3: 267.

32. Ibid., 3: 158-59.

33. Ibid., 3: 155, 156, 157.

34. Rosenberg, *The Genius of John Ruskin*, p. 297.

35. Ibid., pp. 299-300.

36. Ibid., pp. 301-2.

37. Ibid., p. 303.

38. *Modern Painters*, 3: 79-80.

39. Ibid., 1: 51.

40. John Ruskin, *The Works of John Ruskin,* vol. 7, *The Elements of Drawing* (New York: 1885).

41. E.H. Gombrich, *Art and Illusion* (New York: 1960), p. 305.

42. Ruskin, *Modern Painters* 4: 51.

43. Baudelaire, *Oeuvres complètes de Baudelaire,* 1159.

44. *Modern Painters* 3: 163-64.

45. Baudelaire, *Oeuvres complètes de Baudelaire,* p. 1118.

46. Ibid., p. 1119.

47. *Modern Painters* 3: 80.

48. Ibid., 3: 77.

49. Ibid., 3: 79.

50. First paragraph: ibid., 1: 348; second paragraph: ibid., 1: 355.

51. Ruskin, *Modern Painters* 1: 356-57.

52. See Geoffrey Hartmann, *The Unmediated Vision* (New Haven: Yale University Press, 1954).

53. Rosenberg, *The Genius of John Ruskin,* p. 40.

54. Ruskin, *Modern Painters* 3: 118, 119.

55. Patricia Ball, *The Science of Aspects* (London: Athlone Press, 1971).

56. Cited in Frank Kermode, *The Romantic Image* (New York: Knopf, 1957), p. 128.

57. Robert Stange, "Art Criticism as a Prose Genre," in *The Art of Victorian Prose* (New York and London: Oxford University Press, 1968), p. 46.

58. Ruskin, *Modern Painters* 2: 179-80.

59. Ibid., 2: 173-74.

60. Ibid., 2: 180-81.

61. Ibid., 1: 371.

62. Ibid., 2: 180-81.

63. Ibid., 2: 165.

64. Ibid., 2: 170.

65. Ibid., 2: 171.

66. Ibid., 2: 173.

67. Rosenberg, *The Genius of John Ruskin*, p. 522.

68. Ibid., pp. 524-25.

69. Ibid., p. 127.

70. Floris Delattre, *Ruskin et Bergson: de l'intuition esthétique à l'intuition métaphysique* (Oxford: Clarendon Press, 1947).

71. Rosenberg, *The Genius of John Ruskin*, p. 525.

72. Ruskin, *Modern Painters* 3: 78.

73. Ibid., 3: 80.

74. Ibid., 3: 80-81, 83.

75. Ibid., 3: 90.

76. Ibid., 2: 119.

77. Baudelaire, *Oeuvres complètes de Baudelaire*, pp. 148-49.

78. Ibid., p. 467 (see page 57 in Chapter 1).

79. Ruskin, *Modern Painters* 5: 288-89.

80. Ibid., 3: 262.

81. Ibid.

82. Ibid., 3: 263.

83. Ibid., 3: 259.

84. Ibid., 5: 206.

85. Ibid., 2: 169.

86. Ibid., 5: 206-7.

87. Ibid., 5: 208-9.

88. Ibid., 5: 204.

89. Ibid.

90. Ruskin, *The Stones of Venice,* p. 137.

91. Ibid., p. 139-40.

92. Ibid., p. 144.

93. Ruskin, *Modern Painters* 3: 93-95.

94. Ibid., 5: 207.

95. Ibid., p. 158-59.

96. Ibid., 5: 189-90.

97. Ibid., 5: 190.

98. Ibid., 5: 192.

99. Ibid., 4: 21, 22, 23.

100. Ibid., 4: 28-29.

101. Ibid., 2: 152.

102. Ibid., 4: 30-31.

103. Marcel Proust, "La Bible d'Amiens," *Pastiches et Mélanges* (Paris, 1919).

104. Rosenberg, *The Genius of John Ruskin,* p. 164.

105. Frederic Harrison, *John Ruskin* (New York: Macmillan, 1906).

106. Rosenberg, *The Genius of John Ruskin,* p. 166-67.

107. Ibid., pp. 166-67.

108. Ibid., p. 168.

109. Ruskin, *Modern Painters,* 5: 222.

110. Ibid., 5: 224.

111. Ibid., 5: 225.

112. Ibid., 5: 224-25.

113. Ibid., 5: 225.

114. Ibid., 5: 226.

115. Ruskin, *The Stones of Venice,* pp. 147-48.

116. Ruskin, *Modern Painters,* 5: 229.

117. Ruskin, *The Stones of Venice,* p. 170.

118. Ruskin, *Modern Painters* 5: 316.

119. Ibid., 4:54.

120. Ruskin, *Modern Painters* 4: 70-71.

121. Ruskin, *The Stones of Venice,* p. 182.

122. Adrian Stokes has an excellent discussion of the relationship between abstraction and the fidelity to the external scene in Turner's painting: "Even in a very late 'all-over' painting—others, the water-colour exemplars, had dared it only on a small scale—that at first sight seems abstract, since it is featureless in regard to vertical shapes, in the last sea-scapes, for instance, at the Tate, we acknowledge almost immediately that here is a record, an intense record, of an outward as well as an inward scene: we are aware that in virtue of familiarity, detail has been undone by a virtuoso performer who, conscious of power and information, has no fear of too great a freedom that might result in an overriding of the object and cause the artist to construct shapes, to use colours, dictated solely by his design. Turner's reverence for the objects he studied was intact. . . ." Adrian Stokes, *Painting and the Inner World* (London, 1963), p. 71.

123. Ruskin, *Modern Painters* 3: 275.

124. Ruskin, *Praeterita* 2: 71.

125. Ibid., 2: 27.

126. Graham Reynolds, *Turner* (New York: Abrams, 1969).

127. Ruskin, *Praeterita* 2: 38.

128. Ruskin, *Modern Painters* 5: 317.

129. Ibid., 5: 319.

130. Ruskin, *Praeterita,* Library Edition, 3: 20-21.

Chapter 3

 1. *Marcel Proust: A Centennial Volume,* ed. Peter Quennell (New York: Simon and Schuster, 1971), "Bergotte," pp. 62-63.

2. Ibid., p. 22.

3. Marcel Proust, *Remembrance of Things Past,* translated by C.K. Scott Moncrieff and Frederick A. Blossom (New York: Random House, 1934), Vol. 2, p. 509.

4. Marcel Proust, *Contre Ste-Beuve* (précédé de *Pastiches et mélanges* (Paris: Gallimard, 1971), p. 124. (Hereafter abbreviated as *Pastiches* with page number.) Translated by myself with the help of Professor Claude-Marie Senninger.

5. Proust, *Pastiches,* p. 126.

6. Ibid., p. 125.

7. Ibid., pp. 125-26.

8. Ibid., pp. 126-28.

9. Ibid., p. 63.

10. Proust, *R.T.P.,* 1: 143.

11. John Ruskin, *Sésame et les Lys,* translated and introduced by Marcel Proust (Paris: N.R.F., 1906), p. 102-3.

12. John Ruskin, *Sesame and Lilies,* Library Edition (London: Allen, 1908), p. 60-61.

13. Proust, *R.T.P.,* 1:143.

14. Ibid., 2: 642-43.

15. Ibid., 2: 644.

16. Ibid., 2: 645-46.

17. Ibid., 2: 646.

18. Ibid., 2: 557.

19. Ibid., 2: 559.

20. Ibid., 2: 1013.

21. Proust, *Pastiches,* p. 129.

22. J.M. Cocking, *Proust* (London: Bowes and Bowes, 1956), pp. 60-61.

23. Proust, *R.T.P.,* 1: 628-29.

24. Ibid., 1: 631.

25. Proust, *Pastiches,* p. 121.

26. Proust, *R.T.P.,* p. 631.

27. Ibid., 1: 631-32.

28. Ibid., 1: 1124.

29. Ibid., 2: 1114.

30. Ibid., 1: 632.

31. Ibid., 1: 633.

32. Ibid., 1: 77.

33. Cocking, *Proust,* p. 30.

34. Proust, *Pastiches,* p. 299.

35. See E. L. Ferrère, *L'Esthétique de Flaubert* (Geneva: Slatkine Reprints, 1967), p. 49.

36. Proust, *Pastiches,* pp. 300-301.

37. Ibid., p. 304.

38. Ruskin, *Sesáme et le Lys,* trans. Marcel Proust (Paris: N.R.F., 1906), pp. 1-4.

39. Jean-Yves Tadie, *Proust et le roman: essai sur les formes et les techniques du roman dans "A la recherche du temps perdu* (Paris: Gallimard, 1971), pp. 238-39.

40. Ibid., p. 240.

41. Proust, *Pastiches,* pp. 75-76.

42. Proust, *R.T.P.,* 2: 1034.

43. Proust, *Pastiches,* p. 114.

44. Proust, *R.T.P.,* 2: 1024.

45. Ibid., 2: 1111. The network is connected to Time later in the next paragraph:

> We could not recount our relations even with someone we have known only slightly without bringing in, one after the other, the most diverse settings of our life. Thus, every individual—and I was myself one of these individuals—measured the duration of time for me by the revolution he had accomplished, not only on his own axis, but about other individuals and notably by the successive positions he had occupied with relation to myself.
> And in truth, all these different planes on which Time, since I had come to grasp

its meaning again at this reception, was arranging the different periods of my life, thereby bringing me to realise that in a book which aimed to recount a human life one would have to use, in contrast to the 'plane' psychology ordinarily employed, a sort of three-dimensional, 'solid' psychology, added a fresh beauty to the resurrections of the past which my memory had evoked as I sat musing alone in the library, because memory, by bringing the past into the present unmodified, just as it appeared when it was itself the present, eliminates precisely that great dimension of Time which governs the fullest realisation of our lives.

46. *Proust,* J.M. Cocking, p. 64.

47. Proust, *R.T.P.,* 2: 1016-17. Compare this description with Ruskin's account of the painter's and writer's storehouse of memory in his chapter on Turnerian Topography (see pp. 129-32).

48. Ibid., 2: 510-11.

49. Proust, *Pastiches,* p. 111.

50. Ibid., p. 138.

51. Marcel Proust, *On Reading* (preface to the translation of *Sesame and Lilies*) translated by Jean Autnet and William Burford (New York: Macmillan, 1971), pp. 37-39.

Chapter 4

1. Georges Poulet, *L'Espace Proustien* (Paris: Gallimard, 1963), p. 43.

2. See Ruskin's discussion of Turner's scarlet as "absolute color." p. 144.

3. Frank Kermode, in *The Romantic Image,* describes Blake and Pater as constituting the "native English symbolist tradition."

4. Edmund Wilson, *Axel's Castle* (New York: Scribner's, 1931), p. 32.

5. Cocking, *Proust,* p. 65.

6. Walter Pater, *Gaston de Latour* (New York: 1896), p. 70.

7. Walter Pater, *The Renaissance* London: 1914), pp. vii-viii. (Hereafter abbreviated as *Ren.*)

8. Ruskin is not, of course, the only influence on Pater. Many of the same ideas were present in German aestheticians. Bernard Bosanquet says, for example, that Pater read Ruskin and Hegel at the same time at Oxford. Bosanquet himself sees Ruskin and Hegel as similar figures in the history of ideas (Bosanquet, *Science and Philosophy and Other Essays* (London: 1927).

9. Walter Pater, *Appreciations,* "Coleridge" (London: 1900), pp. 65-66.

10. He uses this metaphor throughout *The Renaissance* and in *Marius;* Marius himself lives in the "refined stream of sensation."

11. Thus in *Marius* Pater begins a sentence describing the "fleeting impressions" of the aesthetic critic and shifts the terms at the end of the sentence to the "actual moments." The terms "impression," "sensation," "moment" are used interchangeably, on purpose in order to create an unobtrusive identity.

12. Walter Pater, *Marius The Epicurean* (London and New York: Everyman's Library, 1968), p. 75. (Hereafter abbreviated as *Marius.)*

13. Pater, *Appreciations,* "Coleridge," p. 67.

14. Ibid., p. 66.

15. Walter Pater, *Imaginary Portraits* (New York: Harper and Row, 1964), p. 187.

16. Pater attributes this notion to Plato—*Miscellaneous Studies,* p. 57— and also to Apuleius' version of Platonism in *Marius:*

> For him, the Ideas of Plato were no creatures of logical abstraction, but in very truth informing souls, in every type and variety of sensible things. (*Marius,* p. 191)

17. "The present moment alone really is, between a past which has ceased to be and a future which may never come" (*Marius,* p. 80).

18. Michaud, *Le Message Poétique du Symbolisme* (Paris: Nizet, 1947), v. 11, p. 107.

19. Pater, *Appreciations* (London: Macmillan, 1900), p. 249.

20. Wylie Sypher calls Pater an "academic dandy" and compares him to Mallarmé. (*From Rococo to Cubism,* New York, 1960, p. 224.)

21. Marius thinks "all this would involve a life of industry, of industrious study, only possible through healthy rule, keeping clear the eye alike of body and soul" (*Marius,* p. 89).

22. Anthony Ward, *Walter Pater: The Idea in Nature,* p. 133: "His own predilection for the 'picturesque' here is clear. It is the 'quaintly picturesque' attitude to life which allowed him to select only what was pleasing to the eye, and to live exclusively in certain choice moments."

23. It is probable that Pater had read Baudelaire as early as *The Renaissance.* In the Giorgione essay there is another exact verbal parallel—Baudelaire describes the relationship between the arts as the ability "de se prêter réciproquement des formes nouvelles." Pater describes the same relationship as the ability "to reciprocally lend each other new forces." Also his ideas in the Leonardo essay about curiosity and the addition of strangeness to beauty are remarkably Baudelairean.

24. Pater, *Gaston de Latour,* p. 69.

25. Ibid., p. 71.

26. Ibid., p. 69.

27. This is reminiscent of Ruskin's process of training in order to achieve pure, unclouded vision.

28. James Hafley points out that Marius' understanding of Christianity is entirely *symboliste*, since it is based on *correspondances*. *Modern Fiction Studies* 3 (Summer, 1957): 99.

29. "Throughout that elaborate and lifelong education of his receptive powers, he had ever kept in view the purpose of preparing himself towards possible further revelation some day—towards some ampler vision. . . . " (*Marius*, p. 264)

30. Thus the "aesthetic philosophy" comes to be "an eager, concentrated, impassioned realization of experience" (*Marius*, p. 86).

31. Walter Pater, *Plato and Platonism* (London: Macmillan and Co., 1925), p. 92. Compare this definition to Joyce's definition of the aesthetic object in *A Portrait of the Artist as a Young Man* (p. 212): ". . . temporal or spatial the esthetic image is first luminously apprehended as self-bounded and self-contained upon the immeasurable background of space or time which is not it."

32. Pater, *Plato and Platonism*, p. 94.

33. *Webster's Seventh New Collegiate Dictionary*, G. & C. Merriam and Co., Chicago and Cambridge, 1961.

34. Anthony Ward notes that the musical analogy when applied to painting paradoxically results in the ability to 'modulate one dominant tone.' (*The Idea in Nature*, London, 1966, p. 103.)

35. Pater's understanding of these relationships is set forth clearly in the introduction of the "Giorgione" essay. See *Ren.*, pp. 130-39.

36. See Jerome Buckley, *The Victorian Temper* (London: 1852), or the introduction to *The Last Romantics*, by Graham Hough.

37. Marcel Raymond, *De Baudelaire au surréalisme* (Paris: 1966), p. 17.

38. Gertrude Pelles, *Art, Artists and Society* (Paris: 1966), p. 17.

39. As Gertrude Pelles points out, the situation was slightly different in France, where the artist established his own social identity as a member of a Bohemian elite, than in England where there was no artist class, so that individuals were assimilated into high society—painters through the Royal Academy and writers through West End society.

40. Guy Michaud, *Le Message poètique du symbolisme*, p. 115.

41. Such as Wilde in Mayfair and Proust in the circle of Robert de Montesquiou.

42. As Graham Hough points out in his essay on Pater, this is an attempt to have a "womb with a view" (Hough, *The Last Romantics*).

43. See Proust, *Contre Ste-Beuve* (Paris: 1954); Flaubert, *Correspondances* (Paris: 1922-25); Yeats also distinguished between the creative self and the "breakfast-table self" (see *Essays*, London, 1961).

44. Pater says of Marius that his "struggle with words was a battle with himself." Perhaps because they tried to live like artists, both Pater and Mallarmé were seen as fictional characters by writers who looked back to them as models of the artistic personality. Pater is the ultimate source for Wilde's aesthetes just as Mallarmé is the prototype for Huysmans' Des Esseintes.

45. Walter Pater, *Essays from the Guardian*, "Aesthetic Poetry;" also "Style," p. 14.

46. Pater, *Appreciations*, "Style," p. 13.

47. See Wylie Sypher, "The Neo-Mannerist Condition," *From Rococo to Cubism*, pp. 156-68; and Arnold Hauser, *Mannerism* (New York, 1965).

48. In *Marius* the aesthetic statement constitutes a large part of the book, as Marius' life is lived in aesthetic terms. In *Gaston* there are full-fledged "appreciations" of Ronsard and Montaigne as well as an essay on Giordano Bruno. In later Symbolist novels such as *The Portrait of the Artist as a Young Man* and *A la recherche du temps perdu*, aesthetic criticism is worked into the context of the life of the protagonist.

49. Pater, *Appreciations*, p. 120. Pater also says: "The best sort of criticism is imaginative criticism: that criticism which is itself a kind of construction, or creation, as it penetrates, through the given literary or artistic product, into the mental and inner constitution of the producer, shaping his work" (*Essays from The Guardian*). The emphasis on criticism as creation and on the spiritual bond between critic and artist is again analogous to Baudelaire's ideas.

50. Pater, *Appreciations*, "Style," p. 17.

51. Pater, *Imaginary Portraits*, "An English Poet," p. 45. These sensuous metaphors pervade his writing about language. Another example emphasizes the elemental properties of words: "Racy Saxon monosyllables, close to us as touch and sight, he will intermix readily with those long, savoursome, Latin words, rich in 'second intention' " ("Style," p. 13).

52. In his way of referring everything back to the "moment," Pater states that the "book . . . is lucky or unlucky in the precise moment of its falling in our way, and often by some happy accident counts with us for something more than its independent value" (*Marius*, p. 54).

53. The concept of the book as artifact was prevalent throughout the nineties. Arthur Symons, who describes Pater's words as having "their color, their perfume," also remembers the feel of the pages of the first edition of *The Renaissance (The Symbolist Movement in Literature)*. Wilde saw Pater's *Renaissance* itself as a "golden book" and perpetuated the aesthetic cult of the book in his descriptions of lavish editions of Mallarmé in

Dorian Grey. Huysmans also degraded Mallarmé's idea of *le livre* by concentrating on the exotic bindings rather than the idea of an autonomous work of art.

54. George Saintsbury, *A History of English Prose Rhythm* (London: 1912).

55. Pater, *Gaston de Latour,* p. 30.

56. Ibid., p. 64.

57. See Robert Cohn's discussion of this phrase in his analysis of "L'Après-Midi d'un Faune," in *Towards the Poems of Mallarme* (Berkley: 1965).

58. *Selected Writings of Walter Pater,* p. 110-11.

59. The idea of spirit being translated into particles of matter fascinated Pater. See the description of Mona Lisa in *The Renaissance,* and of Ronsard, in *Gaston de Latour.*

60. Pater, *Appreciations,* p. 106.

61. Ibid., "Style," p. 14.

62. Ibid., "Style," p. 22.

63. Pater, *Plato and Platonism,* p. 37. Anthony Ward compares the description of literary power in this passage to "Mallarmé's employment of French" (*The Idea of Nature,* p. 188).

64. Pater, *Gaston de Latour,* p. 70.

65. Pater, *Appreciations,* "Style," p. 112.

66. Pater, *Appreciations,* "Style," p. 112-13.

67. Pater, *Appreciations,* "Style," pp. 113-14.

68. Pater, *Greek Studies,* p. 3.

69. For a complete discussion of Pater's use of the Mona Lisa as an *anima* figure see Mario Praz, *The Romantic Agony* (London and New York: 1951). The Mona Lisa is linked by Pater to the "daughters of Herodias." As a psychological symbol she is comparable to Mallarmé's Hérodiade, also a Salome figure. Mallarmé has even compared the first section of *Hérodiade* to "une peinture de Léonard."

70. Monsman says "imaginary portraiture is the attempt to isolate some cultural phase . . . The projection of this single figure against the background of humanity is the sort of artistic relief work which constitutes imaginary portraiture." Gerald Monsman, *Pater's Portraits* (Baltimore: Johns Hopkins Press, 1967), p. 39.

71. Throughout the Symbolist period landscape was extended to include interiors. Just as painters were giving interiors more prominence in themselves and not simply as

indefinite background for figures, writers also used exteriors of houses as subjects: beginning with Baudelaire's search for artificial landscape, continuing in Mallarmé's dark rooms strangely alive with glowing objects, and finding the logical conclusion in the fantastic rooms of Des Esseintes' house.

72. Also in the "Rossetti" essay Pater restates this identity of house and body.

73. Pater seems to have been fascinated with the idea of a unique work of art. In the Giorgione essay he only attributes one painting to Giorgione, and he cites the example of Sordello and his single work. In literature he is intrigued by the notion of the "literary morsel," the single, choice phrase "lying among the books, though but for the eyes of one reader only, like a woman's ornament or a child's toy or a sea shell lying safe in the casket" ("An English Poet"). In his essay on Wordsworth he speaks of long, uninteresting compositions "with precious morsels lying hidden within,—the few perfect lines, the phrase, the single word . . ." (*Appreciations*, p. 39).

74. Saintsbury uses this phrase to describe the Mona Lisa passage (*A History of English Prose Rhythm*, p. 75).

Bibliography

Abrams, M.H. *The Mirror and the Lamp.* New York: W.W. Norton & Co., Inc., 1958.
_____ . "Review of Frank Kermode's *The Romantic Image,*" *Victorian Studies* 2 (1958): 75-79.
Amaud, Mario. *Art Nouveau.* London: Dutton Vista, 1966.
Audra, E. "L'Influence de Ruskin en France," *Revue des cours et conferences,* 27 (1926).
Autret, Jean. *L'Influence de Ruskin sur la vie, les idees et l'oeuvre de Marcel Proust.* Geneve, Ulle: Librairie Droz, Librairie Giard, 1955.
Babbit, Irving. *The New Laoköon.* Boston and New York: The Riverside Press, Cambridge, 1910.
Ball, Patricia. *The Science of Aspects: The Changing Role of Fact in the Work of Coleridge, Ruskin and Hopkins.* London: The Athlone Press, 1971.
Baudelaire, Charles. *The Mirror of Art.* Trans. Jonathan Mayne. New York: Garden City Books, 1955.
_____ . *Oeuvres complètes.* Ed. Y.G. Le Dantec et Claude Pichois. Paris: Gallimard, 1961.
_____ . *Paris Spleen.* Trans. Louise Varese. New York: New Directions, 1947.
_____ . *My Heart Laid Bare.* Ed. Peter Quennell, trans. Norman Cameron. New York: The Vanguard Press, 1951.
_____ . *Baudelaire as a Literary Critic, Selected Essays.* Trans. Francis and Lois Hyslop, Jr. University Park, Pennsylvania: The Pennsylvania State University Press, 1964.
_____ . *Curiosités esthétiques, l'art romantique.* Paris: Editions Garnier Frères, 1962.
Beckson, Karl, ed. *Aesthetes and Decadents of the 1890's.* New York: Vintage Books, 1966.
Beguin, Albert. *L'Ame romantique et le rêve.* Paris: Joseph Corti, 1946.
Bergson, Henri. *Introduction to Metaphysics.* New York: Wisdom Library, 1961.
Blin, George. *Le Sadisme de Baudelaire.* Paris: A. Colin, 1948.
Bonard, Olivier. *La Peinture dans la création balzacienne.* Genève: Librairie Droz, 1969.
Bonnet, Henri. *Marcel Proust de 1907 à 1914.* Paris: A. Nizet, 1971.
Bosanquet, Bernard. *A History of Aesthetic:* 1848-1923. London and New York: Allen and Unwin, Humanities Press, 1966.
Brzenk, Eugene J. "The Unique Fictional World of Walter Pater," *Nineteenth Century Fiction* 13 (December, 1958), 217-26.
Buckley, Jerome Hamilton. *The Victorian Temper; a Study in Literary Culture.* London: G. Allen and Unwin, 1952.
Bucknall, Barbara. *The Religion of Art in Proust.* Urbana: University of Illinois Press, 1970.
Butor, Michel. "Les 'Moments' de Marcel Proust" in *Essais sur les modernes.* Paris, 1964.
_____ . "The Imaginary Works of Art in Proust," *Inventory.* Trans. Richard Howard. New York: Simon Schuster, 1961.

————— . *Essais sur les modernes.* Paris, 1964.

————— . "Balzac et Réalité," *Repertoire.* Paris: Les Editions de Minuit, 1960.

Carré, Jean-Marie. "L'Italie de Goethe, de Ruskin et de Taine," *Revue de la littérature comparée* 25 (July-Sept. 1951): 301-10.

Chantal, Rene de. *Marcel Proust, Critique Littéraire.* Montreal, 1967.

Charlesworth, Barbara. *Dark Passages.* Madison and Milwaukee: The University of Wisconsin Press, 1965.

Chernowitz, Maurice E. *Proust and Painting.* New York: International University Press, 1945.

Clark, Kenneth. *The Gothic Revival, an Essay in the History of Taste.* London: Constable, 1950.

————— . *Landscape into Art.* London: Penguin Books, 1949.

————— . *Ruskin at Oxford.* Oxford: Clarendon Press, 1947.

————— . *Ruskin Today.* New York: Holt, Rinehart & Winston, 1965.

Cocking, J.M. *Proust.* London: Bones & Bones, 1956.

Cohn, Robert Greer. *Towards the Poems of Mallarmé.* Berkeley: University of California Press, 1965.

————— . *The Writer's Way in France.* Philadelphia: University of Pennsylvania Press, 1960.

Curtin, Frank D. "Ruskin in French Criticism," *PMLA* (March 1962).

Davie, Donald. *Ezra Pound: Poet as Sculptor.* New York: Oxford University Press, 1964.

Delacroix, Eugène. *The Journals.* Trans. Walter Pach. New York: Crown Publishers, 1948.

————— . *Journal Vols. I-III.* Ed. André Joubin. Paris: Librairie Plon, 1950.

Delattre, Floris. *Ruskin et Bergson: de l'intuition esthétique à l'intuition métaphysique.* Oxford: Clarendon Press, 1947.

Deleuze, Gilles. *Proust et les Signes.* Paris: Presses Universitaires de France, 1964.

Ellman, Richard. *The Artist as Critic.* New York: Random House, 1918.

Ferrère, E.L. *L'Esthétique de Gustave Flaubert.* Genève: Slatkine Reprints, 1967.

Fiser, Emeric. *Le Symbole Littéraire; essai sur la signification du symbole chez Wagner, Baudelaire, Mallarmé, Bergson et Marcel Proust.* Paris: J. Corti, 1941.

Flaubert, Gustave. *Correspondance.* Paris: Librairie de France, 1922-25.

Fletcher, Iain. "Walter Pater," *Writers and Their Work* Series, London: Longmans, Green, 1959.

Fowlie, Wallace. *Mallarmé.* Chicago and London: The University of Chicago Press, 1953.

Frank, Joseph. "Spatial Form in Modern Literature," *Sewanee Review* 53 (1945).

Fraser, G.S. *The Modern Writer and His World.* New York and Washington: Praeger, 1964.

Gage, John. *Color in Turner.* New York: Frederick A. Praeger, Inc., 1969.

Gautier, Théophile. *Mademoiselle du Maupin.* Paris: Garnier- Flammarion, 1966.

Gilman, Margaret. *Baudelaire, the Critic.* New York: Columbia University Press, 1943.

————— . *The Idea of Poetry in France.* Cambridge: Harvard University Press, 1958.

Girard, René, ed. *Proust.* New Jersey: Prentice-Hall, Inc., 1962.

Gombrich, E.H. *Art & Illusion.* New York: Bollinger Foundation, 1965.

Hafley, James. "Walter Pater's 'Marius' and the Technique of Modern Fiction," *Modern Fiction Studies* 3 (Summer, 1957), 99-109.

Hagstrum, Jean H. *The Sister Arts.* Chicago: University of Chicago Press, 1958.

Hall, James B. and Ulanov, Barry. *Modern Culture and the Arts.* New York: McGraw-Hill, 1972.

Harrison, Frederic. *John Ruskin.* New York: Macmillan, 1966.

————— . *Tennyson, Ruskin, Mill.* London: Macmillan Co., 1902.

Harrison, J.S. "Pater, Heine, and the Old Gods of Greece," *PMLA* 39 (September 1924): 655-86.

Hartman, Geoffrey. *The Unmediated Vision: An Interpretation of Wordsworth, Hopkins, Rilke, and Valéry.* New Haven: Yale University Press, 1954.

Hauser, Arnold. *Mannerism: the Crisis of the Renaissance and the Origin of Modern Art.* New York: Knopf, 1965.

Hartley, Anthony, ed. *Mallarmé.* Baltimore: Penguin Books, 1965.

Hayman, David. *Joyce et Mallarmé.* Paris: Lettres Modernes, 1956.

Hindus, Milton. *A Reader's Guide to Marcel Proust.* Toronto: The Noonday Press, 1962.

_____ . *The Proustian Vision.* New York: Columbia Press, 1954.

Hough, Graham. *Image and Experience: Studies in a Literary Revolution.* London: G. Duckworth, 1960.

_____ . *The Last Romantic.* London, New York: University Paperbacks, 1961.

_____ . *The Romantic Poets.* London: Hutchinson, 1953.

Hunt, John Dixon. *The Pre-Raphaelite Imagination.* Lincoln: University of Nebraska Press, 1968.

Hunter, Sam. *Modern French Painting.* New York: Dell Publishing Co., Inc., 1956.

Hussey, Christopher. *The Picturesque.* London: G.P. Putnam's Sons, 1927.

Jephcott, E. *Proust and Rilke.* London: Chatto and Windus, 1972.

Joyce, James. *A Portrait of the Artist as a Young Man.* New York: Viking Press, 1956.

Julian, Philippe. *Dreamers of Decadence.* Trans. Robert Baldice. London: Pall Mall Press, 1971.

Kenner, Hugh. *The Pound Era.* Berkeley and Los Angeles: University of California Press, 1971.

Kermode, Frank. *Romantic Image.* New York: Vintage Books, 1957.

Ladd, Henry Andrews. *The Victorian Morality of Art: An Analysis of Ruskin's Esthetic.* New York: R. Long & R.R. Smith, 1932.

Landow, George. *The Aesthetic and Critical Theories of John Ruskin.* Princeton, New Jersey: Princeton University Press, 1971.

Lang, Cecil Y. *The Pre-Raphaelites and Their Circle.* Boston: Houghton Mifflin Co., 1968.

Langer, Suzanne K. *Problems of Art, Ten Philosophical Lectures.* New York: Scribner, 1957.

Lanson, Gustave. *L'Art de la prose.* Paris: Librairie des Annales, 1908.

Lee, Rensselaer Wright. *Ut Pictura Poesis: The Humanistic Theory of Painting.* New York: W.W. Norton, 1967.

Lehmann, A.G., *The Symbolist Aesthetic in France.* Oxford: Blackwell, 1950.

Lemaitre, Henri. *La Poésie depuis Baudelaire.* Paris: A. Colin, 1965.

_____ . "L'Influence de Ruskin sur l'art de Marcel Proust," *Pyrenées* (1944). Toulouse: Didier.

Lessing, Gotthold Ephraim. *Laocoon: An Essay Upon the Limits of Painting and Poetry.* Trans. Ellen Frothingham, Boston: Roberts Brothers, 1890.

Levin, Harry. *Contexts of Criticism.* New York: Atheneum, 1963.

Levine, George, and William Madden. *The Art of Victorian Prose.* New York: Oxford University Press, 1968.

Lowery, Bruce. *Proust et James.* Paris: Plon, 1964.

Mauron, Charles. *Mallarmé par lui-même.* Paris: Editions du Seuil, 1961.

McDowell, Frederick P.W. *The Poet as Critic.* Evanston: Northwestern University Press, 1967.

Merleau-Ponty, Maurice. *The Prose of the World.* Trans. John O'Neill. Evanston: Northwestern University Press, 1973.

Michaud, Guy. *Message poétique du symbolisme.* Paris: Nizet, 1947.

Miles, Josephine. "Pathetic Fallacy in the Nineteenth Century: A Study of a Changing

Relation Between Object and Emotion." *Publications in English.* Berkeley and Los Angeles: University of California Press, 1942.

Milly, Jean. *Proust et le Style.* Paris: Minard, 1970.

Monnin-Hornung, Juliette. *Proust et la peinture.* Genève: Librairie E. Droz, 1951.

Monsman, George Cornelius. *Pater's Portraits.* Baltimore: The Johns Hopkins Press, 1967.

Morris, William. *Three Works.* New York: International Publishers, 1968.

Moss, Howard. *The Magic Lantern of Marcel Proust.* New York: MacMillan, 1962.

Mouton, Jean. *Le Style de Marcel Proust.* Paris: Nizet, 1968.

Muir, Edwin. *The Structure of the Novel.* London: The Hogarth Press, 1963.

Panofsky, Erwin. *Meaning in the Visual Arts.* New York: Doubleday & Co., 1955.

Pater, Walter. *Appreciations.* London: Macmillan & Co., 1900.

————. *Gaston de Latour.* New York: The Macmillan Co., 1896.

————. *Greek Studies.* New York, London: The Macmillan Co., 1897.

————. *Greek Studies.* New York, London: The Macmillan Co., 1903.

————. *Imaginary Portraits.* New York: Harper & Row, 1964.

————. *Marius, the Epicurean.* London, New York: Everyman's Library, 1968.

————. *Miscellaneous Studies.* London: Macmillan & Co., 1924.

————. *The Renaissance.* London: Macmillan & Co., 1914.

————. *Plato and Platonism.* London: Macmillan & Co., 1925.

Paxton, Norman. *The Development of Mallarmé's Prose Style.* Genève: Librairie Droz, 1968.

Pelles, Geraldine. *Art, Artists and Society: Origins of a Modern Dilemma; Painting in England and France, 1750-1850.* Englewood Cliffs, N.J.: Prentice-Hall, 1963.

Poulet, Georges. *L'Espace proustien.* Paris: Gallimard, 1963.

Pratt, William. *The Imagist Poem.* New York: E.P. Dutton & Co., Inc., 1963.

Praz, Mario. *The Romantic Agony.* London, New York: Oxford University Press, 1951.

Proust, Marcel. *Contre Sainte-Beuve.* Paris: Gallimard, 1954.

————. *Pastiches et mélanges.* Paris: Gallimard, 1919.

————. *Sésame et le lys.* (translation of Ruskin's *Sesame and Lilies* with footnotes and introduction by Proust). Paris: N.R.F., 1906.

————. *A la recherche du temps perdu* (vol. 1-3). Paris: Gallimard, 1954.

————. *Contre Sainte-Beuve précédé de Pastiches et mélanges.* Paris: Gallimard, 1971.

————. *On Art and Literature.* Trans. Sylvia Townsend Warner. New York: Meridian Books, 1958.

————. *Pleasures and Days and Other Writings.* Ed. F.W. Dupee, trans. Louise Varese, Gerard Hopkins and Barbara Dupee. New York: Howard Fertin, 1978.

————. *On Reading.* Trans. and ed. Jean Autret, William Burford. New York: Macmillan, 1971.

————. *Remembrance of Things Past* vols. 1 and 2, Trans. C.K. Scott-Moncrieff. (*The Past Recaptured* trans. Frederick Blossom). New York: Random House, 1934.

Quennel, Peter. *John Ruskin.* London and New York: Longmans, Green, 1956.

————. *Ruskin: Portrait of a Prophet.* New York: Viking, 1949.

————. *Marcel Proust, 1871-1922: A Centennial Volume.* New York: Simon and Schuster, 1971.

Raymond, Marcel. *De Baudelaire au surréalisme.* Paris: Joseph Corti, 1966.

Reynolds, Graham. *Constable, the Natural Painter.* London: Cory, Adams & Mackay, Ltd., 1965.

————. *Turner.* New York: Harry N. Abrams, 1969.

Richard, Jean-Pierre. *Poésie et profondeur.* Paris: Editions du Sevil, 1955.

Rosenberg, John D., ed. *Swinburne: Selected Poetry and Prose.* New York: Modern Library, 1968.

Rothenstein, Sir John. *Turner*. London: Old Oldbourne Book Co., Ltd., 1962.

Ruff, M.A. *Baudelaire: connaissance des lettres*. Paris: Hatier, 1966.

Ruff, Marcel. *L'esprit du mal et l'esthétique baudelairienne*. Paris: A. Colin, 1955.

Ruskin, John. *The Complete Works. Volume 1, Seven Lamps of Architecture*. New York: Thomas Y. Crowell & Co.

————. *The Complete Works. Volume 2, Stones of Venice*. New York: Thomas Y. Crowell & Co., 1885.

————. *The Genius of John Ruskin*. Ed. John D. Rosenberg. Boston: Houghton Mifflin Co., 1963.

————. *Modern Painters*, vols. 1-5. New York: John Wiley & Sons, 1880.

————. *The Works of John Ruskin*. Ed. Cook and Wedderburn. Vol. 35, *Praeterita and Dilecta*. London: George Allen, 1908.

————. *The Works of John Ruskin*. Ed. Cook and Wedderburn. Vol. 33, *The Bible of Amiens*. London: George Allen, 1908.

————. *The Works of John Ruskin*. Ed. Cook and Wedderburn. Vol. 15, *The Elements of Drawing*. London: George Allen, 1908.

Saintsbury, George. *A Short History of English Literature*. New York and London: Macmillan, 1929.

————. *A History of English Prose Rhythm*. London: Macmillan, 1912.

Shattuck, Roger. *Proust's Binoculars*. New York: Random House, 1963.

Stanford, Derek, ed. *Aubrey Beardsley's Erotic Universe*. London: A Four Square Book, 1967.

Starkie, Enid. *Baudelaire*. Norfolk, Conn.: New Directions, 1958.

————. *From Gautier to Eliot: The Influence of France on English Literature, 1851-1939*. London: Hutchinson, 1960.

Steiner, George. *Language and Silence*. New York: Atheneum, 1967.

————. *After Babel*. New York: Oxford University Press, 1977.

Stokes, Adrian. *Painting and the Inner World*. London: Tavistock Publications, 1963.

Strauss, Walter. *Proust and Literature; The Novelist as Critic*. Cambridge, Mass.: Harvard Press, 1957.

Symons, Arthur. *The Symbolist Movement in Literature*. New York: E.P. Dutton and Co., Inc., 1958.

Sypher, Wylie. *Rococo to Cubism*. New York: Vintage Books, 1960.

Tadié, Jean-Yves. *Proust et le roman*. Paris: Gallimard, 1971.

Taine, Hippolyte. *Histoire de la littérature anglaise*. Paris: Hachette, 1911.

Taupin, Rene. *L'influence du symbolisme français sur la poésie américaine [de 1910 à 1920]*. Paris: Librairie Ancienne Honoré Champion, 1929.

Temple, Ruth. *The Critic's Alchemy—A Study of the Introduction of French Symbolism into England*. New York: Twane Publishers, 1953.

Tindall, William York. *The Literary Symbol*. Bloomington: Indiana University Press, 1955.

Turnell, Martin. *The Novel in France*. New York: Vintage Books, 1951.

Ward, Anthony. *Walter Pater: The Idea in Nature*. London: Ebenezer Baylis & Son., Ltd., 1966.

Wilson, Edmund. *Axel's Castle*. New York: Charles Scribner's Sons, 1931.

Yeats, William Butler. *Essays and Introductions*. London: Macmillan & Co., 1961.

Index